The Pop Art TRADITION

Responding to Mass-Culture

Eric Shanes

Text: Eric Shanes

Layout: Baseline Co Ltd, 127-129A Nguyen Hue
Fiditourist, 3rd floor, District 1, Ho Chi Minh City
Vietnam

© 2006, Parkstone Press International, New York, USA
© 2006, Confidential Concepts, Worldwide, USA

Published in 2007 by Grange Books
an imprint of Grange Books Plc
The Grange Kingsnorth Industrial Estate
Hoo, nr Rochester, Kent ME3 9ND
www.grangebooks.co.uk

ISBN 13: 978-1-84013-888-7

Printed in Malaysia

The *Pop Art* TRADITION

Responding to Mass-Culture

Eric Shanes

For John Gage,
friend and mentor

CONTENTS

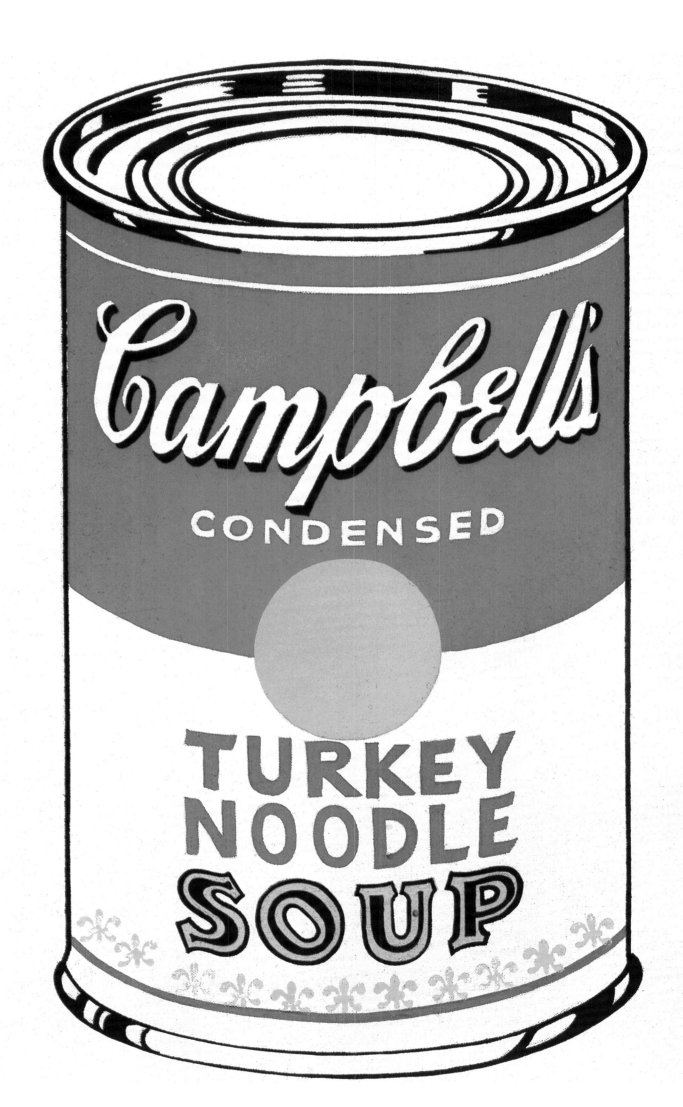

FOREWORD

Since the late-1950s a new tradition has emerged in Western art. Although its initial phase lasting between about 1958 and 1970 was quickly dubbed 'Pop Art', that label has always been recognised as a misnomer, for often it has served to obscure far more than it clarified. If anything, the tradition incepted in the late-1950s should be named 'Mass-Culture Art', for when the British critic Lawrence Alloway coined the phrase 'Pop' in 1958, he was not applying the term to any art yet in existence, let alone to a rebellious youth-orientated 'Pop' culture which was only then in its infancy but which use of the word 'Pop' now tends to suggest (and to do so in an increasingly dated manner). Instead, he was writing about those rapidly increasing numbers of people across the entirety of western society whose very multitudinousness and shared values were causing new forms of cultural expression to come into existence and for whom increasing affluence, leisure and affordable technology were permitting the enjoyment of mass-culture. As we shall see, the central preoccupation of so-called Pop Art has always been the effects and artefacts of mass-culture, so to call the tradition Mass-Culture Art is therefore more accurate (although to avoid art-historical confusion, the term 'Pop' has been retained as a prefix throughout this book). Moreover, mass-culture in all its rich complexity has inspired further generations of artists whom we would never link with Pop Art, thus making it vital we should characterise the tradition to which both they and the 1960s Pop Artists equally contributed as Mass-Culture Art, for otherwise it might prove well-nigh impossible to discern any connection between these groups of artists separated by time and place. The aims of this book are therefore fourfold: to cut across familiar distinctions regarding what is or is not 'Pop Art' by enhancing the latter term; to explore the tradition of Pop/Mass-Culture Art and its causes; to discuss its major contributors; and to examine a representative number of works by those artists in detail.

Andy Warhol, *Campbell's soup (Turkey Noodle),* 1962. Silkscreen ink on canvas, 51 x 40.6 cm. Sonnabend collection.

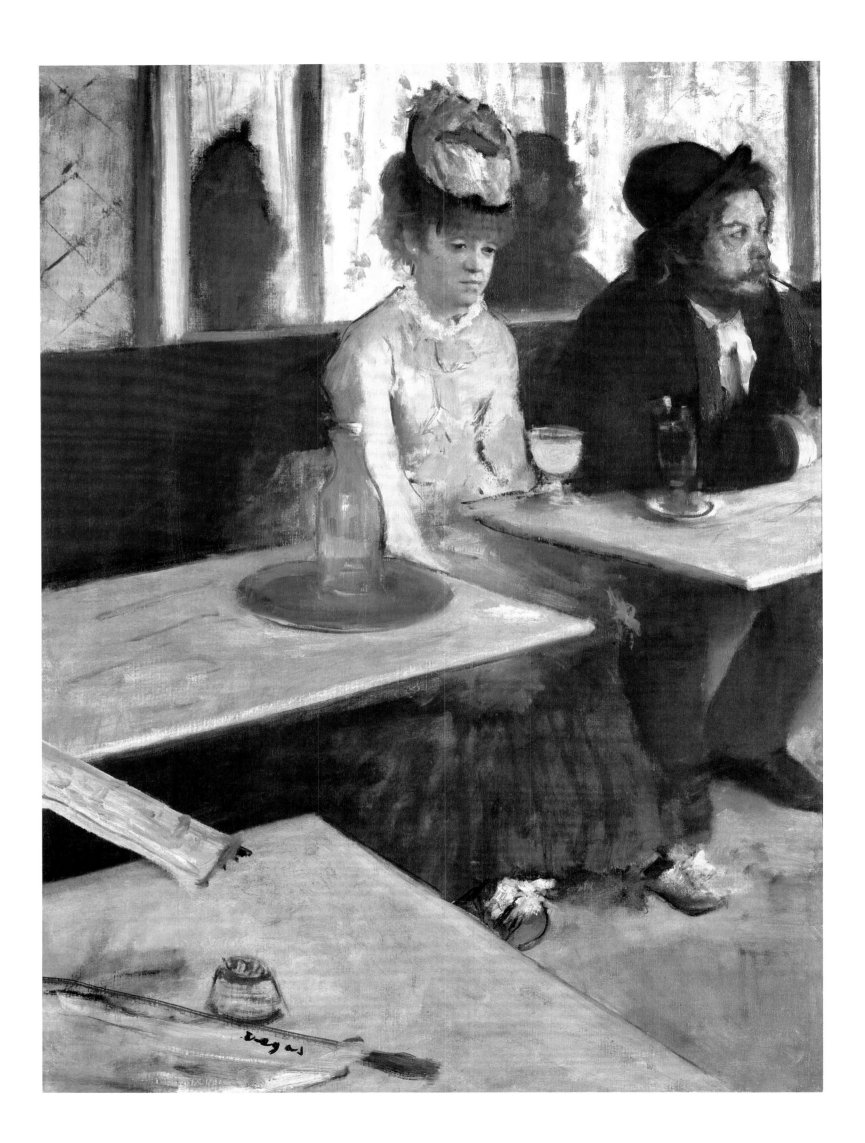

POP / MASS-CULTURE ART

The rise of popular mass-culture was historically inevitable, as was the advent of an eventual response to it in art. We are still living through the modern technological and democratic epoch that began with the British Industrial Revolution and the American and French Revolutions of the late-eighteenth century. As industrialisation and democratisation have spread, increasing numbers of people have gradually come to share in their benefits: political participation, rewarding labour, heightened individualism, and better housing, health, literacy, and social and physical mobility. Yet at the same time a high price has frequently been paid for these advances: a political manipulation often rooted in profound cynicism and self-interest; vast economic exploitation; globalisation and the diminution of national, regional or local identity; meaningless and unfulfilling labour for large numbers; growing urbanisation; the industrialisation of rural areas, which has grossly impinged upon the natural world; industrial pollution; and the widespread loss of spiritual certainty which has engendered a compensatory explosion of irrationalism, superstition, religious fanaticism and fringe cults, hyper-nationalism, quasi-political romanticism and primitive or industrialised mass-murder, as well as materialism, consumerism, conspicuous consumption and media hero-worship. All of these and manifold other developments have necessarily involved the institutions, industrial processes and artefacts created during this epoch, although not until the emergence of Pop/Mass-Culture Art in the late-1950s did artists focus exclusively upon the cultural tendencies, processes and artefacts of the era.

When Lawrence Alloway wrote of 'Pop' in 1958, he belonged to a circle within the Institute of Contemporary Arts in London called the Independent Group. Its members were artists, designers, architects and critics who had come to recognise that by the mid-twentieth century the enormous growth of popular mass-culture and its characteristic forms of communication needed to be addressed – it was not enough snobbishly to consign such matters to the dustbin of lowbrow taste. Naturally, it is only in the modern technological epoch that those wishing to appeal to the growing numbers of consumers of the products of industrialisation have increasingly possessed the large-scale means of doing so. The newspaper printing press, the camera, the radio, celluloid and the film projector, the television set and other mass-communicative technologies right down to those of our own time that make their predecessors look exceedingly primitive (and which supplant their forerunners with increasing rapidity), have each produced fresh types of responses and thus new kinds of visual imagery, all of which obviously constitute highly fertile ground for the artist and designer to explore. Moreover, popular mass-culture possesses energy and potency, and very often its means of transmission such as the cinematic or televisual image, the advertisement, and the poster and magazine illustration, enjoys an immediacy of communication that is not shared by works of greater intellectual complexity: you have to labour a little harder to appreciate, say, the plays of Shakespeare, the symphonies of Beethoven and the canvases of Rembrandt than you do the average Hollywood movie, pop record or billboard poster. So in the 1950s, a decade which saw recovery from war and a growing sense of materialistic well-being in the western world, the Independent Group's suggestion that artists and designers should draw upon the energy, potency and immediacy of mass-culture proved most timely. Indeed, the very relevance of their notions explains why so many other creative figures further afield soon arrived at exactly the same conclusions independently of the British group and, indeed, even of each other.

Because of this unconnected arrival at the same conclusions, in the main Pop/Mass-Culture Art was never a movement as such, for although in Britain some of the artists who followed its ethos exchanged ideas during the period of its inception, that was not the case in the United States where very few of the participatory artists were ever in close contact with one another. It is therefore perhaps more accurate to describe Pop/Mass-Culture Art as a cultural dynamic rather than a movement. Certainly it was one made ready by historical factors to be born in the late-1950s, although it had been preceded by many forerunners.

Edgar Degas, *In a Café*, c. 1876.
Oil on canvas, 92 x 68 cm. Musée d'Orsay, Paris.

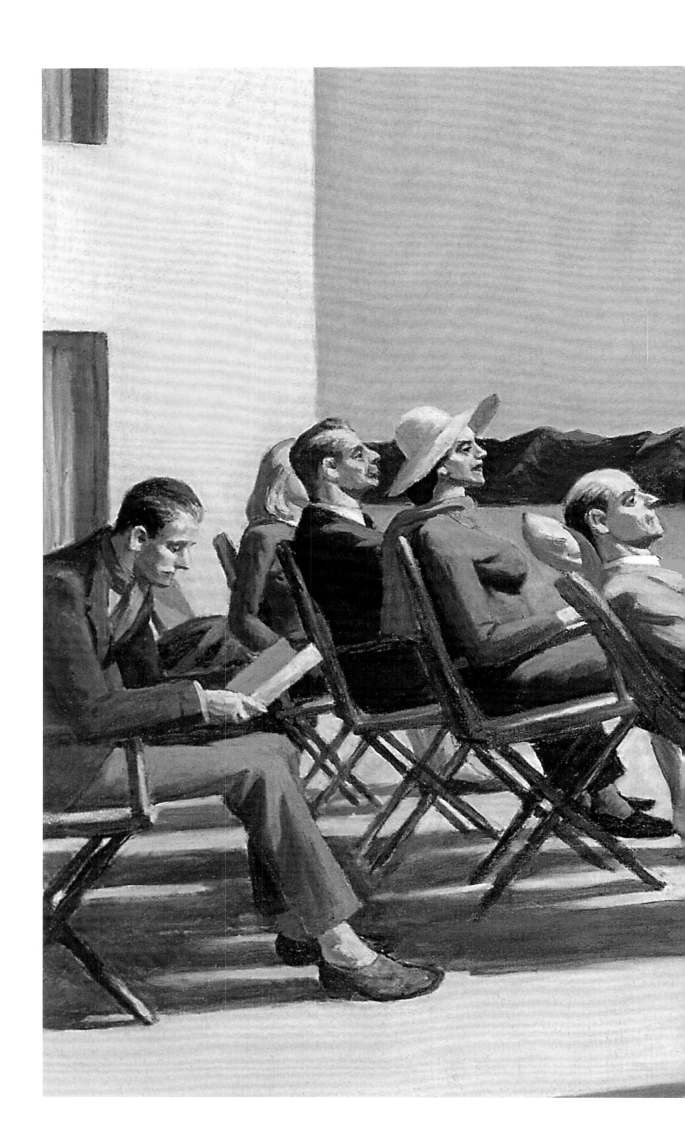

Edward Hopper, *People in the Sun*, 1960.
Oil on canvas, 102.6 x 153.4 cm.
Smithsonian American Art Museum,
Washington, D.C.

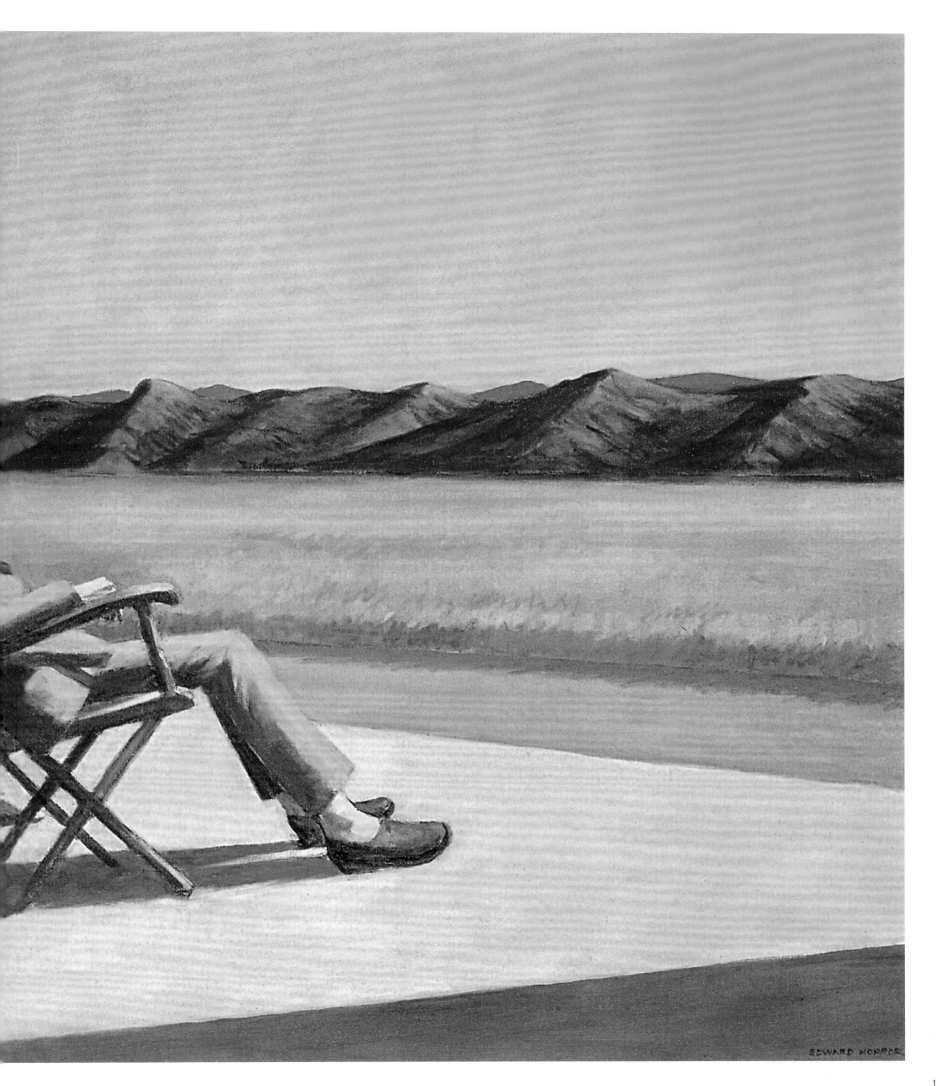

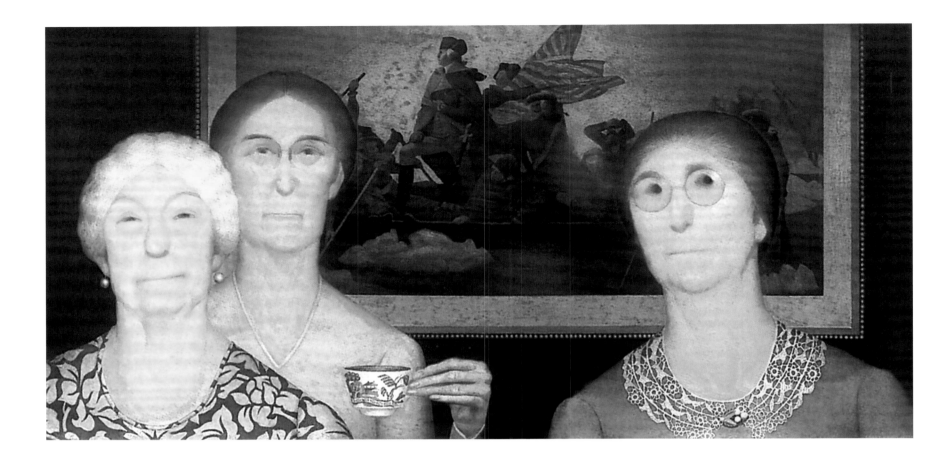

Forerunners of Pop/Mass-Culture Art

Naturally, large numbers of artists, right up to the mid-twentieth century, had dealt with humanity *en masse*. Among those who did so most memorably were the eighteenth to nineteenth-century painters Francisco de Goya, J.M.W. Turner and David Wilkie, all three of whom often depicted ordinary people at work and play. The latter two also created consciously 'low-life' subjects by representing the common people in their humble dwellings, pubs and at village fairs, thereby revitalising a tradition going back to sixteenth- and seventeenth-century painters such as Pieter Bruegel the Elder, Adrian van Ostade and David Teniers the Younger. Later in the nineteenth century Gustave Courbet, Edouard Manet and Edgar Degas, among others, also looked to the life of common humanity for inspiration, as in the latter artist's superb study of alienation, *In a café* of around 1876 (page 8). This depicts a seemingly hard-hearted man and brutalised woman mentally isolated from one another and spatially separated from us. And Degas was a major influence upon two important painters who addressed popular culture directly: Walter Sickert and Edward Hopper.

Sickert openly followed in the footsteps of Degas the painter of mass-entertainments such as café-concerts and circus life by portraying music-hall scenes and pier-side amusements; later in life he developed scores of canvases from newspaper photos in which he emulated the blurring and graininess of the newsprint almost as much as he represented the images it originally projected. Hopper was inspired by Degas (especially *In a Café*, which he knew through a 1924 book reproduction) to open up the entire subject of urban loneliness, *anomie* and alienation, those negative effects of mass-society and mass-culture. Towards the end of his life, in *People in the Sun* (pages 10-1), he even addressed the hedonistic mass sun-worship that has become such a central feature of modern existence.

In *People in the Sun* Hopper's sunbathers typify a cultural trend. Another artist to create such typifications, but much earlier and with far more satirical bite, was Grant Wood who in 1930 created arguably his most renowned image, *American Gothic* (see opposite). Here an apparently typical mid-western farmer dressed in denim stands alongside his wife clad in homespun. Behind them is their simple dwelling, with its gothic-inspired arched window. Together they embody the God-fearing, puritanical values of Middle America. Similarly, in 1932 Wood gave us *Daughters of Revolution* (see above) in which three daunting matrons doubtless belonging to a neo-conservative organisation, the Daughters of the American Revolution, stand before a revered icon of their nationalism, Emanuel Leutze's 1851 canvas, *Washington Crossing the Delaware* (page 73).

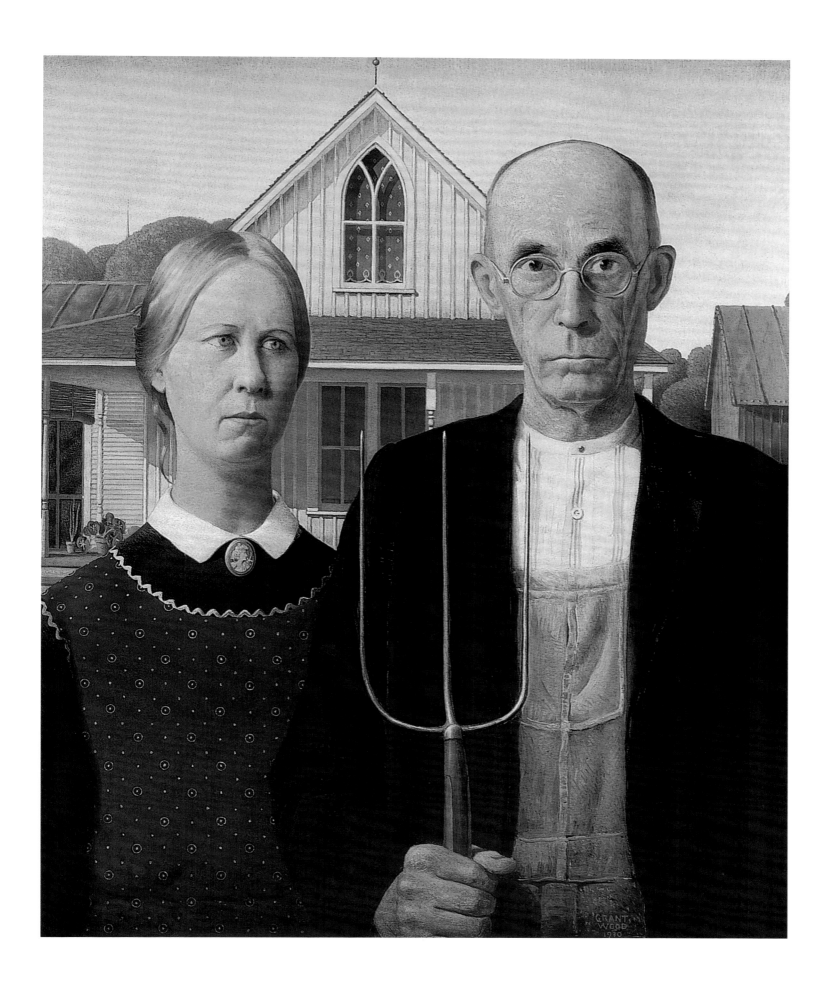

Grant Wood, *American Gothic*, 1930.
Oil on board, 73.6 x 60.5 cm.
The Art Institute of Chicago, Chicago.
American Gothic, 1930 by Grant Wood
All rights reserved by the Estate of Nan Wood
Graham/ Licensed by VAGA, New York, NY

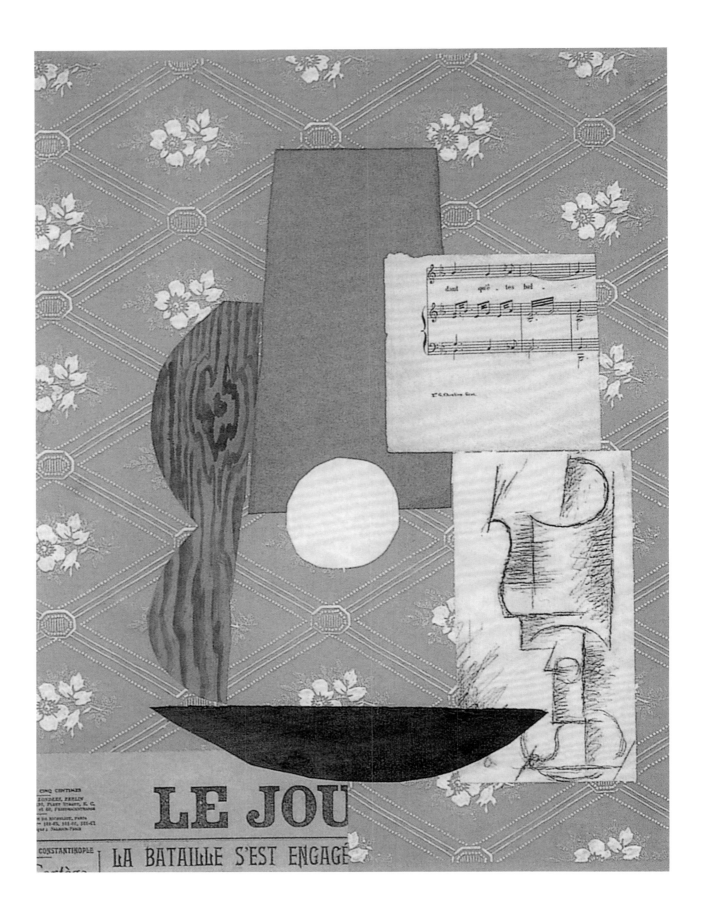

Like earlier painters of 'low' humanity such as Wilkie, Degas and Hopper, Wood represented ordinary life as it is lived, rather than as it is indirectly reflected through the prism of the mass-communications media. Undoubtedly the first artists to treat of the associations of those media and of the popular mass-culture they served were Georges Braque and Pablo Picasso. In 1911 Braque started imitating stencilled lettering in his paintings. This necessarily invokes associations of mass-production, for stencilled lettering is very 'low culture' indeed, being primarily found on the sides of packing crates and the like where identifications need to be effected quickly and without any aesthetic refinement whatsoever. By pasting newspapers and the sheet-music of popular songs into his images around 1912-13, Picasso not only virtually invented collage as a new creative vehicle but necessarily opened up the links between art and the mass-communications media.

Picasso's new artistic channel, as illustrated in *Guitar, Sheet-music and Glass* (see opposite), prompted large numbers of other artists such as Georg Grosz, Raoul Hausmann and Kurt Schwitters to incorporate photographs, scientific diagrams, maps and the like into their images. One or two of these works, such as a Schwitters collage of 1947, would even include comic-strip images (page 16). Another German artist, John Heartfield, invented a new art form, the photo-collage, in which much of the material was taken from newspapers. As a result it necessarily included humanity *en masse*.

Heartfield began to open up this new visual territory using pre-existent material from the early-1920s onwards, and by that time a French-born painter resident in the United States since 1915, Marcel Duchamp, had already created a number of 'ready-mades' or sculptures that appropriated industrially mass-produced objects. Whether used alone or in amalgamation with each other, such artefacts not only created new overall forms but simultaneously typified aspects of industrialised society. Perhaps the most notorious of these 'ready-mades' was *Fountain* (page 17) of 1917, which was simply a ceramic urinal purchased from a hardware store. Duchamp intended to exhibit the work in a vast New York exhibition he had been instrumental in setting up in 1917. A major motivation underlying this show was democratic access (all the thousands of works submitted to it were automatically displayed), and this at a time when democracy was very much in the news because of impending American entry into the First World War. Ultimately Duchamp's wittily-titled pisspot made a wholly valid point about shared human activity, for all people everywhere have need of urinals from time-to-time. Democracy indeed.

According to Duchamp (or initially at least), a major reason he had chosen to exhibit such an article was to raise it to the status of an art-object by forcing us to recognise the inherent beauty of a mass-produced artefact which normally provokes no aesthetic response whatsoever. This was a doubly clever ploy, for although *Fountain* was probably destroyed in the early 1920s because Duchamp set no value upon it, the piece certainly got him talked about, an increasingly vital requirement for any artist in the age of mass-communications. (Later, in the 1950s, Duchamp denied he had wanted his *objet trouvé* to give pleasure to the eye, while simultaneously he created a number of replicas of the artefact to sell to museums clamouring to own such an infamous attack upon art. Like many a creative figure before and since, he therefore had his cake and ate it). Ultimately Duchamp's *Fountain*, like his other 'ready-mades', completely broke down the distinction between the work of art as crafted object and the work of art as mass-produced artefact. In doing so it necessarily democratised the entire notion of being an artist, for by means of the selfsame process by which a urinal became *Fountain* – 'it is a work of art simply because I proclaim it to be such' – thereafter anyone could become an artist (and quite a few have followed that course ever since). For better or for worse, but mainly for the latter, the democratisation that stands at the very heart of the modern technological, mass-cultural epoch perhaps inevitably began to flood into the field of the visual arts on a massive scale with Duchamp's 'ready-mades', and especially with *Fountain*.

Apart from any aesthetic thinking, sensory pleasures and moral outrage Duchamp's object undeniably sparked in 1917 (and still generates by means of its museum replicas), the manner in which it had originally come into being made it automatically act as a signifier of mass-production more generally. Such a process of objects functioning as signifiers would become central to Pop/Mass-Culture Art, as we shall see. But *Fountain* was not the only precursor in this sphere. From the mid-1910s onwards, and directly as a result of

Pablo Picasso, *Guitar, sheet-music and glass*, 1912. Pasted papers, gouache and charcoal on paper, 48 x 36.5 cm. Marion Koogler McNay Art Institute, San Antonio, Texas.

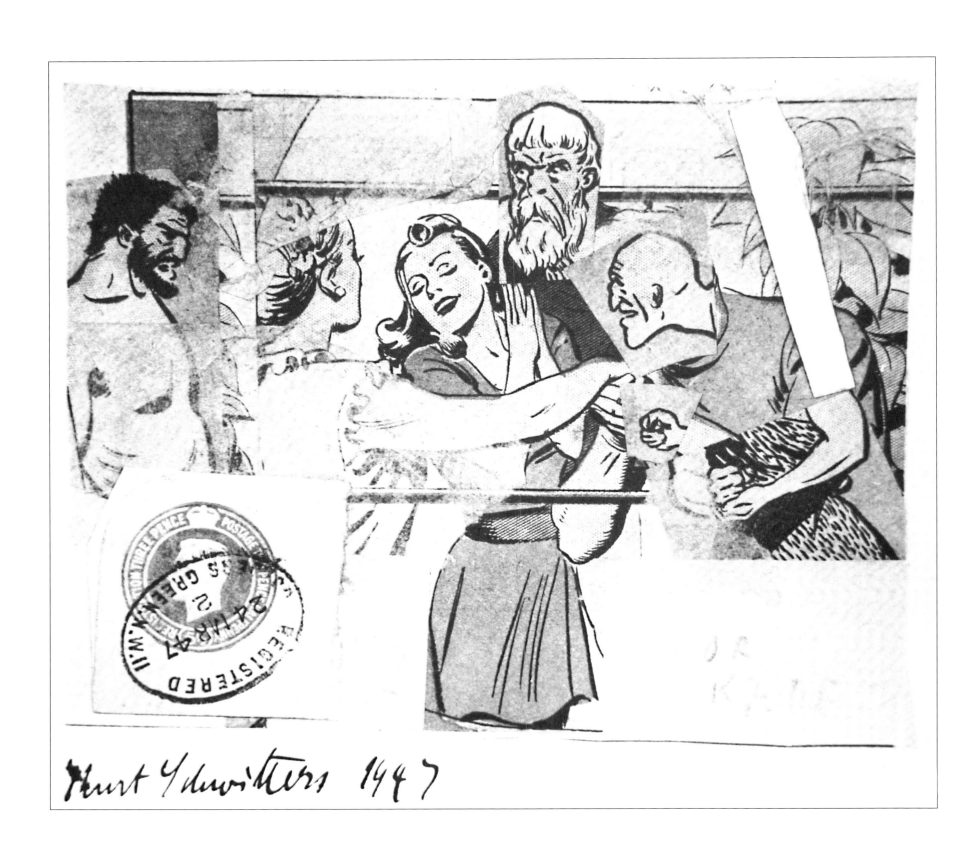

Kurt Schwitters, *For Käte*, 1947.
Paper collage, 10.5 x 13 cm.
Pasadena Art Museum, California.

Marcel Duchamp, *Fountain*, 1917.
Photograph by Alfred Steiglitz from *The Blind Man*,
May 1917. Philadelphia Museum of Art,
Louise and Walter Arensberg collection.

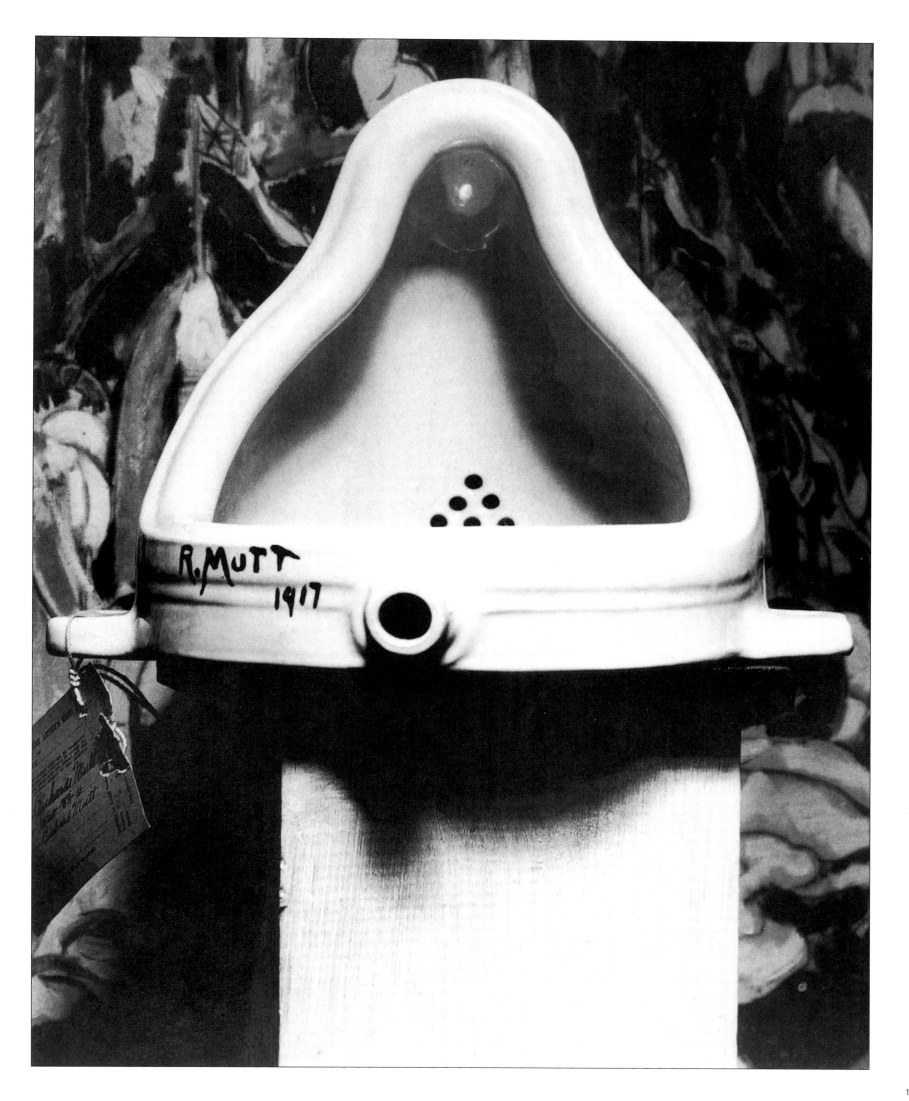

the influence of Picasso's Cubist explorations, artists often depicted objects taken from mass-culture, not to demonstrate their cleverness in emulating the appearances of things, but instead to draw upon the familiarity of the objects they represented as national or cultural signifiers.

To take national signification first, in 1914-15 (and thus during the First World War) the American painter Marsden Hartley employed flags in several of his canvases, while in oils like his *Portrait of a German Officer* (page 23) he did so to denote a military personage, as his title informs us. Cultural signification is especially apparent in early works by the American painter Stuart Davis, who around 1924 created pictures depicting or incorporating Lucky Strike cigarette packs and the *Evening Journal* sports page (pages 20-1) or the Odol bathroom disinfectant. As with Picasso's earlier incorporations of cigarette packs and wine-bottle labels, Davis's imagery hints at a throwaway culture. In the early-1950s the painter would return to mass-communications imagery, fusing abstractive and highly colourful patterning that derived stylistically from late Matisse, with slogans and phrases taken from advertising, supermarket signs and retail exhortations to consume (see opposite). Such images certainly put Davis in the forefront of the growing wave of artists who would prove responsive to mass-culture.

Another painter who had grown increasingly aware of mass-culture was the Surrealist painter, Salvador Dalí. The invasion of France in 1940 had forced him to flee to the United States, and the eight years he lived there affected him deeply, for he was thoroughly exposed to American mass-culture. Not least of all he came into contact with the Hollywood movie industry, designing a film sequence for Alfred Hitchcock and developing a cartoon for Walt Disney (although that short would not be completed and shown until 2003, more than thirteen years after the painter's death). Dalí especially wanted to create cartoons because he felt they articulated the psychology of the masses. Dalí's American years undoubtedly made him more populist, more aware of the ability of the media to communicate on a vast scale, and more conscious of the power of money. He returned there most years after 1948, in the mid-1960s not only becoming friendly with Andy Warhol but even undertaking a screen test for him. Slightly later he created a very witty image that stands at the frontier between Surrealism and Pop/Mass-Culture Art (page 22). This is a fusion of two faces, one of which had already figured importantly in Warhol's work, while the other was just about to do so.

Early Pop/Mass-Culture Art in Britain

During the late-1940s a further artist deeply influenced by Surrealism strongly anticipated Pop/Mass-Culture Art. This was the British sculptor Eduardo Paolozzi, who would subsequently become a key member of the Independent Group. In 1949 Paolozzi embarked upon a set of highly inventive and witty collages bringing together popular magazine covers, adverts, 'cheesecake' photos and the like (page 72). Everywhere the banality of the imagery interested him, although in 1971 he was careful to point out that "It's easier for me to identify with [the tradition of Surrealism] than to allow myself to be described by some term, invented by others, called 'Pop', which immediately means that you dive into a barrel of Coca-Cola bottles. What I like to think I'm doing is an extension of radical surrealism." Surrealism was an exploration of the subconscious and clearly, by the late-1940s that part of Paolozzi's mind readily absorbed the imagery of popular culture. Subsequently, in the mid-1950s, he would make inventive collages incorporating diagrammatic machine images (page 24) that would again clearly point to things-to-come.

Paolozzi was not the only artist working in Britain who intuited the future. In 1956 the painter Richard Hamilton created a poster-design collage bearing the ironic title *Just what is it that makes today's homes so different, so appealing?* (page 74), which brings together many of the images and objects soon to be explored by others. They include household artefacts in abundance, such as a television set supposedly projecting the image of a stereotypically 'perfect' face; banal 'cheesecake' and 'beefsteak' nudes or semi-nudes; a trite *Young Romance* comic-strip image, apparently enlarged in relationship to its surroundings and framed to hang on the wall; a traditional portrait accompanying it on the wall; a corporate logo adorning a lampshade; and an image of a superstar, in this case Al Jolson seen in the distance. A paddle carried by the Charles Atlas figure bears the word 'POP'.

Stuart Davis, *Premiere*, 1957.
Oil on canvas, 147 x 127 cm.
Los Angeles County Museum of Art, California.

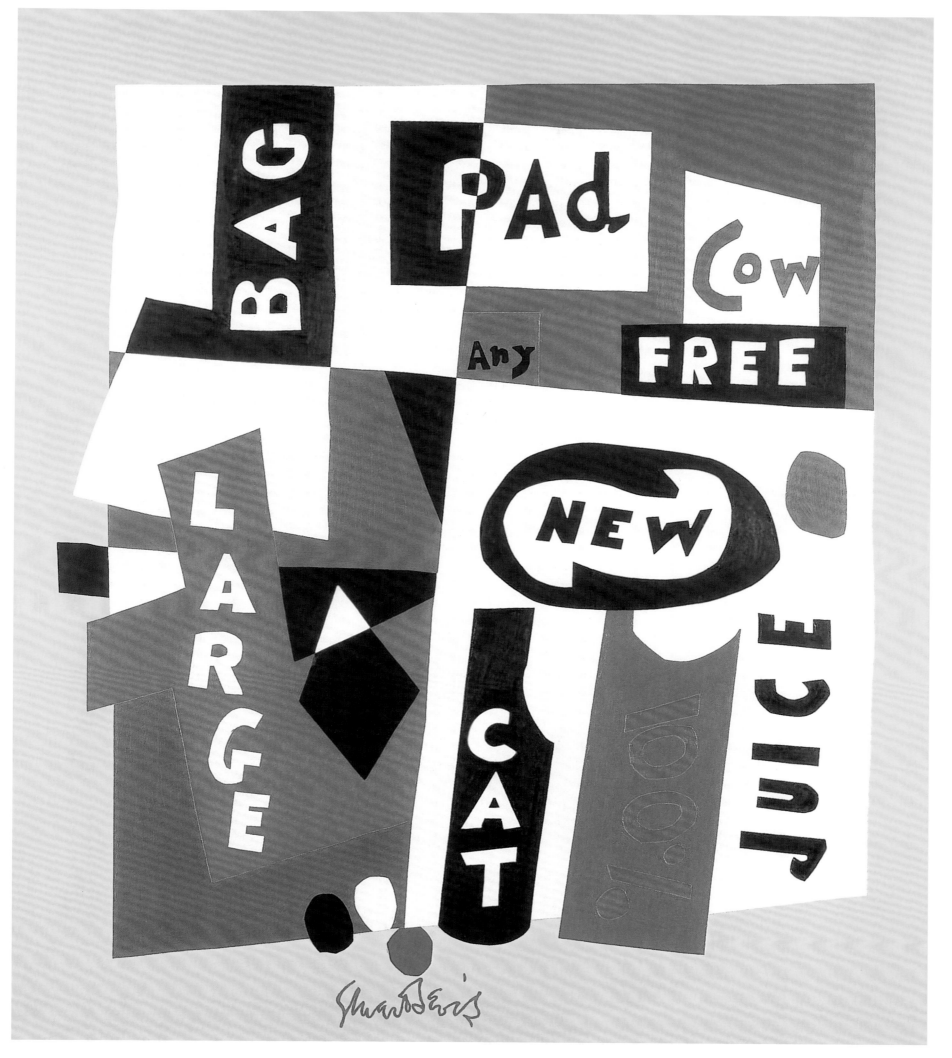

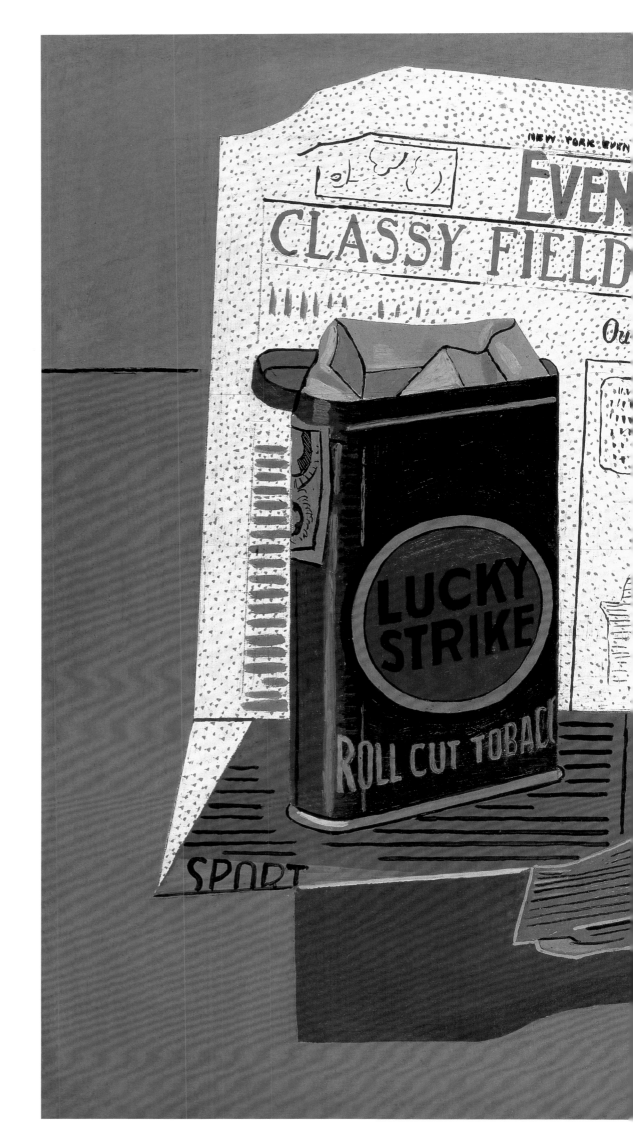

Stuart Davis, *Lucky Strike*, 1924.
Oil on paperboard, 45.7 x 60.9 cm.
Hirshhorn Museum and Sculpture Garden,
Smithsonian American Art Museum,
Washington, D.C.

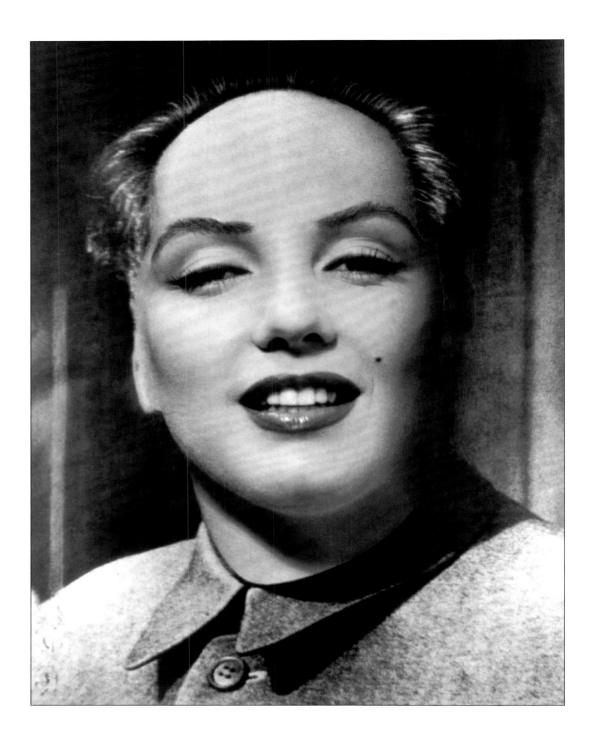

Usefully, in the year after Hamilton created *Just what is it that makes today's homes so different, so appealing?* he listed the qualities a new 'Pop Art' would need to possess for it to appeal to a mass-audience; it must be:

Popular (designed for a mass audience)

Transient (short-term solution)

Expendable (easily forgotten)

Low cost

Mass produced

Young (aimed at youth)

Witty

Sexy

Gimmicky

Glamorous

Big Business

Salvador Dalí, *Mao/Marilyn*, cover design,
December 1971-January 1972 issue of French
edition of *Vogue* magazine,
Condé Nast publication, Paris.
Photo: Philippe Halsman.

It might be thought that this constitutes a good, working definition of 'Pop Art' but a number of factors demonstrate the need for caution. Firstly, the list was written in a private letter that was not made public until well after the large-scale advent of Pop/Mass-Culture Art, and so it could never act as some kind of manifesto. Secondly, Hamilton was outlining the needs of the mass-audience for so-called 'Pop Art' and only therefore implying the needs of its creators, which would not necessarily be the same thing at all. Thirdly, and most importantly, the subject-matter that would be dealt with by artists contributing to the Pop/Mass-Culture Art tradition would quickly range far beyond the parameters Hamilton listed. To take but one example, Andy Warhol would certainly create an art that was popular, mass-produced, aimed at youth, witty, sexy, gimmicky, glamorous and Big Business, but he would also deal with hero-worship, religious hogwash, the banality inherent to modern materialism, world-weariness, nihilism and death, all matters that certainly did not figure in Hamilton's shopping list. So does that mean that Warhol should not be linked to Pop/Mass-Culture Art, or does it suggest that Hamilton's notion of what would constitute 'Pop Art' is unnecessarily limiting and inexact? Surely it is the latter. Moreover, much of the art to come would prove to be anything but transient, easily forgotten, cheaply priced or mass-produced.

Marsden Hartley, *Portrait of a German Officer*, 1914. Oil on canvas, 173.3 x 105 cm. The Metropolitan Museum of Art, New York.

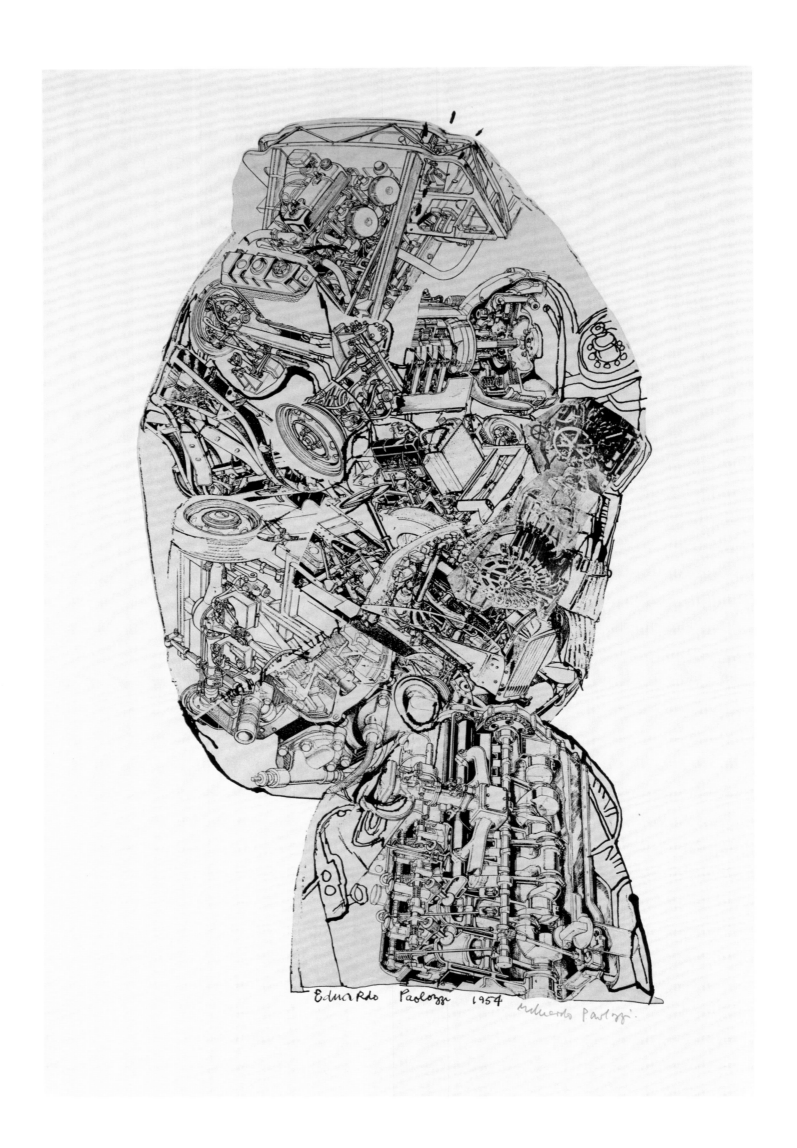

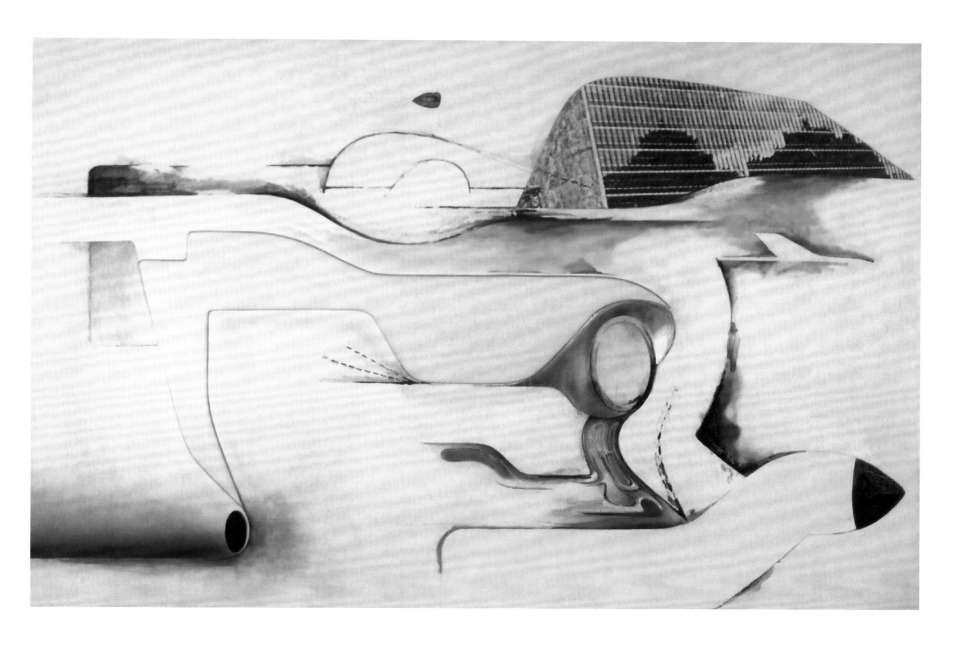

Hamilton followed up his 1956 collage by producing paintings such as *Hommage à Chrysler Corp* of 1957 (page 76), in which he abstracted car body parts; *Hers is a Lush Situation* of 1958 (see above), in which sections of a 1957 Cadillac are linked to a photo of the glass facade of a building; and *$he* of 1959-60, in which he brought together areas of a female body, a refrigerator, a toilet seat and a toaster. However, Hamilton would never be a painter interested in churning out long series of works exploring any particular area of mass-culture, and consequently he has never enjoyed the impact of artists such as Lichtenstein and Warhol who would later do so. Instead, he preferred to act more as an aesthetic explorer in the mould of Marcel Duchamp, whom he reveres, and whose damaged *Large Glass* he replicated in the early 1960s. For this reason the degree to which Hamilton was an aesthetic pioneer is certainly underestimated, especially in America.

A further British painter was also tapping into the mainstream of popular mass-culture from the mid-1950s onwards, albeit in a highly nostalgic way. This was Peter Blake (pages 26-7, 66-7, 70, 75, 78, 85-6 and 217). He would later state, "I started to become a pop artist from my interest in English folk art... Especially my interest in the visual art of the fairground, and barge painting too... Now I want to recapture and bring to life again something of this old-time popular art." Additional stimulus was derived from an early art teacher who had been particularly interested not only in barge painting but also in tattoos, patchwork quilts, and painted and hand-written signs. Usually none of these types of images and patterns had been regarded as art, simply because most such work is naive and untutored (which is, of course, the source of its visual strength and communicative directness). Early in life Blake equally developed an unusually intense interest in collecting postcards, curios, knick-knacks, old tickets, fly posters, metalled advertisements, 'primitive' paintings, examples of child art and

Eduardo Paolozzi, *Automobile Head*, 1954-62.
Screenprint on paper, 61.6 x 41.3 cm.
Tate, London.

Richard Hamilton, *Hers Is a Lush Situation*, 1958.
Oil, cellulose, metal sheet, collage on panel,
84 x 122 cm. Colin St John Wilson, London.

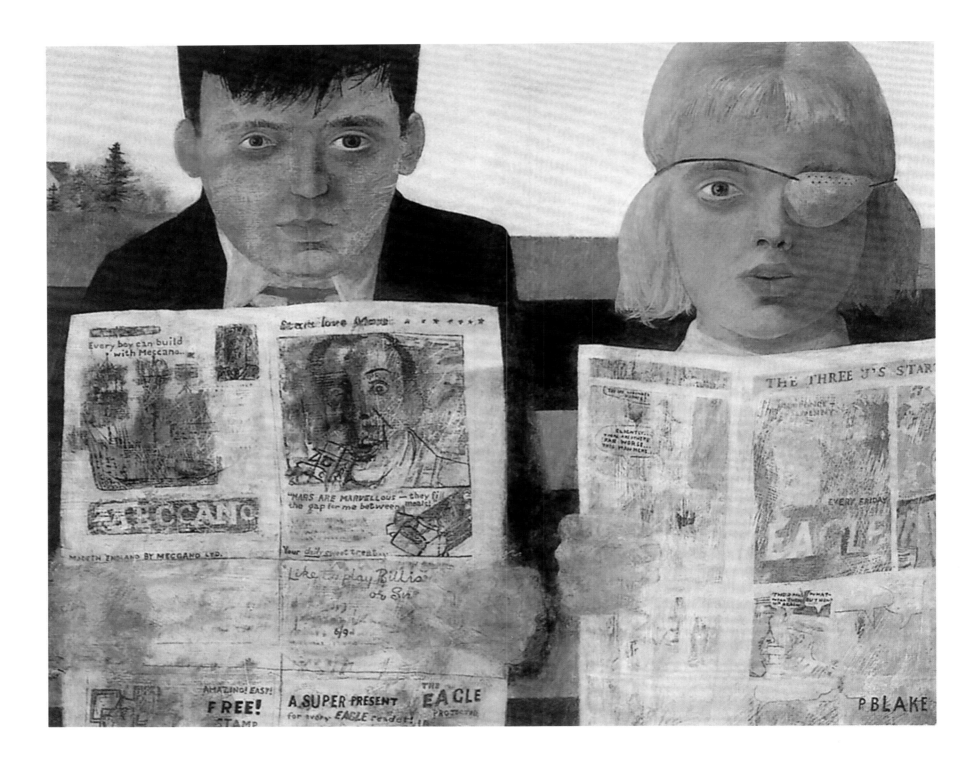

comic strips, all of which fed into the imagery of his work. The latter attractions are especially clear in *Children reading Comics* of 1954 (see above). Under such an influence, and armed with an awareness of the works of American painters and illustrators Ben Shahn, Saul Steinberg, Bernard Perlin and Honoré Sharrer (whose pictures he saw in London at a Tate Gallery show held in 1956), Blake also went on to create representations of circus folk, wrestlers and the like. This phase of his output came to a climax with *On the Balcony* (page 75) of 1955-7 in which two simulated photos of members of the Royal Family on the balcony of Buckingham Palace are surrounded by five children, other images of people on balconies (including one by Manet), and a mass of small pictures taken from art and life, including the latter as represented by the mass-media *Life* magazine. By 1959, when Blake created *Couples* (see opposite), his interest in popular printed ephemera could form the stuff of art, by drawing our attention to cultural ubiquity and the narrow borderline between sentiment and sentimentality.

By the late-1950s Paolozzi, Hamilton and Blake were still unknown in the United States, and thus they could not contribute to the rise of Pop/Mass-Culture Art there. So what did propel the emergence of that creative dynamic on the western side of the Atlantic Ocean?

Sir Peter Blake, *Children reading Comics*, 1954.
Oil on hardboard, 36.9 x 47 cm. Tullie House Museum and Art Gallery, Carlisle, Cumbria, UK.

Sir Peter Blake, *Couples*, 1959.
Collage on notice board, 89 x 59.7 cm.
Collection of the artist.

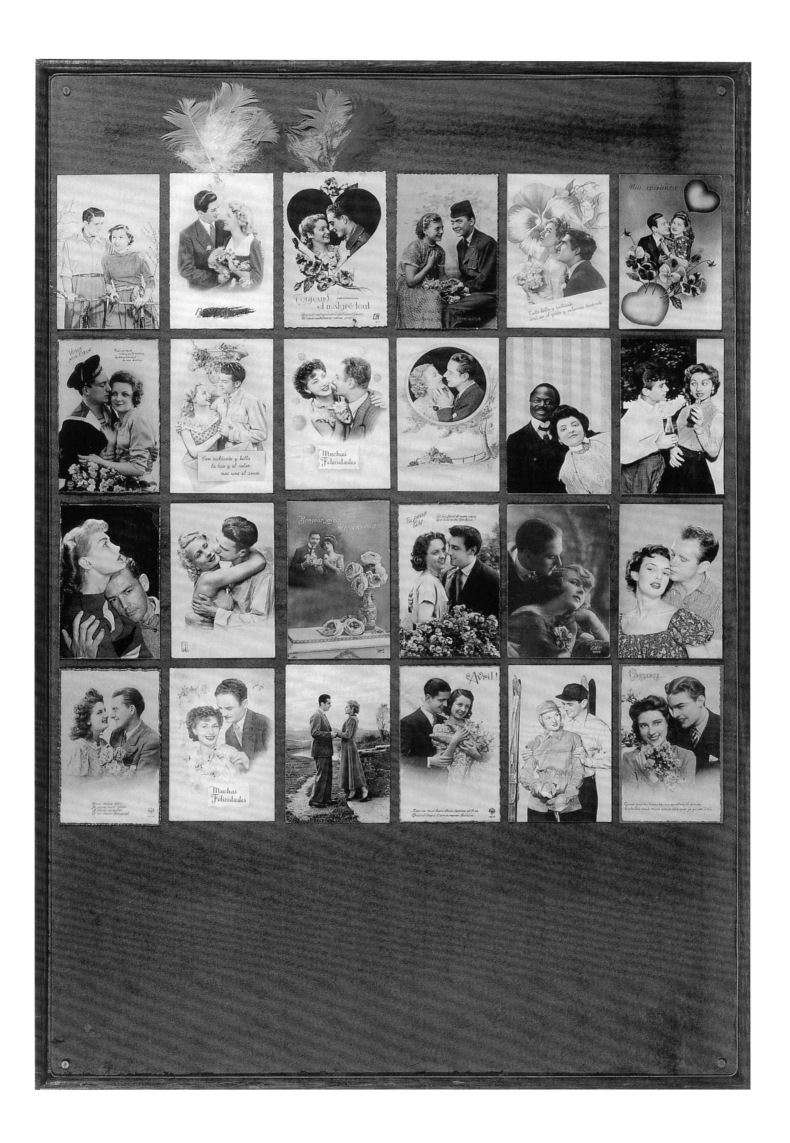

The Rise of Pop/Mass-Culture Art in America

Primarily an important artistic movement contributed towards the advent of Pop/Mass-Culture Art in America, albeit in an entirely antithetical way. This was the prevailing avant-garde tendency of the day, Abstract Expressionism (which was also termed 'Action Painting' and 'New York School painting'). Such a movement had emerged in the mid-1940s and it flourished during the 1950s, in the process shifting the centre of art-world power from Paris to New York. American artists and émigrés to New York, who included Jackson Pollock, Willem de Kooning, Franz Kline, Hans Hofmann, Adolph Gottlieb, Clyfford Still, Robert Motherwell, Arshile Gorky, Mark Rothko, Barnett Newman and Helen Frankenthaler, all forged a completely innovative aesthetic by exploring new expressive, painterly, formal, colouristic and psychological dimensions to painting and drawing. For the most part theirs was an art committed to non-representation, although the imagery and scale of their works often addressed reality metaphorically (as with, say, the paintings of Motherwell dealing obliquely with the Spanish Civil War, and the canvases of Pollock which were openly intended to articulate his responses to the age of the radio, the automobile and the atomic bomb). Several members of the New York School, most notably Pollock, came close to fulfilling an automatism which was implicit in Surrealism but which had not been thoroughly explored by members of that earlier group, while most of the Abstract Expressionists carried through the gestural implications of earlier phases of Expressionism. But what connected all of these painters was a shared determination to create an art that would reach down through the subconscious to touch core values of spirituality, emotion, seriousness, intellectual complexity and authentic experience.

It is perhaps to be expected that such noble aspirations would engender a reaction, and certainly they did so amongst the next generation of artists who felt that the territory explored by the Abstract Expressionists had been thoroughly exhausted, leaving them nowhere to go. Undoubtedly these younger figures were creatively committed, but as they looked at the world of the late-1950s they gradually turned their backs on the goals so prized by their immediate forebears. After all, where were such lofty qualities to be readily found in an increasingly cynical, emotionally fearful, youth-orientated, irreligious and hedonistic society filled with the bogus posturing of advertising men and the materialistic emptiness of mass-consumption? If an artist holds a mirror to society, then surely he or she should be reflecting the emergence of Bill Haley and Elvis Presley around 1955, the advent of Disneyland and McDonalds that selfsame year, the automotive and aeronautical revolutions that really took off in the 1950s, the emergence of a new generation of teenagers around 1960 (the so-called 'baby-boomers' sired by military personnel returning from service in World War II some fifteen years earlier), the very moment when television began to outstrip cinema as the principal means of global visual communication, and the sexual revolution that began when the oral contraceptive pill became available in 1960-1. Accordingly, they ditched the values of Abstract Expressionism and instead adopted a 'cool' or emotionally distanced response to the world, an orientation towards youth and hedonism, and a witty irreverence about everything ranging from religion to art, if not even a cynicism regarding the world they had inherited. Such an attitude allowed them to comment ironically upon the false promises of admen and the vacuity of mass-consumption, as typified by its fetishes or objects of worship such as the Coca-Cola bottle, the hamburger, the comic-strip, the pop idol and the Hollywood superstar.

The rejection of the values of Abstract Expressionism can already be witnessed prior to the mid-1950s, for example, in Robert Rauschenberg's total erasure of a drawing by Willem de Kooning in 1953. (This highly symbolic neo-Dadaist or anti-art gesture comprises a virtually blank sheet of paper that now sits in a frame and resides in the San Francisco Museum of Modern Art. Originally, it may have equally demonstrated Rauschenberg's complete disdain for the financial value invested in such an object but today, of course, it is worth a fortune.) In that same year Rauschenberg also made all-white paintings in which the shadows cast by the spectator generate the only visual dynamic in the works. Such a transfer took to its logical conclusion the notion of Duchamp and others that it is the viewer who completes the communicative circuit of any given work of art, and thereby creates its ultimate significance. This is certainly undeniable, if hardly profound.

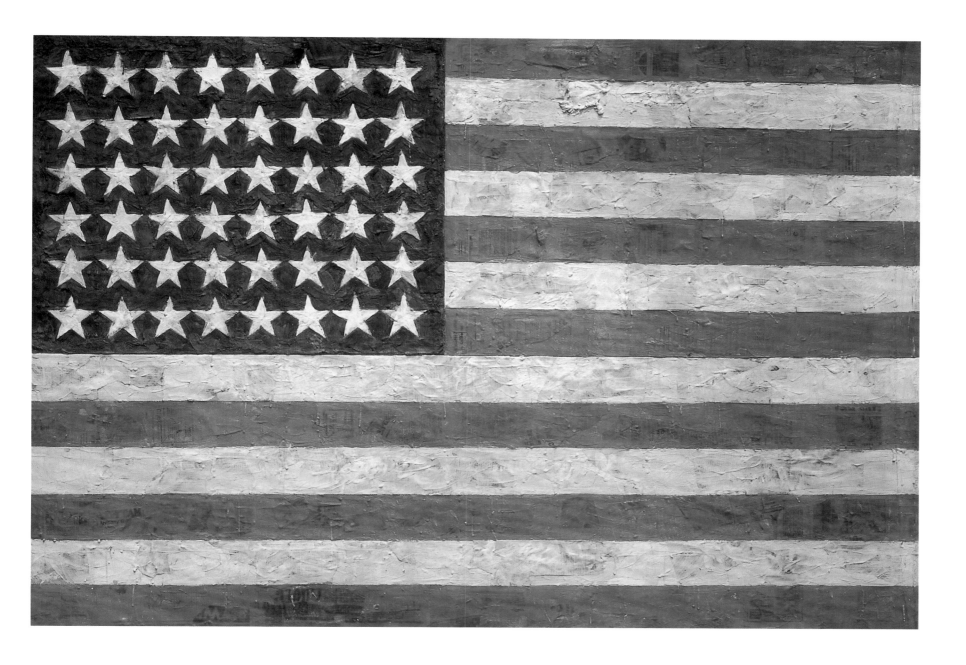

No less importantly, in 1953 Larry Rivers broke with Abstract Expressionism by reworking the imagery of a hallowed representation of American history, Emanuel Leutze's painting of George Washington crossing the Delaware river (page 73), which we have already seen indirectly because it appears in the background of Grant Wood's *Daughters of Revolution* (page 12). Rivers gave the subject the full Abstract Expressionist treatment of heavily gestural brush marks (page 73), and by such messy means he attained his stated intention of communicating the true discomfort that George Washington and his fellow-revolutionaries must have felt when making a winter river-crossing, feelings that are not imparted by the absurdly heroic posturing of Leutze's figures. As well as attacking the orthodoxy of Abstract Expressionism by placing its painterly approach at the service of history painting, Rivers also used the re-working of the Leutze as a means of undermining the values of conservative America, which was then going through a period of extreme Cold War paranoia.

In 1954 a friend and neighbour of Rauschenberg's in Manhattan, Jasper Johns, created a parallel to the Rivers image, and did so in iconic terms not unlike those of the latter, by beginning a series of paintings and drawings of the American flag (see above). Over the next four or so years he would give this most familiar and integral of all emblems of American culture an apparently gestural painterly treatment similar to that of Abstract Expressionism (although to perceive a subtle contradiction in his technical approach, see the commentary below the reproduction on page 77). In the process, he fused imagery that enjoys profound symbolic value with a conscious denotation of the act of painting, just as Rivers had done in 1953. However, the apparent energisation of the surfaces of the paintings and drawings does not break down the flag in any

Jasper Johns, *Flag*, 1955.
Oil and collage on canvas, 107 x 153.8 cm.
The Museum of Modern Art, New York.
Art © 2006 Jasper Johns/ Licensed by VAGA, New York, NY

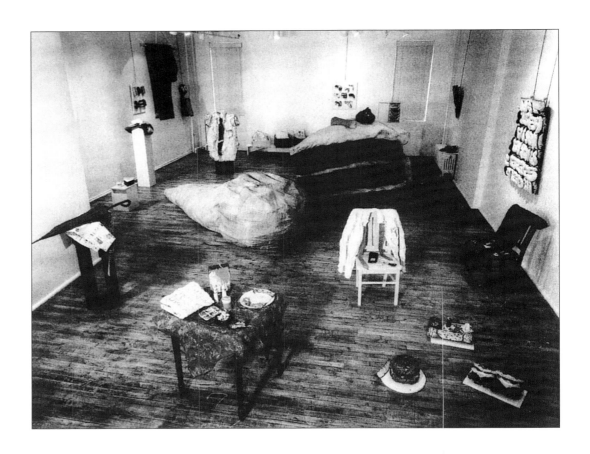

Claes Oldenburg, *The Store*, 1962.
Photo of installation. Green Gallery, New York.

way, as Rivers had done with his representation of George Washington and others. This is because Johns was equally concerned to emphasise the purely formal and colouristic qualities of the symbol. In most of the works he furthered this aim by isolating the banner within the overall design, while in a number of the pictures (such as representations of the flag in white) he also made the emblem hard to see. In other Flag paintings he varied the colours of the sign, thereby subverting our notions of the real. Some of the images (such as the very first of the Flag paintings) are built up over layers of newsprint, and where these levels remain evident they necessarily introduce mass-media associations. As always, Johns emphasised the flatness of the flag by avoiding any notions of spatial recession – constantly it remains a frontal arrangement of shapes on a flat background. The end result of all these factors is to make the flags appear physically disembodied and drained of iconic, nationalistic purpose. Such disassociation would have an enormous impact upon Andy Warhol in particular when he saw the Flags pictures in Johns's debut solo exhibition held at the Leo Castelli Gallery in New York in January 1958, as he would subtly make clear in paintings he would produce in the 1960s.

Just a couple of months after Leo Castelli had exhibited Johns's Flag paintings early in 1958, the dealer displayed Robert Rauschenberg's first Combine paintings, so-named because of their amalgamation of flat, painted surfaces with three-dimensional objects. The gesturality of Abstract Expressionist brushwork is still very much in evidence in these works and, indeed, it would never really disappear from Rauschenberg's output thereafter, being a useful way of both imparting enormous energy to the images and necessarily making analogous points about the dynamism of the contemporary world. Additionally, Rauschenberg occasionally pasted newspaper photographs and comic-strip material into the Combines, thereby creating mass-media associations, while in some of the works he introduced a particular icon of popular culture, the Coke bottle, and did so in rows that ineluctably induce thoughts of both mass-production and mass-consumption. In yet other Combines Rauschenberg incorporated actual Coca-Cola signs, thus touching upon signification directly.

The 1958-61 period also saw the debut exhibitions in New York and Los Angeles of further artists who would soon be prominent in the Pop/Mass-Culture Art dynamic. They included Marisol, Allan D'Arcangelo, Ed Kienholz, Jim Dine, Claes Oldenburg, Richard Smith and Tom Wesselmann, all of whom are discussed below. On the other side of the Atlantic, a number of emergent Pop/Mass-Culture Art painters came together in 1959 as post-graduate students at the Royal College of Art in London. They included David Hockney, Allen Jones and Peter Phillips who each receive further mention in this book.

The Triumph of Pop/Mass-Culture Art

The international emergence of Pop/Mass-Culture Art finally took place in 1961-2. In London the 1961 'Young Contemporaries' exhibition served notice to the world that Hockney, Jones, Phillips, Patrick Caulfield and others were bringing a new 'Pop' sensibility into being. The following year saw shows in New York, Los Angeles and London of works by Claes Oldenburg, Jim Dine, James Rosenquist, Roy Lichtenstein, George Segal, Robert Indiana, Peter Blake, Andy Warhol, Tom Wesselmann and Wayne Thiebaud who all made the public more aware of mass-production and/or mass-culture. By the time these exhibitions were mounted, Leo Castelli had been followed by a growing number of dealers, such as Ivan Karp, Richard Bellamy, Sidney Janis, Martha Jackson, Eleanor Ward, Allan Stone and Irving Blum, who proved equally receptive to Pop/Mass-Culture Art. Naturally, they quickly realised the economic potential such work enjoyed, especially to those many collectors, museum directors, members of their boards and ordinary art-lovers who had never engaged with abstract art.

Amid all these debuts a particularly significant show was mounted by Claes Oldenburg outside the normal gallery system. This was the first of his two *The Store* exhibitions, which took place between December 1961 and January 1962. For this display Oldenburg rented a shop in a depressed, downtown part of Manhattan and filled it with pieces that emulated everyday consumer objects. These he nailed to the walls, hung from the ceilings and arranged on the floors. They all bore price tags and were surrounded by advertising signs that were intended to break down the barriers not only between art and reality but also between the art gallery and the shop, and between the artist and the dealer (for Oldenburg was constantly present to act in that capacity during the show). In September 1962, with his second *The Store* exhibition, held at the midtown Green Gallery (page 30), Oldenburg moved in the direction of greater refinement by making fewer but bigger emulations of consumer objects, such as a larger-than-life hamburger (page 36), a gigantic ice cream cone and a huge slice of chocolate cake. Again, and by dint of the physical augmentation of size that was already becoming his stock-in-trade, the objects and comestibles of everyday life were brought out from under the noses of a public that took them for granted and given a new measure of cultural life.

Another important group show opened in New York on the last day of October 1962 and it finally set the seal on the international emergence of Pop/Mass-Culture Art. The 'New Realists' exhibition mounted at the Sidney Janis Gallery brought together an international spectrum of artists ranging from the Americans Roy Lichtenstein, Andy Warhol, James Rosenquist, Claes Oldenburg, Jim Dine, Robert Indiana, George Segal, Tom Wesselmann and Wayne Thiebaud, to the Europeans Peter Blake, Arman, Peter Phillips, Martial Raysse and Mimmo Rotella, all of whom are discussed below. Confronted with works that included Oldenburg's assemblage *The Stove*, which featured a real stove topped by plaster food, Jim Dine canvases that incorporated real objects (page 96), a sculptural ensemble of a dinner table by George Segal, a James Rosenquist oil juxtaposing a car grill with a kissing couple and a tangle of spaghetti, an Arman *accumulation* of swords and rapiers, Roy Lichtenstein's picture of an exploding MIG fighter (page 93), still-lifes of consumer objects and food by Tom Wesselmann and Wayne Thiebaud, and Andy Warhol's paintings of Campbell's Soup cans – both singly and in a group of 200 – the New York art world was hit "with the force of an earthquake", to quote the critic Harold Rosenberg.

A particularly witty exhibit was one of Warhol's Dance Diagram pictures (see above). This was displayed under thick glass on the floor, with a label attached inviting members of the public to remove their shoes and follow the dance steps across the painting itself. Not only was such behaviour unusual in the normally hallowed precincts of an art gallery, but the invitation was highly appropriate in a space owned by Sidney Janis, for the dealer was an enthusiastic dancer. With the exception of Willem de Kooning, all the Abstract Expressionists who had shown with Janis until then were so horrified by the dealer's broadened taste that they fled to other galleries. De Kooning's open-mindedness was unsurprising, for during the late-1940s he had happily incorporated into some of his paintings newspaper images that had been accidentally transferred there. Moreover, in 1950 he had pasted a woman's smiling mouth from a Camel cigarette advertisement into

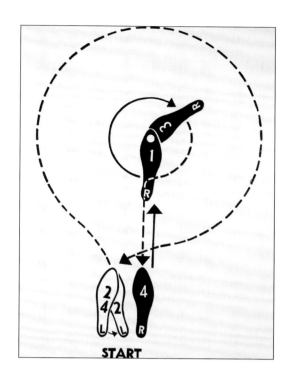

Andy Warhol, *Dance Diagram (Fox Trot)*, 1962.
Synthetic polymer paint on canvas, 182.8 x 137.1 cm.
The Museum of Modern Art, Frankfurt am Main.

a study for one of his Woman series of paintings. But his attitude towards Pop/Mass-Culture Art was singular among his peers, and his openness clearly reflected the fact that he was always ambivalent in his commitment to abstraction anyway.

Some Individual Artists and their Creative Development

From this point onwards the history of Pop/Mass-Culture Art becomes too complex to recount chronologically; throughout the rest of the 1960s and ever since, all of the Pop/Mass-Culture Art painters and sculptors discussed above, as well as others we shall come to, held numerous one-person exhibitions and/or participated in group shows, and a listing of every one of those displays would become very tedious indeed. It will suffice to mention significant events within the larger cultural context of the developing Pop/Mass-Culture Art tradition. Perhaps at this point, therefore, we can usefully switch to discussion of the creative development of a number of the artists who have contributed to the growth of that sensibility.

Jasper Johns

Jasper Johns only dealt with mass-cultural imagery at the outset of his long career, in the years between 1954 and 1963. We have already discussed the Flags paintings which proved seminal to the development of Pop/Mass-Culture Art. By 1958, when that series was coming to an end, Johns also began producing sculptural representations of everyday household objects such as light-bulbs and flashlights. By casting them in bronze, he transformed the cultural status of those commonplace artefacts. In time Claes Oldenburg, Roy Lichtenstein, Andy Warhol, Tom Wesselmann and many others would similarly replicate the appearance of the most mundane of consumer items, and raise them to the level of art when doing so. Alternatively, others such as Ed Kienholz, Jeff Koons and Haim Steinbach would simply alter the context within which we view real artefacts, as Duchamp had done, or even combine emulated objects with real objects, as Kienholz would do as well.

In his Targets pictures of the late 1950s, Johns made a subtle statement about his own homosexual orientation and the concealment this forced on him. He achieved this by employing roundels to signify his sense of being a potential target in a homophobic society, while across the tops of the canvases he ranged boxes containing various parts of the human body in order to allude to the compartmentalisation sexual secrecy engendered. A related work, the 1960 *Painting with Two Balls*, hints more obliquely at the same problems. His Numbers and Alphabets series pictures of the late-1950s and early-1960s incorporate familiar symbols both to act as pegs upon which to hang a highly energetic gestural painting and to make statements about primary elements of communication. In painted bronze sculptures of 1960, such as *Two Beer Cans* (page 81), Johns also made neo-Dadaist points about art, art capitalism and mass-culture. A subsequent group of pictures representing the map of the United States certainly comments upon mass-culture, if only by dint of its stencilled lettering (page 83). But in the main, after 1963 Johns began slowly turning away from popular culture and the mass-media, moving instead towards an exploration of abstract forms.

Robert Rauschenberg

Unlike Johns, down the years Robert Rauschenberg has engaged ever more closely with the mass-culture he had first dealt with obliquely in the 1950s. He was always profoundly involved with the supreme art of movement, namely dance, and no less important to him was chance and the accidental, an outlook reinforced by his close friendship with that master of musical radicalism and the aleatory, the composer John Cage. As a measure of Rauschenberg's belief in chance operating as a guiding light for creativity, he would frequently incorporate into his works objects he had found quite by accident in Manhattan, even on occasion specifically setting out to walk around his city block picking up discarded objects and placing them on his canvases in the very same order he had originally encountered them. Such a process reflects life accurately, for invariably our lives are ruled by chance.

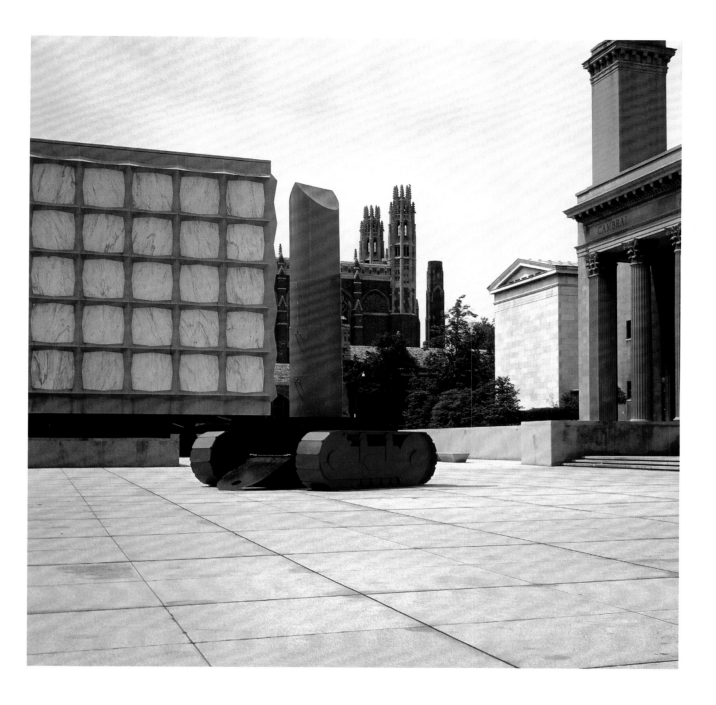

In 1959 Rauschenberg completed his sculpture, *Monogram* (page 79), in which the encirclement of a stuffed angora goat with a car tyre clearly suggests the way nature is increasingly being confined by man. Between the end of the 1950s and 1962 Rauschenberg continued to make complex Combine paintings, linking real objects with forceful paintwork to express the dynamism and changeability of existence in lower Manhattan, where he continued to live. In 1962 Rauschenberg found a technical way of harnessing reality even more directly. In July of that year Andy Warhol's studio assistant had suggested that if his boss wished to avoid the laboriousness of painting repetitive images, he should use the photo-silkscreen printing technique instead. This process permits the transfer of photographic images onto a screen of sensitised silk stretched on a frame. The fine mesh of the silk allows ink or paint to pass through it onto a canvas or other support only where it is not prevented from doing so by a membrane of resistant gum. Soon after Warhol had taken up photo-silkscreen, Rauschenberg adopted the same process, not to utilise repetitious imagery but because he liked the freedom it allowed.

This technical breakthrough spurred Rauschenberg to an enormous productivity over the following years, during which he created many of his most memorable works. In canvases such as *Kite* and *Estate* of 1963 (pages 107-8), and *Retroactive I* of 1964 (page 127), he purposefully used the reality projected by photographs, the dynamics of energy and tension released by emphatic brushwork, and the loose juxtaposition of images

Claes Oldenburg, *Lipstick (Ascending) on Caterpiller Tracks*, 1969-74. Cor-Ten steel, steel, aluminium, cast resin, painted with polyurethane enamel, 7.2 x 7.6 x 3.3 metres. Samuel F.B. Morse College, Yale University, New Haven, Connecticut.

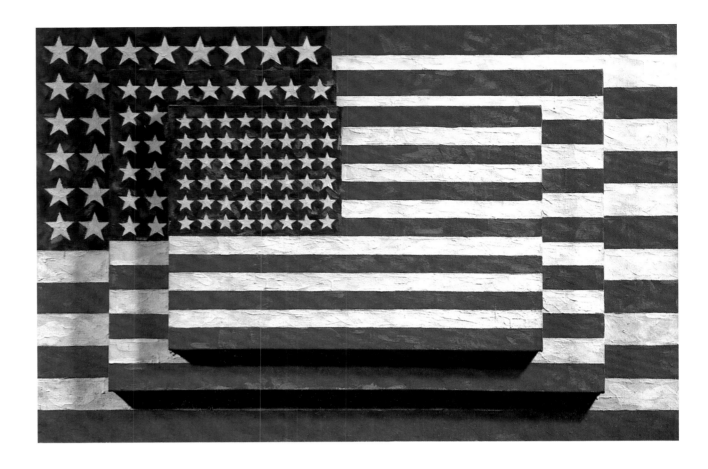

to create subtle meanings and embody the perceptual bombardment we all now experience. Such pictures appear increasingly relevant, not least of all because the grainy blurring of their photo-silkscreened areas induce all manner of associations with mass-produced imagery.

Dance is necessarily an exploration of space, and quite clearly Rauschenberg's involvement with that art-form has generated the freewheeling spatiality apparent throughout his work. Yet this has not only resulted in pictorial enhancement; since the 1980s an involvement with real space has been evident in his work, for the artist has become utterly entranced by the excitement and beauty of the Space Age. The results have been works that have at their heart the technological complexities of rocketry, the implied movement of those giant machines and the human dimensions of space exploration. More recently still he has refined his art even further, moving away from his earlier gestural freedom to a far more controlled picture-making that is somewhat sculptural in form.

Claes Oldenburg

Spatiality has always come naturally to Claes Oldenburg. He first moved towards Pop/Mass-Culture Art after experimenting in the late-1950s with Happenings and other live artistic events that already foreshadowed Performance Art. Usually such staged episodes were anarchic, neo-Dadaist affairs, attacks upon art and its conventions that echoed the uncertainty of the times in which they were created. Oldenburg's first environmental work, *The Street*, was created in New York in 1960 and comprised an intentionally ragged, debris-strewn arena whose chaos was intended to parallel the confusion of the city in which it appeared. We have already touched upon Oldenburg's two versions of *The Store* dating from 1961-2 (page 30). As we have seen, with the second of these he discovered an important constituent of his metier, namely the enormous enlargement of everyday objects of mass-consumption whose size we invariably take for granted. Such enhancement not only cuts across normality but equally it comments upon the materialism of an age that assuredly puts a premium upon size and economic growth. (Unfortunately truth is always stranger than fiction; a sculpture of a hamburger more than two metres wide that Oldenburg created in 1962 (page 36), is now almost in danger of being eclipsed in size by a new generation of real, fast-food chain 'Monster Thickburgers' exploding with calories and vast suppurations of fat.)

Jasper Johns, *Three Flags*, 1958.
Encaustic on canvas, 76.5 x 116 x 12.7 cm,
fiftieth anniversary gift of the Gilman Foundation,
Inc., The Lauder Foundation,
A. Alfred Taubman, an anonymous donor.
Whitney Museum of American Art, New York.
Art © 2006 Jasper Johns/ Licensed by VAGA,
New York, NY

Robert Rauschenberg, *Bed*, 1955.
Combine painting: oil and pencil on pillow,
quilt, and sheet on wood supports,
191.1 x 80 x 20.3 cm.
The Museum of Modern Art, New York.
Gift of Leo Castelli in honor of Alfred H. Barr, Jr.
Art © 2006 Robert Rauschenberg/ Licensed by
VAGA, New York, NY

Claes Oldenburg, *Floor Burger*, 1962.
Canvas filled with foam rubber and cardboard
boxes, painted with latex and Liquitex,
132.1 x 213.4 cm.
Art Gallery of Ontario, Canada.

Oldenburg also found another, related way of interfering with our sense of the real: as well as using hard materials such as plaster and wire to imitate the appearance of fairly soft matter such as bread, meat and ice cream, he reversed the process and turned soft materials into very hard things indeed. A good example is his *Soft Toilet* of 1966 (page 151). Down the years Oldenburg has created many other memorable and amusing pieces. One is the mock vehicle bearing a rising and falling lipstick (page 33) which was destined for the Yale University campus in 1969 but which proved to be a little too challenging for the academic elders; first they had it removed and then they consigned it to a nearby museum. No less witty is the vast clothes-pin Oldenburg created for a public plaza in Philadelphia in 1976. Sadly or otherwise, many of Oldenburg's projects have never come to fruition, such as his 1966 notion of replacing Nelson's Column in Trafalgar Square, London, with an equally high automotive gear stick, which would have proven a most apt symbol for a public space and a country soon to be overrun by cars. No less whimsical was his 1978-81 plan to create a bridge in Rotterdam, Holland, in the form of two huge screws bent to the shapes of arches; only from the 1980s onwards would 'post-Modernist' architects take such imaginative conceits seriously. Since 1976, in association with his wife and artistic collaborator, Coosje van Bruggen, Oldenburg has continued to produce large numbers of sculptures that vary the size and density of everyday objects around us. Many of these, such as a 1988 bridge in the form of a spoon and cherry resting on a small island in a pond at the Walker Art Center in Minneapolis (page 236), enjoy a beauty

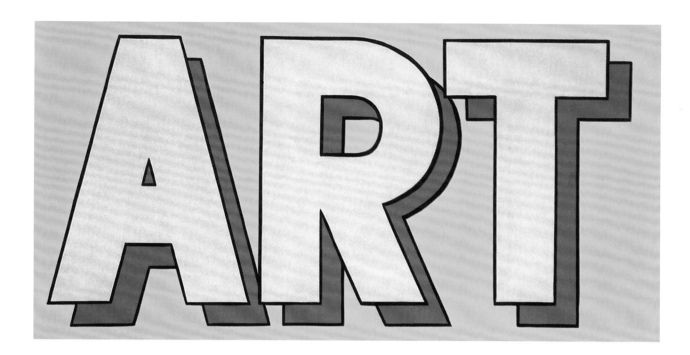

of line and colour that removes them far from the triviality of the everyday consumer objects and foodstuffs that inspired them.

Two of the most inevitably trivial everyday objects within modern mass-culture are the children's comic and the adolescent romance magazine. Given the nature of modern society it is perhaps sad but inevitable that boys should find intellectual sustenance and imaginative empowerment in sequences of images recounting easily-assimilated tales of cowboys, soldiers, spacemen and the like, while the adjustment from childhood to the initial stages of womanhood readily compels many girls to resort to romanticised visual fiction, feminist protests notwithstanding. From the perspective of adulthood the imagery of the boys' comic usually seems mock-heroic and banal, while that of the girls' romance magazine appears hopelessly sentimental, gauche and banal. But comics and romance magazines are enormously popular, and thus industrialised. It was therefore unsurprising that artists would eventually turn their attention to such means of mass-communication.

Roy Lichtenstein

Roy Lichtenstein was certainly not the first of them to do so but he was the first to realise that in order to enhance his statements about the way both comics and teenage romance magazines embody mass-culture, he needed to emulate the very processes by which they are printed. Most especially this concerned the method by which halftones – that is, the intermediate, light-to-dark shades of the various colours used – are arrived at in mass-printing. To such an end Lichtenstein began to emulate the Benday dot, a process of halftone printing first developed in New York in 1875 by the printer Benjamin Day. By the 1960s such a process was already being overtaken by automated photolitho techniques but this didn't worry Lichtenstein, for his emulation of the method turned his paintings from simply being magnified copies of comic-strip images into comments about the nature of mechanical reproduction.

Like many other artists who contributed towards the Pop/Mass-Culture Art sensibility – Warhol and Hockney also immediately come to mind – Lichtenstein had first worked through Abstract Expressionism in an undistinguished and unsatisfied way. His epiphany occurred in June 1961 when he painted *Look Mickey*, a picture he developed from a Mickey Mouse cartoon (page 88-9). Not long afterwards he realised the potential for employing the imagery of war comics to comment obliquely upon contemporary political and military developments. This was extremely apposite, for the 1960s saw continuing American involvement in the Cold War and deepening entanglement in Vietnam. In works such as *Blam* of 1962 (page 93) and *Torpedo...Los!* of 1963 (page 109), Lichtenstein may have developed material that clearly dealt

Roy Lichtenstein, *ART*, 1962.
Oil on canvas, 91 x 173 cm. Gordon Locksley and George T. Shea collection, USA.

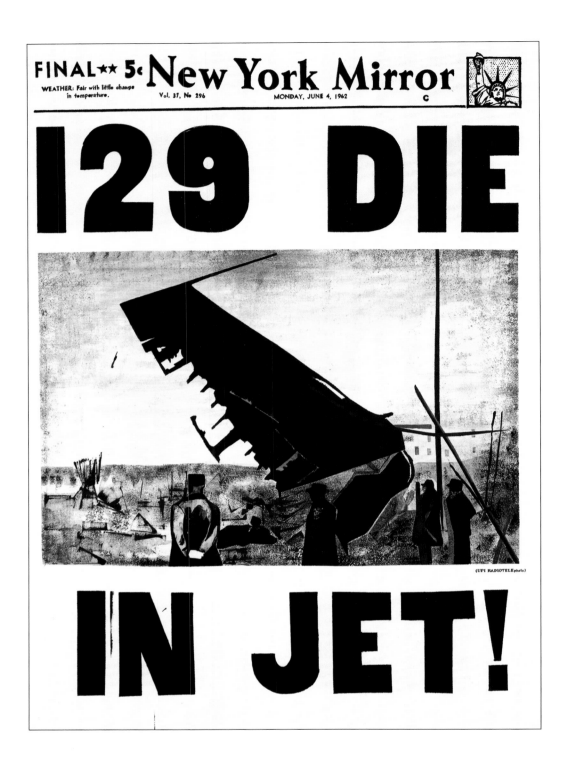

respectively with the Korean War and the Second World War but its relevance to contemporary America was surely obvious to all but the most obtuse.

The use of material drawn from teenage romance magazines, in paintings such as *Hopeless* of 1963 (page 110) and *We Rose Up Slowly* of 1964 (page 128), permitted Lichtenstein to comment sardonically upon immature perspectives regarding human relationships. Naturally, by enlarging the original images greatly, the painter necessarily amplifies the banality of the original material and thereby accentuates something of the falsity – of taste, imagery and even economic value – that lies at the very heart of the increasingly inauthentic global mass-culture that continues to expand and surround us. Moreover, the magnification of kitsch or laughable bad taste serves just as usefully as a distancing process, allowing both artist and viewer to look down upon the original imagery with cultural condescension, as though to say 'such banality is only for lesser mortals – *I'm* not taken in by it'. We shall encounter exactly the same distancing process in the work of other Pop/Mass-Culture Art figures, most notably Andy Warhol and Jeff Koons.

Andy Warhol, *129 Die in Jet (Plane Crash)*, 1962.
Acrylic paint on canvas, 254 x 183 cm.
Museum Ludwig, Cologne.

From the start Lichtenstein also directed his shafts at 'Art'. In *Mr Bellamy* (page 90), which he created in his breakthrough year of 1961, he wittily created an art world in-joke, while in the following year, with *Masterpiece* (page 94), he satirised the perpetual New York clamour for the fame that he was certainly seeking for himself. In 1962 too, Lichtenstein made the first of a set of images dealing with the single word ART (page 37). By the mid-1960s he began to apply his mechanical reproduction emulation technique to images by Monet, Cézanne, Picasso, Mondrian, Léger and a great many other masters. He did not do much (if anything) for the originals but he certainly made the point that a large amount of art is today disseminated through mechanical reproduction, although this hardly constitutes a profound insight. Yet in one series of works dealing with artistic matters he did crack an excellent visual joke. This was his set of gigantic emulations of what in reality would have been fairly small Abstract Expressionist brushstrokes (page 149); the witticism emerges from the disparity of size between what we know of the originals and what the imitations project, as well as the difference between the original, emotionally-charged brushstrokes and Lichtenstein's utterly unemotional transformation of them.

Because Lichtenstein could not go on churning out comic-strip and reworked-art images forever, he was forced to expand his repertoire of subjects. As a result, he accorded the same Benday dot treatment to landscapes, interiors, architectural details, banal advertising images, household objects and a mass of other artefacts. He also juxtaposed images from a variety of sources, creating montages analogous to Cubist collages. Certainly his paintings and sculptures can look extremely seductive, and assuredly he never ran out of things to say, but eventually his output all became somewhat wearisome, for although the Benday dots assume a life of their own by contributing an abstractive air to the proceedings, they no longer seem pertinent when divorced from their comic-strip surroundings. (Moreover, in an age of electronically-created halftones they became totally irrelevant technologically). Like many creative figures before and since, Lichtenstein eventually ran his art into the quicksand of a particular style, ending up simply as a mannerist.

Andy Warhol

The same charge could justifiably be levelled at a good deal of the later work of Andy Warhol, for although he never restricted himself to a single style, he did eventually go through patches of having nothing to say, and consequently ended up producing wave after wave of images that are all style and no substance. Warhol was a top New York advertising illustrator in the 1950s, grossing hundreds of thousands of dollars annually and winning industry awards for his work. But after seeing the Johns and Rauschenberg shows in 1958 he became desperate to forge a new career for himself as a fine artist. In 1960 he took up painting seriously, understandably toying with Abstract Expressionism but to no avail; by then the style was passé. He also tried neo-Dadaism in the Rauschenberg manner, which got him nowhere fast. Then he painted Coke bottles and similar artefacts drawn from mass-culture but did so in a sloppy expressive manner that didn't hit the visual spot either. Around the same time he explored comic-strip images, until he found out that Roy Lichtenstein had beaten him to the draw on that one too. So where could he go next, he asked himself with increasing desperation?

The answer came one evening in December 1961. An interior decorator friend claimed to know exactly what he should be painting and demanded fifty dollars for the idea. Warhol quickly paid up and was told he should be painting his two favourite things in the world: money and the canned soup he ate for lunch daily. He loved these suggestions and the very next day was seen in his local supermarket buying all forty varieties of Campbell's Soup. He immediately set to work, and over the next six months or so produced a group of forty small, laboriously painted oils (page 91), each of which inexpressively portrayed a can containing a separate flavour of soup. While slaving over these works he kept his radio, television and record-player simultaneously going at full blast, just to purge his mind of all subjectivity; he wanted to be an automaton, and his paintings to look as utterly impersonal as possible. This was because, with an insight only given to genius, he had recognised three fundamental truths of mass-culture: that we live in a supreme age of impersonally-crafted, mass-produced objects; that those objects are usually only affordable because they are

created in enormous quantities; and that repetitiousness and replication – of labour, production and marketing – are what makes and eventually sells them. All of this he wanted to parallel exactly in his art.

The first Campbell's Soup Cans and Dollar Bills paintings were followed by pictures of teach-yourself-to-dance diagrams, paint-by-numbers images, and serried ranks of Coca-Cola bottles, S & H Green Stamps, airmail stamps and stickers, and 'Glass – Handle with Care' labels. Many of these were produced using hand-cut stencils or rubber stamps and woodblocks, devices Warhol had employed as an illustrator. But the gap between hand-made and machine-made images was truly closed in July 1962 when, as we have seen, Warhol's attention was drawn to the photographic-silkscreen technique as an efficient, non-laborious means of making large numbers of repeated images. Soon these included pictures of baseball, pop music and movie stars, as well as of the *Mona Lisa*, many of which were represented as repetitiously as possible; this repetitiveness paralleled the way that images of such persona and icons of art are constantly being repeated by the mass-media. By the time he created these images Warhol had also begun to move in a different direction as well, for early that June an art-curator friend had told him to stop affirming life and instead portray the death that pervaded America. As a consequence, Warhol produced a picture of a newspaper front page which bore the headline '129 DIE IN JET!' (page 38). He followed it with a long sequence of Disaster pictures. Among other sources, these drew upon photos of car crash victims taken from police and newspaper files; an image of the electric chair whose use was a matter of heated debate in New York State at the time; and a photo of a newspaper report of botulism fatalities. He also produced a series of pictures of people committing suicide. In many of the Disaster pictures Warhol coupled each canvas with an identically-sized support painted all over with the same basic colour as its companion (see page 111 for an example). He claimed to have done so in order to give his purchasers twice as much painting for their money, but that was a diversion; clearly his true intention was to complement each positive image with an utterly negative one. In the context of the tragic events depicted, the blank canvas can only signify the total void created by death.

After 6 August 1962, one of the suicides Warhol portrayed was Marilyn Monroe, who had killed herself the previous day. For her image Warhol arrived at yet another inventive way of dealing with things: he reproduced a photo of the dead star over areas of flat colour that suggest perfect skin, perfect hair, perfect eyeliner, perfect flesh and perfect lip colourings, thereby making Marilyn look as artificial and banal as possible. In one of the Marilyns (page 99) Warhol even set the film star down on a field of gold, thus reminding us that the lady was at the cutting edge of a vast industrial apparatus for transforming her manifold attractions into gold. Arguably an even more inventive contribution to the Marilyns series is the *Marilyn Diptych* of 1962 (page 100) in which Warhol contrasted the actress's 'perfect' and colourful public persona with her messy, disintegrating, uncolourful and gradually fading private self. Any notion that Warhol was never a serious artist is completely confounded by this one picture alone.

Further Disaster images followed, notably race riot pictures and, following John F. Kennedy's death on 22 November 1963, the 'Jackie' series which drew upon newspaper photos taken after the assassination. In 1964 Warhol turned his attention to art capitalism and to sculpture in equal measures. He had carpenters make 400 wooden boxes which he and his assistants then silk-screened so as to replicate the outer cardboard packing cases of Campbell's Soup cans, Brillo Pads, Del Monte Peach Halves and similar consumer products which might be found in a supermarket stockroom. Subsequently, he exhibited these sculptures (page 131), filling the Stable Gallery in New York from floor to ceiling with the objects and thereby making the space look just like such a stockroom. This was his entire point, for commercial art galleries are never much more than that.

Protest and notoriety followed Warhol's creation of a gigantic mural showing thirteen of the FBI's Most Wanted Men on the New York State Pavilion at the New York World's Fair in April 1964; faced with demands for its removal because most of the suspects were Italian-Americans, Warhol simply obliterated the image with aluminium paint, a neo-Dadaist gesture that was surely appreciated by his friends Marcel Duchamp and Robert Rauschenberg, among others. Later that summer Warhol turned away from destruction and criminality by creating flower pictures from photos of real flowers (page 132). By giving them exactly the same flat and separated colour treatment he had accorded to Marilyn Monroe, he made the flowers look extremely banal and artificial, thus driving a wedge between nature and art.

Andy Warhol, *The Last Supper*, 1986.
Synthetic polymer paint and silkscreen,
198.1 x 777.2 cm.
The Andy Warhol Museum, Pittsburgh.

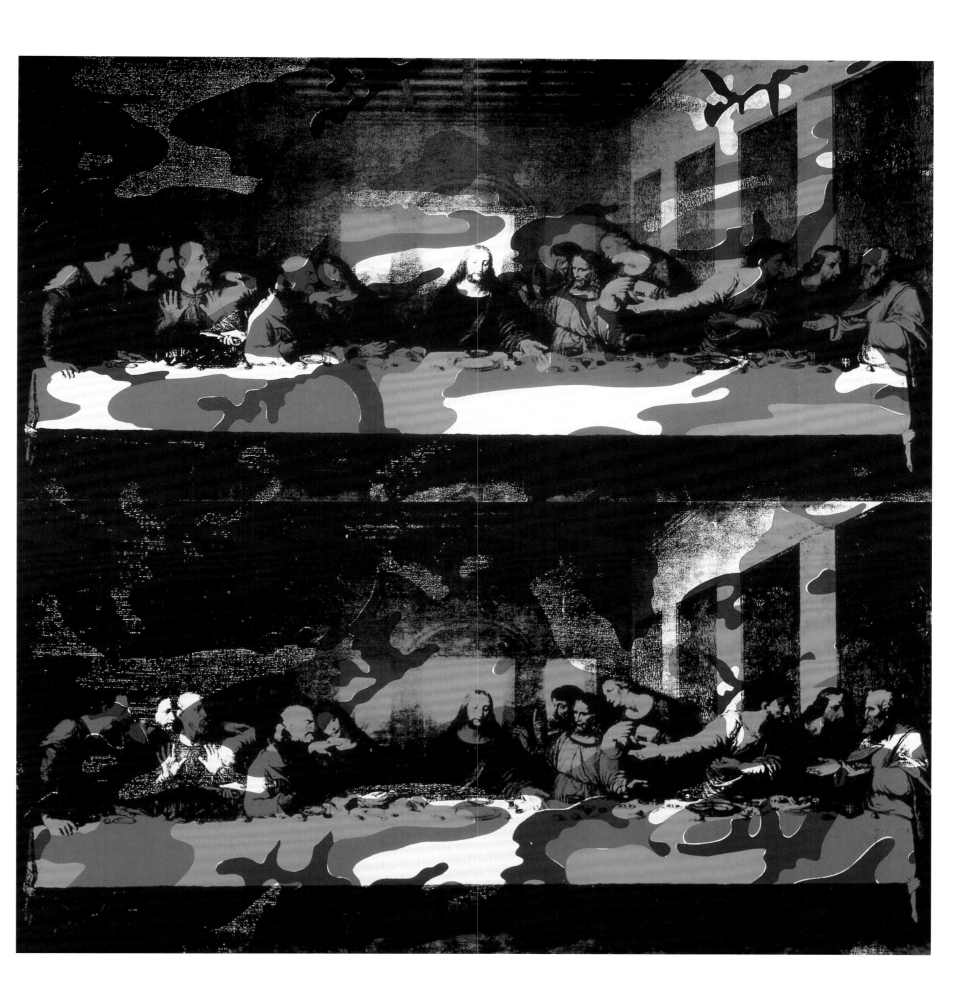

In April 1966 Warhol brought this burst of painterly creativity to an end with a show of *Cow Wallpaper* and floating helium balloons. The wallpaper was intended to summarise the pastoral tradition in western art; the balloons were very much part of the 'Flower Power' consciousness of the day. By now Warhol was utterly disenchanted with creating pictures and so he turned away from doing so for some time. Instead, he ran the Velvet Underground rock group and made films, none of which relate to the Pop/Mass-Culture Art sensibility. Not until 1971-72 would he return to form in the visual arts by creating 2000 images of the Chinese leader Chairman Mao Zedong, many of them in the form of a wallpaper; this lining would serve as the backdrop to an exhibition Warhol would mount of the Chairman Mao paintings and prints in 1974. The series constitutes a masterly piece of irony, for the communist politician represented everything that capitalistic purchasers of art despised, an antipathy that didn't prevent them from buying the pictures. Naturally, the Chairman Mao series also made highly relevant points about the worship of politicians and the proliferation of idolising images of them.

In 1972 Warhol began a new career by turning into a society portraitist. This should not entirely surprise us; coming as he did from working-class Pittsburgh, where he had been born on the wrong side of the tracks, he was always in thrall of glitz and glamour, celebrity and the cult of personality. But his new direction didn't do his art much good, for over the following years he produced vast numbers of commissioned portraits,

many of which have an entirely vacuous visual appeal; probe the images and there is absolutely nothing behind them, which is certainly not the case with portraits by, say, Titian, Rembrandt or Degas. But in one way Warhol was again holding up an accurate mirror to society, for in most cases the people he painted were as superficial as their portraits. Once again he effected a complete congruence between subject and object.

More irony followed in 1976, the year in which Warhol made his last film. The Hammer and Sickle images follow in the footsteps of the Chairman Mao paintings and prints by presenting capitalist art buyers with symbols of communist revolution, which is just what they truly abhorred. Yet in a subsequent sequence of works, namely the Skulls series of paintings and prints also dating from 1976 (page 197), Warhol did again become a serious artist, at least for a while. This is perhaps unsurprising, for in 1968 he had been shot by one of his followers, an attack that undoubtedly brought home to him his own mortality. The Skulls are not great paintings but they do enjoy a certain poetic resonance, and they undeniably add something to the long tradition of *momento mori* images in western art.

Over the rest of his career until his untimely death in 1987, Warhol's work was highly variable in quality. He made large numbers of very bland portraits whose generic subjects range from athletes to American Indians. Predictably the gay-orientated Warhol gave us representations of sexual organs. Likenesses of the Queens of England, Denmark, Holland and Swaziland must rate among the blandest royal portraits ever created. Art continued to be a source of subject-matter, as in sequences of works dedicated to exploring imagery by Munch, de Chirico, Leonardo da Vinci and various lesser Renaissance painters. Warhol's affinity with the anti-art neo-Dadaism of Rauschenberg and Johns in the 1950s resurfaced in 1977 when he created a highly smelly Oxidation series of canvases by getting his pals to urinate on to wet copper paint, thereby causing the chemical reaction of the titles. In a sequence of wholly abstract paintings, the Shadows series exhibited in 1979, Warhol's lifelong tendency to bring out the purely formal qualities of the images he used came wholly to the fore, although to no artistic effect whatsoever. Between 1979 and 1986 he returned to the subjects of Marilyn Monroe and Campbell's Soup cans, although now he treated them in the manner of photographic negatives, thereby creating a parallel with the negativity of the world around us. In highly inventive, photo-negative-like portraits of his admirer, the German artist Joseph Beuys (whose work he did not esteem in return), Warhol covered each canvas with diamond dust, thereby making a witty and valid point about art world glitz and glamour. A new set of dollar sign images again allowed him to portray the money he loved so much, while in the opposite vein he transformed yet another arch-enemy of capitalism, Vladimir Ilych Lenin, into a glamorous figure whom he set before the haute-bourgeoisie for their delectation and their money. Perhaps most tellingly Warhol created a series of pictures of handguns in 1981 (page 213). These are not any old guns, however; they are .22 snub-nosed revolvers, one of the two types of weapon his assailant had carried in 1968.

Just before his death resulting from poor medical attention following a minor operation in 1987, Warhol made a couple of series of religious images. In one he dealt with the repetitiousness of kitsch sculptural reproductions of Leonardo da Vinci's *Last Supper*, while in the other he transformed a Raphael Madonna and Child into a tawdry advertisement; both series therefore make valid (if rather slight) points about the bogusness, commercialism and cheapening of religious imagery in the modern world. After Warhol's death it emerged that he had been a dedicated if secretive Roman Catholic, so quite evidently he did hold genuine views about the debasement of religious art in our time. His concealment of that authentic side to himself was entirely in keeping with the way he worked hard to appear mindless and robotic after 1963, for he was anything but brainless and mechanical. That he was aware he masked his true self is proven by another late series of works, his Camouflage Self-Portraits (page 230), for camouflage serves no other purpose than to cloak what is real.

Of all the artists who have contributed to the Pop/Mass-Culture Art tradition, it seems valid to claim that Warhol was one of the most thematically varied, visually inventive and humanly insightful, which is why he has been accorded so much space here. In the five or so years between 1962 and 1966, and on occasions thereafter, he created works that still have an enormous amount to say about the modern world. Admittedly he was a largely associative artist, setting off chains of mental links by means of his images, rather than producing images that possess much pictorial resonance (as is the case with, say, those many

Old Master painters whose exploration of both the visual and the associative can seem inexhaustible). But if he was a largely associative artist he did possess the rare ability to project huge implications through the mental connections he set in motion (as with the parallels he drew between pictorial repetitiousness and industrial repetitiousness). By such means he threw a great deal of direct or indirect light upon modern nihilism, materialism and conspicuous consumption, world-weariness or *anomie*, political manipulation, economic exploitation, media hero-worship, and the creation of artificially-induced needs and aspirations. He also carried forward the assaults on art and bourgeois values that the Dadaists had earlier pioneered, so that by manipulating images and the public persona of the artist he was able to throw back in our faces the contradictions and superficialities of contemporary art and culture. Ultimately it is the trenchancy of his cultural critique, as well as the vivacity with which he imbued it, that will surely lend his works their continuing relevance long after the objects he represented have become technologically outmoded, and the famous people he depicted have come to be regarded merely as the faded superstars of a bygone era.

James Rosenquist

If Andy Warhol's art generates associations, so too does that of James Rosenquist, albeit in a far less explicit and much more visually fractured way. Rosenquist spent about seven years of his early working life as a billboard painter, both in the mid-western United States, from where he hails, and in New York, to which city he moved in 1955. In 1960 he terminated that activity in order to concentrate on his art. He had continued to work in the wholly abstract manner he had been pursuing for about three years, but then he finally brought his imagery into creative focus at the end of 1960.

Like Warhol, Rosenquist had also been enormously impressed by the Jasper Johns show in 1958, as well as by works by the same artist viewed later. What particularly attracted him was the degree of abstractiveness Johns had elicited from images of real things, such as flags and other signs such as numbers and the letters of the alphabet. After tentatively exploring this influence, Rosenquist finally decided, "...to make pictures of fragments, images that would spill off the canvas instead of recede into it... I thought each fragment would be identified at a different rate of speed, and that I would paint them as realistically as possible." The results were canvases such as *President Elect* of 1960-61 (page 84). Here the face of US President John F. Kennedy is juxtaposed with a slice of chocolate cake being pulled apart by some perfectly manicured female hands, alongside the shiny body and wheel of a car. Essentially the work marks a return to Picasso's assembled Cubist images of exactly half a century earlier, except that instead of pasting down bits of visual flotsam and jetsam on small-to-medium sized pieces of paper or canvas as the great Spanish artist had done, Rosenquist hugely scaled up fragments of imagery taken from magazine photos and the like, painting them impersonally and with enormous verisimilitude. The constituent images are strongly bound to each other with intersecting lines and interpenetrating masses, and they help construct an overall meaning, relating the President to the society he governed by means of some of its artefacts and glossy images.

Rosenquist went on mining this pictorial vein thereafter. As he commented, "I'm interested in contemporary vision – the flicker of chrome, reflections, rapid associations, quick flashes of light. Bing – bang! I don't do anecdotes. I accumulate experiences." Thus *Painting for the American Negro* of 1962-3 (pages 112-3) uses all kinds of images taken from the mass-media to project generalised points about ethnicity, sexuality and consumerism. Again an allusive overall meaning emerges from the constituent images, although the lack of any direct relationship between the people and objects represented says much about the fracturing of communication, identity and self-confidence that was very much the lot of American blacks when the picture was painted.

The use of visual connection and fragmentation can equally be encountered in what is arguably Rosenquist's masterpiece, the gigantic *F-111* of 1965 (pages 138-9). Totalling more than 26 metres in length and running around four walls, the composition is underpinned by the shape of what was then the very latest American fighter-bomber, the F-111 of the title. In overall terms the work makes a running statement about the visual overload of the contemporary world, its rampant, glossy materialism and, not least of all, its militarism

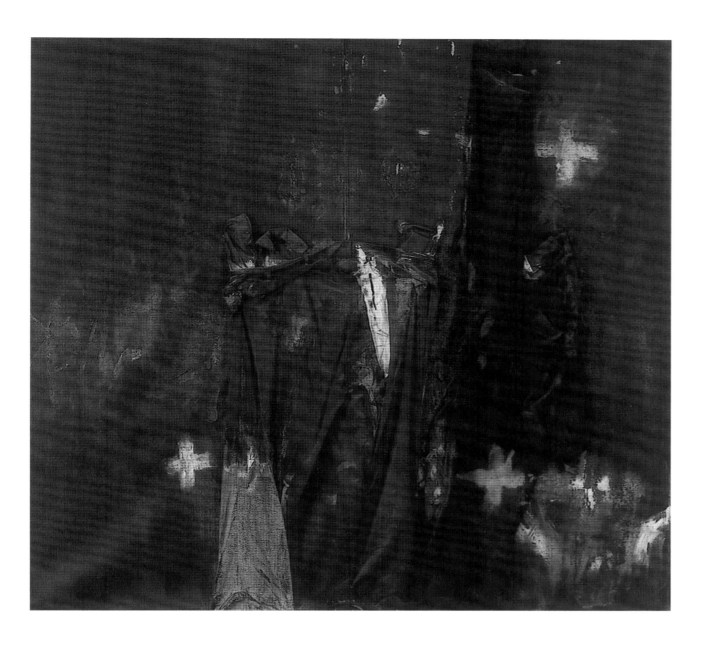

(for when the picture was painted, things were really hotting up in Vietnam). The work also incorporates a number of inventive visual metaphors, as will be seen in the commentary on the colour plate below.

The same sense of scale, an even more sophisticated sense of abstractive form and some wonderful colours are all present in Rosenquist's next major work, his *Horse Blinders* of 1968-9 (pages 172-9) which is largely about the way we perceive things. Although Rosenquist's art went into decline following a horrendous road crash in 1971, it slowly regained in strength. This is made abundantly clear by superb paintings such as *Star Thief* of 1980 (pages 206-7), which acts as a metaphor for the earth in space; and by *4 New Clear Women* of 1983 (pages 218-9), which addresses the fragmentation of women in modern society. If nothing else Rosenquist has developed the power to create beauty out of all the disparate visual phenomena that surround us, and to do so with the most impressive dash. It is a rare achievement.

Jim Dine

Jim Dine has always been termed a 'Pop' artist simply because he became prominent around 1960 and participated in the 1962 'New Realists' exhibition, in which he displayed a ceramic wash-basin attached to a canvas, a panel of bathroom fixtures, a painting with a lawnmower attached, and a canvas supporting five feet of coloured hand tools (page 96). Yet Dine very speedily disassociated himself from 'Pop Art', and he was quite right to do so, for rather than address any aspects of popular mass-culture, he merely made use of many of its familiar objects to express aspects of his inner life. As time has gone on that self-exploratory trend has continued, with his recent output bearing no links to mass-culture whatsoever.

Jim Dine, *Car Crash*, 1959-1960.
Oil and mixed media on burlap,
152.4 x 162.6 cm. Private collection.

George Segal, *Cinema*, 1963.
Plaster, metal, plexiglass and fluorescent light. 299.7 x 243.3 x 99 cm.
Albright-Knox Art Gallery, Buffalo, New York, gift of Seymour H. Knox, 1964.
Art © 2006 The George and Helen Segal Foundation/ Licensed by VAGA, New York, NY

George Segal

An artist whose output has continued to enjoy such a connection, however, is George Segal. He began his career as a painter who occasionally tried his hand at sculpture, but the turning point in his development was reached in 1961 when a technical breakthrough enabled him to achieve a very direct degree of sculptural realism. On the back of this he went on to fashion an art dealing with the anonymity of modern life, the complex and often inexpressible relations between men and women, the disconnection of the individual from the crowd, our links with the media and technology, and much else besides (pages 46, 130, 136 and 180). We are on familiar American territory here, of course, for anonymity, insularity, loneliness and alienation are the characteristic themes of Edward Hopper's work, and Segal has not only admitted his artistic indebtedness to that painter but done so in a way that reveals as much about himself as it does his creative forebear:

> …for [Hopper] to use the real stuff of the world and somehow – not suddenly but painstakingly, painfully, slowly – figure out how to stack the elements into a heap that began talking very tellingly of his own deepest feelings, he had to make some kind of marriage between what he could see outside with his eyes, touch with his hands, and the feelings that were going on inside. Now, I think that's as simply as I can say what I think art is about.

As in Hopper's work, the world represented by Segal is somehow stocked with people filled with a mute sense of their drab ordinariness. In Segal's case that sensibility is communicated by the figures appearing in monochrome amid fully-coloured environments that are often created out of real objects.

Ed Kienholz

Another sculptor who emerged during the first great phase of the Pop/Mass-Culture Art dynamic also frequently used real objects in his works. Often he employed wit to mask his seriousness about the contemporary world, thereby creating some very deadly barbs indeed. Ed Kienholz had worked as a handyman in Los Angeles for a long period during the 1950s, and so he had become very adept at re-utilising cast-off materials. It was therefore logical that he should eventually incorporate such throwaway stuff into his works. As he once stated, "I really begin to understand any society by going through its junk stores and flea markets. It is a form of education and historical orientation for me. I can see the results of ideas in what is thrown away by a culture."

Ed Kienholz, *Roxy's*, 1961-1962 (detail).
Paint and resin on mannequin parts, furniture, lamps, bric-a-brac, boar skull, papier maché jack-o-lantern, jukebox, string puppets, garbage can, potato sack, sewing machine stand, treadmill, towel, paintings, live goldfish in bowel, disinfectant, perfume, clothing, rugs, wood, wainscoting and wallpaper, variable dimensions. Reinhard Onnasch collection.

Kienholz's use of found materials can be readily witnessed in his breakthrough piece, the large sculptural ensemble entitled *Roxy's* of 1961-2 (pages 47, above, 49 and 51). Here he re-created on a life-size scale a suite of rooms in a cheap brothel in Kellogg, Idaho, which he remembered from his youth (although the work is named after a similar bordello in Nevada). The space is filled with real pieces of furniture, a jukebox, live goldfish in a bowl, lamps, rugs, wallpaper, bric-a-brac and all kinds of other artefacts, including pictures and posters. Naturally the creatures and objects help the rooms act as a realistic backdrop to the extremely disturbing representations of the prostitutes. These ladies enjoy picturesque names such as Cockeyed Jenny and Five Dollar Billy, and their forms are constructed from parts of shop-window mannequins covered in paint and resin.

A less spatially ambitious work of Kienholz's breakthrough years is *The Illegal Operation* (page 102) which makes a horrifying statement about back street abortion. By definition the work touches upon sexuality, but *Back Seat Dodge '38* of 1964 (page 129) is openly explicit about such matters, for it shows a couple making love. The work caused outrage in some quarters of the Los Angeles County Museum of Art when it was shown there in 1966, although just to regard the piece as a statement about people fornicating in a junked car is clearly to miss the point, for the work offers a wittily trenchant critique of the coarsening of sexual relations in a throwaway society. But there was a tragic side to Kienholz too, as he made clear in his superb ensemble of 1964-5, *The Wait* (page 137), which is surely one of the most moving treatments of old-age, loneliness and mortality to be found anywhere in art. Again, Kienholz's genius for expressively and associatively re-cycling found objects is vividly apparent, for the work aptly includes some old bones and a stuffed cat. As the frequent

marginalisation of old people is one of the saddest effects of modern life, *The Wait* indubitably forms part of a creative tradition dealing with mass-culture.

Another ensemble Kienholz created in 1965 also addresses mortality, for according to the sculptor himself the people in the work are all trying to bypass their awareness of death. *The Beanery* (pages 146-7) represents a crowded West Hollywood restaurant and bar, complete with the tape-recorded sound of the clientele drinking and talking running continuously in the background. The customers propping up the bar each sport clocks instead of faces, with all the hour and minute hands stopped at exactly the same moment in order to denote the ennui and killing of time typically encountered in such an establishment. And a subsequent work was far more disturbing. In *The State Hospital* of 1966 (page 155), Kienholz drew upon his experiences as an orderly in a state mental hospital almost two decades earlier to create not just an isolation cell but some profound metaphors for the assaults upon both mind and body encountered in such an institution. Kienholz created what is possibly his best-known work in 1968 with *The Portable War Memorial* (pages 170-1). Here patriotism, militarism and their symbols, plus the futility of war, the contradictions of Christianity and the brevity of historical memory are contrasted with the banal consumerism that modern war is ostensibly concerned with defending. Such a contrast was most apposite when American involvement in Vietnam was at its height, and sadly the work has lost none of its relevance down the years.

In a host of subsequent ensembles and single sculptures, Kienholz dealt brilliantly with an enormous array of social and cultural issues: trashy television (page 184); the onset of middle age; racial violence (pages 192-4)

Ed Kienholz, *Roxy's*, 1961-1962 (detail).

and Nazi oppression; marriage, sexual identity and sexual voyeurism; the loneliness of hotel life (page 211) and the separateness of compartmentalised living; family memory; religious fixation and insincerity expressed as a form of masturbation (page 245); the American judiciary and the economic interests it serves; and much else besides. One of Kienholz's wittier later pieces was *The Art Show* (pages 198-200) which he completed in 1977 in collaboration with his partner after 1972, Nancy Reddin. In 1988 the two of them completed another treatment of the brothel theme, now re-creating a street in Amsterdam's red-light district in all its tawdry glamour. In *The Merry-Go-World Or Begat By Chance And the Wonder Horse Trigger* of 1994, the two artists made a statement about the accidents of birth that confer an affluent lifestyle upon some but accord many others extreme poverty, and not just outside the USA.

As every one of his works makes clear, Kienholz (either alone or in tandem) was a highly associative artist, setting in motion all kinds of mental links concerning memory and the associations that materials might hold, which is partly why discarded elements proved so necessary to him. He not only consistently contributed to the Pop/Mass-Culture Art tradition but will in time surely come to be regarded as one of its towering figures. Certainly some of his output crosses the frontiers of good taste, but as polite decorum played no part in his scheme of things, such banality is unimportant. (In any case, as Warhol and others have made equally clear, banality is entirely congruent with what is being critiqued.)

Some Further American Pop/Mass-Culture Artists

We can deal with a number of other American contributors to the first phase of the Pop/Mass-Culture Art tradition more briefly, simply because their work is less inventive, or because essentially these figures have just had one thing to say and have stated it repeatedly without much development, or both.

Tom Wesselmann specialised in producing still-life pictures of consumer objects and packaged comestibles, using pasted photographs of supermarket goods such as food cans, beer bottles and cigarette packs to project a visually brilliant and sharply-focused awareness of the garish side of American consumerism (pages 120-1). In some works he also employed real objects such as televisions, refrigerators and bathroom fittings to heighten the banality of what he painted or incorporated around them. In a series dealing with the American nude Wesselmann represented the female form in a flattened manner derived from Matisse and Bonnard, thereby touching upon the territory covered by both art and soft-core pornography, as well as slightly spicing things up sexually (page 52). Often Wesselmann related mass-consumption to art by including reproductions of works by Cézanne, Picasso and Mondrian among others (pages 120-1); as art is yet another marketed area of human activity, the relationship seems germane. Everywhere in Wesselmann's work the falsity and garishness of modern mass-culture are allied to the frigid, frozen realism of the advertising image. In time, his way of representing things freed up and, in the process, loosely allied itself to the flattening of forms encountered in the pictures of the non-representational painter Ellsworth Kelly. On occasion Wesselmann's images also became more sculptural and even larger in size (page 168). Finally, his later works became both sketchy and sculptural, as he created vivacious images of still-lifes and landscapes in enamel on cut-out pieces of steel or aluminium.

Like his contemporaries Warhol, Rosenquist and Wesselmann, Wayne Thiebaud also dealt with American plenitude, specialising in pictures of food, arranged succulently and painted with a thick, creamy impasto that heightens the sense of appeal (pages 101, 133). Often the wide numbers of dishes on offer is reminiscent of the multitudinousness of repeated images found in Warhol's work, although the only associations engendered by such massive duplications are those of a flavoursome availability.

Allan D'Arcangelo mapped out the great American highway as his artistic territory, making graphically flattened and wry comments upon the bland ubiquity of landscapes filled with gas stations, diners, motels, advertising emblems, road signs, neon lights and the like. Sometimes the emblems could double as romantic symbols (page 104) and occasionally the signs could figure in political protests (page 145). After portraying American media heroes and villains, Mel Ramos produced endless images of pin-ups (page 144), frequently coupling them with consumer objects or animals, to summon forth the associations of advertising. And Robert Indiana specialised in the symbolism of words (page 80), often in connection with the behavioural exhortations of modern consumerist culture.

Meanwhile, back in Europe...

We have already seen that some of the earliest contributors to the Pop/Mass-Culture Art tradition lived and worked in Europe. In the 1960s Eduardo Paolozzi began creating large numbers of screenprints drawing upon technological imagery, works that in their pictorial density, propensity for witty, surrealistic juxtaposition, elegant colouring and formal variety constitute some of the most vivid portrayals of the image-bombardment of our era (page 140). No less relevant and stimulating is his sculpture, which often includes impressed patterning taken from machine parts, electronic circuit-boards and the like, thereby reminding us of the effects of technology upon humankind.

Richard Hamilton never relinquished his interest in mass-culture, although sadly his output failed to pick up very much creative momentum. He could deal with consumerism, as he did in a small number of views of domestic interiors created in the mid-1960s (page 74); with stardom, as he did in a 1965 treatment of a group of photographs of Marilyn Monroe as though they had been selected by a newspaper editor or advertising executive after a photo shoot; and the art world, as he did in a rather pointless sequence of 1965-6 views of the Guggenheim Museum, New York. But it is all very inconsequential. Even images from the 1980s, such as his *Soft Pink Landscape* (page 69), with its single roll of toilet tissue set in a washy landscape reminiscent of an English watercolour, do not say a lot about the banality of publicity, and certainly nothing that advertising does not itself proclaim much more loudly.

Peter Blake has proven to be far more productive and visually inventive down the years. Throughout the 1960s and beyond he produced vibrant images that portray or even incorporate elements taken directly from

Ed Kienholz, *Roxy's*, 1961-1962
(details, left and right).

popular mass-culture. A good example is his self-portrait of 1961 (page 85). By covering himself with badges that proclaim his tastes and star-worshipping affinities, Blake affords us a clever insight into the inner man. As the work makes clear, he loves jazz and pop music, and the latter appreciation was further articulated in *Got a Girl* of 1960-61 (pages 66-7) which actually incorporates the vinyl record of that title by the Four Preps, as well as photos of leading pop stars of the day, including Elvis Presley. In 1967, along with his first wife, Jann Haworth, Blake took a further step towards putting his art at the service of pop music by designing the cover for one of the best-selling albums of all time, *Sgt Pepper's Lonely Hearts Club Band* (page 70). This is a photographed image of a witty assembly of pieces of sculpture, waxworks figures, life-size photographs of politicians, musicians, artists and media stars, musical instruments and, of course, the Beatles themselves, dressed in quasi-military costumes that now look embarrassingly dated. As a portrait of a pop group and its cultural affinities the cover is perhaps unequalled, and it is surely the most widely-communicated Pop/Mass-Culture Art image of all time.

At the end of the 1960s Blake moved away from London and for many years thereafter indulged his sense of nostalgia by becoming a 'Ruralist', or a painter dedicated to extolling rustic values. Only occasionally would he return to aspects of mass-culture, as he did in 1981 with his witty homage to Courbet, *The Meeting* or *Have a Nice Day Mr Hockney* (page 217). This shows Blake standing alongside the painters Howard Hodgkin and David Hockney before some of the hedonistic pleasures afforded by southern California.

David Hockney

David Hockney is, of course, perhaps the most admired painter of the Pop/Mass-Culture Art tradition to have emerged in Britain. Born in the north of England, he studied art in his hometown of Bradford before becoming a post-graduate at the Royal College of Art in London between 1959 and 1962. At the college Hockney almost immediately met R.B. Kitaj who encouraged him to abandon the Abstract Expressionist approach he was dutifully following, in favour of his true artistic interests. As a result, Hockney entered the first of his many mature stylistic phases.

Like his supreme artistic hero, Pablo Picasso, Hockney has passed through differing creative stages. The first of these lasted between 1961 and 1966, and arguably it proved the most visually inventive period of his entire career. Stylistically it owed much to the influence of the French painter Jean Dubuffet, who had developed an intentionally crude manner of painting based upon the visual and expressive directness of graffiti and child art. The slightly childlike side of Hockney's nature found this approach highly congenial. Other influences were ancient Egyptian sculpture, the paintings of Piero della Francesca and Jan Vermeer, and the pictures and prints of William Hogarth. By drawing upon such stimuli, Hockney was able to explore a number of preoccupations that have remained constants in his work down to the present day: the relationship between art and illusion; perspective and its contradictions; and his homosexual impulses, which he has never denied. Occasionally he even demonstrated an awareness of mass-culture and its artefacts, as can be seen in his *Tea Painting in an Illusionistic Style* of 1961 (page 87). Here he attained a number of goals simultaneously: he represented a familiar consumer product; he got in a cheap joke at Francis Bacon's expense; and he explored the nature of pictorial space. To do so he used a shaped canvas in a sideways look at what American painters such as Kenneth Noland and Frank Stella were doing contemporaneously with such supports.

Between 1961 and 1963 Hockney projected a far more complex set of responses to contemporary mass-culture in his series of etchings, "The Rake's Progress", of which one example is reproduced opposite and some others are discussed below (pages 54, 106). In this sequence he updated William Hogarth's famous set of engravings by transporting his rake to present-day New York and Washington, and charted his downfall there. Amid other subjects the images deal with contemporary religious mass-meetings, body-building athleticism, gay sexuality, political elections, the cinema and race relations, psychiatric deterioration and the mental subjugation enforced by pop music.

In 1964, following his first visit to southern California, Hockney began dealing pictorially with American art collectors and the artificial ambiance in which they lived; a memorable painting in this vein is the *California Art Collector* of 1964 which owes a good deal stylistically to Piero della Francesca (page 134). However, by 1966, Hockney began to move away from the freewheeling spatial organisation and intentionally crude drawing of his initial manner and gravitated towards a more conventional organisation of space and a more traditional way of modelling forms. This is unsurprising, for by now he was becoming increasingly reliant upon photographs to supply the visual information needed for his pictures. In this second phase, Hockney surveyed the clean-cut but somehow inert side of Los Angeles life. Such an approach is typified by the portrait of Nick Wilder of 1966 (page 152). Here the influence of Vermeer is quite apparent, for almost all the major compositional lines run parallel to the edges of the canvas and thus imbue the image with a still, hieratic quality. In *A Bigger Splash* of 1967 (page 162) Hockney captured to perfection the artificiality, heat and stillness of affluent, hedonistic Los Angeles, where the sun is always shining and the pool constantly beckons.

During the 1970s Hockney generally lost interest in the mass-culture around him, preferring to paint his friends and relatives, as well as landscapes and still-lifes. However, towards the end of that decade he started exploring the subject of swimming pools once again, especially in a memorable set of prints in which he was able to take advantage of a new method of bonding pigment and paper (pages 202-3). Throughout this fourth phase of his development the influence of Picasso's Cubism constantly increased, motivating Hockney to explore all kinds of perspectival contradictions. And the garish colouring of Fauvism also began to creep into his work, which proved exceedingly handy when he began representing the hot landscapes of Los Angeles and its environs in a fifth phase of his development around 1980. In these works Hockney ably projected the suburban sprawl,

David Hockney, *The 7 Stone Weakling* from 'The Rake's Progress' series of etchings, 1961-63. Etching, 30.3 x 40.6 cm. The Royal College of Art, London.

garish colours and varieties of form encountered in one of the most inelegant cities on the planet. His exploration of Polaroid photography, with the spatial disjunctions and intense focusing of attention upon details it can bring into play when used in collaged form, also permitted him to create a most memorable image of the American landscape and its despoliation by endless signs (page 229).

Allen Jones and Others

The output of Allen Jones between 1960 and about 1964 tended towards the abstractive, reflecting his interest in the workings of the subconscious mind as informed by his readings of Nietzsche and Jung. By 1962, however, in paintings of planes and buses, Jones also began taking his subject-matter from mass-culture, giving us stylised representations of vehicles in movement, mainly in the form of areas of colour which he has always explored for its perceptual and expressive qualities, as well as for its structural importance. Subsequently, Jones began to probe sexuality as the central subject of his work, initially in a semi-abstractive way. But in 1964 David Hockney drew his attention to sexual fetish magazines, the imagery of which has informed his paintings, drawings, sculptures and prints thereafter (pages 55, 142-3, 163, 164 and 181). Throughout his work the psychological relationship between the sexes has obviously proved important, and although sculptures such as *Chair* and *Hatstand* of 1969 (pages 55 and 181 respectively) clearly downgrade women to the role of sex-objects – although that does not utterly obviate their aesthetic value, which is why the pieces are included in this book – Jones has also portrayed females as winners in the constant war between the sexes; they may be dressed according to male fantasies but they

can be dominant nonetheless. Sadly, over the past 40 years Jones's work has gradually descended into slickness, mannerism and cultural irrelevance as he goes over the same ground time and time again.

Other British painters and sculptors who have either dealt directly or tangentially with facets of mass-culture are Peter Phillips, Michael Andrews, Patrick Caulfield, Clive Barker and Richard Smith. To take the first, Phillips's works are bright, glossy and often huge in size, and they certainly celebrate mass-culture and its artefacts (pages 141, 190-1). This is unsurprising, for as Phillips has commented:

My awareness of machines, advertising, and mass-communication is not probably in the same sense as an older generation that's been without these factors; I've been conditioned by them and grew up with it all and use it without a second thought…
I've lived with them ever since I can remember and so it's natural to use them without thinking.

Although the resulting paintings may lack intellectual complexity and associative resonance, they do pack a hefty visual punch with their unashamed embracing of automotive imagery, technological patterning, soft-porn kitsch and the like, all deployed in vivid colours and frequently enjoying the silkiest of airbrushed surfaces.

For a time during the 1960s the figure, portrait and landscape painter Michael Andrews created large and memorable pictures of international jet-set life, with all its banal bonhomie, glitz and glamour. The people in these works are set within dynamically projected spaces that contain internal disjunctions suggestive of cinematic jump cuts (page 105). In spirit such images are not very far from the more stylistically inventive but far more static sculptural ensembles of Marisol, and they also relate to pictures of art world beautiful people by the American Howard Kanovitz (pages 160-1).

Allen Jones, *Chair*, 1969.
Painted fiberglass, leather and hair, full-size.
Neue Galerie, collection Ludwig, Aix-la-Chapelle.

The vacuity of mass-cultural images and objects has always been the overriding subject of Patrick Caulfield's work. In the main, he has painted landscapes, interiors and still-lifes, all depicted in a flat way that subtly emphasises the blandness and vapidity of what is represented. Occasionally he has also injected triteness into renowned images of past art, as well as invested images treated in his customary deadpan fashion with passages painted in a photographically realistic manner, in order to heighten, by contrast, the overall artificiality of what is represented (pages 196, 208). Like other artists working within the Pop/Mass-Culture Art tradition, such as Roy Lichtenstein and Jeff Koons, Caulfield has emphasised the poor taste and bad design that often surround us, and thus expressed a sense of cultural superiority to such defects. The resulting paintings can certainly make for some sardonic, richly coloured and compositionally complex experiences.

Perhaps more subtly ironic are the objects of Clive Barker. These are usually made by workmen following his instructions, as a post-Duchampian way of entirely removing the artist from the creative process. Often his sculptures take art as their theme, as can be seen in a version of Vincent van Gogh's chair at Arles which comments upon the accruing of value by works of art (page 153). And Richard Smith drew the basic forms and colours of works he made during the 1960s from the shapes, surface designs and arresting colours of objects such as cigarette packets and the like. As he stated in 1966:

The carton is an incessant theme in present-day civilisation: shops are full of boxes and you see these before you see the goods…

I have tried to keep close to the sensibility, ethos almost, of objects and themes in present-day life (like boxes) rather than reconstructing the boxes themselves.

After 1963 Smith began using shaped canvases which pull away from the wall, thereby initiating an intense spatial dialogue. Everywhere on view is the dynamism of billboards without any particular products being identified, for consumer culture and its large-scale images merely acted as pictorial starting points in this phase of Smith's art (page 123). Later in his career he became a wholly abstract artist.

Photorealism and Mass-Culture

Smith demonstrated that abstractiveness could healthily develop out of the familiar imagery of mass-culture. At the opposite end of the visual spectrum, intense verisimilitude served as a highly useful tool for the exploration of that culture. Around the end of the 1960s a new type of representational painting emerged in the United States, namely photorealism. This was based upon the close analysis of colour photographs and/or the overpainting of colour slide projections, and it flourished for a number of reasons other than the mere absence of visual imagination: the intense scrutiny of photos permitted the seeing of a large amount of detail that the eye might overlook; it made possible the focusing upon everything at once, unlike the eye; it allowed for total objectivity and a complete absence of emotion; and it carried on a tradition of visual realism that went back to the Renaissance. Yet photorealism was not necessarily backward culturally, for because a significant amount of the work made via photography dealt with the empty promises, garishness and visual overload of the American Dream, photorealist painting strongly allied itself to the Pop/Mass-Culture Art tradition.

An approach to mass-culture through the transcription of photographs was certainly validated by the fact that painters such as Rosenquist, Rauschenberg and Warhol had either replicated photographic material with enormous faithfulness or even incorporated actual photographs into their images. In part photorealism was about both the processes of painting and the most minute examination of appearances, almost putting reality under a microscope. Following such an approach, artists who included Robert Cottingham (page 195), Richard Estes (pages 157, 169 and 182-3), Ralph Goings (pages 214-5) and Don Eddy (page 227) turned their cameras on people, the exteriors and interiors of buildings, street scenes and all kinds of consumer objects, usually with a sharp alertness to the cultural values of a given subject. The images were then laboriously transferred on to canvas, a process that could take many months. Due to the fact that much photorealist painting draws attention to corners of the urban environment that we usually take for granted or even overlook, it has had much to say about the world of mass-consumption, the availability of cheap products and services, and the banality that often surrounds us.

Duane Hanson, Sandy Skoglund and Ed Paschke

A realism bordering on the photographic is equally to be found in the sculptures of the American Duane Hanson. This is unsurprising, for like George Segal, Hanson cast his figures directly from life. He then went on to make them utterly faithful to appearances by first spray-painting them with flesh tints, then adding hair and similar details, and finally clothing them in real apparel. However, the attainment of an intense verisimilitude was not Hanson's ultimate goal. Instead, he wished to draw attention to particular social types within our mass-culture, and indeed, he often achieved that aim quite scathingly (pages 185-6). Reality is used to comment upon mass-culture in quite another way by the American Sandy Skoglund. She sets up sculptural ensembles employing live models and real objects, which she then photographs and disseminates through the sale of Cibachrome prints, books, posters and postcards. Certainly there is a somewhat surrealistic level to much of her work but she has turned her attention to the lifestyle and values inherent to mass-culture, as in her installation/photograph *Germs are Everywhere* (pages 222-3), with its witty comment upon the problems of an anally-retentive suburban existence. In the paintings of the Chicago-born artist Ed Paschke we encounter the vivid patterning and colours that are often displayed by the electronic mass-media (pages 210, 224-5). Sometimes the pictures are invested with a violence that can prove very disturbing (page 205). The transformations that famous faces often receive electronically was also the subject of Paschke's work (see above).

Ed Paschke, *Matinee*, 1987.
Oil on linen, 172.7 x 203.2 cm.
Robert H. Bergman collection, Chicago.

Keith Haring, Jeff Koons and Mark Kostabi

Because of his highly communicative, clear-cut and funky graphic style, the American painter and sculptor Keith Haring quickly rose to prominence in New York during the 1980s. He had first perfected his approach while painting graffiti-like images on blanked-out poster sites within the Manhattan subway system. Amid his vast numbers of cartoon-like images we can often encounter statements about contemporary sexuality, the relationship of the individual to the mass, and aspects of technology (pages 221, 238). Often the American Jeff Koons leads us back to the familiar territory of cultural and social banality previously explored by Andy Warhol in, say, his Marilyn paintings, although Koons goes much further than his predecessor in forcing the artificiality, falsity and tastelessness of modern life up to an incredible pitch (page 237). Like others before him, Koons's apparent embrace of kitsch really masks a rejection of such crassness, for in truth the artist is subtly affirming his superiority to the degradation of taste in modern society. And the American Mark Kostabi does not just hire others to make the objects to which he adds his name (like, for instance, Koons and Barker); he also gets his employees to conceive his works as well, not usually interfering in the process at all. Like the chairman of an

Arman, *À Lourdes*, 1962.
Group of wooden crutches on panel,
244 x 122 x 29.5 cm. Collection Arman.

Arman, *La Chute des courses*, 1996.
Group of supermarket trolleys, 345 x 433 x 115 cm.
Galerie Vallois, Paris.

industrial manufacturing company he simply manages things strategically, leaving the conception and production of the artefacts to others. By such means Kostabi attains three aims simultaneously: he mimics the processes of mass-production; he comments upon the divorce between means and ends commonly encountered in an industrial society; and he takes to its logical conclusion the creative method first advocated by Duchamp with his 'ready-mades', whereby the artist plays no part whatsoever in the production of artefacts. He simply 'chooses' them – or, in Kostabi's case, he doesn't even do that.

Arman

As we have already noted, a number of leading creative figures from the continent of Europe took part in the autumn 1962 Sidney Janis Gallery 'New Realists' exhibition that finally launched Pop/Mass-Culture Art into the aesthetic and commercial stratosphere. They included some artists whose works implicitly explored aspects of mass-culture. One was the French-born Arman who has specialised in bringing together large accumulations of artefacts to pinpoint the materialism of modern life (pages 59, 204 and 228). Often his gatherings attain beauty simply through sheer weight of numbers (page 154), and many of them have alluded to violence (pages 82, 125). In 1995 he even created one of the world's most impressive war memorials (page 250), a 32-metre high, 6000-ton concrete tower in Beirut, Lebanon, that incorporates the very machinery of conflict itself, namely tanks and heavy artillery. As most wars since well before 1939 have witnessed the infliction of equal violence upon both soldiers and civilians, Arman's piece not only commemorates a major local tragedy; it cuts to the heart of modern mass-cultural experience.

Martial Raysse, Mimmo Rotella, Erró and Others

In the 1962 'New Realists' show the Frenchman Martial Raysse displayed everyday objects as part of a larger project to demonstrate the vast, bewildering and ultimately meaningless variety of choice in a consumer society. Subsequently he created a great many works that typify the synthetically-coloured or neon-lit artificiality of modern life (pages 62, 126 and 135). And another 1962 'New Realists' exhibitor was the Italian Mimmo Rotella who displayed torn advertising posters as a way of attacking the values such visual appeals embody (see opposite and page 95).

Erró, *American Interior n° 7*, 1968.
Oil on canvas, 97 x 115 cm. Ludwig Forum für Internationale Kunst, Aachen.

Mimmo Rotella, *Cinemascope*, 1962.
Torn overpasted posters, 173 x 133 cm.
Museum Ludwig, Cologne.

The Icelandic-born painter Erró first came into contact with Pop/Mass-Culture Art during his initial visit to the United States in 1963, after which time he began using the imagery of mass-culture to explore the cosmos of endless consumption (page 60). Not much of his output is particularly original but occasionally he has produced some memorable images of cultural overload (page 165). Similarly the German artist Wolf Vostell, who was a founding figure of the FLUXUS group that sought to overthrow all conventions of artistic expression and taste, occasionally created works that afford new perspectives on mass-culture. One sculpture in particular, his *Television Obelisk – Endogenous Depression* of 1978 (page 201), wittily piles up the principal means of mass-communications in the modern world.

In France the sculptor Niki de Saint Phalle occasionally touched upon political-military issues that involve us all, as in her striking *Kennedy-Khrushchev* of 1963 (page 124). For a time the Frenchman Alain Jacquet was particularly interested in the breakdown of images by printing techniques (page 148), moving matters much further towards abstractiveness than, say, Roy Lichtenstein, who was no less concerned with the replication of such processes.

The Italian artist Michelangelo Pistoletto literally involved people in his works, for he drew or photo-silkscreened life-sized figures on to mirrored surfaces, thereby blurring the distinction between levels of reality and forcing the viewer to enter the images (page 150). And entry to a work by means of mirrors was also afforded to vast numbers of people by *The Weather Project* which the Icelandic/Danish artist Olafur Eliasson created in 2003 within the massive interior of Tate Modern, London (pages 250-1). The centrepiece of this installation was a semi-circular disc made from the mono-frequency lights usually used for street illumination, and its reflection by a ceiling covered in mirrors turned it into a vast yellow/orange sun, beneath which visitors often lay on the floor to revel in the simulated light and form shapes with their bodies which were reflected by the mirrors. By dint of its concern with the cultural aspects of the weather, Eliasson's giant work implicitly addressed mass-culture. Because it was experienced by over two million people, it is also discussed below, for art and mass-culture often form a two-way dialogue.

Haim Steinbach, Ashley Bickerton and Others

Back in the USA the American artist Haim Steinbach uses everyday, mass-produced objects as the building blocks of his works (page 231). These artefacts are purchased on shopping expeditions, thereby reinforcing a sculptural tradition that goes back to Marcel Duchamp. Subsequently such elements form groupings which impose order and balance upon the chaos of consumerism. Because Steinbach possesses a good eye, the resulting sculptures are usually very elegant, and they certainly force us to look anew at everyday objects we might normally underestimate aesthetically. Undoubtedly there can be a feeling of banality to the proceedings, but this is entirely understandable, given that Steinbach clearly selects many of the objects he uses for that very reason.

For a time Ashley Bickerton made non-representational sculptures that enjoy a machine-like look. He then adorned them with the identifiable logos of large corporations (page 239), thus reminding us of the economic powers that engender most artefacts in reality. The American Allan McCollum has addressed the multitudinous output of mass-society by manufacturing sculptural ensembles comprising enormous accumulations of objects. These include framed pictures of nothing which inescapably remind us that art galleries the world over are often filled with aesthetically empty images pressed behind glass (page 220).

The American sculptor and performance artist Chris Burden has also created some telling comments upon modern industrial society. In 1987 he made clear the historical magnitude of his nation's military might in his stunning ensemble, *All the Submarines of the United States of America* (page 232). His *Medusa's Head* of 1990 is a huge and potent metaphor for a gorgon or monster of ancient mythology (pages 242-3). Medusa turned every living creature that looked upon her into stone; in Burden's work our entire planet has been transformed into rock by technology, as represented by a covering of miniaturised railroad tracks which double as tropes for the snakes that writhed upon the ogre's head.

Martial Raysse, *Peinture à haute tension*, 1965. Photographic film, neon, oil and fluorescent paint on canvas, 162.5 x 97.5 cm. Stedelijk Museum, Amsterdam.

British Sculptors and Mass-Culture

A number of leading sculptors in Britain have also dealt with aspects of mass-culture. Perhaps the foremost of these is Tony Cragg, the major part of whose work is not at all representational. Yet Cragg does possess a marked sense of metaphor, and around 1980 he put this advantage to good use by creating striking ensembles out of the detritus of industrial society, such as objects retrieved from scrap heaps and the like. Thus in *Britain Seen from the North* of 1981 (page 212) Cragg constituted a sculptural representation of mainland England and Scotland that expresses both personal disorientation and national fragmentation. And in *Zooid* of 1991 (page 244) he took two kitsch, interior decorator's porcelain statues of leopards, broke them into pieces and placed those fragments within industrial containers whose metal bars remind us of cages. The meaning of the resulting work is strongly hinted at by the title of the piece, and it says much about the contemporary containment of the natural world, both in zoos and beyond.

David Mach creates site-specific sculptures, often on a massive scale. One of his favourite devices is to use tens of thousands of pristine newspapers or magazines to project the vast ebb and flow of information in our time (pages 246-8). No less site-specific is Rose Finn-Kelcey's 1987 *Bureau de Change* (pages 234-5), with its coins arranged to simulate a van Gogh painting and its gallery attendant included to prevent their theft. Given that the Dutch artist's works have moved upwards in value perhaps more than those of any other painter in history, Kelcey's statement about art-as-money seems both witty and relevant. Another site-specific work was Tim Head's 1990 *Techno-Prison* (see above). Here the walls of a room in a London art gallery were briefly covered with lurid Day-Glo colours, over which were painted huge bar-codes, to remind us that every aspect of life today is being processed, tagged, logged and stored in electronic databanks: a techno-prison indeed.

Tim Head, *Technoprison*, 1990.
Installation for the exhibition 'Seven Obsessions', paint on walls, variable dimensions. Whitechapel Art Gallery, London.

A Necessary Change of Name

In the preceding paragraphs we have touched upon just a few of the artists who have dealt memorably with mass-culture down the decades since the late-1950s. Their inclusion demonstrates exactly why it is necessary to alter 'Pop Art' to 'Mass-Culture Art', for while it may seem appropriate to describe creative figures such as Lichtenstein, Oldenburg, Rosenquist and Wesselmann as 'Pop artists' because they communicate generally light-hearted moods in their works, it would seem wholly inappropriate to apply the same term to artists such as Warhol, Kienholz and Segal in whose output the darker side of life has frequently figured. Moreover, to characterise sculptors such as Steinbach, Burden, Mach and Finn-Kelcey as 'Pop artists' would seem utterly ridiculous (which is why it has never been attempted). But if we apply the term 'Mass-Culture Artists' to all the creative figures discussed in this book (and to many more who have not received coverage), then not only does that designation fit them all very aptly; it also makes evident the tradition that binds them.

Lack of space has necessitated the omission from this book of many artists who have explored mass-culture but whose insights have proved fairly insignificant, figures such as Raymond Hains, Eduardo Arroyo, Oyvind Fahlström, Derek Boshier and others. Naturally, painters who have often been (wrongly) associated with 'Pop Art', such as R.B. Kitaj, but who have never even been remotely concerned with mass-culture, have also been omitted. As may have become apparent from the space already accorded to them above, and hopefully will become even more so below, some artists have proven themselves to be of major status, while others with substantial reputations have revealed themselves to be minor contributors to the Pop/Mass-Culture Art tradition, having often been hyped up by art-nationalism and/or the marketplace. Quite a few contributors to the Pop/Mass-Culture Art tradition have produced only a small number of works that deal with mass-culture, but have done so most memorably in those pieces, while others have frequently addressed that culture but in a singular way, saying the same thing over and over

Charles Frazier, *American Nude*, 1963.
Bronze, 19.6 cm high. Collection of Dr and Mrs Leonard Kornblee, New York.

Sir Peter Blake, *Got a Girl*, 1960-61.
Oil and mixed media on hardboard,
92 x 153 cm.
Stuyvesant Foundation, London.

again. Merely a small number of artists – Oldenburg, Rosenquist, Kienholz and Arman – have consistently created large numbers of good works, although perhaps the failure of most others to do so is a measure of the fragmented culture everyone has had to deal with. Then there is the question of transience, for much Pop/Mass-Culture Art created during the 1960s and 1970s already looks exceedingly dated, just as words like 'fab', 'trendy' or 'groovy' were once in vogue but now belong to the language of a bygone era. Doubtless such dating will continue but it has always greatly served art by dividing the relevant from the irrelevant, and the good from the bad.

The Cultural Status of Pop/Mass-Culture Art?

But where, finally, does Pop/Mass-Culture Art stand within the historical continuum of art? Has it just been a passing phase, or has it constituted something more lasting and significant?

To attempt an answer to these related questions, we need to go back to the end of the 1960s, when Pop/Mass-Culture Art had already firmly established itself as a valid area of cultural expression. At that time, many within western art circles increasingly concluded that Modernism, or the positive response to the challenges posed by living in an industrialised epoch, had come to an end simply because it had supposedly exhausted its potential. Where painting and sculpture were concerned this meant that a sequence of movements that included Impressionism, Post-Impressionism, Cubism, Surrealism and Abstract Expressionism had eventually and most logically culminated aesthetically in Minimalism and Conceptualism, with Pop Art as a transient, unimportant aberration or side-show. Beyond conceptualism there seemed to be nothing left to explore, for where do you go beyond empty spaces or blank canvases, written statements denying the validity of art that you pin to walls or pop in the post, and the notion that art is simply a concept whose existence does not require any physical realisation whatsoever?

Certainly an attempt to answer these questions and thereby sidestep such an 'end of history' was made by cultural historians in the mid-to-late 1970s, when they came up with a wholly spurious new phase in western art (and indeed life) which they termed 'Post-Modernism'. This concept remains especially bogus because it presupposes a complete divorce between art and society: faced with the ostensible 'end of history' that formalism and conceptualism represented, 'Post-Modernist' artists were encouraged to range freely over the entire gamut of visual experience and art history, of necessity appropriating from the past in order to cobble together some valid style for the present. Yet the Modernist epoch in which they operated had not come to an end in any way – indeed, it still went on evolving in scientific, technological, democratic, mass-cultural and multi-cultural terms exactly as it had done since its beginnings in the late eighteenth century. Moreover, far from the Modernist technological epoch being a phase in the development of humanity that had come to an end, as advocates of 'the end of history' and 'Post-Modernism' would have us believe, if anything it is clearly still continuing and intensifying. In the process, it is making the world an ever-more homogenised place, thereby producing one of our major global problems, namely the erosion of ethnic and geographical identities. But how can art be 'Post-Modern' if the surrounding society it reflects is still fervently Modernist in outlook, and indeed is increasingly so?

The tradition of Pop/Mass-Culture Art as it has developed over the past four decades supplies the answer, for that creative impulse has utterly negated the validity of 'Post-Modernism'. This is because Pop/Mass-Culture Art is quite clearly an artistic dynamic that for the entirety of its comparatively brief history has been wholly rooted in the Modernist outlook, with all its technological, cultural, social and visual complexities. One just has to look at the core concerns of its contributors to perceive this very easily, as hopefully the present book will demonstrate. Artists who have subscribed to the Pop/Mass-Culture Art tradition have in fact completely sidestepped the supposed 'end of history' created when a barren formalism and an even more arid conceptualism ran artistic Modernism into sterile ground and ultimately led to the invention of 'Post-Modernism'. In doing so, they and their heirs have made no end of relevant comments about the contemporary, Modernist world. The promulgation of observations about the arena in which humankind lives has always been a prime purpose of art, and those creative figures who have specialised in exploring mass-culture have therefore proven both highly relevant and aesthetically innovatory. In the light of all this, Pop/Mass-Culture Art can therefore legitimately claim to be the central creative area of the visual arts in our time, with hopefully still much to give us in the future. We look forward to things to come.

Richard Hamilton, *Soft Pink Landscape*, 1980.
Lithograph and screenprint on paper,
73 x 91.8 cm. Tate Britain, London.

Overleaf: **Sir Peter Blake**, Cover for the Beatles' album,
Sgt Pepper's Lonely Hearts Club Band, 1967.
Mixed media including photographs, plaster casts,
stone sculptures, and musical instruments.

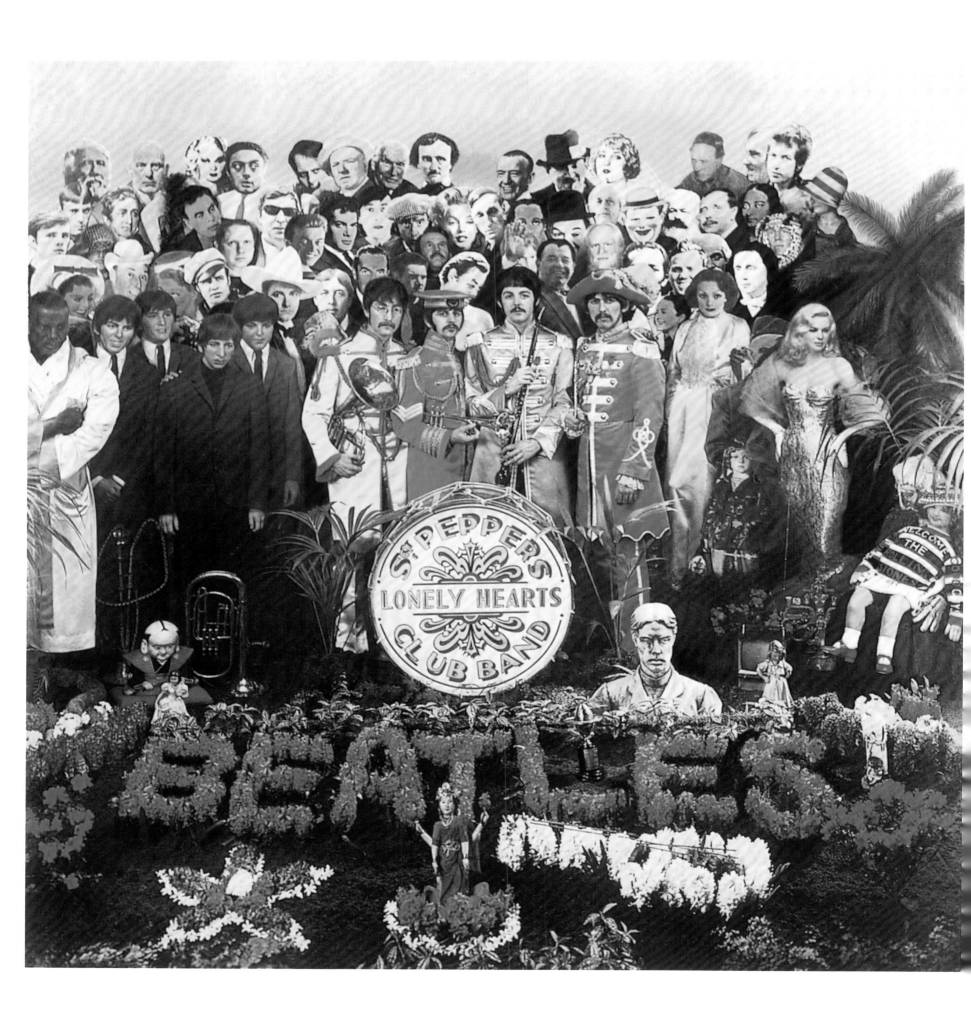

THE PLATES

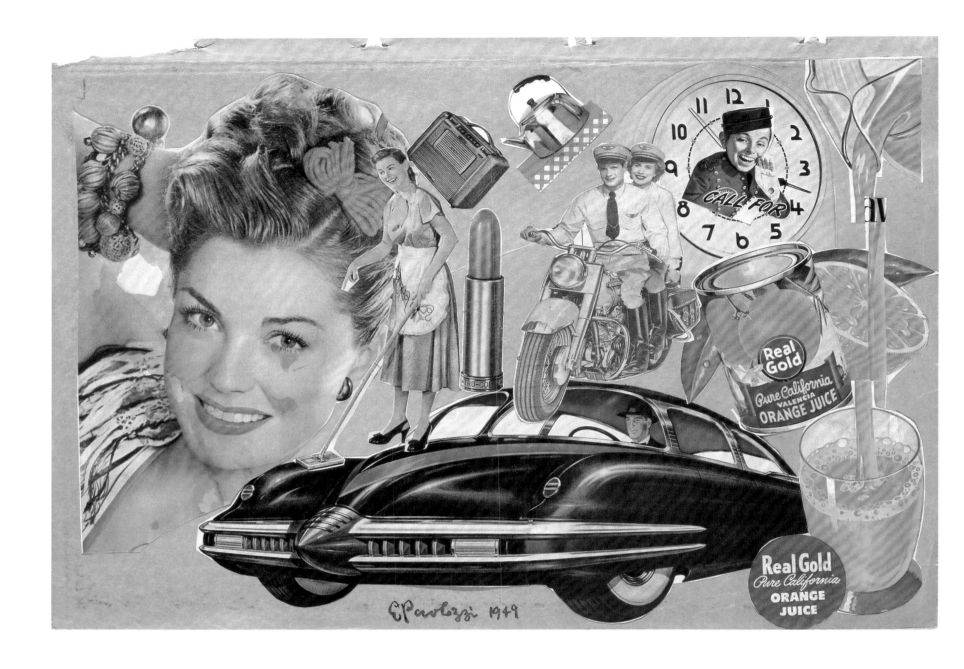

Sir Eduardo Paolozzi, *Real Gold*, 1949.
Collage on paper, 28.2 x 41 cm. Tate Gallery, London, presented by the artist 1995.

Eduardo Paolozzi was born in Edinburgh, Scotland, in 1924. After attending Edinburgh College of Art and St Martin's School of Art in London between 1943 and 1945, he studied sculpture at the Slade School of Art (which was then temporarily based in Oxford). He first exhibited at the Mayor Gallery in London in 1947. That same year he moved to Paris where he met Brancusi, Arp, Giacometti, Hélion, Tzara, Braque and Léger, among others. Following his return to London in 1949 he taught at the Central School of Art and Design until 1955, and at St Martin's School of Art between 1955 and 1958.

In 1952 he was one of the founding members of the Independent Group at the Institute of Contemporary Arts (ICA) in London which was a forum for debate about the relationship of art and mass-culture. This interest found expression in Paolozzi's organisational contribution to the 'Parallel of Life and Art' exhibition mounted at the ICA in 1953, as well as his participation in the 'This is Tomorrow' show put on at the Whitechapel Art Gallery in 1956.

After 1960 he taught in Hamburg, Berkeley, London, Berlin, Cologne and Munich. He exhibited at the Venice Biennale in 1952 and again in 1960, in which year he also displayed work at the Betty Parsons Gallery in New York. Four years later his work was exhibited at the Museum of Modern Art, New York. In 1967 he received the First Prize for Sculpture at the Carnegie International exhibition in Pittsburgh. A major retrospective of his output was mounted at the Tate Gallery, London in 1971. He was knighted in 1989, and died in 2005.

Although Paolozzi was primarily a sculptor, his prints and works on paper always formed an integral part of his output. In Paris in 1947 he began creating a series of ten collages, using images taken from magazines he had been given by American ex-servicemen who were also studying in the city. He called this series 'Bunk', a title taken from the famous dictum by Henry Ford that "History is more or less bunk...we want to live in the present." At the early-1952 inaugural meeting of the Young Group within the Institute of Contemporary Arts in London (a circle that led to the creation of the Independent Group the following autumn), Paolozzi employed an epidiascope to project the Bunk series images on to a screen, as part of a talk he gave on the possible iconography of the future.

Real Gold is one of the most startling and prescient works in the Bunk series, for it anticipates the imagery of artists such as James Rosenquist, Tom Wesselmann and Peter Phillips by well over a decade. Given Paolozzi's true artistic interests, the collage was doubtless intended to look surrealistic but it certainly projects the banal over-glamorisation of people and objects that is central to mass-culture.

Larry Rivers, *Washington Crossing the Delaware*, 1953.
Oil, graphite and charcoal on canvas, 212.4 x 283.5 cm.
The Museum of Modern Art, New York.
Art © 2006 Estate of Larry Rivers/ Licensed by VAGA, New York, NY

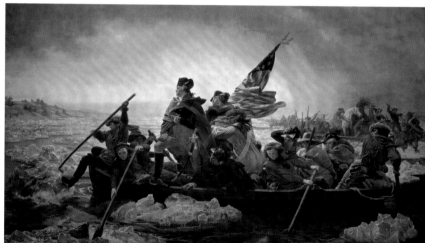

Larry Rivers was born in the Bronx, New York in 1923, under the name Larry Grossberg. He began his professional life as a jazz saxophonist, during which time he changed his name. He took up painting in 1945, studying between 1947 and 1948 at the Hans Hofmann School in New York, and then under William Baziotes at New York University. Because of these contacts, during the late 1940s he became acquainted with some of the leading Abstract Expressionists, including Jackson Pollock and Willem de Kooning. He died in 2002.

By the early 1950s Rivers was already beginning to resent the conformist thinking that advocates of Abstract Expressionism were attempting to impose upon all American artists who harboured modernist aspirations. This painting was the result, for as Rivers commented, "I was...cocky and angry enough to want to do something no one in the New York art world would doubt was disgusting, dead and absurd." On a direct level the picture was a response to one of the principal American national icons, namely Emanuel Leutze's *Washington Crossing the Delaware* of 1851. National familiarity with this canvas was very widespread due to its frequent reproduction in school history-books and the like. Because of this awareness, the Leutze therefore acted as a fitting vehicle for an attack on accepted thinking.

George Washington and his ragtag revolutionary army crossed the Delaware River on Christmas Day 1776, during a ferocious blizzard. By doing so they were then able to fall upon unsuspecting Hessian forces at nearby Trenton and defeat them. Rivers determined to re-conceive the entire subject of the river-crossing, substituting a messy, quasi-Abstract Expressionist paint-handling and somewhat disorganised composition for the perfect facture, bombastic poses and artificial pictorial organisation of Leutze's image. As he commented:

> *What I saw in the crossing [of the Delaware] was quite different [from what Leutze saw there]. I saw the moment as nerve-wracking and uncomfortable. I couldn't picture anyone getting into a chilly river around Christmas time with anything resembling hand-on-chest heroics.*

To that end the employment of painterly and structural freedom served admirably. But Rivers not only re-thought the subject and simultaneously spat in the eye of accepted modernist orthodoxy – he also subtly attacked political orthodoxy as well, for in 1953 the anti-communist political witch-hunt being led in the US Congress by Senator Joseph McCarthy was greatly intensifying. By showing up the pomposity and dramatic falsity of Leutze's propagandistic image, Rivers alluded to the self-righteousness and intellectual dishonesty of McCarthyism.

Understandably, the work was frostily received by both Abstract Expressionists and right-wing American patriots, the former because it compromised their artistic vocabulary, the latter because it demeaned a revered national image.

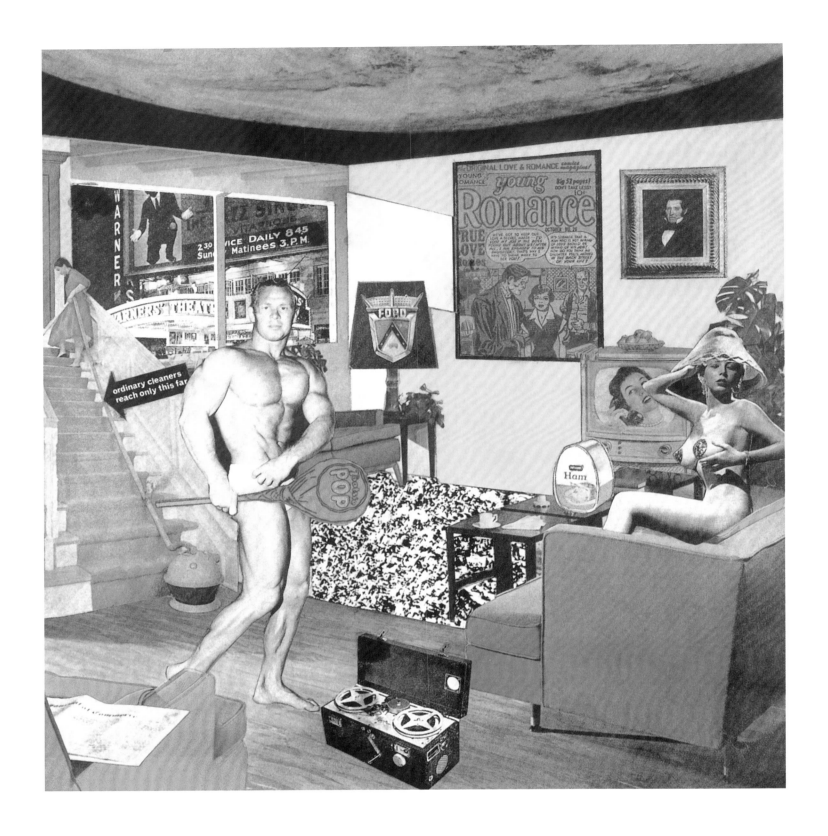

Richard Hamilton, *Just what is it that makes today's homes so different, so appealing?* 1956. Collage on paper, 26 x 25 cm. Kunsthalle, Tübingen, Prof. Dr. Georg Zundel collection.

Richard Hamilton was born in London in 1922. After taking evening classes in art he studied at the Royal Academy Schools between 1938 and 1940. During the Second World War he put his drawing skills to good use in industry and then briefly returned to his old art school before attending the Slade School of Art at London University, from where he graduated in 1951. After 1952 he taught at both art school and university, as well as at the Royal College of Art. He held his first one-man show at the Gimpel Fils Gallery in London in 1950. Throughout the 1950s he was highly active in the organisation of exhibitions that explored the relationship between mass-culture and art. His interest in the work of Marcel Duchamp culminated in his creation of a simulacrum of Duchamp's Large Glass, and he organised a Duchamp retrospective for the Tate Gallery in 1966. By the end of that decade he was widely recognised as one of the most important pioneers of Pop/Mass-Culture Art, in Britain at least.

This small collage was a design for the monochrome poster advertising the very first Pop/Mass-Culture Art exhibition ever to be held, namely the 'This is Tomorrow' show mounted at the Whitechapel Art Gallery in London in 1956 by the Independent Group, of which Hamilton was a member. The design demonstrates exactly why its creator is deemed so important to the tradition of Pop/Mass-Culture Art, for it is almost a lexicon of all the themes that would soon be touched upon by both Hamilton and others. Thus the Young Romance comic strip image hanging on the wall points towards things to come from Roy Lichtenstein; the nude on the right coupled with the adjacent tin of ham, bowl of fruit and television set suggests future images by Tom Wesselmann; the word-bearing pointer on the stairs would be paralleled in works by Andy Warhol, just as that selfsame artist would devote a major part of his art to 'superstars', as seen here in the form of Al Jolson in The Jazz Singer of 1929; the word 'POP' carried on a paddle by the semi-nude male points the way to the future employment of words by Ed Ruscha, Robert Indiana, Allan D'Arcangelo and by Hamilton himself; and the corporate logo appearing on the lampshade anticipates the work of Ashley Bickerton by several decades.

Sir Peter Blake, *On the Balcony*, 1955-57.
Oil on canvas, 121.3 x 90.8 cm. Tate Gallery, London.

Peter Blake was born in Dartford, Kent, England in 1932. He studied at art school in nearby Gravesend and then, following compulsory military service, at the Royal College of Art in London between 1953 and 1956. After graduating with a first-class diploma he was the recipient of a research grant to travel through the Lowlands, France, Italy and Spain studying folk art. In 1958 he was also accorded a Guggenheim Painting Award. After 1960 he taught at a number of art schools, including the Royal College. In 1961 he won First Prize in the Junior Section of the prestigious John Moores Exhibition of contemporary painting in Liverpool. His first one-man exhibition was mounted at the Portal Gallery in London in 1963. Since then he has shown all over the world. He was knighted in 2002.

Blake painted this canvas while he was a student at the Royal College of Art, its subject being set as part of his course work. As he recently commented in an interview with Natalie Rudd:

> My version of 'on the balcony' is a continuation of my earlier pictures of children.
> I started by collecting references to 'on the balcony' and soon realised there were many.
> I wanted to get them all in and so borrowed a device from a painting called Workers and
> Paintings by the American artist, Honoré Sharrer. She painted a row of manual workers
> holding up their favourite paintings… I suppose my interest in the world of children
> came from the fact that I had such a complicated childhood. In a way I wanted to bring
> it back to make it better. The children in On the Balcony are like tiny adults. They are

> certainly odd: almost everyone I paint has an oddness — there is a subtext usually. I
> based the figures on family photos of my sister and brother, but although they are from
> people they are not portraits — they are 'children'.

Because reliance upon photographs and postcards was discouraged at the Royal College of Art, Blake was forced to use such material surreptitiously when making this work. As well as replicating a well-known photograph of Winston Churchill standing alongside the Royal Family on the balcony of Buckingham Palace on Victory in Europe Day 1945 (seen towards the upper right), Blake also imitated a photo of one of his former teachers at the Royal College, the then recently-deceased British painter John Minton (1917-1957). His image hangs from a neckband strung around the figure on the right, and it supports a small placard also memorialising the late painter. A youth standing in a corresponding position on the left holds a framed reproduction of Manet's renowned picture of people on a balcony of 1868-9 (Musée d'Orsay, Paris). Such a commentary upon art, plus all the observations concerning photography, would prove integral to much Pop/Mass-Culture Art.

The flattening of pictorial space throughout the image induces associations of notice boards, and that link is strengthened by the green of the overall ground which parallels the colour of the baize frequently used on such supports. In general, the picture looks as unsophisticated as so-called 'folk art' created by amateur, untrained painters but of course this is deceptive, for Blake brings to bear an enormous painterly sophistication in pursuit of an untrammelled sense of vision.

Richard Hamilton, *Hommage à Chrysler Corp.*, 1957.
Oil, metal foil and collage on panel, 122 x 81 cm. Private collection.

This is one of a number of paintings created in the second half of the 1950s in which Hamilton took his starting point from the shapes of mass-produced objects. Here he balanced his attraction to non-representational painting with his thinking that 'automobile body stylists have absorbed the symbolism of the space age more successfully than any artist'. As well as subtly accentuating the somewhat sexual curves inherent to the glamorous American automobiles which were then setting the stylistic tone for popular car design in Britain, Hamilton also pasted red lips on to the panel (slightly up from the left of centre), thereby further alluding to the sexuality that frequently motivates our attraction to cars.

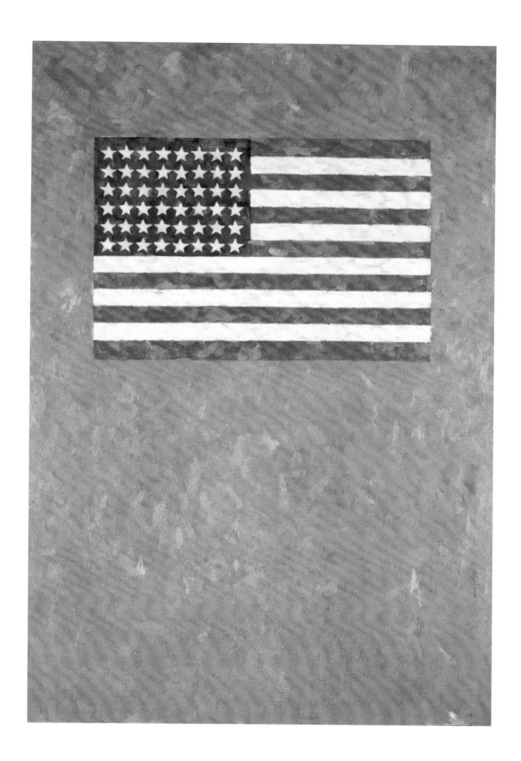

Jasper Johns, *Flag on Orange Field II*, 1958.
Encaustic on canvas, 92.7 x 37.2 cm. Private collection, courtesy of Castelli archives.
Art © 2006 Jasper Johns/ Licensed by VAGA, New York, NY

Jasper Johns was born in 1930 in Augusta, Georgia, although he grew up in Allendale, South Carolina. After spending a short time at the University of South Carolina in 1947-8, he moved to New York where he took classes in commercial art. Following his military service he returned to New York, where he supported himself by painting window displays and working in a bookshop. In 1954 he met Robert Rauschenberg who was living in the same building in lower Manhattan. He started painting the American flag in 1954, and his sequences of Target and Numbers images were begun during the following year. His 1958 debut exhibition at the Leo Castelli Gallery in New York put him very much on the artistic map, a position he has never lost.

Given the ostensible subject of his Flags paintings, Johns could hardly avoid the nationalistic and cultural associations of the Stars and Stripes. However, because he represented the flag in a wholly objective way, as simply constituting an arrangement of shapes and colours on a flat surface, to a certain degree he divorced the banner from what it symbolises. The isolation of the flag within the overall composition makes it look disembodied and emotionally neutral, and Johns certainly separated himself from any overly emotional entanglement with what he was painting by creating the work with a quick-drying wax medium, which necessitated

patiently building up the surface in layers. Paradoxically, the apparent animation of the final painting parallels the surface dynamism of Abstract Expressionist pictures, and Johns surely welcomed such a difference between means and ends.

Naturally, portrayals of the American flag and banner-waving had been highly topical at the height of the Cold War in 1954 when Johns began the series to which this later image belongs, for Soviet Russia had recently acquired the atomic bomb, Red China had shown its true expansionist colours by intervening in the Korean War, and Senator McCarthy and his political henchmen were ostensibly finding communists under every bed. By painting the national flag, Johns was therefore apparently affirming his American identity, although by treating it merely as a coloured and formally-varied shape he made clear his lack of passion about its nationalistic meaning. He furthered such a lack of jingoism in other paintings of the series by making the flag difficult or almost impossible to see, sometimes by painting it in silver or in white-on-white, and occasionally by radically altering its colours and proportions. All of these interventions and changes served to stress the freedom of the artist and to make it clear that nothing is visually sacred, not even the most hallowed of American icons.

Sir Peter Blake, *Tattooed Lady*, 1958. Ink and collage, 68.6 x 53.3 cm.
Victoria and Albert Museum, London.

Here Blake took an even closer step towards the complete encompassing of popular imagery. The drawing incorporates material taken from a number of sources ranging from old postcards (including one of the 'saucy' variety), passport photos and children's book illustrations, to comic-strips, tickets, advertising sticky-labels, magazine photos and other such images. A particularly witty note is struck by the lady's cantilevered brassiere.

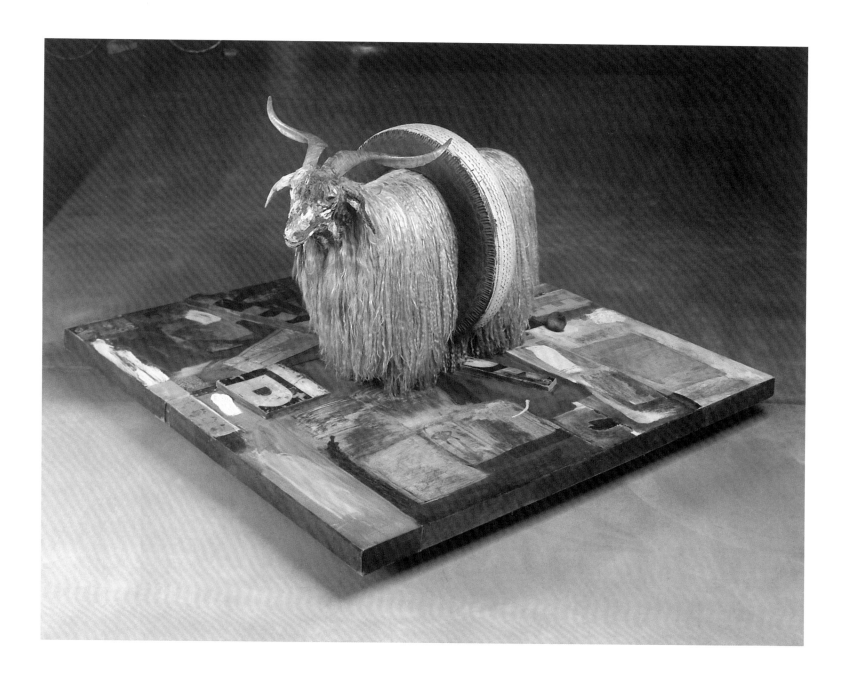

Robert Rauschenberg, *Monogram*, 1955-59.
Combine painting, 106.7 x 160.7 x 163.8 cm. Moderna Museet, Stockholm.
Art © 2006 Robert Rauschenberg/ Licensed by VAGA, New York, NY

Robert Rauschenberg was born in Port Arthur, Texas in 1925. Following military service in the Second World War, he studied art at the Kansas City Art Institute in 1946-7, at the Académie Julien in Paris in 1947, under Josef Albers at Black Mountain College in North Carolina in 1948-9, and at the Art Students League in New York City in 1949-50. He held his first solo show at the Betty Parsons Gallery, New York, in 1951, and subsequently his work has been exhibited all over the globe. In 1964 he won the Grand Prix at the Venice Biennale. Retrospectives were held in Paris and New York in 1963, with another such show touring the USA in 1976-8, while a further retrospective toured Berlin, Düsseldorf, Copenhagen, Frankfurt, Munich and London in 1980.

Even by the time of his first exhibition in 1951, Rauschenberg was already in the forefront of American artistic experimentation. Among other images he made from the mid-1950s onwards were a series of all-white paintings in which the only visual activity was provided by the viewer when casting shadows across the surfaces; all-black paintings, in which crushed and torn pasted newspapers were overworked with black enamel paint; and 'combine' paintings, or painted supports to which were added real objects, including photographs, sections of comic-strips, Coca-Cola bottles, stuffed birds and the like.

This is another of the combines, although its spatiality makes it function equally as a sculpture, and a manoeuvrable one at that, for the platform supporting the goat is mounted on wheels. As a youth Rauschenberg had owned a goat, so the work might well contain an autobiographical element. The artist first saw the stuffed animal he used here in a pawnshop window and eventually purchased it, which went against his normal practice of gleaning his materials from the streets. Because the head was damaged, the affected section was camouflaged with paint.

The combine passed through two stages before its final form was reached. In the first, the goat stood on a platform extending from a vertically-orientated panel, while in the second it was lowered onto the floor. The encirclement of the animal with the tyre occurred at this time. Rauschenberg was certainly aware of the dynamic role of tyres in modern life, for in 1953 he had created a monoprint by getting his friend, the composer John Cage, to drive a car across twenty sheets of mounted paper, leaving the imprint of a tyre along its entire length. Also included on the wheeled platform of the third and final version of *Monogram* is a photo of people inside a building; a tennis ball which is painted brown and located at the goat's rear to suggest excreta; a broken street barricade; a signboard bearing lettering; the heel of a shoe; and a man's shirtsleeves. All these objects serve to remind us of the detritus of urban life.

The wheeled platform introduces associations of the dollies employed to transport heavy objects such as pianos through the streets, precisely the kind of supports that had inspired Rauschenberg to create his wheeled base in the first place. The stuffed animal is an Angora goat and therefore the most valuable commercial breed of the species. Rauschenberg was surely aware of this from his home state of Texas, where Angora goats are bred on a large scale to supply America with most of its mohair.

Given all these factors, it does not seem fanciful to interpret the goat encircled by the tyre as making a statement about the encirclement of nature by industrialisation, just as the mobile support might paradoxically allude to the freedom provided by such development.

Robert Indiana, *The American Sweetheart*,
signed and dated '*R INDIANA COENTIES SLIP NYC 1959*'.
Oil on homasote, 243.8 x 122 cm. Private collection.

Robert Indiana was born in New Castle, Indiana in 1928, under the name Robert Clark. After taking classes in art and then serving in the US Army Air Force in 1946, Indiana studied in Indianapolis, Utica, Chicago, Edinburgh and London between 1947 and 1954. By the mid-1950s he was making abstract paintings using strong geometrical shapes.

With the present work and another painting, *The American Dream* of 1960, Indiana began incorporating into his pictures words and symbols, such as the stars that appear here. By the mid-1960s this exploration of the role of words and cultural signifiers had taken over his work completely. Because words and signs are integral to mass-culture, independent of any messages they might convey, Indiana's art necessarily comments upon a vital aspect of our age.

The 'COENTIES SLIP' cited in the signature of the painting is a waterfront neighbourhood in lower Manhattan where Indiana was living when he created the work. All the names appearing above the legend 'THE AMERICAN SWEETHEART' on the image bear personal connotations. Thus 'MAY' denotes the actress Mae West; 'LIL' links to the early twentieth century beauty, Lillian Russell; 'IDA' refers to the actress Ida Lupino; 'FLO' commemorates Indiana's next-door neighbour when he was four, a 'sweetheart' who introduced him to the use of gold paint, which he would often employ when mature; 'AMY' tempted him before he was six; 'BEE' was one of his mother's friends; 'SUE' beat him to first place when graduating from high school; 'LIZ' signifies Elizabeth Taylor, who starred in a film, *Raintree County*, which was based on a novel set in Indiana's hometown; 'PAT' was a youthful crush; 'INA' was a famous lady of the tabloid press in the 1930s; 'ANN' was a New York neighbour who had pushed Andy Warhol around when they had

been children together in Pittsburgh; 'NAN' applies to the Nancy of a famous cartoon series of the 1940s; 'SAL' invokes an infamous fan dancer of the 1930s, Sally Rand; 'MIN' links to a character actress of old; 'PET' was Indiana's grandmother's 'pet' name; 'MEG' once broke his heart; 'FAY' alludes to the actress Fay Wray of *King Kong* fame; 'UNA' denotes the actress Una Merkel; 'IVY' was someone buried deep in Indiana's family history; and 'EVA' was another friend of the painter's mother.

Jasper Johns, *Two Beer Cans*, 1960.
Oil on bronze, 14 x 20.3 x 12.1 cm. Offentliche Kunstsammlung, Basel.
Art © 2006 Jasper Johns/ Licensed by VAGA, New York, NY

Johns created this sculpture in response to a remark by Willem de Kooning that the art dealer Leo Castelli could sell anything, even two beer cans. It therefore primarily enacts a comment upon art-capitalism, the way that artefacts made by artists can harbour (and even accrue) financial value when placed in the right hands.

Because of its very subject the work equally comments upon the inherent aesthetic values of mass-produced objects. It necessarily addresses the wider question of artistic validity too; if it was legitimate for, say, Cézanne to portray apples, then why would the representation of beer cans not prove equally acceptable, especially as Johns did not cast the work from such receptacles but used all his powers to shape and paint likenesses of them?

Arman, *Home, Sweet Home*, 1960.
Group of gasmasks in wooden box with plexiglass cover, 160 x 140.5 x 20.3 cm.
Musée national d'art moderne, Centre Georges Pompidou, Paris.

Arman was born Armand Fernandez in Nice, France, in 1928; a printer's error led him to drop the last letter of his forename in 1958 and later, in 1967, he abandoned his surname altogether. Between 1946 and 1951 he studied art in Nice and Paris, and in 1960 he became a founding member of the Nouveaux Réalistes group of artists in Paris. Some members of this group shared his interest in mass-culture and its artefacts and, like him, they exhibited in the 'New Realists' exhibition held in New York in 1962, the show that provided the ultimate breakthrough for Pop/Mass-Culture Art. Arman settled in New York in 1963 and in the following year he held his first museum exhibition, at the Walker Art Center in Minneapolis. He has shown widely ever since, and a major retrospective of his work was mounted in Paris in 1998. He died in 2005.

Initially, Arman employed rubber stamps to make abstract pictures, to which end he also dipped functional objects in paint. In 1959 he began creating a series of works known as Accumulations, to which this sculpture belongs. Further such objects are discussed below. Another series of sculptures placed in boxes under plexiglass covers followed in 1960. These were the Poubelle or Wastebin works, in which Arman brought together random collections of rubbish, to typify the wastefulness of our throwaway society. Occasionally this would include the garbage generated by artists, as happened with Rauschenberg and

Dine in 1961, to make good-natured points about those iconoclastic figures. In that same year Arman also embarked upon a set of Destructions in which he smashed objects, partially to denote a break with the past but also frequently to bring those objects together again in new formulations. Thus a long series of musical instruments was first smashed and then reconstituted visually, to act as effective metaphors for the rhythm, harmony or dissonance of music itself. And in a series of Robot works, Arman collected the belongings of specific individuals, which he then presented under plexiglass in boxes. Because we are what we consume, these gatherings of objects all function effectively as indirect forms of portraiture.

Naturally, the Accumulations cannot but comment upon the vast aggregations of objects that form within modern industrialised society, while often the constituent artefacts set other chains of associations in motion. Thus we might read this dense jungle of gasmasks as forming a parallel to the density of a gas attack itself. Certainly gasmasks bear particularly tragic connotations for all historically-aware Frenchmen, as France is one of the few countries that has suffered from the use of gas in a military conflict (as it did between 1914 and 1918). That Arman may have had such memories in mind when creating this work seems supported by the somewhat ironic title he gave it. Certainly the dense throng of masks might aptly remind us of both the vast numbers of men and objects involved in modern warfare, and of one of the most disgusting and destructive methods of creating human carnage.

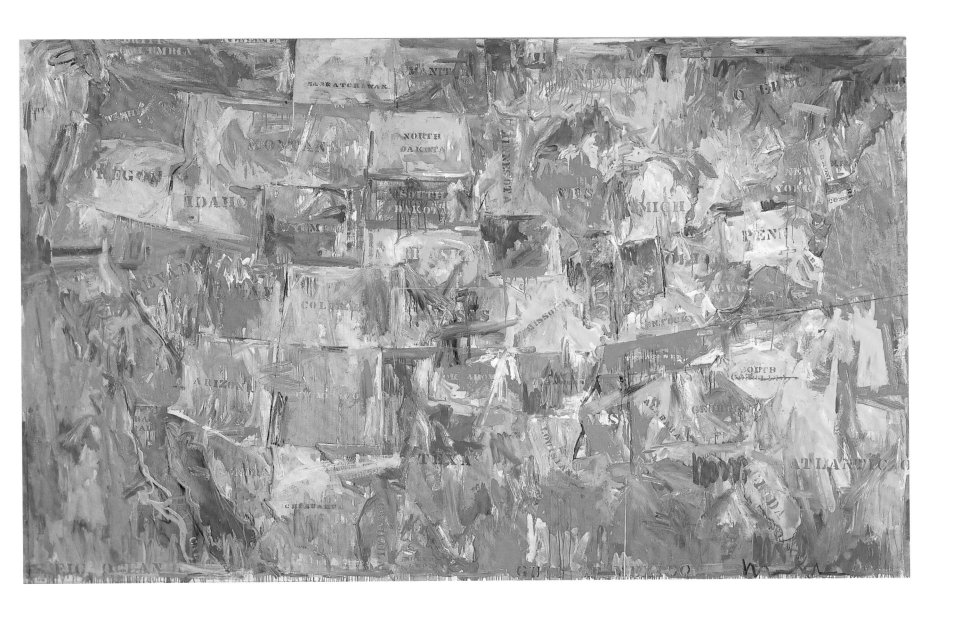

Jasper Johns, *Map*, 1961. Oil on canvas, 198.2 x 307.7 cm.
The Museum of Modern Art, New York.
Art © 2006 Jasper Johns/ Licensed by VAGA, New York, NY

In his Flags, Targets and Numbers series of paintings, Johns employed encaustic paint in order to build up the surfaces patiently, and thus prevent any excess emotionalism entering the images. For the Maps paintings, however, he moved in the opposite direction and used oil paint for its dynamism, a gesturality normally associated with Abstract Expressionism. This enacted a clever paradox, for the flurried surfaces go against the grain of most true maps, which are almost always pictorially flattened, diagrammatic affairs, totally devoid of any expression whatsoever.

Naturally, the emphatic marks used by Johns often blur or totally obliterate the boundaries of individual states, thereby possibly commenting upon the increasing political irrelevance of such divisions within an America that had grown enormously in political coherence and wealth since the Second World War. At a time of growing transcontinental air and road travel, national television coverage, the countrywide distribution of mass-produced goods, and nationwide advertising campaigns for those products, such a breakdown or disregard of local boundaries seems highly relevant.

Johns's use of stencilled lettering invokes exactly the same associations of mass-production it had when employed after 1911 by Picasso and Braque, for it is very 'low culture' indeed, being primarily found on the sides of packing crates and the like where identifications need to be effected quickly and without any refinement. As employed by Johns, the use of such a uniform type of lettering says much about the blurring of local individuality, the increasing homogeneity of national identity, and the growth of consumerism everywhere.

James Rosenquist, *President Elect*, 1960-61. Oil on masonite, 213.3 x 365.7 cm.
Musée national d'art moderne, Centre Georges Pompidou, Paris.
Art © 2006 James Rosenquist/ Licensed by VAGA, New York, NY

James Rosenquist was born in Grand Forks, North Dakota in 1933, although he grew up mainly in Minneapolis. Between 1952 and 1955 he studied art at the University of Minnesota in Minneapolis, while simultaneously working as a billboard artist throughout Minnesota and Wisconsin. In 1955 he received a scholarship to study at the Art Students League in New York. Between 1957 and 1960 he worked almost full-time as a commercial billboard painter, creating his own works in his spare time. By this time he had built up a network of artistic friends and acquaintances which included Jasper Johns, Robert Rauschenberg, Claes Oldenburg and Robert Indiana. His first one-man show was held at the Green Gallery in New York in February 1962, and completely sold out. Many exhibitions followed, including retrospectives in Ottawa in 1968, in Cologne and New York in 1972, in 1985-7 in Denver, Houston and Des Moines, in 1991 in Moscow and Valencia, and in 2003-4 in New York and Bilbao.

John F. Kennedy was elected President of the United States on 8 November 1960, and this painting was begun very soon afterwards. It was one of two pictures created in 1960-1 that proved to be Rosenquist's breakthrough works in artistic terms. The other painting is entitled *47, 48, 50, 61* and it shows three men's ties above the dates 1947, 1948 and 1950, thereby implicitly commenting upon fashion and history. The present painting seems no less meaningful, given the happy visage of one of America's most famous, youthful and handsome presidents, from whose head emerges two perfect female hands holding some pieces of appetising cake placed in front of a shining car. With merely a hint of irony – for everything is just a little too faultless – Rosenquist alludes to the perfect consumer society as projected by its ever-optimistic politicians.

The work was developed from a three-part collage Rosenquist had made using an old magazine photo of Kennedy and ads for cake and a 1949 Chevrolet. The study reveals more of the vehicle than seen here, and includes two figures standing behind the car, looking at it admiringly.

Sir Peter Blake, *Self-Portrait with Badges*, 1961.
Oil on hardboard, 172.7 x 120.6 cm. Tate Gallery, London.

When creating this image, Blake may well have had a portrait by the French artist Watteau in mind, a depiction dating from 1718-19 (Musée du Louvre, Paris). It represents the actor Gilles standing in a similarly gawky pose and identically positioned looking straight out at us. Moreover, by representing himself in blue, Blake may also have been building upon memories of Thomas Gainsborough's *The Blue Boy* (Huntington Library, San Marino, California) although the eighteenth-century painter placed his subject in open countryside, rather than some suburban back garden. He also dressed him in silk rather than the blue denim that was equally fashionable in some quarters in 1961.

This uncompleted self-portrait won Blake the Junior Prize of the 1961 John Moores' Liverpool exhibition of contemporary painting. As we have already seen, a favourite device of the artist was to spread painted or pasted images across notice boards and walls. Here he used himself as that kind of support, somewhat flattening his body in the process and using the background fence to reinforce the sense of flatness.

Blake posed before a mirror for the likeness, although he also draped his jacket over a dummy. He had always been a fan of denim clothing, which was still difficult to obtain in Britain by 1961; he had only been able to purchase his first-ever set of jeans when visiting the Continent in 1956. In reality Blake never wore badges but merely collected them, along with all other kinds of ephemera. The images on the badges range from the American and British flags, to an American presidential candidate's voting exhortation 'ADLAI [Stevenson] is OK'. A Pepsi-Cola bottle-top and several coins can also be made out. Elvis Presley figures twice, on a badge and on the cover of his fanzine.

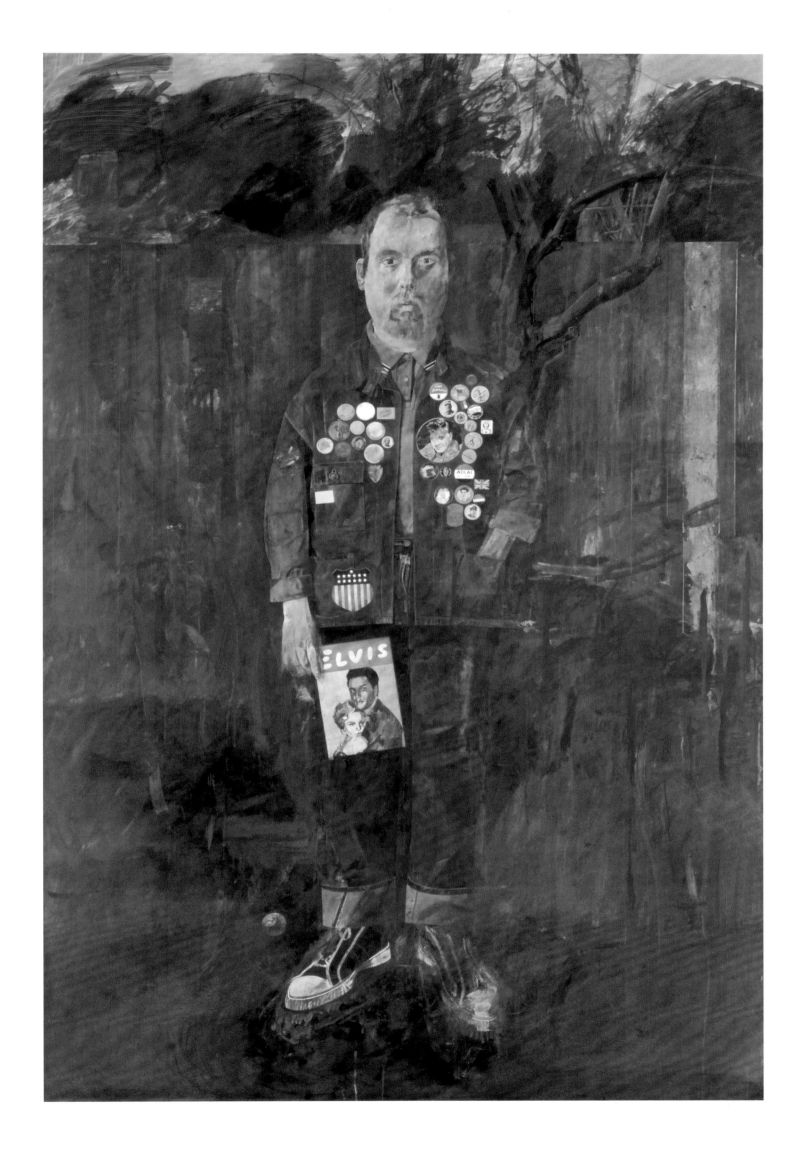

David Hockney, *Tea Painting in an Illusionistic Style*, 1961.
Oil on canvas, 185 x 76 cm. Private collection.

David Hockney was born in Bradford, Lancashire in 1937. After studying at the local art college between 1953 and 1957 he served as a conscientious objector rather than perform military service. In 1959 he began attending the Royal College of Art in London, from where he graduated in 1962. In the previous year he had been awarded the institution's Gold Medal and various other important prizes. His first one-man show was held at the Kasmin Gallery in London in 1963 and proved a huge critical and commercial triumph. Since then he has held a multitude of exhibitions, including retrospectives in London in 1970 and 1989, the latter show also being mounted in Los Angeles and New York. In addition to being a painter and printmaker, Hockney has also enjoyed great success as a photographer, stage-designer and writer on art.

Sir Peter Blake, *Love Wall*, 1961.
Collage construction in mixed media, 125.7 x 205.7 cm.
Fundaçao Calouste Gulbenkian, Modern Art Centre, Lisbon.

This was one of the first works in which Blake fashioned a low-relief support for the ephemera he collected. The many differing levels of sophistication to human relationships are wittily indicated by a rich and tightly-structured web of popular imagery. Among the pointers to love is the word itself placed above the heart-shaped symbol commonly used to denote such feelings. A picture of Marilyn Monroe symbolises physical pulchritude, while a postcard of Millais' *Order of Release* of 1852-3 (Tate Britain, London) shows a wounded clansman of the 1745-6 Scottish rebellion being freed from prison by his wife, who exemplifies faithfulness. A large array of kitsch and 'naughty' postcards of young lovers in varying degrees of physical entanglement also indicates love.

On the left, a real door and porch typify the domestic entranceways that are often acquired through love and marriage. On and above the door the number 2 appears several times, both to signify street numbers and to remind us of the pairing necessary to build liaisons. On the far side of the wall images of children and related low numbers taken from birthday cards suggest the offspring of such relationships.

Hockney has always firmly maintained that he has never been a pop-painter. That assertion is correct, for he has only occasionally shown any interest in mass-culture, the visual vocabulary of advertising and mass-communications, and the glamorous lifestyle of modern consumerism. But in the present work he did pay regard to a particular consumer product, using a Typhoo Tea packet to explore the ambiguities inherent to two-dimensional surfaces, which has always been one of his overriding preoccupations. To that end he painted the picture on a shaped canvas which makes it look inescapably three-dimensional. The figure is mostly contained within the box, with only a small part of his head protruding, and he is represented in an intentionally crude manner which derives from the influence of Jean Dubuffet, who developed his own style from the influence of graffiti, child art and pictures by the mentally disabled.

Clearly the representation of a man within a box stems from Francis Bacon who often placed his figures within similarly defined spaces. However, Hockney sends up that inspiration by seating his character on the toilet.

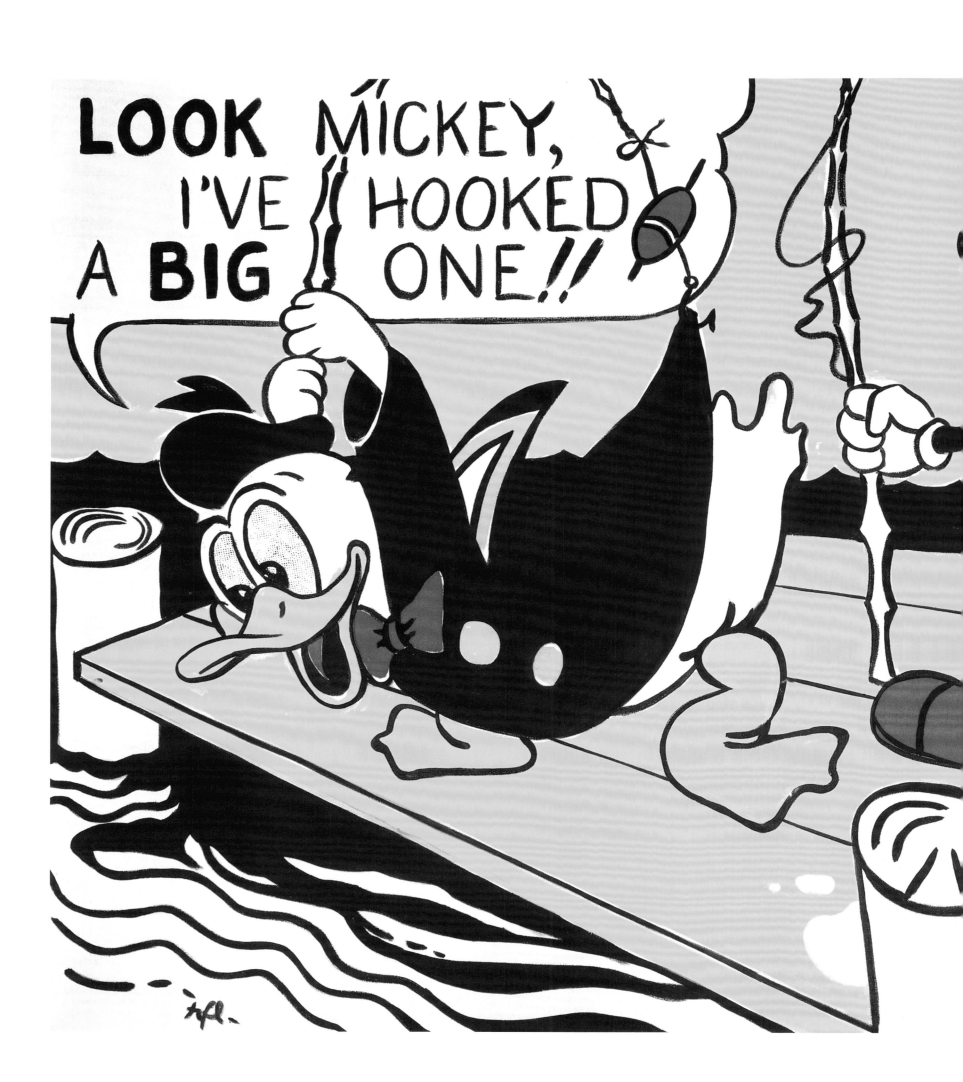

Roy Lichtenstein, *Look Mickey,* 1961.
Oil on canvas, 122 x 175 cm. The National Gallery of Art, Washington, D.C.

Roy Lichtenstein was born in New York in 1923. In 1939-40 he studied under Reginald Marsh at the Art Students League in New York. He then attended Ohio State University in Columbus, Ohio from 1940 to 1943, and from 1946 to 1949, completing his military service between those two periods of study. Upon graduation he taught at Ohio State University. He held his first one-man exhibition at the Carlebach Gallery, New York in 1951, showing assemblages made from metal, wood and found objects. Between 1951 and 1957 he worked as a freelance designer and commercial artist in Cleveland, Ohio, and in New York, following which he taught at New York State University in Oswego, New York between 1957 and 1960, and at Douglass College, Rutgers University, New Jersey, between 1960 and 1963. After his breakthrough into a new pictorial idiom in 1961, he exhibited in New York and around the world, including several times at the Venice Biennale. Major retrospectives of his mature paintings and prints have been held in Cleveland, Minneapolis, Amsterdam, London, Berne, Hanover, New York, Paris and Berlin, while a retrospective organised by the St Louis Art Museum in 1981 then toured the USA, Europe and Japan. Lichtenstein died of pneumonia in 1997.

Although Lichtenstein painted in an Abstract Expressionist idiom up until 1961, he had occasionally incorporated printed advertisements, words and comic-strip figures into his pictures before that date. However, in mid-to-late June 1961 he discovered his true metier with the painting reproduced here. By then he had tired of abstraction, realising it held no artistic or professional future for him. So he took a gamble. As he told Milton Esterow many years later:

> *The idea of doing [a cartoon painting] without apparent alteration just occurred to me…and I did one really almost half seriously to get an idea of what it might look like. And as I was painting this painting I kind of got interested in organizing it as a painting and brought it to some kind of conclusion as an aesthetic statement, which I hadn't really intended to do to begin with. And then I really went back to my other kind of painting, which was pretty abstract. Or tried to. But I had this cartoon painting in my studio, and it was a little too formidable. I couldn't keep my eyes off it, and it sort of prevented me from painting in any other way, and then I decided this stuff was really serious….I would say I had it on my easel for a week. I would just want to see what it looked like. I tried to make it a work of art. I wasn't trying just to copy. I realized that this was just so much more compelling.*

In relation to the comic-strip image that inspired this seminal work, the key phrase in the above quotation is 'brought it to some kind of conclusion as an aesthetic statement', for Lichtenstein made subtle alterations to the image that greatly increased its pictorial impact, especially where linear clarity and colour are concerned. Of course by vastly expanding the original he also moved an insignificant image onto another aesthetic plane altogether.

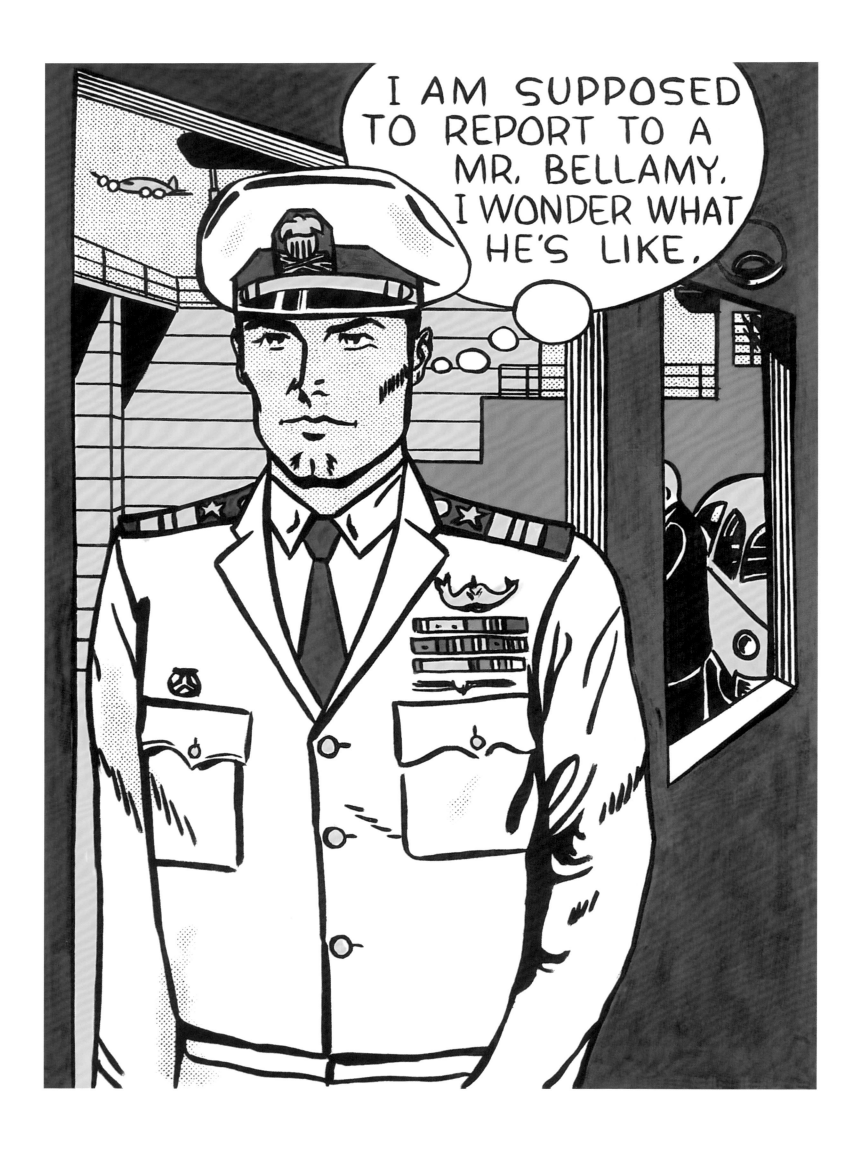

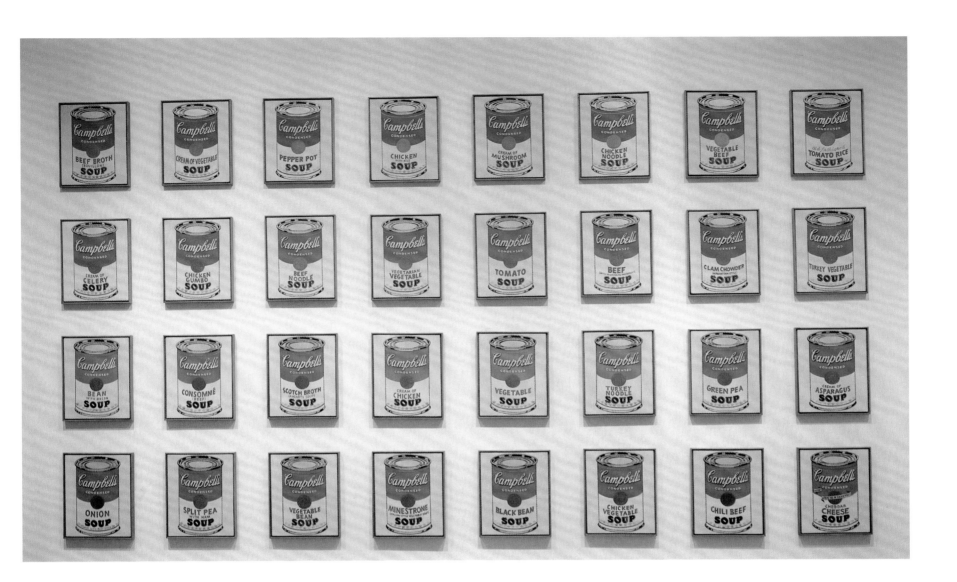

Roy Lichtenstein, *Mr Bellamy,* 1961.
Oil on canvas, 143.5 x 107.9 cm. Fort Worth Art Museum, Fort Worth, Texas.

By the time Lichtenstein created this painting later in 1961 he had come to realise that he could not only draw his imagery from popular mass-culture; he could also emulate the means by which such images were customarily disseminated through mass-media reproduction, thereby making a broader cultural point. He attained this by emulating the Benday dot technique of mechanical halftone printing, as discussed on page 37.

To imitate those dots Lichtenstein obtained thin metal sheets which contained regular rows of circular holes, across which paint could be spread with a roller and then pushed through the apertures with a stiff scrubbing brush on to taped-off sections of the canvas. When combined with dark outlines and areas of the support left bare or flatly coloured, this technique allowed Lichtenstein to replicate the printing technique used by the comics and magazines from which he sourced his material.

The picture not only projects an all-American, clean-cut officer on his way to an important meeting, but also acts as an in-joke, for the 'Mr Bellamy' referred to clearly alludes to the important New York art dealer Richard Bellamy of the Green Gallery, one of the coterie of art world figures who took Lichtenstein and his Pop/Mass-Culture Art contemporaries seriously.

Andy Warhol, *32 Soup Cans,* 1961-62. Synthetic polymer paint on thirty-two canvases, each 50.8 x 40.6 cm. The National Gallery of Art, Washington, D.C.

Andy Warhol was born Andrew Warhola in Pittsburgh in 1928. After studying art at the Carnegie Institute of Technology there, in 1949 he moved to New York City where he rapidly built up a highly successful practise as a commercial illustrator, winning many top awards in the process (and dropping the final letter of his surname when doing so).

By 1960 Warhol wanted to be a famous painter, and he spent a couple of years desperately trying out different approaches, none of which proved successful.

As a result, he became very depressed. Finally, one evening in December 1961 he made his aesthetic breakthrough when an interior decorator friend, Muriel Latow, sold him just what he needed:

> *...Andy said, "I've got to do something that really will have a lot of impact, that will be different enough from Lichtenstein and Rosenquist, that will be very personal, that won't look like I'm doing exactly what they're doing....I don't know what to do. So, Muriel, you've got fabulous ideas. Can't you give me an idea?" And Muriel said, "Yes, but it's going to cost you money." So Andy said, "How much?" She said, "Fifty dollars....get your checkbook and write me a check for fifty dollars." And Andy ran and got his checkbook, like, you know, he was really crazy and he wrote out the check. He said, "All right, give me a fabulous idea." And so Muriel said, "...you've got to find something that's recognizable to almost everybody. Something that you see every day that everybody would recognize. Something like a can of Campbell's Soup." So Andy said, "Oh, that sounds fabulous." So, the next day Andy went out to the supermarket (because we all went by the next day), and we came in, and he had a case of... all the soups. So that's how [he obtained] the idea of the...Soup paintings.*

As Latow was well aware, Warhol had lunched on soup and crackers every day for over twenty years, and her idea therefore took root in extremely fertile ground. Warhol immediately set to work upon this set of 32 small canvases featuring all the different varieties of Campbell's Soup, and it proved to be the seminal work in his oeuvre. With their flat, frontal presentation and devotion to a single object the pictures owe much to Jasper Johns's Flag paintings, which Warhol had greatly admired in 1958.

The deadpan arrangement of the images enforces a rigid disconnection from emotion, whilst their number and machine-like appearance parallels the industrial processes that had brought the original cans into existence. Ultimately the set of canvases addresses mass-culture, for as Warhol would state more generally about his works in 1962:

> *I adore America and these are some comments on it. My [images are] a statement of the symbols of the harsh, impersonal products and brash materialistic objects on which America is built today. [They are] a projection of everything that can be bought and sold, the practical but impermanent symbols that sustain us.*

Marisol, *Love,* 1962. Plaster and Coca-Cola bottle, 15.8 x 10.5 x 20.6 cm.
The Museum of Modern Art, New York.

Marisol was born Marisol Escobar of Venezuelan parents in Paris in 1930. After studying at the École des Beaux-Arts and the Académie Julien in Paris, in 1960 she moved to New York where she continued her studies at the Hans Hofmann School and the Art Students League. Influenced by folk art, she began making sculptures in metal and wood, and first exhibited at the Leo Castelli Gallery in New York in 1958. From about 1960 onwards her work became more straightforwardly figurative, often representing people with sharply defined heads and other parts of the body; these effigies were frequently arranged in groups. In 1961 her work was shown in the influential 'Art of Assemblage' exhibition held at the Museum of Modern Art in New York, and important one-person shows later

followed in New York, London, Rotterdam, Venice (the 1968 Biennale), Philadelphia and Worcester, Massachusetts. A show dedicated to her many portrait sculptures was held in Washington DC in 1991.

For all its simplicity this is one of the most immediate and wittiest sculptures of the entire Pop/Mass-Culture Art tradition. As well as commenting upon the enthusiastic intake of a beverage that has come to symbolise consumer culture, it also tellingly points up the inherent sexuality of objects and the fetishisation of those artefacts that underlies our society.

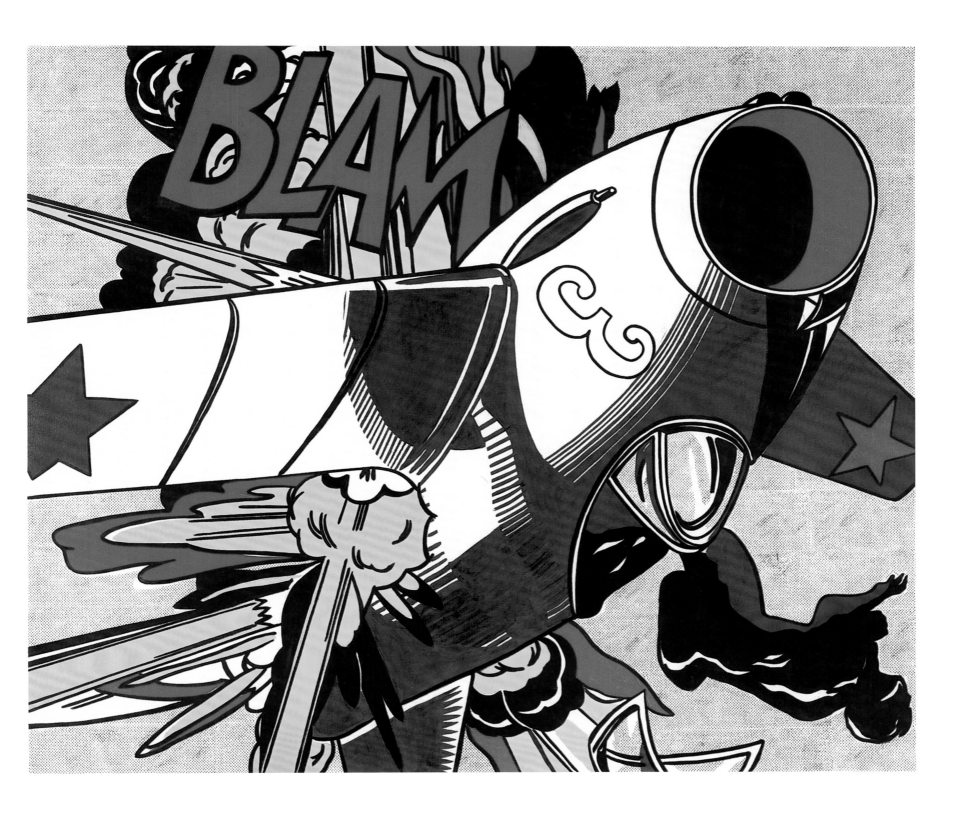

Roy Lichtenstein, *Blam*, 1962. Oil on canvas, 170 x 200 cm.
Yale University Art Gallery, gift of Richard Brown Baker, Yale, New Haven.

When this picture was painted the Cold War was still in full flow, with the conflict in Indochina just beginning to brew up again. The red star on one wing of this MIG-15 fighter identifies it as a communist airplane, and thus for many Americans an eminently sensible target for destruction. Lichtenstein was certainly not undermining any prevailing political attitudes here.

The detailing and modelling of the aircraft, the curvilinear shape made by the ejecting pilot, the path of the rocket and the forms created by the explosion are immensely more sophisticated than they would be in any comic-strip rendering. Flat-patterned shapes and steady rows of imitation Benday dots divest the proceedings of any emotionalism, and that distancing seems ironically at odds with the explosive nature of the subject.

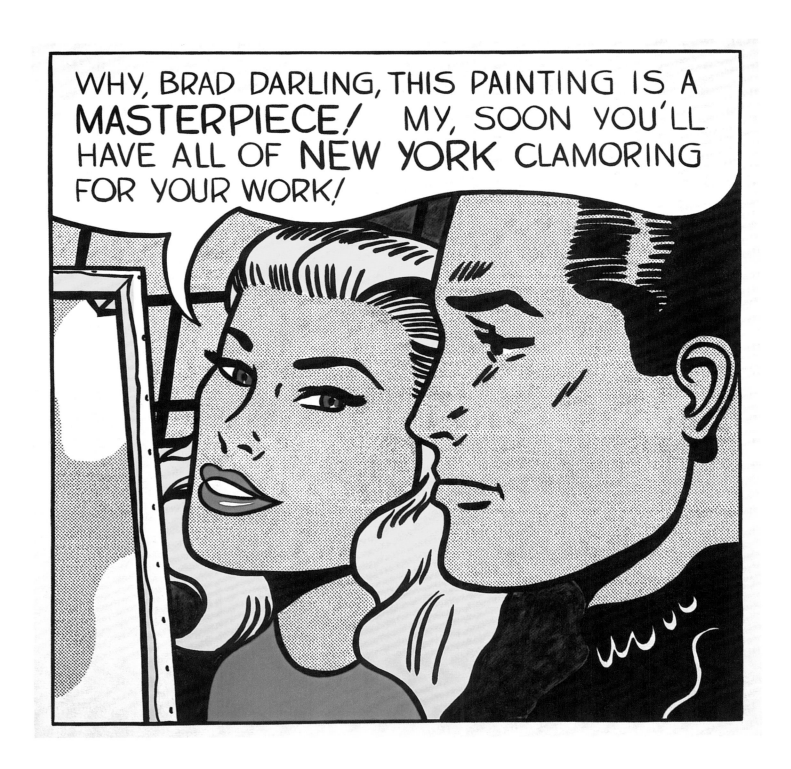

Mimmo Rotella, *Marilyn*, 1962. Torn posters, 125 x 95 cm. Maria Cohen collection, Turin.

Mimmo Rotella was born in Catanzaro, Calabria, Italy, in 1918. After studying art in Naples during the Second World War he moved to Rome, where he held his first one-man show at the Galleria Chiurazzi in 1951. In 1951-2 he studied at the University of Kansas City. He was one of the founding members of the Nouveaux Réalistes group in Paris in 1961. With Alain Jacquet (whose work is discussed below), Rotella was also one of the founders of 'MEC Art' in 1963. This involved the projection of images originally reproduced in newspapers on to photo-sensitised canvases, and incorporations of mass-media typography. In the 1980s Rotella returned to painting.

Among Rotella's various explorations of material drawn from popular mass-culture are assemblages of junk, created in 1961-2. However, his most original contribution to the Pop/Mass-Culture Art tradition has been his *décollages* or posters torn down and mounted on canvas, of which the work seen here is a good example. As Rotella has commented, 'Tearing posters down from the walls is the only recourse, the only protest against a society that has lost its taste for change and shocking transformations'.

In *Marilyn*, of course, Rotella both mounted such an attack and obtained the maximum mileage out of what he purported to vilify, for whatever else Marilyn Monroe may have signified, she never symbolised a hidebound society.

Roy Lichtenstein, *Masterpiece*, 1962.
Oil and magna on canvas, 137.2 x 137.2 cm. Agnes Gund collection, New York.

Stereotypical male and female glamour goes hand-in-hand with art and fame here, as Lichtenstein wittily sends up the preoccupations of the glitzy New York art world. He could, of course, afford to be sardonic, for his career was on the ascendant by 1962. Again, clean design and ordered rows of replicated Benday dots add greatly to the sophistication of the image.

Jim Dine, *Five Feet of Colorful Tools*, 1962.
Oil on unprimed canvas surmounted by board with 32 painted tools on hooks, overall 141.2 x 152.9 x 11 cm. The Museum of Modern Art, New York.

Jim Dine was born in Cincinnati, Ohio, in 1935. Between 1951 and 1958 he studied successively at the Art Academy of Cincinnati, the Boston Museum School, and Ohio University. He held his first one-man show at the Reuben Gallery in New York in 1960. Along with Claes Oldenburg and others, Dine was in the forefront of the Happenings events of the late-1950s. He incorporated real objects in his works from the late-1950s onwards.

When presented with a wall of familiar household tools, all painted or sprayed with bright colours, as seen here, it is easy to comprehend why Dine initially became identified with Pop Art. A picture like this readily suggests an affinity with the industrial culture that produced such artefacts. However, that identification did not exist, as Dine emphasised in 1966 when he characterised two of the essential traits of Pop/Mass-Culture Art:

> *I'm not a Pop artist. I'm not part of the movement because I'm too subjective. Pop is concerned with exteriors. I'm concerned with interiors. When I use objects, I see them as a vocabulary of feelings. I can spend a lot of time with objects, and they leave me as satisfied as a good meal. I don't think Pop artists feel that way. Their work just isn't autobiographical enough. I think it's important to be autobiographical. What I try to do in my work is explore myself in physical terms – to explain something in terms of my own sensibilities.*

To the latter end Dine would utilise objects that would include men's suits, dressing-gowns and artists' palettes, often enhancing them with the gestural brushwork normally encountered in Abstract Expressionist painting. The results can seem very contemporary in feeling but they have nothing to do with Pop/Mass-Culture Art.

Andy Warhol, *Green Coca-Cola Bottles*, 1962.
Silkscreen ink on synthetic polymer paint on canvas, 211 x 144.8 cm.
Whitney Museum of American Art, New York.

Another icon of mass-culture, American identity and industrial production was here represented dispassionately and in strict ranks in order to emphasise the mechanical repetitiousness that had originally created the bottles. Moreover, the picture simultaneously touches upon democratic access, for as Warhol would explain in 1975:

> *…America started the tradition where the richest consumers buy essentially the same things as the poorest. You can be watching TV and see Coca-Cola, and you can know that the President drinks Coke, Liz Taylor drinks Coke, and just think, you can drink Coke, too. A Coke is a Coke and no amount of money can get you a better Coke than the one the bum on the corner is drinking. All the Cokes are the same and all the Cokes are good.*

This was one of Warhol's first silkscreened canvases, employing a process that removed much of the laboriousness of painting repetitious imagery (details of the procedure are given in the introductory essay). When producing images in this way, Warhol would actually build things up in reverse: first he would underpaint the background and individual colour areas constituting, say, the green of the bottles, before finally overprinting the silkscreened image of the Coke bottle itself. (Sheets of transparent acetate printed with the final image of a Coke bottle were temporarily laid down over the painting at each stage of its creation as an interim means of ensuring the precise alignment of the various levels of the picture.) In this instance Warhol first underpainted areas of green to denote the drink within the bottles, while leaving other areas blank so as to make the subsequently overpainted bottles appear empty. These variations create a subtle visual rhythm.

Rather than use photographs of Coke bottles for the present canvas, Warhol employed a graphic style to draw a few bottles on to a silkscreen by hand. He then moved the silkscreen along the constituent rows. The graphic shorthand employed for the bottles imbues them with a subjectivity that slightly offsets the sterile mechanisation projected by so much repetition.

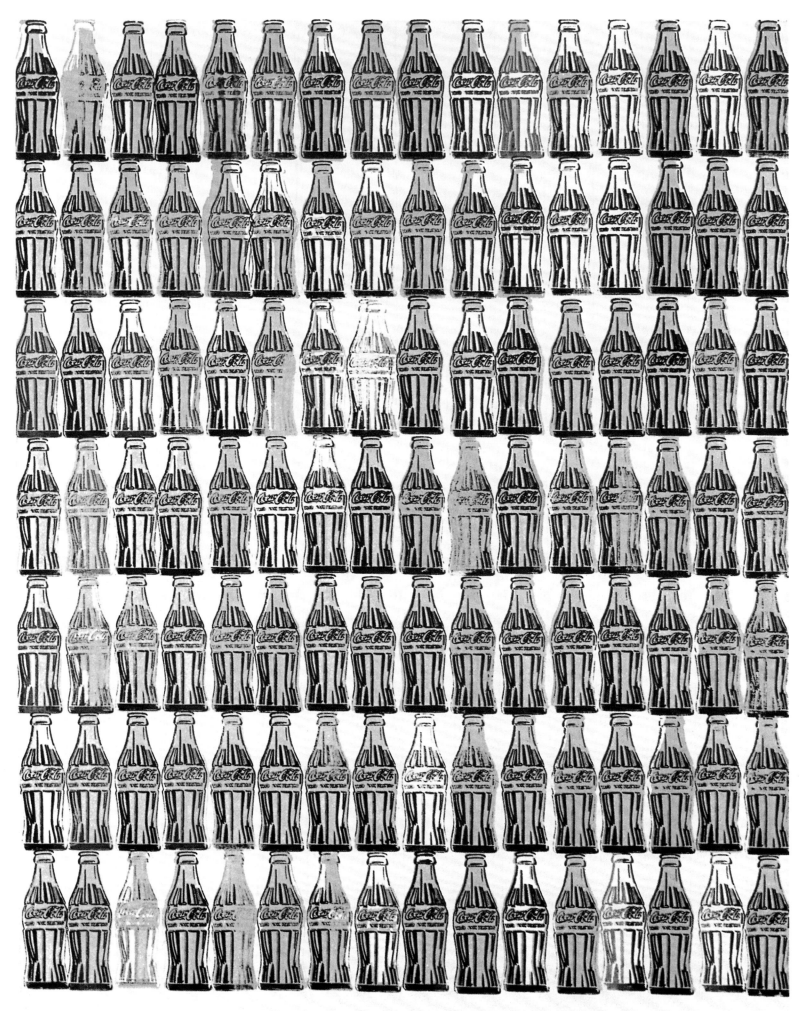

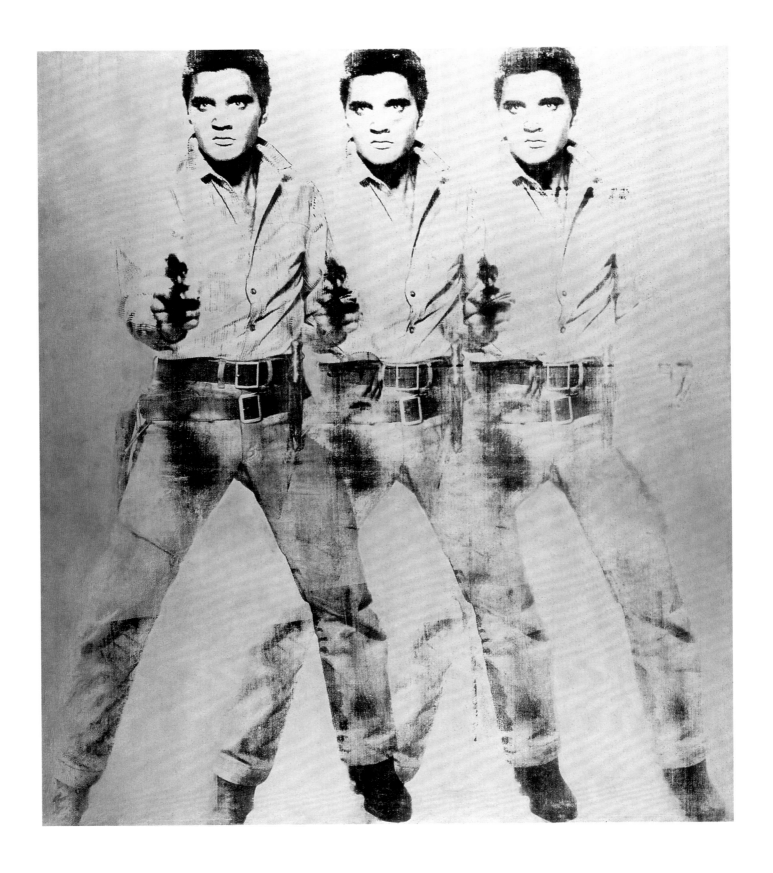

Andy Warhol, *Triple Elvis*, 1962.
Silkscreen ink on aluminium paint on canvas, 208.3 x 152.4 cm.
Virginia Museum of Fine Arts, Richmond, Virginia.

A publicity still made for the 1960 film *Flaming Star* provided Warhol with this image of Elvis Presley. Originally the painter created a large number of the Elvises on a single roll of canvas which he took with him to Los Angeles in September 1963 for his second one-man show there. On his arrival at the Ferus Gallery he asked its director, Irving Blum, to cut the roll into conventional sizes for stretching on to wooden supports, and told him, "The only thing I really want is that they should be hung edge to edge, densely – around the gallery. So long as you can manage that, do the best you can." In the event Blum left space around each painting, although the hang still looked fairly crowded. It was complemented by twelve pictures of Liz Taylor hung in an adjacent room.

Gerard Malanga was Warhol's painting assistant when the Elvises were created, and he claimed to have been responsible for the overlapping, multiple imaging in these paintings, saying that he "...deliberately moved the image over to create a jump effect", which Warhol liked. By heightening the inherent abstraction of the forms, such multiplicity prevents the images from merely operating on an informational level. Naturally that multiplicity also calls forth associations of the inherent repetitiousness of cinematography, with its twenty-four frames per second. Moreover, the aluminium paint employed for the background looks silvery, and thereby introduces equally appropriate reminders of the silver screen.

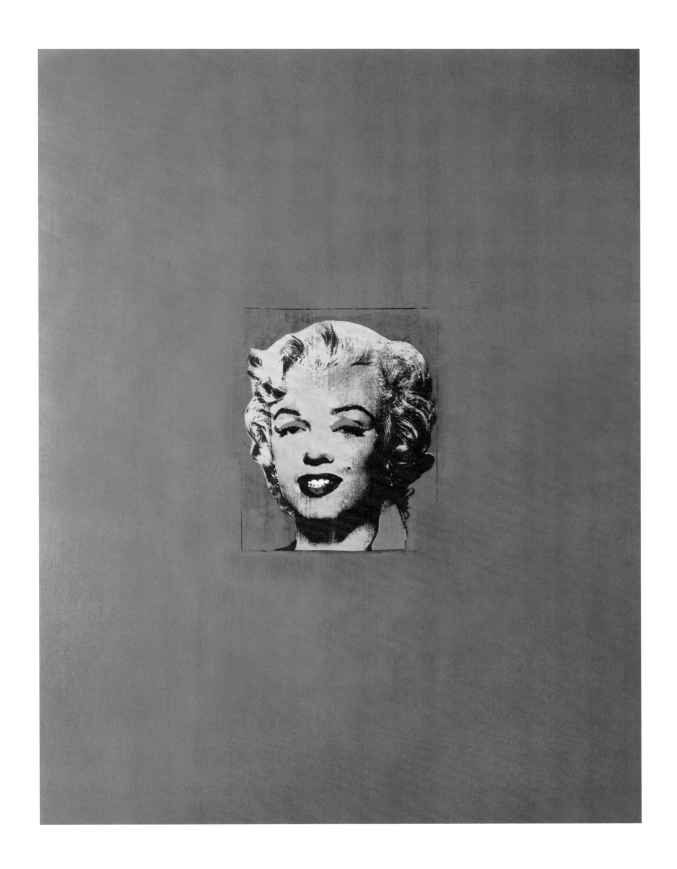

Andy Warhol, *Gold Marilyn*, 1962.
Silkscreen ink on synthetic polymer paint on canvas, 211.4 x 144.7 cm.
The Museum of Modern Art, New York.

Warhol was prompted to embark upon his series of paintings of Marilyn Monroe by news of her suicide on 4 August 1962. For his representations of the actress he used a photograph taken in 1953 by Gene Kornman to publicise the film *Niagara*. In Warhol's images of Marilyn Monroe, Elvis Presley and similar 'superstars' (a word he invented), he made apparent his realisation that more and more people today now live in a globalised culture in which traditional icons – of the Virgin Mary, the saints, great kings and dictators – are all being gradually replaced by icons of mass-media fame, especially by the young.

If in recent times Marilyn Monroe perhaps represented the supreme symbol of western male notions of womanhood and sexuality, then Andy Warhol's *Gold Marilyn* is surely the supreme artistic icon of that mythology, for because of its golden background, this picture comes closer to looking like a religious icon than most of the painter's other iconic images. Ultimately, Warhol developed the picture from the Flags paintings of Jasper Johns, although he engaged different ideas and associations in the work. The canvas was included in Warhol's first New York exhibition mounted in November 1962.

Marilyn Monroe's peroxide hairdo, coloured eyelids, lips, facial-skin area and shirt collar are each separately and luridly heightened in colour in order to stress the garishness of glamour. By surrounding the actress's head with a large area of gold paint, Warhol introduced unmistakeable associations of wealth and economic value that remind us most appropriately that Marilyn Monroe was at the cutting edge of a vast and highly exploitative financial operation, as are all successful media superstars.

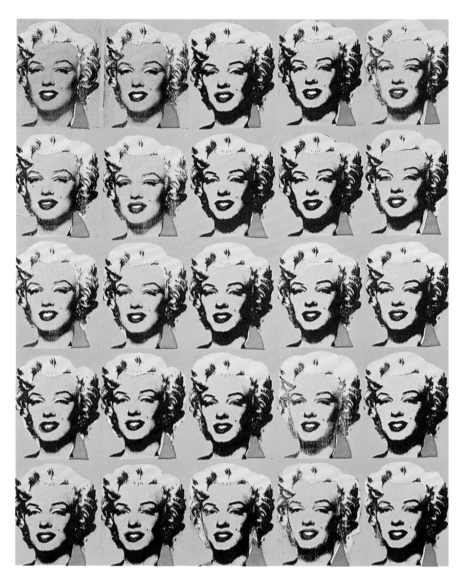
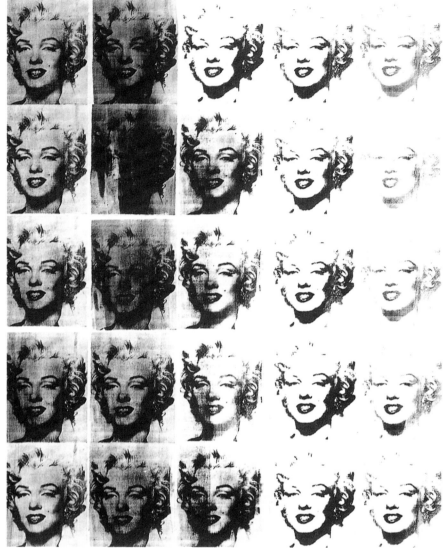

Andy Warhol, *Marilyn Diptych*, 1962.
Silkscreen ink on synthetic polymer paint on two canvases, each 208.3 x 144.8 cm.
Tate Gallery, London.

This is perhaps the most commemorative of all Warhol's Marilyn pictures, and it too was included in the artist's New York debut exhibition in 1962.

The areas of bright colour on the left effectively stress the garishness of Marilyn Monroe's media personality. Any slight tonal variations in the heads lend variety to the proceedings without diminishing the sense of general repetitiveness that bears its usual implications of mass-communications-media repetition. However, the profoundly commemorative meaning of this painting resides in the contrast between its two halves.

On the left, clean colours and the accurate registration of the individual silkscreened images project the late Marilyn Monroe's bright and attractive public persona. On the right, uneven inking, smeariness and tones that diminish in intensity clearly denote the unstable, emotionally messy and waning powers of an actress whose life tragically ended in suicide. Marilyn seems to fade before our very eyes. The notion that Warhol was not a serious artist, with a profound sense of metaphor, is utterly belied by this marvellous work.

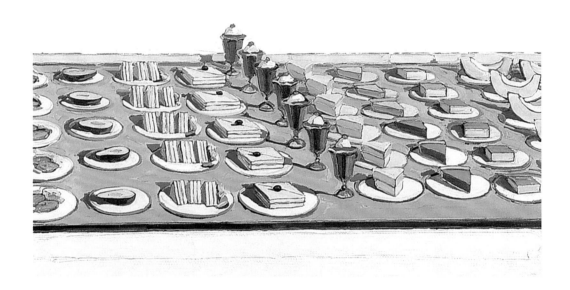

Wayne Thiebaud, *Salads, Sandwiches and Desserts,* 1962.
Oil on canvas, 139.7 x 182.9 cm.
Nebraska Art Association, Thomas C. Woods Fund, Lincoln, Nebraska.
Art © 2006 Wayne Thiebaud/ Licensed by VAGA, New York, NY

Wayne Thiebaud was born in Mesa, Arizona in 1920. Initially he worked as a commercial artist, illustrator, designer, cartoonist and publicity manager in New York and Hollywood. Between 1942 and 1945 he served in the US Army Air Force, following which he studied between 1949 and 1953 at various art schools in California. He held his first one-man show in Sacramento, California, in 1953.

Over the next three years he made educational films, for which he won a prize in 1961. Between 1951 and 1976 he taught at art schools in California. A major survey of his work was mounted at the Walker Art Center, Minneapolis in 1981.

Like Warhol, Thiebaud also responded to the banality, replication and repetition inherent to mass-culture, although unlike the former he devoted his attention mostly to commonplace objects and food, as here. The multiplicity of what is projected both comments culturally and pushes the imagery towards abstraction through the sheer repetitiousness of shapes and colours, just as it does in Warhol's work. Until fairly recently Thiebaud employed strident colours, quite evidently to bring out the falsity inherent to his subjects, especially artificial food colourings. All the objects depicted are located within a traditional recessional space, and they are invariably painted with a thick, creamy pigment whose sensuality transfers associatively to the subjects, making them seem truly tempting and luscious.

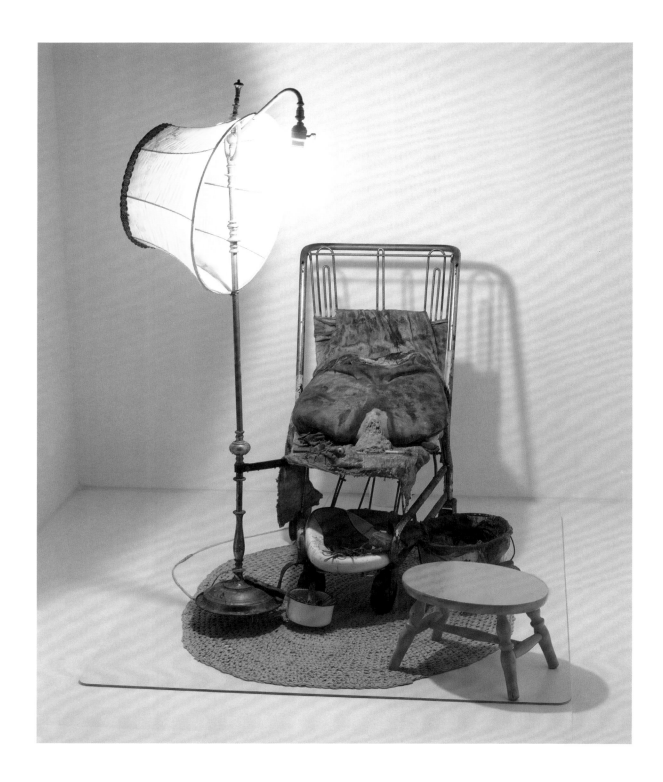

Ed Kienholz, *The Illegal Operation*, 1962. Polyester resin, paint, shopping cart, furniture, concrete, lamp, cloth, bedpan and medical implements, 149.9 x 121.9 x 137.2 cm. Betty and Monte Factor Family collection.

Ed Kienholz was born in Fairfield, Washington in 1927. He received very little higher education and no proper art training. Instead, he spent his formative years working at a variety of jobs, including nursing in a psychiatric hospital, managing a dance band, selling used cars, acting as a general handyman, decorator, caterer and vacuum-cleaner salesman, and even becoming the part-owner of the cutting-edge Ferus Gallery in Los Angeles (where, under subsequent ownership, Andy Warhol would first exhibit his seminal group of 40 Campbell's Soup paintings in 1962 – see above). Kienholz took up sculpture in 1954, initially making wood reliefs. His breakthrough work, Roxy's *of 1961-2 (pages 47-9, 51), is briefly discussed in the introductory essay above; it caused a sensation at the* Dokumenta *exhibition at Kassel, Germany, in 1968. In 1972 Kienholz met Nancy Reddin, whom he later took as his fifth wife and with whom he collaborated on all his subsequent ensembles. Retrospectives of his work were held in Los Angeles in 1966, a show that generated much outrage; in London in 1971; in Berlin and Paris in 1977; in New York, Los Angeles and Berlin in 1996-7; and in Newcastle and Sydney in 2005. He died in 1994.*

From a shopping trolley emerges a piece of metal attached to a lamp, as though clinging to it for security. The lampshade is awry, obviously to reflect light on to what had recently taken place before it. On the trolley, filthy pillows prop up a fairly shapeless bag, at the base of which an opening seems to ooze a dried-up fluid. It is surely correct to interpret the bag, breach and flow as the body and blood of a woman who has suffered an abortion, especially as the gap very much resembles the dilated female orifice and is surrounded by various metal instruments that in reality might well have been used to terminate a life.

On the lower platform of the trolley is a squalid and filthy bedpan loaded with scissors and other sharp instruments; beneath it a saucepan is similarly filled with cutting tools. By the side of the trolley stands a bucket brimming with soiled rags, while before it a stool suggests the low seat employed by a back street abortionist to perform her gruesome business.

Clearly, Kienholz was not attacking abortion *per se* here; instead, he aimed his venom at the outlawing of abortion, which by 1962 had forced millions of women to resort to the subterfuge, dangerous and utterly unhygienic methods the sculpture projects (and indeed, still compels them to do so in many parts of the world).

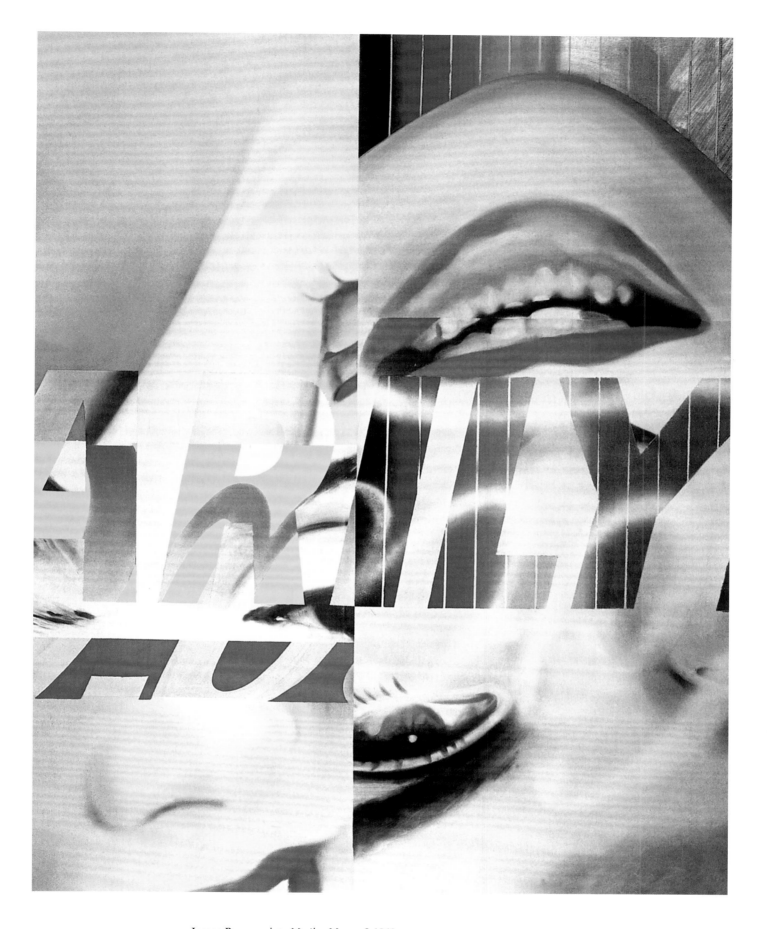

James Rosenquist, *Marilyn Monroe I,* 1962.
Oil and spray enamel on canvas, 236.2 x 183.5 cm.
The Museum of Modern Art, New York.
Art © 2006 James Rosenquist/ Licensed by VAGA, New York, NY

Rosenquist's tendency to abstract from reality is apparent here. Although Marilyn Monroe appears upside-down across the right-hand side of the canvas, the work hardly resembles a traditional portrait. Instead it signifies the actress more obliquely, for Rosenquist has projected the general if glossy fragmentation of imagery and language that is such a constant factor in the world today.

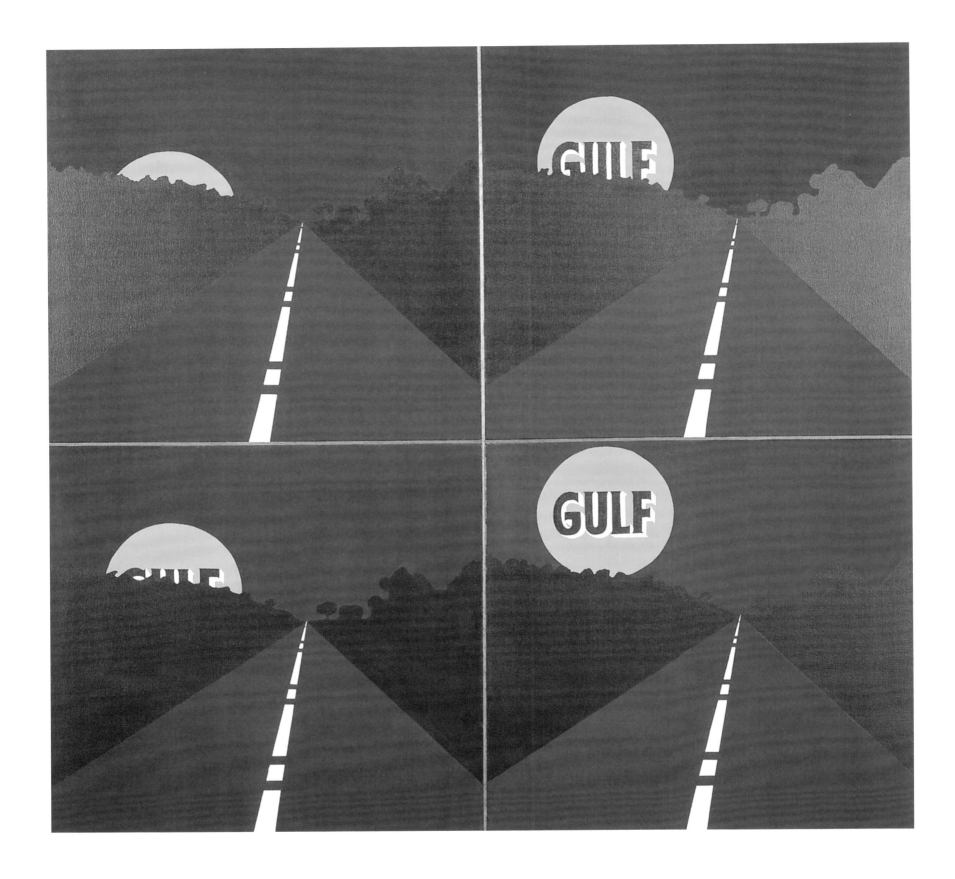

Allan D'Arcangelo, *Full Moon*, 1962. Acrylic on four canvases, each 60.9 x 60.9 cm. The Sidney and Francis Lewis collection, courtesy of The Virginia Museum of Fine Arts. Art © 2006 Estate of Allan D'Arcangelo/Licensed by VAGA, New York, NY

Allan D'Arcangelo was born in Buffalo, New York in 1930. He studied at the University of Buffalo between 1948 and 1953, and then for a further year in New York City. Between 1957 and 1959 he also spent two years studying in Mexico City, where he held his first one-man show in 1958. His first US exhibition was mounted at Long Island University in 1961. Since then he has exhibited many times throughout America, as well as in Brazil, Germany and Holland.

In the early 1960s D'Arcangelo not only painted pictures of media personalities but also turned his attention to a new social and cultural development which eventually became his major preoccupation. From the mid-1950s onwards, and partly in response to the Cold War, the United States had begun an enormous road-building programme. Moreover, post-war prosperity had equally engendered a car culture that gradually transformed the look of America by creating a massive amount of building development which often filled roadside strips with a seemingly endless confusion of gas stations, motels, chain restaurants, street lights, advertising billboards, road-signs and the like.

All this proved grist to D'Arcangelo's mill, as here. The highway stretches away endlessly in each of these sequential images. At the top-left we might think we are seeing a moonrise, given the partially-masked disc with its orange colour. However, in the next canvas we begin to learn that the landscape is dominated by a manmade orb which, in the following pictures, fully sheds light and consumer identity upon the world. D'Arcangelo may have created a simple pictorial statement in this work, but culturally he was very prescient.

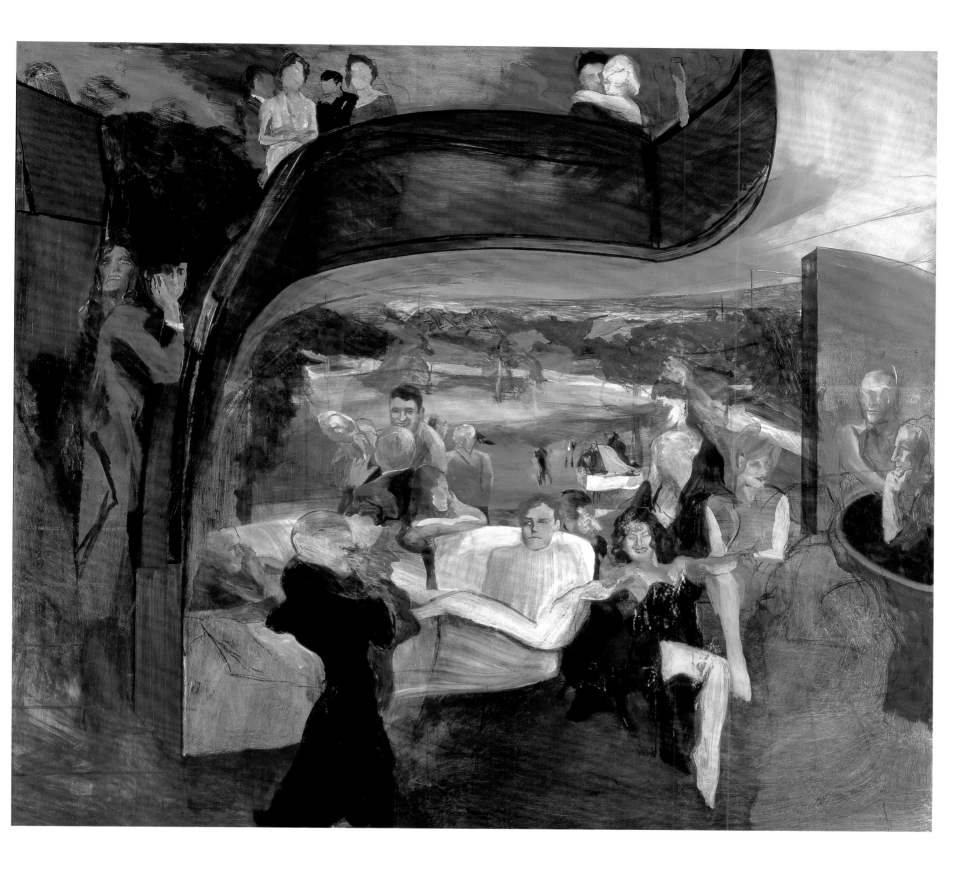

Michael Andrews, *The Deer Park*, 1962.
Oil on board, 214 x 244.5 cm. Tate Gallery, London.

*Michael Andrews was born in Norwich, Norfolk, England, in 1928. He studied at the local art
school and then, after his compulsory military service, at the Slade School of Art, London, between
1949 and 1953. Upon graduation he was awarded two important scholarships, one of which
enabled him to work in Rome. His paintings were already in demand by that time, and he held
his first one-man exhibition at the Beaux-Arts Gallery in London in 1958. Francis Bacon, who
was a friend and drinking-companion, once called him Britain's most interesting young artist. A
major retrospective of his work was held in London in 1980-1. He died in 1995.*

The falsity of a Hollywood glitzy and glamorous view of the world is the subject of this
work, as it is of a number of pictures Andrews produced during the early-to-mid 1960s.
The painting took its title from Norman Mailer's 1955 novel *The Deer Park* which not only
explores the troubled politics of McCarthyite America in the early 1950s but also the
Hollywood highlife and its sexuality, including homosexuality (one critic in 1955 called
the book, "The year's worst snake pit in fiction"). Another stimulus for the painting may
have been Federico Fellini's 1960 film *La Dolce Vita* ('The Sweet Life') which similarly
projects the amoral, hedonistic and shallow existence of the international jet set.

Some of the visual imagery of the painting derived from observations made in a Soho
drinking dive, the Colony Club, where both Andrews and Bacon hung out, along with
many other likeminded nihilists, bohemians and culture-lovers. In the centre the French
symbolist poet Arthur Rimbaud (1854-91) typifies that unruly lifestyle.

David Hockney, From 'The Rake's Progress' series of etchings, 1961-63.
Etchings, 30.5 x 40.6 cm. The Royal College of Art, London.

These are four of the designs in a series of sixteen etchings that Hockney began when studying at the Royal College of Art in 1961. He embarked upon the project because, being somewhat impoverished, he ascertained that students working in the printmaking department received their materials for nothing. In many ways The Rake's Progress series of etchings is the key to the first phase of Hockney's artistic maturity, for in these designs he perfected the approach to space and figuration that would inform his work in oil and acrylic contemporaneously. The set is a reworking of the famous series of paintings and prints by William Hogarth dating from 1735, in which a rake progresses from wealth obtained through loveless marriage, to debauchery, madness and death.

Hockney's Rake's Progress is almost unique within the Pop/Mass-Culture Art tradition, for it explores contemporary society in a narrative way, and often touches upon aspects of mass-behaviour, as here. It is mainly set in New York, which the artist first visited in 1961. In the first etching we see the rake – who looks like Hockney somewhat – arrive in a city with skyscrapers, one of which strongly resembles the Empire State Building. In the subsequent prints the rake receives his inheritance, meets the good people of Washington DC, attends a gospel meeting in Manhattan, embarks upon a spending spree, is reminded of his physical puniness in a send-up of a Charles Atlas advertisement (page 54), goes drinking in gay bars (above), marries an old maid (presumably for her money), witnesses an election campaign, visits a cinema showing the 1958 film *The Defiant Ones* starring Tony Curtis and Sidney Poitier, visits a Harlem funeral parlour (in an image adapted from a Cecil Beaton photograph), begins to run out of money and to disintegrate psychologically, is cast aside socially, and finally ends up in a psychiatric ward. That is the final scene illustrated here, with the nickname given to the Bethlehem mental hospital in Hogarth's eighteenth century London written on the wall. Unlike the earlier painter's inmates however (who range around a mad ward in varying states of lunacy), Hockney's psychiatric patients are stood in a line and kept mindlessly docile by being forced to listen through earpieces to endless pop music being broadcast by the radio station WABC.

In 1975 Hockney would return to the subject of The Rake's Progress by designing sets and costumes for the opera of that name written by Stravinsky to a libretto by W.H. Auden.

Robert Rauschenberg, *Kite*, 1963. Oil and silkscreen on canvas, 213.3 x 152.4 cm.
Ileana and Michael Sonnabend collection.
Art © 2006 Robert Rauschenberg/ Licensed by VAGA, New York, NY

The Cuban missile crisis, which brought the world to the very brink of nuclear
catastrophe, occurred not long before Rauschenberg painted this picture, and the United
States was also militarily engaged elsewhere by 1963. With its American bald eagle, US
Army helicopter and battle scene from the 1939 film *Gone with the Wind*, the picture
brings together images associated with both patriotism and conflict. Such links were very
prescient, for as the 1960s progressed the United States would become increasingly bogged
down in Vietnam, with its domestic, political and social structures progressively coming
under strain as a result. The dynamic paintwork and plenitude of spatters augment a
pictorial restlessness that fully projects the instability of the day.

Robert Rauschenberg, *Estate*, 1963.
Oil and silkscreen on canvas, 243.2 x 177.1 cm.
Philadelphia Museum of Art, Philadelphia.
Art © 2006 Robert Rauschenberg/ Licensed by VAGA, New York, NY

As noted in the introductory essay, Rauschenberg discovered the expressive potentialities of photographic silkscreen printing in 1962, after Andy Warhol's studio assistant had suggested it would prove a helpful technique for his employer. For Rauschenberg it opened up a new, more direct and faster way of operating 'between art and life', which was one of his stated objectives. It also helped him impart a greater overall cohesion to his images, for the photos act as fairly stable visual building blocks amid the welter of gestural brushwork, which Rauschenberg carried over from Abstract Expressionism to impart dynamism to his pictures.

At the upper-left a confusion of street signs typifies the muddle of urban life. The signs themselves had originally been erected on the corner of Pine and Nassau Streets in lower Manhattan during the construction of the Chase Manhattan bank complex. Also apparent are five entire or cropped photos of a 1940s six-storey warehouse that stood at 123 Front Street; in the one appearing at the top-right we can also see part of the East River beyond

it. Details of other buildings are also incorporated to enhance the sense of urban jumble. On the left, three images of birds appear sideways and are overpainted to varying degrees; perhaps they are intended to suggest that nature is being crowded out by the city. Across the lower part of the picture appear images of a rocket and the Statue of Liberty, possibly to suggest America more generally. To their right, a repeated image of a glass of water might allude to the containment of water that proves essential to city life. Just above the glasses can be seen a general view of the Sistine Chapel in Rome, with a clock face superimposed over it. Naturally, it is difficult to make out Michelangelo's ceiling and wall frescoes through all this but the inclusion of such an image might have been intended to signify that religion and the great art of the past are gradually being drowned out by time, by the speed and confusion of contemporary life, and by the constant urban development of modern cities, as specified by the title of the painting.

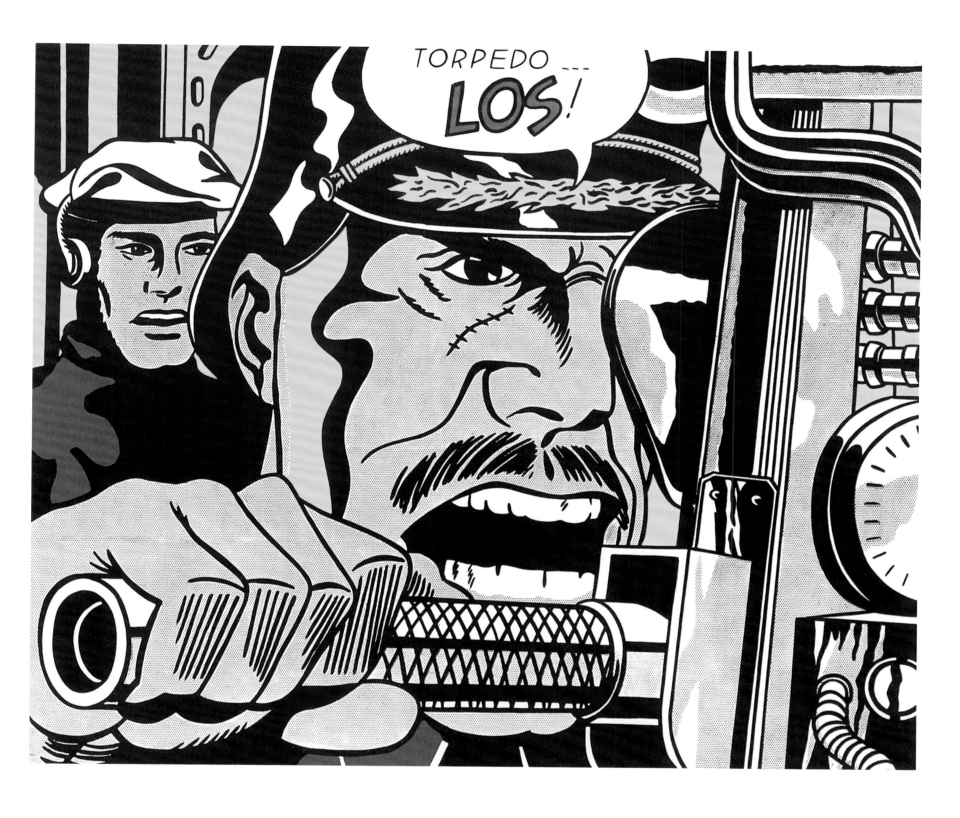

Roy Lichtenstein, *Torpedo…Los!,* 1963.
Oil on canvas, 172.7 x 203.2 cm. Collection of Mrs Robert B. Mayer, her son,
Robert N. Mayer and her daughter, Ruth M. Mayer.

The original cartoon image from which Lichtenstein developed this design had appeared in a comic-book entitled *Battle of the Ghost Ships!*. This related how a Second World War German U-boat had repeatedly torpedoed the same ship without any effect other than to drive the submarine skipper crazy.

Among the more significant alterations Lichtenstein made to the original was to delete all but two words from the original speech-bubble; to move the scar from the captain's nose to his cheek, so as to make it more readily apparent; to change the eye by which the officer peers through the periscope; and to open the man's mouth and thus make him seem more aggressive. Additionally, Lichtenstein added various bits of paraphernalia to the submarine's interior, to augment our sense of the mechanical complexity of the ship. The overall effect of all these changes is to intensify the sense of threat posed by the image although, paradoxically, that menace is counterbalanced by the extreme detachment with which the work is painted.

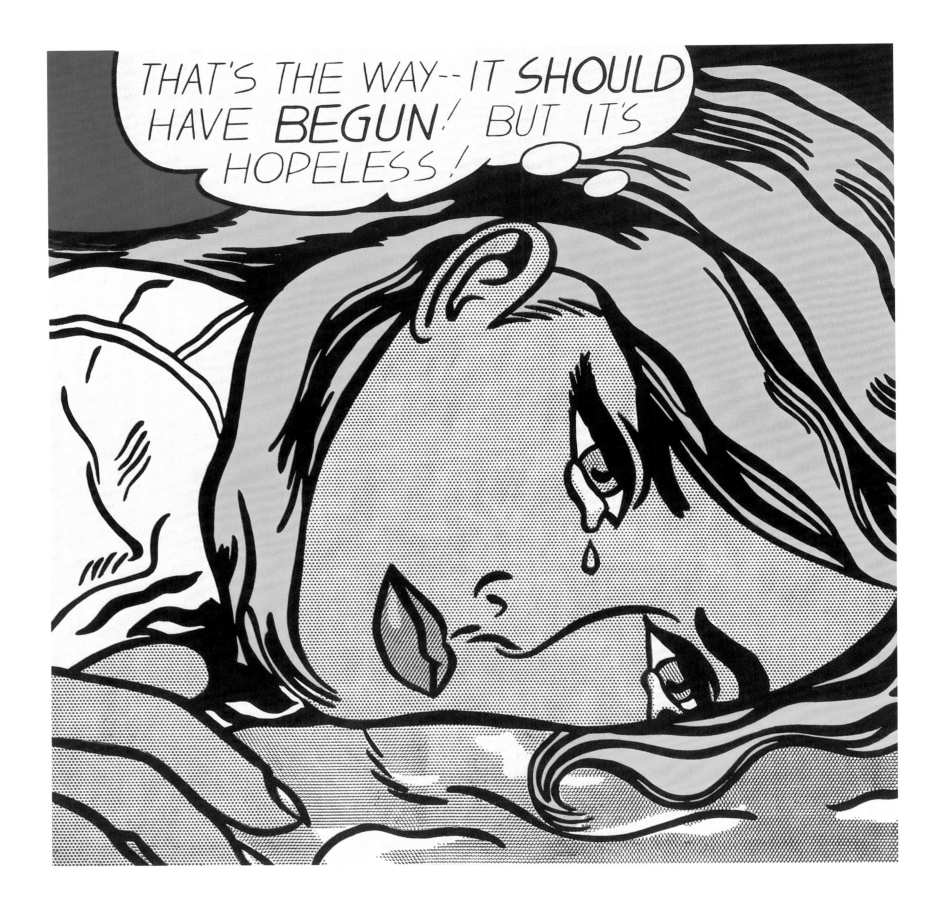

Roy Lichtenstein, *Hopeless,* 1963.
Oil on canvas, 112 x 112 cm. Wallraf-Richartz Museum, Cologne.

In works such as *Hopeless* Lichtenstein operates in the space between sophistication and the lack of it by affording us a culturally condescending perspective of a young girl's emotional responses. By emulating a technique of mechanical reproduction he also reminds us of the magazines through which adolescent emotions are often laid bare. In the context of the original comic-strip story, those feelings may have appeared genuine; taken out of context and physically enlarged they seem overwrought, sentimental and facile. By this simple but effective means Lichtenstein projects the general debasement of authentic feeling in the contemporary world.

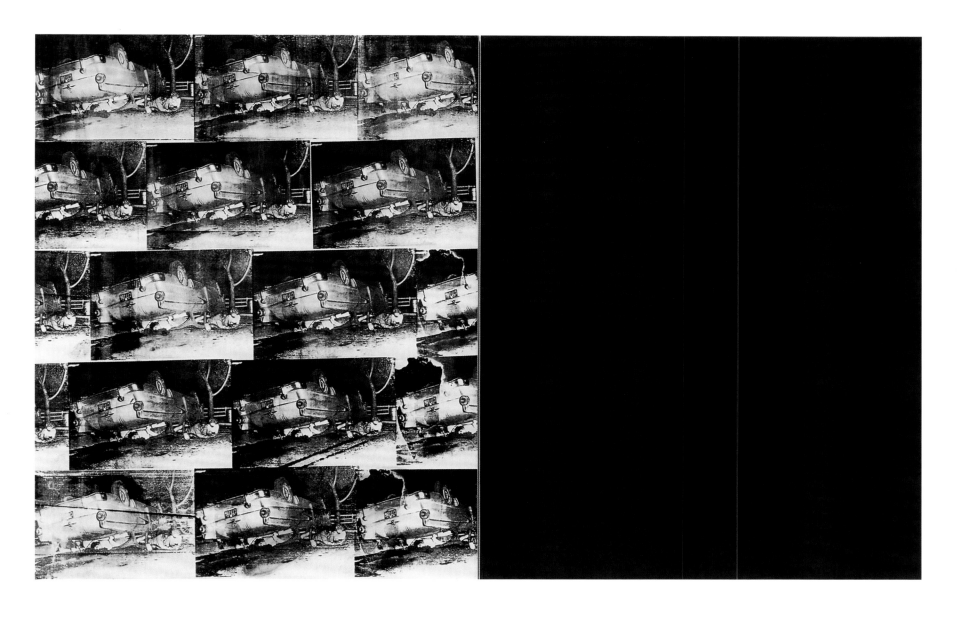

Andy Warhol, *Five Deaths Seventeen Times in Black and White*, 1963.
Silkscreen ink on synthetic polymer paint on two canvases, each 262 x 209 cm.
Oeffentliche Kunstsammlung, Kunstmuseum, Basel.

Warhol obtained the photographs he used for his many car-crash canvases from police and press sources; these organisations held the pictures back because they were deemed too horrific to be viewed publicly. Initially he may have obtained the idea of dealing with smashed cars from a sculpture entitled *Jackpot* by the American, John Chamberlain, which he had purchased in 1961. The piece comprises the crushed body of an automobile painted in factory colours.

Through its monochromatic starkness, this is one of the most visually powerful of all of Warhol's car-crash pictures. It certainly justifies Julian Schnabel's claim that Warhol "...presented the horror of our time with the thoroughness of Goya in his time." As in other Warhol paintings, visual repetition confuses the eye and thereby augments the inherent abstraction of the image. That repetitiveness also reminds us that death is everywhere. The uneven inking enforces subtle differences between the individual images, thus lending visual variety to the work. But ultimately the imaginative power of the picture resides in the relationship between its two distinct halves.

Warhol attached identically-sized and identically-coloured but wholly monochromatic canvases devoid of all imagery to many of the paintings he produced during the early 1960s. On different occasions he claimed that such couplings gave purchasers twice as much art for their money, or that he was defrauding those buyers by getting them to pay for partially empty images, or that the blanks emulated the near-empty canvases of the abstract artist, Ellsworth Kelly, one of which he owned. But clearly there was another, more serious reason for such pairings, namely the expression of negation.

Blankness does not necessarily lack meaning, for it can easily signify vacancy or the absence of something. Given that in many of his works Warhol expressed his sense of *anomie* or utter alienation from life, it is clear that in his paired disaster paintings he employed large blank areas of adjacent colour or tone to suggest negation and nothingness. Such a cosmic emptiness is surely the lot of the dead victims on the left.

James Rosenquist, *Painting for the American Negro*, 1962-63.
Oil on canvas, 203 x 533.5 cm. National Gallery of Canada, Ottawa.
Art © 2006 James Rosenquist/ Licensed by VAGA, New York, NY

At the time this work was created, full civil rights and the true economic and cultural emancipation of American blacks were being urgently demanded across the United States. In his customary fashion, Rosenquist avoided tackling this major social issue head on. Instead he created a fragmented, allusive addressal of the subject, with a white figure balanced in a crouching position upon the head of a black youth at the top-left, the inverted legs of both black and white basketball players at the lower-left, and part of the head of a black male represented in red monochrome towards the right. All the other images – the car in green monochrome, the slice of cake, the couple about to kiss, the

adjacent head of a baby, the computer-card punch holes, the horse's head and the spectacles – merely imply the behaviour, creatures and artefacts that help form the American Dream.

Yet Rosenquist did subtly inject one small but significant reference to the race issue here, for just behind the neck of the head with parted lips towards the left of centre, he painted a small, circular dial. Lettering next to it implies or reads 'DARKEN', 'NORMAL' and 'LIGHTEN', as though skin colour could be altered just by turning a dial. Undoubtedly, many Americans would have loved such an easy means of avoiding racial conflict in 1963 but fortunately for human diversity things are not that simple.

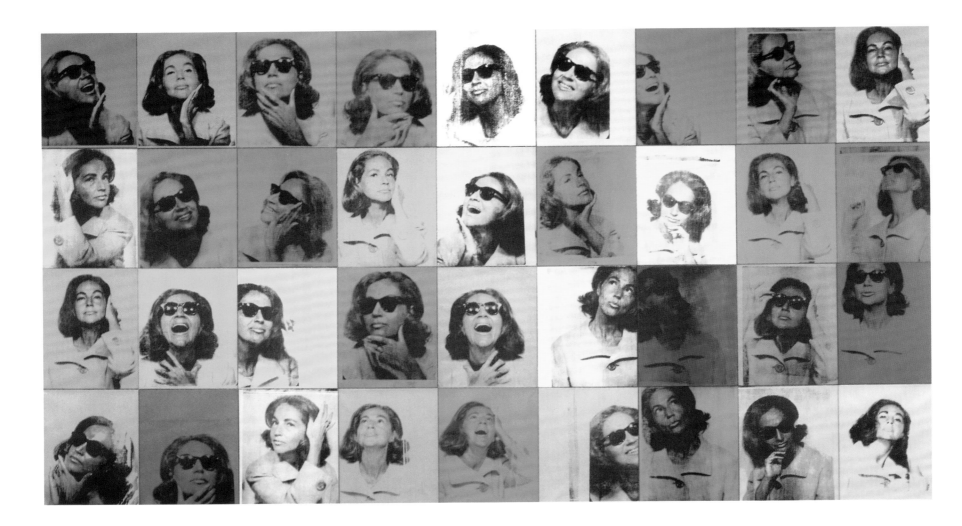

Andy Warhol, *Ethel Scull 36 Times*, 1963.
Silkscreen ink on synthetic polymer paint on thirty-six canvases, 202.6 x 363.2 cm overall. Whitney Museum of American Art, New York.

Robert Scull, a New York taxi-fleet owner who was one of the most prominent collectors of new art in the early 1960s ordered and paid for this work, which was Warhol's first commissioned silkscreen portrait.

Here the artist's customary habit of dealing directly with reality paid off handsomely. Knowing that Warhol wanted to use photographs for her portrait, Ethel Scull imagined that he would ask a photographer of the stature of Richard Avedon to take such pictures. Accordingly she dolled herself up in an Yves St Laurent suit for the photographic session. However, Warhol took her instead to a group of 42nd Street photo-booth machines that he fed with small change; as the sitter later related:

> He said, "Just watch the red light," and I froze. I watched the red light and never did anything. So Andy would come in and poke me and make me do all kinds of things, and I relaxed finally. I think the whole place…thought they had two nuts there. We were running from one booth to another, and he took all these pictures, and they were drying all over the place.

Subsequently Warhol selected seventeen of the photographs for the portrait, in which some of them appear several times. He then photo-silkscreened the pictures onto the individual panels which he finally brought together to form one work in the Scull's Fifth Avenue apartment.

The novel result of Warhol's approach was that effectively Ethel Scull portrayed herself, and did so in the round, for by finally posing unselfconsciously she revealed facets of her personality that would normally be hidden by more conventional approaches. She herself liked the work, stating that, "It was a portrait of being alive and not like those candy box things, which I detest, and never ever wanted as a portrait of myself."

Andy Warhol, *Mona Lisa*, 1963.
Silkscreen ink on synthetic polymer paint on canvas, 319.4 x 208.6 cm.
Blum Helman Gallery, New York.

The *Mona Lisa* by Leonardo da Vinci (Louvre, Paris) is certainly the world's most famous artistic icon. For that reason it has long acted as a target for anyone wanting to attack traditional cultural values. Perhaps the most infamous of these assaults is Marcel Duchamp's *L.H.O.O.Q* of 1919, in which a moustache and goatee were added to a reproduction of the painting; when uttered phonetically in French, the title of the work enacts a pun which can be translated as 'She sure has a hot arse'. Warhol undoubtedly knew the Duchamp.

In February 1963 da Vinci's painting was lent for a month to the Metropolitan Museum of Art, New York. The tremendous media hullabaloo sparked off by the loan motivated Warhol to produce a number of large-scale paintings which recycled the image. As a means of mirroring the endlessly repetitive cultural treatment that was being meted out to the *Mona Lisa*, Warhol emphasised replication in those works, and even entitled one of them *Thirty Are Better Than One* (private collection), a wry comment on the popular equation of artistic and economic value with multiplicity. In the version reproduced here, he dealt with the reproduction of the work of art by the print media, and specifically by colour printing.

Colour reproductions are composed of three primary colours: cyan, a sharp sky-blue; magenta, a deep red; and yellow, plus black and white, all of which are visible here. The disorganised array of *Mona Lisa* reproductions makes the overall image look exactly like a colour printer's rough proof sheet. These are single sheets of paper that printers use again and again for testing the quality of their work when they do not want to waste multiple pieces of paper. Naturally those sheets contain large numbers of arbitrary overprintings. Warhol must have seen such rough proofs many times during his commercial art career, which is clearly why he emulated them here.

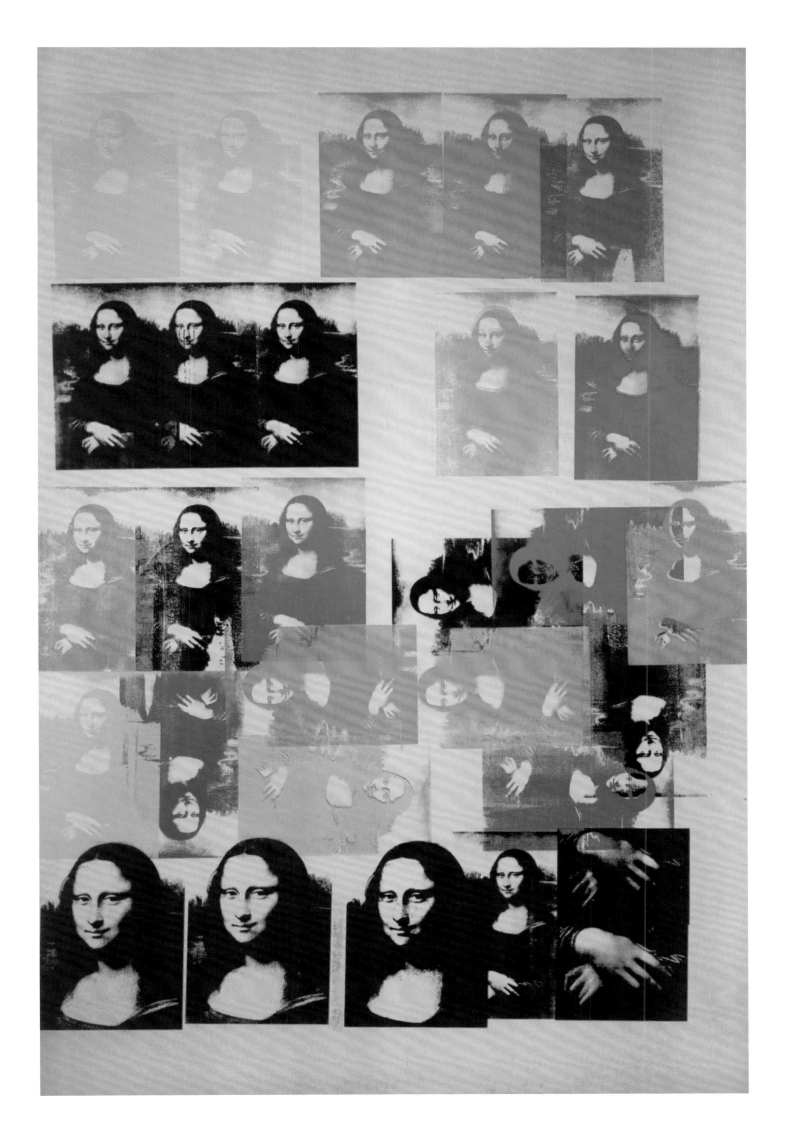

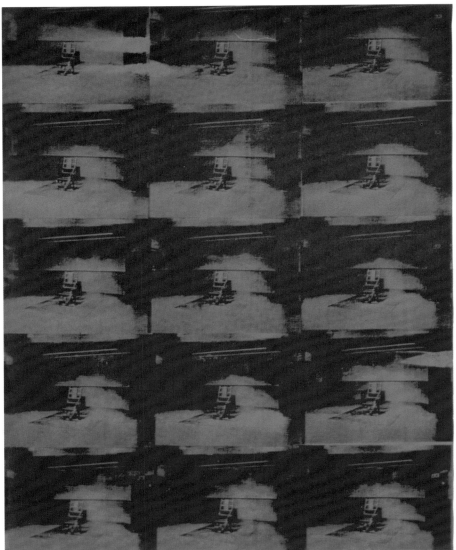

Andy Warhol, *Blue Electric Chair*, 1963.
Silkscreen ink on synthetic polymer paint on two canvases, each 266.7 x 203.8 cm.
Saatchi collection, London.

Death by electrocution was being strongly debated in New York State in 1963, for it was used for the last two times in Sing Sing prison in March and August of that year. Warhol was clearly inspired by that controversy to make a set of Electric Chair images. In some of them he superimposed the black, silkscreened images of the chair over areas of attractive colour, thereby creating an ironic juxtaposition of horror and prettiness, a linkage he probably regarded as a metaphor for life itself. In other versions he silkscreened the chair over extremely polarised colours that carry unmistakeable associations of the effects of high-energy electrical discharges upon photographic emulsions.

The vivid blue of the present work was surely intended to suggest the colour given off by a powerful electrical discharge. Certainly the repeated chairs serve to remind us of the long series of executions the piece of furniture had effected. And once again a complementary void on the right clearly communicates the emptiness of death itself.

Andy Warhol, *Atomic Bomb*, c. 1963.
Silkscreen ink on synthetic polymer paint on canvas, 264.1 x 204.5 cm.
Saatchi collection, London.

This painting has usually been dated to 1965, but it seems likely it was created earlier. As Warhol celebrated his birthday on 6 August, he had every reason to be aware of atomic explosions, for it was on his seventeenth such celebration that the very first atomic bomb had been dropped on Hiroshima on 6 August 1945.

Despite Warhol's disclaimers to have expressed any meanings in his works, this painting indubitably demonstrates that he *did* want his imagery to say something about the world. The garish red colour (which bears connotations of fire) and the gradual blackening of the image so that it ends in total darkness at the lower right, together create an outstandingly inventive metaphor for the fiery annihilation rapidly brought about by atomic explosion.

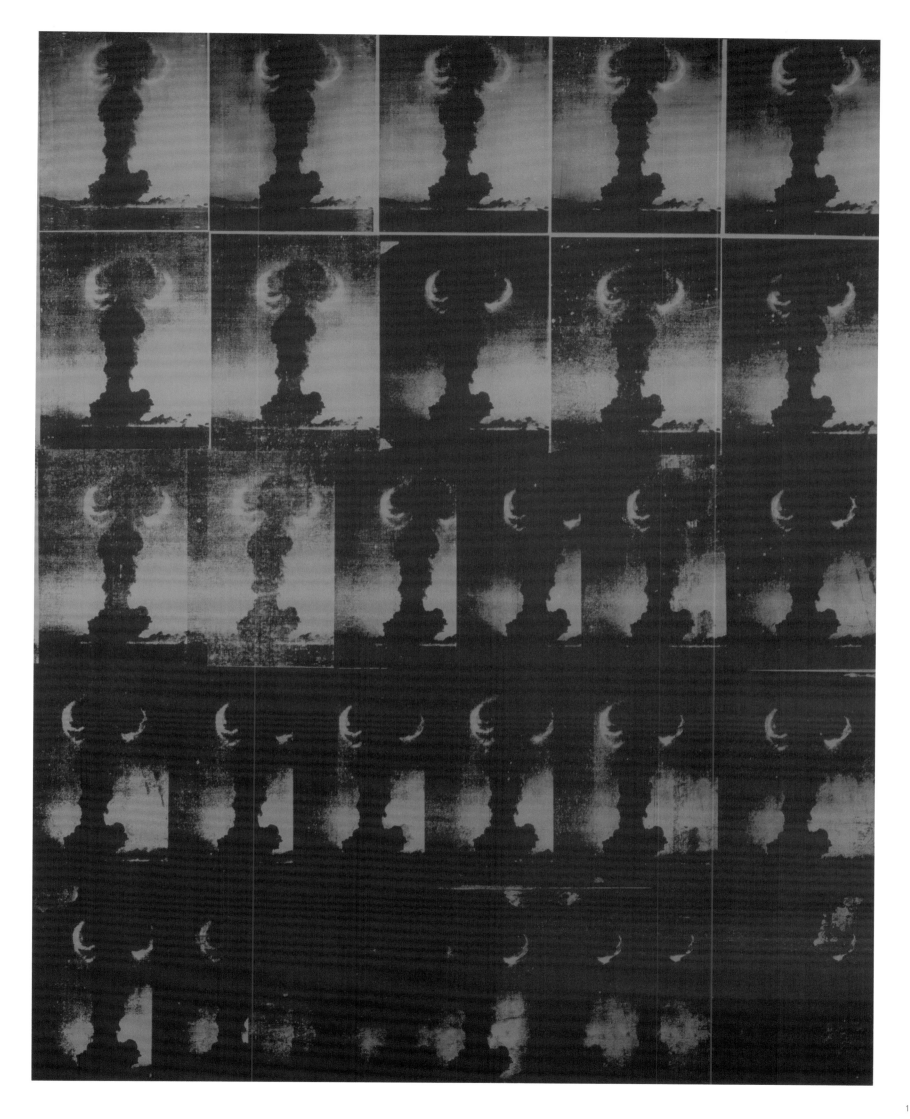

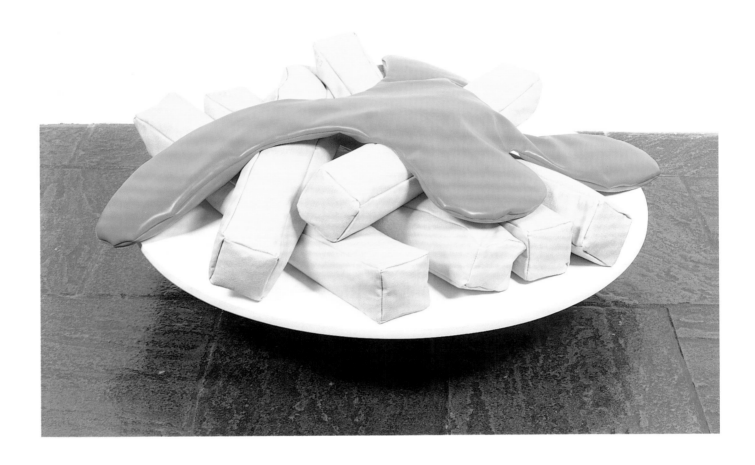

Claes Oldenburg, *French Fries and Ketchup*, 1963.
Vinyl and kapok, 26.6 x 106.6 x 111.7 cm. Whitney Museum of American Art, New York.

Claes Oldenburg was born in Stockholm, Sweden, in 1929 but he was taken to the United States the following year when his father was appointed a Swedish Consul-General there. Initially Oldenburg lived in New York City and Rye, New York, and then mostly in Chicago between 1936 and 1956. Since the latter date he has lived almost continuously in New York City. Between 1946 and 1950 he studied at Yale University, and between 1950 and 1954 at the Art Institute of Chicago. His early works were influenced by Abstract Expressionism. After moving to New York in 1956 Oldenburg came into contact with the highly experimental artist Allan Kaprow, following whose example Oldenburg mounted a number of Happenings around 1958. He held his first one-man exhibition at the Judson Gallery in New York in 1959. As touched on above, in 1961 and 1962 Oldenburg aped the marketing processes of capitalism by holding two exhibitions on the subject of retail stores, for the second of which he created his first batch of larger-than-life emulations of everyday consumer objects and foodstuffs (page 30). In 1976 he first worked with the Dutch artist and curator Coosje van Bruggen whom he married in 1977 and with whom he has collaborated on all subsequent projects. Since 1964, major showings of his works have been held in Venice, Kassel, New York, Amsterdam, Stockholm, Tübingen, Cologne, Krefeld, Duisberg and London.

Oldenburg once stated, "I have always been fascinated by the values attached to size", and the enhancement of normal dimensions has been a constant factor within his mature work, rendering the familiar unfamiliar and thus forcing us to question what we usually take for granted. Naturally, because of the sheer physical immensity of the United States and its grandiose political and materialistic aspirations, Oldenburg's enlargements of common things have consistently paralleled a very deep vein within that nation's psyche. And because of his conversion of familiar articles into other materials, he has always stressed the inherent formal qualities of both the items he replicated and of the representations themselves. Thus the work seen here not only portrays fried potatoes and tomato ketchup but equally it forces us to appreciate the shapes, colours and textures of the materials used for their denotation.

Oldenburg's first mature works were usually made of canvas. This was often internally reinforced with wire armatures and filled with foam rubber or even cardboard boxes before being soaked in plaster and painted when dry; for an example see *Floor Burger*, (page 36). Here, however, the artist used artificial fabrics to parallel and project the somewhat synthetic nature of fast food.

Claes Oldenburg, *Soft Fur Good Humors,* 1963.
Fake fur filled with kapok, painted wood, four units, 48.2 x 24.1 x 5 cm.
Roger I. Davidson collection.

In 1920 Harry Burt, a candy maker in Youngstown, Ohio, created a smooth chocolate coating for ice cream. Unfortunately the new combination was too messy to eat, but luckily for Burt his son came up with the clever idea of freezing a lollipop stick into the ice cream, thereby creating the world's first such comestible. The resulting ice cream bars on sticks were named Good Humors and they were marketed by Burt by means of chauffeur-driven trucks which initially carried bells to attract customers. By 1963 the Good Humor Corporation owned and operated 200 such trucks throughout the United States. Oldenburg's take on the various attractive flavours of Good Humor ice creams is seen here. By being converted into fake fur his Good Humors emphasise both the artificiality of much modern food and the equally false whetting of appetite commonly encountered in mass-culture.

It should be noted that in addition to chocolate and vanilla, and lemon and orange coatings to the ice creams, Oldenburg gives us tiger-skin and leopard-skin coverings too. This choice of outer casings may have been dictated by the types of artificial furs he was forced to work with, but it could equally allude to the sacrifice of rare animals to pleasure relatively affluent tastes. Such a message certainly remains very relevant today.

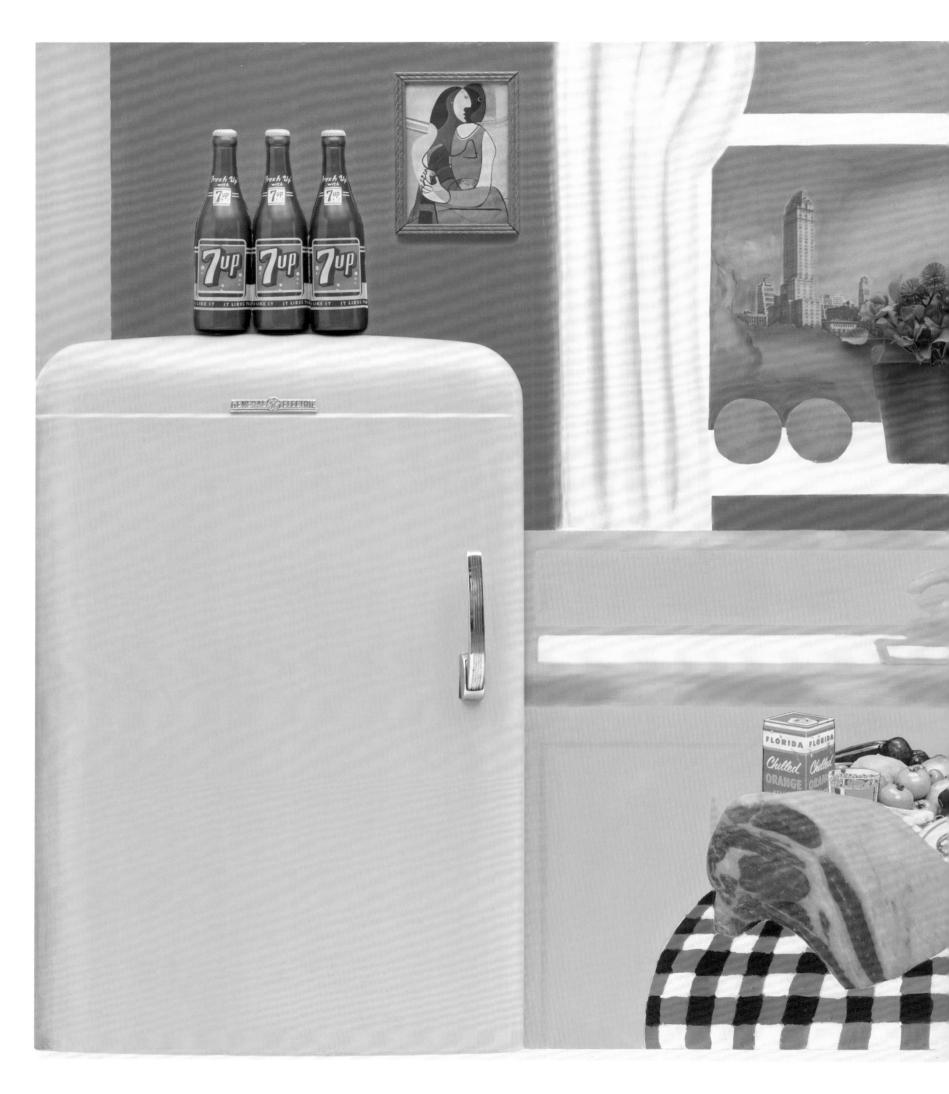

Tom Wesselmann, *Still-Life #30*, 1963.
Oil, enamel and synthetic polymer paint on composition board with collage of printed advertisements, plastic artificial flowers, refrigerator door, plastic replicas of 7-Up bottles, glazed and framed colour reproduction, and stamped metal, 123.1 x 167.6 x 10.1 cm.
The Museum of Modern Art, New York, gift of Philip Johnson.
Art © 2006 Estate of Tom Wesselmann/ Licensed by VAGA, New York, NY

Tom Wesselmann was born in Cincinnati, Ohio in 1931. After studying psychology at the University of Cincinnati, he went into the army, where he took up cartooning. He then attended the Art Academy of Cincinnati in 1955-6, and also studied painting at the Cooper-Union School of Art in New York between 1956 and 1959. At that time he created small, non-representational collages, and Abstract Expressionist works very much in the style of Willem de Kooning. In 1960 he turned to painting representationally. He held his first one-man exhibition at the Tanager Gallery in New York in 1961 and subsequently exhibited in many American group shows. His works were displayed in São Paulo, Brazil in 1967, and in Germany in 1968 and 1977. Many other exhibitions followed, both in the United States and beyond. Wesselmann died in 2004.

The artificiality of the American Dream, as represented by its foods, artefacts and the associations they generate, was the central subject of much of Wesselmann's work painted during his first mature phase throughout the 1960s, as the present piece makes particularly apparent. Arrayed before us in a gleaming manner are the comestibles and appurtenances of an ideal consumerist existence. On the wall a framed Picasso print brings art into the realm of the good life while usefully reminding us that such works are also objects of mass-consumption. Wesselmann makes everything very glossy, bright and ultra-perfect, and therein lies his subversion of the truth, for in reality things are just not like this, although the advertising men always promise they will be.

Edward Ruscha, *Standard Station, Amarillo, Texas,* 1963.
Oil on canvas, 165.1 x 308.9 cm.
Hood Museum of Art, Dartmouth College, Hanover, New Hampshire.

Richard Smith, *Staggerly,* 1963.
Oil on canvas, 226 x 226 cm. National Museum of Wales, Cardiff.

Edward Ruscha was born in Omaha, Nebraska in 1937 and grew up in Oklahoma City. At nineteen he moved to Los Angeles where he became a commercial artist, worked in the Walt Disney school for illustrators, studied fine arts at the Chouinard Art Institute, learned about book printing and was employed in an advertising agency. In 1958 he became aware of the work of Robert Rauschenberg and Jasper Johns. He made his first pictures of words in the early 1960s, and in 1963 published a book, Twenty-six Gasoline Stations, *which grew out of his general interest in the American environment. Ruscha produced many books and paintings throughout the 1960s, mainly of words and of buildings, but by the end of that decade he had moved towards Conceptual Art, and in 1969 he gave up painting altogether, although he returned to it later. In the interim he also made films. Large retrospective exhibitions of his oeuvre have been held in Lyons, Nassau and Münster.*

Ruscha's training as a designer is apparent in all his output, and in this representative work his graphic skills impart a simplicity and immediacy to the image. The gasoline station looms out of the darkness, with searchlights moving across the sky beyond it. Because the gas station is lit up, it seems welcoming, although it is curiously deserted.

Richard Smith was born in Letchworth, Hertfordshire, England, in 1931. He studied at Luton School of Art between 1948 and 1950. Following his military service he attended St Albans School of Art between 1952 and 1954, before going on to the Royal College of Art between 1954 and 1957. As a result of being awarded a Harkness Fellowship, he spent 1959-61 in the USA. He held his first exhibition at the Green Gallery, New York in 1961. Thereafter he resided for periods both in New York and London, until finally settling in the American city in 1976. He was awarded the Grand Prize at the São Paulo Bienale in 1967 and represented Britain at the 1970 Venice Biennale. Among his many shows around the world were retrospectives in London in 1966 and 1975, and in Cambridge, Massachusetts in 1977.

Although Smith has always been a non-representational painter, his connection with mass-culture was at its closest during the 1960s when he took many of his pictorial starting-points from the packaging of products such as Lucky Strike cigarettes, as here. The work is about visual rhythm, with the red roundels and white rectangular shapes staggering across the canvas, an implied movement furthered by the shape of the support. Naturally, the repetition not only creates visual dynamism but simultaneously introduces associations of the mechanical repetition by which industrial products such as cigarette packets are produced.

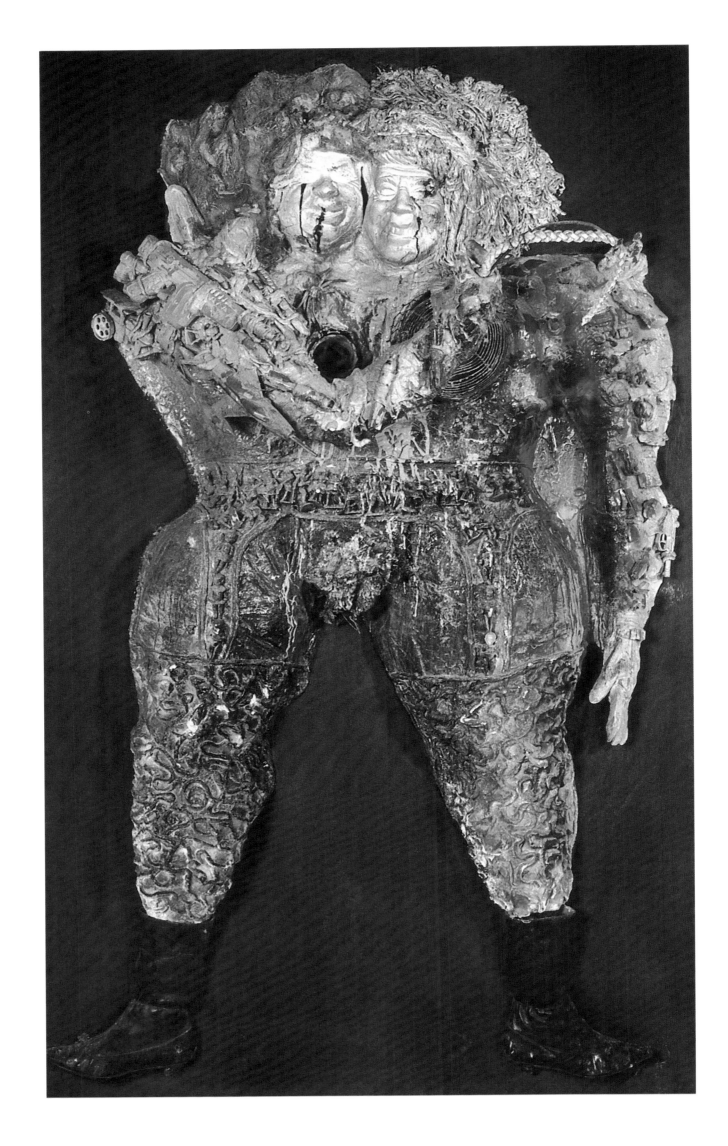

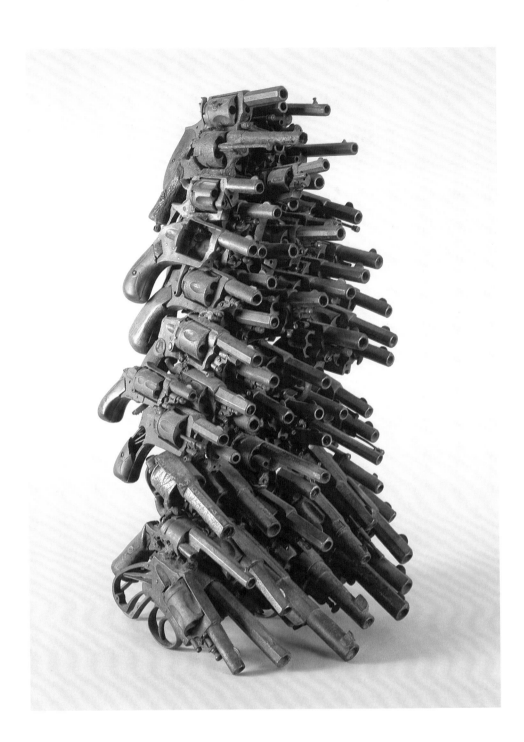

Niki de Saint Phalle, *Kennedy-Khrushchev*, 1963.
Mixed media, 202 x 122.5 x 40 cm. Sprengel Museum, Hanover, New Hampshire.

Niki de Saint Phalle was born in Paris in 1930 but spent her childhood in New York. Self-taught as an artist, she took up painting in 1950. In 1952 she returned to Paris. After 1960 she lived with the sculptor Jean Tinguely. In 1961 she began creating 'shot-reliefs', works in which she used a rifle to pierce receptacles of paint suspended above relief assemblages of found materials; as the paint spilt from the bags it completed the works beneath. She held her first solo exhibition at the Alexander Iolas Gallery in New York in 1961. By that time she had joined the Nouveaux Réalistes group of artists in Paris and also begun making slightly more conventional sculptures, many of which enjoy a politicised bias, as here. She went on to create some extremely large works, including the 1966 She, *a reclining female whose innards contained film shows, installations and machines, and which was entered through an aperture between its legs. Subsequently de Saint Phalle has written plays, made films, created architectural projects and continued to sculpt. A large retrospective of her work was mounted in Munich in 1987.*

Here de Saint Phalle has commented acidly upon aspects of Cold War politics. Soviet Premier Nikita Khrushchev and United States President John F. Kennedy were never likely to have embraced as closely as we see them doing here, for in October 1962 they had brought the world to the brink of nuclear disaster during the Cuban missile crisis. But by presenting them in such tight proximity de Saint Phalle attains a number of

things simultaneously: she projects the dualism of the two major superpowers; she reminds us of the puffed-up nature of vast military machines; she introduces associations of the space race, for because the overall form sports just two legs it looks rather like a single man dressed in a space suit; she suggests a grotesque fusion of two bodies, as might be wrought by a nuclear explosion; and she evokes the hideously bloated and discoloured appearance of a corpse, such as might be encountered in some post-apocalyptic wasteland.

Arman, *Nail Fetish*, 1963.
Group of revolvers glued together, 50.8 x 22.8 x 25.8 cm.
Private collection, Courtesy Galerie Vallois, Paris.

Mass-culture can mean mass-guns, especially in America. By the time Arman made this work he had settled in New York, and thus was living in a more weapons-orientated culture than Paris. The mountain of small arms stands as a mini-monument to human aggression and clearly points the way to the huge war memorial Arman would create three decades later in war-torn Beirut, Lebanon (page 250).

Martial Raysse, *Souviens-toi de Tahiti, France en 1961,* 1963.
Photograph, acrylic and screenprint on canvas, parasol, ball, 180 x 170 cm.
Louisiana Museum of Modern Art, Humblebaek, Denmark.

Martial Raysse was born in Golfe-Juan, France in 1936. In 1954 he attended the University of Nice. His first solo exhibition was held at the Gallery Longchamp in Nice in 1957. In 1960 he was one of the founders of the Nouveaux Réalistes group of artists in Paris. His first American exhibition took place at the Dwan Gallery, Los Angeles in 1963; he made his New York debut at the Alexander Iolas Gallery the following year. Several European and American shows followed, with a retrospective at the Pompidou Centre, Paris in 1981, a survey at the Palazzo Grassi, Venice, in 1983; and an exhibition touring Scotland, France, Denmark and Belgium in 1985. In 1966 Raysse began making films and soon afterwards gave up painting entirely, although he returned to it in the mid-1970s.

Raysse's first mature works were assemblages of banal consumer products with which he underlined the pointless range of choice within modern society. In 1962 he turned to painting, producing images saturated with garish colours to underline the gaudiness of contemporary life, while a little later he also began employing neon lighting to further that same end, as is seen on page 135.

In 1962 Raysse participated in a group exhibition held at the Stedelijk Museum in Amsterdam. His contribution was *Raysse Beach*, an assemblage made up of photographs of women, store mannequins dressed in bikini bathing costumes, plastic and rubber beach toys, parasols, a working jukebox and the like. Obviously the present piece was an offspring of that ensemble.

Some of the same colours visible on the parasol and beach ball appear on the woman, thereby suggesting she is just another artificially-coloured industrial product.

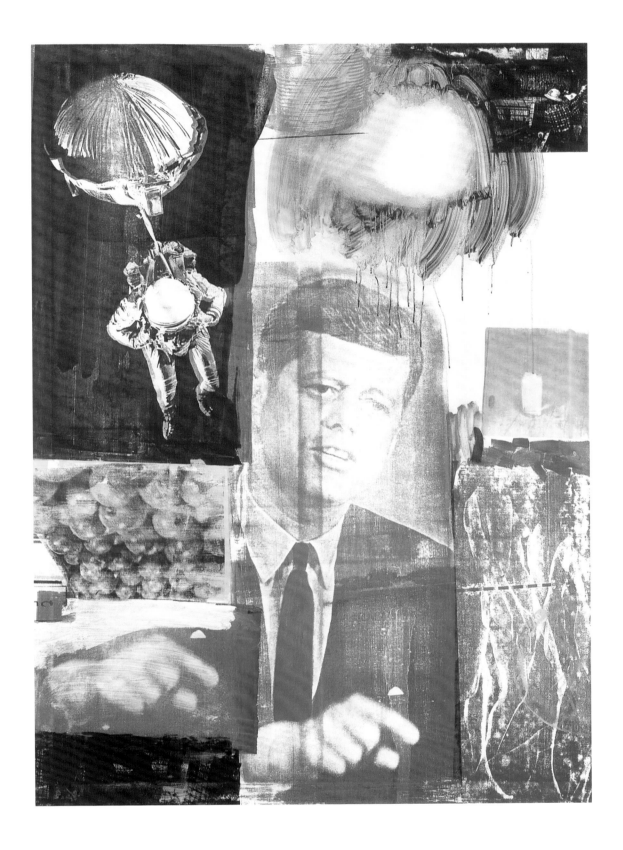

Robert Rauschenberg, *Retroactive I,* 1964.
Oil and silkscreen on canvas, 213 x 152.4 cm. Wadsworth Athenaeum, Hartford, Connecticut.
Art © 2006 Robert Rauschenberg/ Licensed by VAGA, New York, NY

Among its various meanings the word 'retroactive' denotes the extension of things to the past. By the time this work was created John F. Kennedy was dead, and so a portrait that brings him back to life is necessarily 'retroactive'.

By repeating the dead President's hand-gesture, Rauschenberg stressed the man's decisiveness. Clearly the astronaut alludes to the fact that Kennedy had been largely responsible for expediting the American space programme, as the artist was well aware. The nude woman seen walking in multiple positions at the lower-right might equally serve to remind us that the human drive towards the exploration of space has its roots in very primal aspirations indeed: biologically, our species first crawled out of the swamp, then we stood upright and learned to walk, and as a result sooner or later we might conquer the stars.

This is another of the crowded pictures Rauschenberg created not long after discovering the visual immediacy afforded by photo-silkscreen. The apparently arbitrary organisation of the blocks of imagery strongly parallels the randomness of life itself, and certainly the density of imagery parallels the overload we receive daily through the media. Rauschenberg exploits to the full the graininess that results from using silkscreen on a fairly open-weave canvas, as well as the drips that flow from extremely thinned paint. These differing ways of mark-making add to the vivid sense of spontaneity throughout.

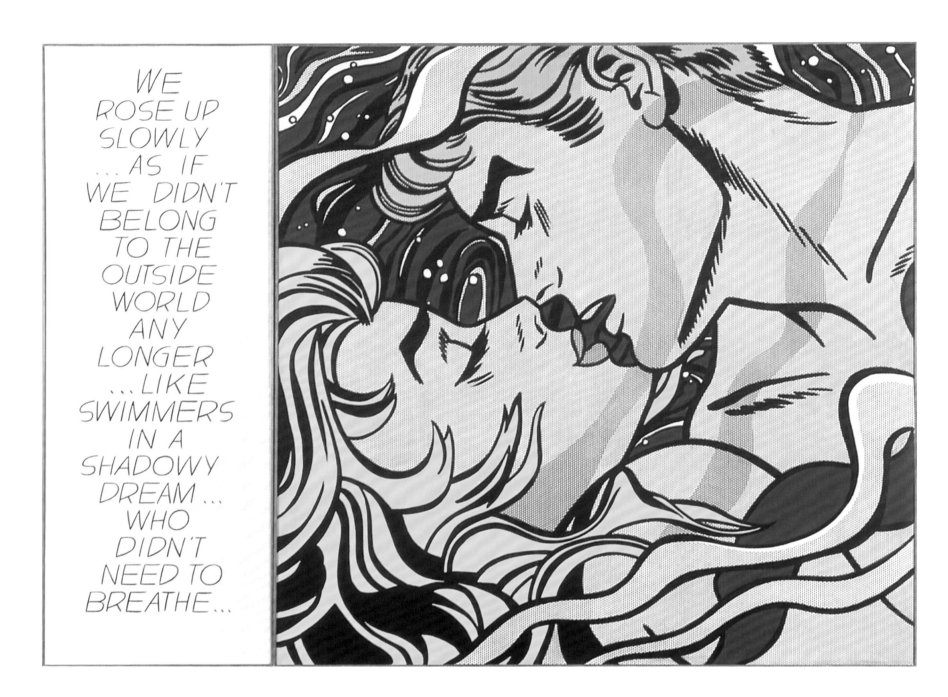

WE
ROSE UP
SLOWLY
...AS IF
WE DIDN'T
BELONG
TO THE
OUTSIDE
WORLD
ANY
LONGER
...LIKE
SWIMMERS
IN A
SHADOWY
DREAM...
WHO
DIDN'T
NEED TO
BREATHE...

Ed Kienholz, *Back Seat Dodge '38*, 1964.
Polyester resin, paint, fibreglass, truncated 1938 Dodge automobile, clothing, chicken wire, beer bottles, artificial grass and plaster cast, 167.6 x 609.6 x 365.8 cm.
Los Angeles County Museum of Art, California.

For this sculpture Kienholz took a 1938 Dodge automobile, cut out a section between its engine and passenger compartment (including its front wheels) and then joined up the severed elements, disguising their linkage with filler and paint. The result of such compression is to place more emphasis upon the open compartment and its occupants making love. Kienholz was very precise about his choice of car, requiring a Dodge dating from around 1938 because it would remind him of a vehicle owned by his father which he had borrowed for an identical purpose way back in 1944. The racoon's tail hanging from the car aerial and the empty Olympia beer bottles littering the scene also bore associations of that era for Kienholz.

The body of the man inside the car is made from chicken wire, while beneath him lies a girl whose form is composed of mannequin body-parts; the two figures share a head

Roy Lichtenstein, *We Rose Up Slowly*, 1964.
Oil and magna on canvas, overall 174 x 235 cm.
Museum für Moderne Kunst, Frankfurt am Main.

Lichtenstein did not have to work hard to make these glamorous young lovers look trite, for they appeared idealised, dreamy and saccharine in the original comic-strip picture from which he developed the painting. Moreover, the wording on the left also takes us deep into the territory of the banal. The enormous magnification of both image and words further stresses the inflation of cheap emotions in the contemporary world.

because, as Kienholz made clear, "...they both have the same thing on their mind." The sculptor christened the man Harold and the girl Mildred, names he took respectively from an engraved watch and a pin he found in a junk shop and attached to the figures. Mildred wears a real dress, stockings and suspenders, while a female undergarment adorns the car bonnet; presumably it belongs to her also. A phallic object placed near the top of Harold's legs obviously denotes his sexual arousal.

Inside the vehicle a radio plays continuously, although the music broadcast is necessarily contemporary rather than dating from the late-1930s. By this means Kienholz bridged the temporal gap between then and now, thereby making the point that young people still make love in the backs of cars. By placing the words 'Everywhere, U.S.A.' on the car's rear number plate, the sculptor transformed a singular incident into a more universal statement about the furtive search for sexual thrills and spills in a modern junk-filled environment.

Kienholz added extra lights to the front of the vehicle; they are on full beam, as are the regular lamps. This bright light not only suggests that the action is taking place at night (to which end the sculptor directed that the surrounding gallery lights be dimmed), and

that Harold has forgotten to turn them off in his sexual eagerness, but also that the couple are all lit up by their sexual arousal. Naturally, by giving his car a working radio and lights, Kienholz suggested that Harold has recently driven here. Yet simultaneously the sculptor further ignored the constraints of time, for by placing the partially wheel-less vehicle on artificial grass he equally suggested it has been abandoned in a field somewhere.

This ensemble was first displayed in the Kienholz retrospective mounted at the Los Angeles County Museum of Art in 1966, where it generated indignation among some narrow-minded members of the museum's board of supervisors. Fortunately, the museum's controlling board stood its ground and the work remained on display, although incredibly the car door was kept closed and only opened during exhibition tours. Naturally the controversy was reported by the media and the sculpture consequently acted as an enormous crowd-puller, turning the retrospective into the most successful contemporary art exhibition ever mounted at the museum (which subsequently purchased the piece). Now, of course, the projection of sexual activities that might take place after a Saturday night hop seems very tame when compared to the far more sexually-explicit works that are frequently encountered in art galleries, let alone everywhere else.

George Segal, *The Dry-Cleaning Store*, 1964.
Plaster, wood, metal foil and neon light, paper and pencil, 243.8 x 274.3 x 218.4 cm.
Moderna Museet, Stockholm.
Art © 2006 The George and Helen Segal Foundation/ Licensed by VAGA, New York, NY

George Segal was born in New York in 1924. Between 1942 and 1946 he studied at the Cooper-Union School of Art in Manhattan, as well as at Rutgers University in New Jersey. He then studied between 1947 and 1949 at the Pratt Institute of Design in New York, and at New York University, from where he graduated with a teacher's degree. He first exhibited at the Hansa Gallery, New York in 1956 (although on that occasion he displayed paintings rather than sculptures). As a result of the technical breakthrough detailed below, in 1961 he moved over almost completely to sculpture. Throughout the rest of that decade and subsequently he has exhibited his sculptures and sculptural ensembles to growing acclaim throughout America, Europe and the Far East.

What transformed Segal's art in 1961 was the drawing of his attention to a new type of medical bandage which was coated with plaster and which therefore only needed to be wetted to solidify; by wrapping such dressings around real people and then using the hardened casts to constitute his figures, he could very quickly close the gap between actuality and art. This freed him up from representation *per se*, and allowed him to think more intensely about how to present his figures. The strange disparity between people depicted in white plaster and the multicoloured objects and environments that often surround them serves to stress the insubstantiality, anonymity, insularity, loneliness and alienation of those figures, thus making telling comments about our age.

Here an unpretentious dry-cleaning establishment becomes a place of isolation and loneliness as a solitary woman stands at her counter writing out a receipt and awaiting customers. The figure is coated in metallic paint and she holds a real pencil poised above a real piece of paper. Nearby a display-cabinet is lined with purple-coloured metal foil. This reflects the neon light in dazzling reds and blues, thereby offsetting the whiteness of the wedding dress made out of plaster which hangs at the centre of the case.

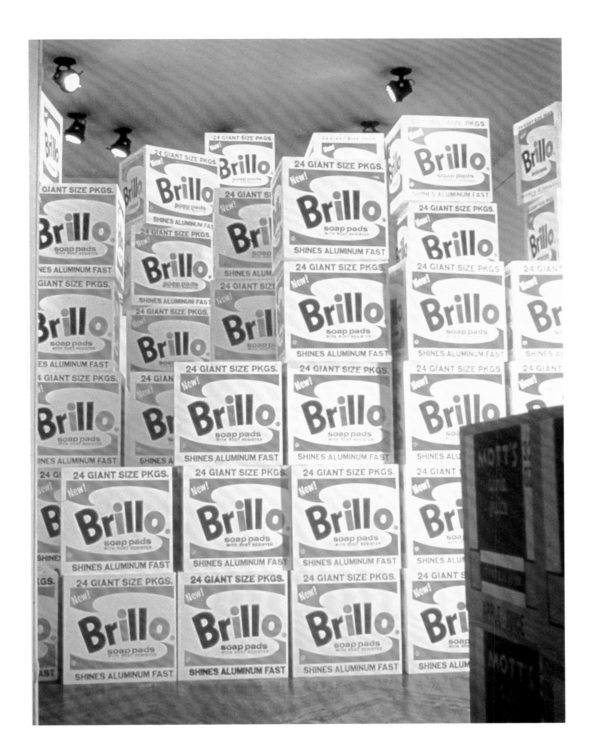

Andy Warhol, *Brillo Boxes*, 1964. Silkscreen ink on synthetic polymer paint on wood,
each box 51 cm high x 51 cm wide x 43 cm deep.
The Andy Warhol Foundation for the Visual Arts, Inc., New York.

This is a colour photograph of part of Warhol's packing carton sculptures exhibition held at the Stable Gallery, New York, in April 1964. Warhol probably derived the idea for the display from being greatly impressed by one or other of the two *The Store* exhibitions held by Claes Oldenburg in 1961-2 which were made up of emulations of everyday objects of mass-consumption. However, here he gave us a somewhat more subversive and relentless project than Oldenburg's witty comment upon consumerism.

For his sets of sculptures Warhol and his assistant, Gerard Malanga, silkscreened the designs of the cardboard outer packing cartons of Campbell's Tomato Juice, Del Monte Peach Halves, Mott's Apple Juice, Brillo Soap Pads, Heinz Ketchup and Kellogg's Cornflakes on all six sides of over 400 wooden boxes that had been made to order by a team of carpenters. Naturally the boxes took to a logical conclusion the cultural implications of the 1960 painted bronze replica of two Ballantine beer cans by Jasper Johns (page 81). By being created and displayed *en masse*, Warhol's boxes raise pointed questions about the nature of appearance and reality, as well as the commercial value of a work of art *versus* the object it represents. And by almost filling the Stable Gallery with these sculptures, Warhol thereby converted the space into a glorified supermarket stockroom, thus reminding us that art galleries are usually only glorified supermarket stockrooms anyway.

Although Warhol had visions of purchasers carting away large numbers of the sculptures, sales were poor, for people were loath to spend good money on cheap-looking objects when they could obtain the real thing for nothing behind a supermarket. As a result, the owner of the Stable Gallery withdrew her backing from the painter, who moved elsewhere as a result.

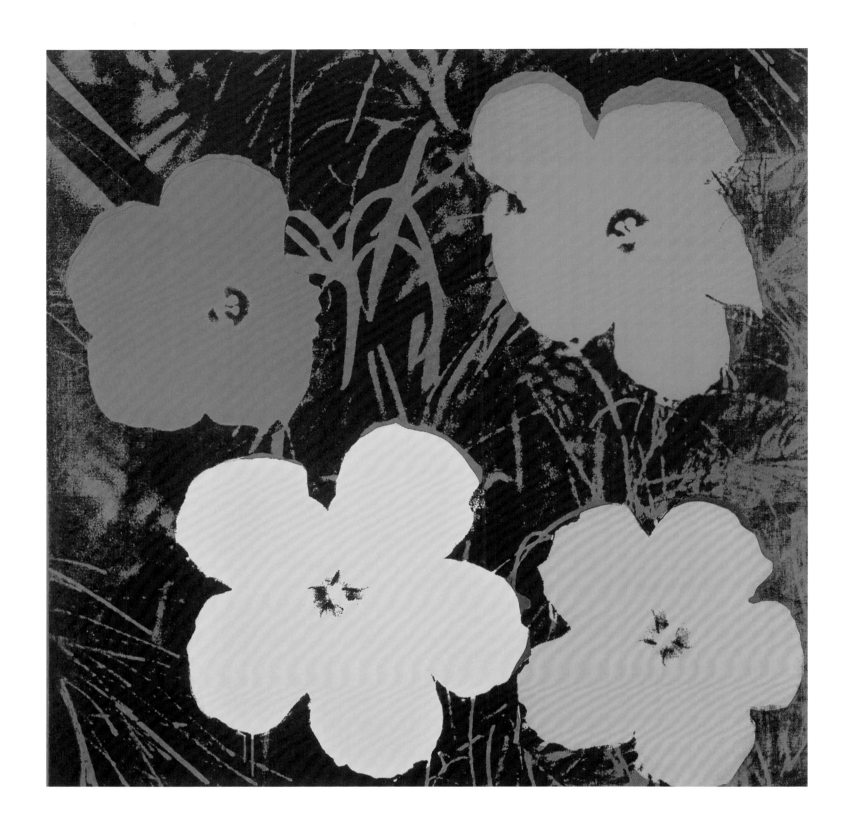

Andy Warhol, *Flowers*, 1964.
Silkscreen ink on synthetic polymer paint on canvas, 293.4 x 293.4 cm.
The Andy Warhol Foundation for the Visual Arts, Inc., New York.

In his Flowers paintings Warhol covered yet another major area of life and art, for flowers form a principal component of the natural world and there is a long and hallowed tradition of depicting them in western art. The series came about at the suggestion of a curator friend who met up with Warhol in April 1964 at the New York World's Fair and suggested that instead of producing yet more death and disaster pictures, he should instead paint flowers. Warhol thereupon had sets of silkscreens made up from a photograph of some hibiscus flowers that he cropped and rearranged from the June 1964 edition of *Modern Photography* magazine. Assisted by Gerard Malanga, he then made over 900 flower paintings throughout that summer, although he forgot to obtain permission to reproduce the original flower photograph before doing so. As a consequence he was successfully sued for breach of copyright by the photographer, Patricia Caulfield. The vast replication of images makes the clear point that the natural world has become prettified, commodified and marketed on a mass scale during the present era. Naturally, this prettification, commodification and marketing were paralleled by Warhol himself, for the first exhibition of the Flowers paintings at the Leo Castelli Gallery in November 1964 completely sold out.

The original picture in *Modern Photography* magazine illustrated an article on variations in colour printing, so Warhol's many colour variations are very apt. Because of the formal repetitiveness and colour variation, the works almost function simultaneously as investigations into the ways that such stresses and changes alter our perceptions of form, which could conceivably have been one of Warhol's intentions, given his highly developed visual sensibility. As usual, the painter's alertness to the intrinsic properties of forms made him push the shapes of the flowers to the interface with abstraction. That effect is heightened by the repetitiousness, crowding and colour variation of the flowers when they are seen *en masse*, as they were both in the Castelli Gallery and at the Ileana Sonnabend Gallery in Paris in May 1965. Warhol chose to display these pictures in the French capital at that time because, as he commented later, "In France they weren't interested in new art; they'd gone back to liking the Impressionists mostly. That's what made me decide to send them the Flowers; I figured they'd like that."

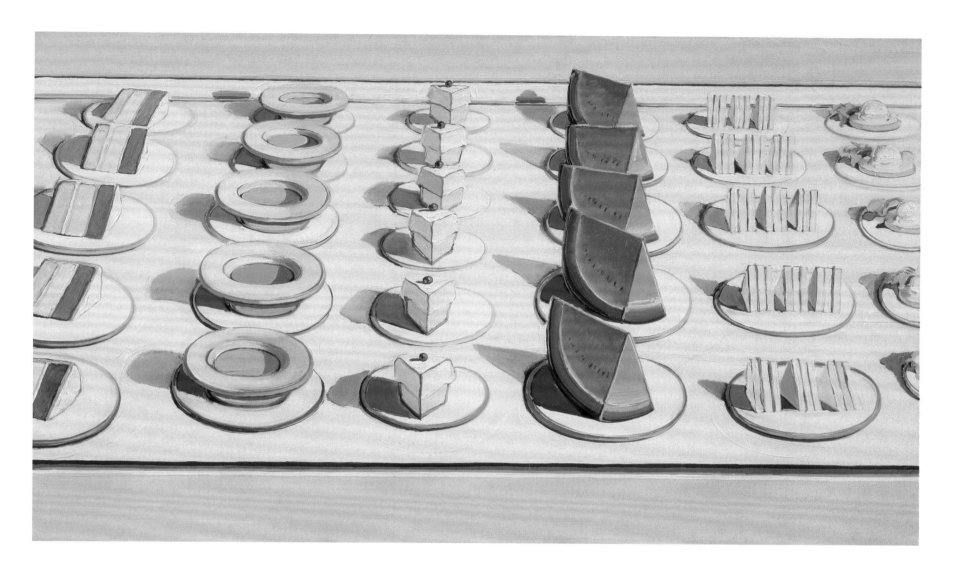

Wayne Thiebaud, *Lunch Table*, 1964.
Oil on canvas, 91.4 x 152.4 cm. Stanford University Museum of Art,
Palo Alto, California.
Art © 2006 Wayne Thiebaud/ Licensed by VAGA, New York, NY

Unlike Warhol, with whom he shared a preoccupation with the abundance, repetitiousness, replication and artificiality of modern life, Thiebaud dealt with things in traditional spatial terms. He was therefore able to invest his images with a great variety of shapes, as here. By arraying the dishes in strict perspective he pulls us into the image.

The colours of most of the foodstuffs, as well as those of the tabletop, foreground and background, are fairly bland, and by contrast they make the rich reds of the shadowed sides of the watermelons virtually leap off the canvas. Thiebaud's use of the edges of the support to cut off the rank of layer cakes at the left, and the line of cottage cheese salads on the right, furthers the suggestion that we are merely seeing a portion of what is on offer, and that the food stretches away to infinity.

David Hockney, *California Art Collector*, 1964.
Acrylic on canvas, 153 x 183 cm. Private collection.

Hockney painted this picture shortly after touring Los Angeles with his art dealer in 1964 on prospective selling trips to various wealthy ladies who collected art. He found the women fairly ignorant but was impressed by their homes, especially their open-plan living spaces and large picture-windows which opened directly on to their gardens. From that experience, and also with art-historical associations in mind, he created this spatially ambiguous image.

The work is a parody of a traditional Italian Renaissance Annunciation scene, with the Californian art collector seated on the edge of her armchair occupying the position often taken by the Virgin in such religious paintings, and a tripartite abstract sculpture by the British artist William Turnbull standing in for the angel Gabriel in those pictures. Within the base of the Turnbull sculpture, bent, stylised legs are drawn in slightly darker tones of the surrounding golden brown, and they allude to the genuflection of the angel. The collector's ignorance of art is externalised immediately beyond her by another, larger but monochromatic head painted in a somewhat primitive manner. Up to the right a small white cloud drifts away, pretty much as the Holy Dove that often appears above the

Madonna in Annunciation scenes might presumably fly away after the proceedings are concluded. Instead of providing the white lily and stone floor that also normally appear in Annunciation scenes, Hockney respectively covers the armchair in flowers and the floor with a white, fluffy rug. All of this is contained within a room whose roof rests upon two poles. In one of Hockney's typical spatial contradictions, the depth of the roof does not match that of the carpet beneath it. Very evidently the wide but shallow roof derives from the covering of the manger that appears in the background of a nativity scene of around 1470 by Piero della Francesca in the National Gallery, London.

Another allusion to art – albeit to contemporaneous painting – is embodied in the rainbow, for its colour stripes are reminiscent of the colour stripes painted by the American artist Kenneth Noland whose work was all the rage in avant-garde circles in 1964. And beyond the rainbow is a ubiquitous Californian swimming pool with accompanying palm trees. In time Hockney would make such typifications of the high life an important part of his art, as we shall see.

Martial Raysse, *America America*, 1964.
Neon lighting and metal paint, 240 x 165 x 45 cm.
Musée national d'art moderne, Centre Georges Pompidou, Paris.

The pointed shapes held by this giant hand evoke stars, which is most apt, given the title of the work. Yet at the same time those forms are extremely reminiscent of the pictorial devices employed by cartoonists to denote explosions, as Raysse would certainly have been aware from the work of Roy Lichtenstein (see page 93). And then there are the associations brought into play by the Statue of Liberty in New York, where the female figure with head encircled by a pointed, starry crown grasps a torch that symbolised the hope America represented for Europe's 'huddled masses' when the monument was created in 1886 and, indeed, still does for others. By encircling the hand with neon, Raysse reminds us of the artificial advertising techniques that are integral to America.

George Segal, *The Diner*, 1965.
Plaster, wood, chrome, formica, masonite and fluorescent light, 259 x 274.3 x 220.9 cm.
Walker Art Center, Minneapolis.
Art © 2006 The George and Helen Segal Foundation/ Licensed by VAGA, New York, NY

This is a three-dimensional offspring of Edward Hopper's famous 1942 painting *Nighthawks* (Art Institute of Chicago) which shows three customers and a barman in a café in the dead of night. Here, a lone diner waits while a barmaid draws hot water from an urn. The man's entire body is expressive of solitariness and boredom.

Ed Kienholz, *The Wait*, 1964-65. Wood, polyester resin, paint, flock wallpaper, furniture, bones, clothing, stuffed cat, live bird, photographs and glass, 203.2 x 375.9 x 198.1 cm. Whitney Museum of American Art, New York.

Loneliness in old age is a central problem of modern, atomised societies, as Kienholz made clear in this work. The skeletal figure of an elderly lady sits in her armchair, with her sewing strewn across her footstool and sewing-basket. Except for the (stuffed) cat that she fondles upon her lap and her pet bird – which is a live creature kept fed and watered daily by the museum staff – she is utterly alone with her memories and knick-knacks. The former are represented by the numerous framed photos on her table and on the wall behind her, while the latter cram the numerous jars hanging from her neck. They include an assortment of toys, figurines, mementos, small coins, thimbles and similar utilitarian household objects.

The head of the lady is represented by a large jar bearing a photo of a young woman on its lid. This bottle points outwards, and clearly we are expected to surmise that the picture shows the lady as she had looked when young. Behind the photo, filling the large jar, is the skull of a deer, with staring eyeballs. The skull and eyes remind us of our shared animal fate and that one day we too will stare death fully in the face.

James Rosenquist, *F-111*, 1964-65.
Oil on canvas with aluminium, 304.8 x 2621.3 cm.
The Museum of Modern Art, New York.
Art © 2006 James Rosenquist/ Licensed by VAGA, New York, NY

With its vast scale, richness of imagery, pictorial variety and confident handling, this is both Rosenquist's masterpiece and one of the finest works to have emerged from the entire Pop/Mass-Culture Art dynamic during the 1960s. Because the painter was unable to create the work on a single support due to the lack of studio space, he created it in 51 panels, which he later joined together in four sections. The picture was first shown in the Leo Castelli Gallery in New York in April 1965, ranged around the walls of the gallery in its four sections.

Rosenquist always avoided making direct statements about politics in his work and, indeed, about almost everything else for that matter. An oblique, fragmentary approach was his preferred means of dealing with the world, and so it proved here. Rather than directly attack the growing American involvement in Vietnam, with its military manpower, advanced technology and waste, he created a vast work that hints at that war, as well as at larger issues.

Underlying everything is the form of the General Dynamics F-111 fighter-bomber of the title. This machine first flew in December 1964, so it was the most advanced American attack plane of the day when Rosenquist painted this picture (in fact it would not actually come into use until the end of 1967). Over, through and behind the plane are ranged the images of a consumer society, some of which relate in an associative manner to the machine. Thus the parasol appearing in front of the word 'FORCE' and the nuclear mushroom cloud behind it clearly links to the idea of the nuclear 'umbrella' supposedly

afforded by atomic weapons. Similarly, the winsome child under her pointed hairdryer is the only human in the image and she is located directly before the area of an F-111 where the only humans would be located within such a machine, namely the cockpit which was placed just in front of the leading edge of the wing and its nacelle. The fact that a child is situated here does not seem insignificant in symbolic terms either. Her hairdryer somewhat resembles both a huge crown and a large military shell, both of which seem very meaningful within a political-military context. And the spaghetti might allude to political and military entanglement, of the type that America was learning about extensively and expensively in human and logistical terms in Vietnam in 1964-5.

According to Rosenquist himself, the slice of cake to the left is reminiscent of a sunken missile silo by dint of its low pictorial position and its shape. Above it the tyre somewhat amplifies its circularity and adds a staccato rhythm by way of its jagged tread. The wallpaper pattern apparent towards the nose and tail of the airplane was likened by the artist to a veil hanging in the atmosphere like radioactive dust. Clearly the light bulbs and broken eggshell in front of the bomb-bay allude to bombs, the way that light bulbs can make a loud bang when shattered, and to the fragility of life when bombs are around. In a clear visual simile, the shape of the atomic cloud is echoed by the large air bubble given off by a swimmer to the right of it. Associations of the materials used to create an F-111 are introduced by the aluminium panels located in front of the nose and around the tail of the airplane.

Sir Eduardo Paolozzi, *Wittgenstein in New York*, 1965.
Screenprint on paper, 76.3 x 53.8 cm. Tate, London.

This complex image forms part of the 'As is When' set of twelve screenprints which has justly been called "the first masterpiece of [that] medium." Ludwig Wittgenstein (1889-1951) was arguably the most important philosopher of the twentieth century, his *Tractatus Logico-Philosophicus* being his most influential work. Paolozzi was a long-time admirer of the philosopher and, indeed, once stated "I wanted to identify myself with Wittgenstein through [these] prints; to make a kind of combined autobiography."

Wittgenstein visited the United States between July and October 1949 as the guest of the Professor of Philosophy at Cornell University, Norman Malcolm (1911-1990). In 1958 Malcolm published *Ludwig Wittgenstein, A Memoir*, from which the following passage on page 84 of the book is quoted on the print itself:

I went to New York to meet Wittgenstein at the ship. When I first saw him I was surprised at his apparent physical vigour. He was striding down the ramp with a pack on his back, a heavy suitcase in one hand, cane in the other.

That vigour certainly comes across pictorially. New York looks wholly mechanistic, as do both Wittgenstein and Malcolm. We see inside the two, with electrical, plumbing and medical diagrams forming the basis of their innards. Across the stomach of the man on the right, the upper part of a face appears in photo-mechanical dots that resemble computer pixels. Even the Stars and Stripes, near the top-left, is represented rather like an electronic circuit board. An antique flying boat and an aircraft engine, complete with propeller, add to the overall sense of technology, much of which dates from Wittgenstein's day. The rich colours include polarised orange and silver near the lower-right.

Peter Phillips, *Custom Painting #3*, 1965.
Oil on canvas, 213.4 x 152.4 x 22.9 cm. Private collection.

Peter Phillips was born in Birmingham, England, in 1939. Between 1953 and 1955 he studied at the Moseley Road Secondary School of Art where he was taught a variety of fine and applied art techniques. He then went on to Birmingham College of Art between 1955 and 1959, and the Royal College of Art between 1959 and 1962. Like Allen Jones, he too was punished by the college authorities in order to discourage radical artistic thinking amongst his peers, although unlike Jones he was not expelled but simply moved to the television school; he just went on painting. Like Jones, Hockney and others, he was a moving force within the Young Contemporaries exhibiting group which first brought Pop/Mass-Culture Art to the attention of the British public. Further 'Pop Art' shows held on the Continent in 1963-4 also helped spread his reputation. In 1964 Phillips received a Harkness Fellowship which led him to move to New York for two years. His first one-man show was held in New York, at the Kornblee Gallery in 1965, and retrospectives of his work were mounted in Münster in 1972, in London in 1976 and in Liverpool in 1982.

During the early 1960s Phillips became aware of the Flags paintings of Jasper Johns and accordingly made pictures that unite the formal patterning of flags with the type of graphics encountered on the fasciae of pinball machines. He also created disparate types of portraits whose subjects ranged from American Civil War veterans to pin-ups and film stars (including Marilyn Monroe, painted a year or so before Warhol did so). By a little later he began creating larger pictures of consumer objects, including the working parts of cars and motorcycles, as the canvas reproduced here demonstrates.

Allen Jones, *Female and Male Diptych*, 1965.
Oil on canvas, 365.7 x 304.8 cm,
each panel 182.8 x 152.4 cm. Hirshhorn Museum and Sculpture
Garden, Smithsonian American Art Museum, Washington, D.C.

*Allen Jones was born in Southampton, England, in 1937. After studying at
Hornsey College of Art in 1958-9 he attended the Royal College of Art between
1959 and 1960. Unfortunately he was then expelled, not for anything he had
done but simply to warn his fellow-students not to be too radical artistically, a
ludicrous move that predictably backfired. From 1960 Jones exhibited with the
Young Contemporaries group in London, and he also displayed work at the Paris
Biennale in 1961 and 1963. He held his first solo show at the Arthur Tooth
Gallery in London in 1963. A multitude of exhibitions at important venues
have followed down the years. Outstanding among these were his first New York
show in 1965; a survey of his prints in Rotterdam in 1969; a large one-man
show in London in 1972; and a retrospective in Liverpool in 1979 that
subsequently travelled to Sunderland, Baden-Baden and Bielefeld. Jones has
taught in London, New York, Hamburg, Tampa, Los Angeles and elsewhere,
although London has always remained his base.*

This painting was begun when Jones was living in New York in 1964-5;
it was completed back in London. At that time he was still working at
the interface between semi-abstraction and figuration, with a
pronounced emphasis upon colour, a concern that would only grow
with time. The division between the female and male halves of the
image are self-evident, as is the large phallic sweep on the right, a shift
that takes us up from the legs of the male to his hat. Opposite the hat
a visual pun is enacted by a squiggly line which suggests both a nose
above a female mouth, and a sperm cell in motion. The two arms at the
centre lock the pictorial halves together. Towards the lower-right are five
legs; judging by the shoes worn, all but one of these are male.
Collectively they balance the dress, legs and shoes on the left.

Mel Ramos, *Miss Firestone*, signed, titled and dated 1965 on the stretcher.
Oil on canvas, 177.8 x 177.8 cm. Collection of Louis K.Meisel.
Art © 2006 Mel Ramos/ Licensed by VAGA, New York, NY

Mel Ramos was born in Sacramento, California in 1935. He studied at various colleges in Sacramento and San Jose between 1954 and 1958, following which he taught in schools and colleges throughout his home state. He held his first New York show at the Bianchini Gallery in 1964. He has exhibited throughout America and Europe, while retrospectives of his work were mounted in Krefeld in 1975 and Oakland in 1977.

Ramos's mature work has passed through several main phases. Among other subjects, he has painted comic-strip heroes, combined glamorous pin-ups with commercial artefacts (as here), and linked nudes with animals. The combination of attractive young women and industrial products, in particular, has always proven central to marketing in the modern technological epoch, and here Ramos took matters to a conclusion unrivalled by most advertisers. Doubtless a Freudian analyst could really go to town on the amplification of the girl's breast by the rotundity of the tyre, as well as the fact that she seems to be rubbing her right knee against a wheel-hub that somewhat resembles an unextended phallus.

Allan D'Arcangelo, *U.S. 80 (In Memory of Mrs Liuzzo)*, 1965.
Acrylic on canvas, 60.9 x 60.9 cm. Collection of the artist.
Art © 2006 Estate of Allan D'Arcangelo/Licensed by VAGA, New York, NY

Viola Liuzzo, to whose memory this painting is dedicated, was a Detroit housewife and mother of five married to a trade union official. In March 1965 she learned of the struggle for black civil rights then taking place in Alabama. Accordingly, she drove down to the southern state where an important protest march was being led by Martin Luther King along Route 80 from Selma to Montgomery. On 25 March 1965, while driving along Route 80, Mrs Liuzzo was shot and murdered by three Klu-Klux-Klansmen. They were immediately apprehended, having unknowingly been accompanied by an FBI informer. At their Alabama State trials they were all acquitted, although they were also prosecuted for conspiracy in the federal courts where they were convicted and sentenced to ten years in prison (however, one of them died of natural causes in 1966).

Given this context, the highway sign doubles as a memorial monument, with paint standing in for blood. The holes in both sign and sky were made by real bullets.

Ed Kienholz, *The Beanery,* 1965.
Mixed media environment, 213.4 x 182.9 x 55.9 cm. Stedelijk Museum, Amsterdam.

The inspiration for this work was a 28 August 1964 *Los Angeles Herald-Examiner* newspaper headline 'CHILDREN KILL CHILDREN IN VIET NAM RIOTS'. From that stimulus Kienholz first fashioned a small sculpture showing a hand clamping a television-like screen over the headline, as though television might blot out all consciousness of the horror aroused (as probably it did). A blotting-out of life's ugly realities is the underlying theme of this work too.

'Barney's Beanery' is a cheap eating place and bar on Santa Monica Boulevard (which doubles as Route 66) near La Cienaga in West Hollywood, California. The business was founded by John 'Barney' Anthony in Berkeley, California in 1920 and it moved to the Los Angeles site in 1927. Now considerably expanded and modernised, when Kienholz lived in LA it was still the 'little wooden shack' it had been for decades. The bar was frequented by both film people and artists. In addition to Kienholz, the latter included Mel Ramos and Ed Ruscha, painters already discussed in this book. For Kienholz the bar represented the kind of unpretentious watering hole he liked and, indeed, he exhibited this work for the very first time in its parking lot.

The sculpture reproduces the entirety of the bar-restaurant, including its exterior walls. The outer wall incorporates a simulacrum of the street facade of the shack, including its porch, window, street sign and stand carrying copies of the newspaper bearing the Vietnam

riots headline that initially inspired Kienholz. The doors in this facade permit us to enter the bar and squeeze past its sixteen figures and a toy poodle. The majority of these characters were cast from real people by means of plaster-impregnated bandages, a technique first employed by George Segal, as we have seen. Behind the bar are two signs bearing the misspelt message 'FAGOTS - STAY OUT'; these used to hang in Barney's until greater tolerance forced their removal in the 1970s (although gays had always been welcomed in the Beanery in actuality).

A hidden tape recorder plays a continuously running soundtrack of people chatting and drinking, with a juke box operating continuously, and with the noise of clattering dishes and washing-up emanating from the kitchen. (When the work was displayed in Chicago in 1966, it is said to have been sprayed daily with stale beer to augment the sense of authenticity even further.) At the end of the bar stands Barney, whose head is represented in conventional terms, unlike all the customers (and the two other staff). Their faces each sport clocks with their hands set at exactly the same moment, ten minutes past ten; by such symbolic means the artist denoted the freezing of time and the arresting of the sense of mortality that establishments such as Barney's frequently provide – as Kienholz stated, virtually all of the Beanery's occupants are "...postponing the idea that they're going to die."

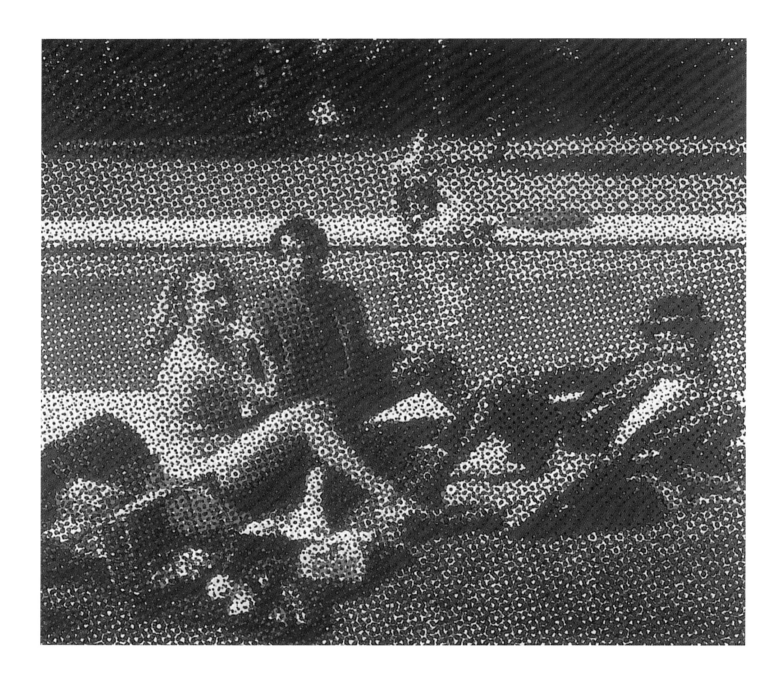

Alain Jacquet, *Déjeuner sur l'herbe*, 1965. Silkscreen on canvas, 175 x 195 cm.
Arts Council of Great Britain, South Bank Centre, London.

Alain Jacquet was born in Neuilly-sur-Seine, France in 1939. He graduated from the University of Grenoble in 1959, and then studied architecture at the École des Beaux-Arts in Paris where he also came into contact with the Nouveaux Réalistes. He held his first solo exhibition at the Gallery Breteau in Paris in 1961, and his initial American show at the Alexander Iolas Gallery in New York in 1964, when he first visited the city. After 1969 he began to live in New York as well as in Paris. Numerous exhibitions of his work have been held in Paris and throughout Europe. He has also shown in South America. In 1976 his work was displayed at the Venice Biennale.

For about three years before making this picture Jacquet had been creating what he called 'Camouflages' or paintings and sculptures in which he superimposed banal imagery upon reproductions of works of art. For example, in 1963 he superimposed a Shell petroleum sign and the image of a petrol pump over a simulation of Botticelli's *Venus*. But by 1965, when he made the present work, he had begun to create what he termed 'MEC Art'. This involved the photo-mechanical reproduction of images by means of silkscreen printing. Like Roy Lichtenstein, who since 1961 had been mainly exploring the mechanical breakdown of images familiar from newspaper and magazine reproductions, Jacquet applied his imitation of a mass-media technique to famous works of art, as is demonstrated by this take on Manet's *Dejeuner sur l'Herbe* of 1863 (Musée d'Orsay, Paris). Jacquet had friends substitute for the models used by his predecessor, thereby updating what had already constituted a complex statement about sexuality and gender. However, unlike Lichtenstein, Jacquet enlarged the constituent dots so as to make us work harder at apprehending what is visible in overall terms. He also created his imitative images in theoretically endless variations, and with intentional mis-registrations, in order to make the works look improvised. They could be very much enlarged, as proved the case with one version of this re-invented Manet picnic that appeared on the side of a building. Jacquet also produced multiple editions of his images, which naturally made them more economically accessible. Until 1969, when he moved towards the relative minimalism of Arte Povera, he was often engaged in such a dialogue between the art of the past and the visual language of modern mass-communications.

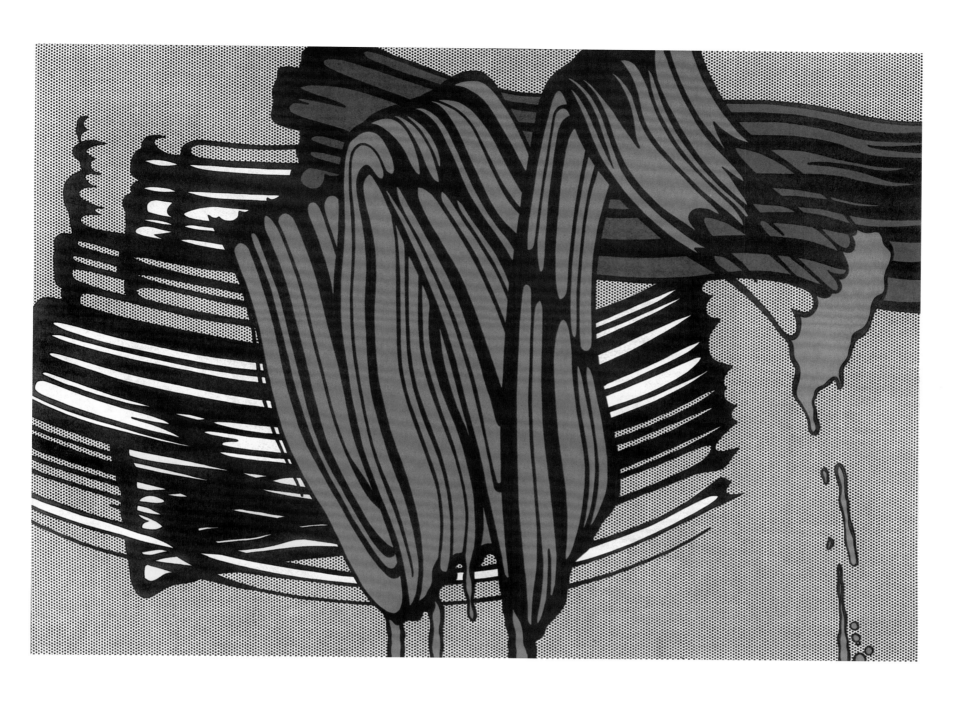

Roy Lichtenstein, *Big Painting VI*, 1965. Oil and magna on canvas, 233 x 328 cm. Kunstsammlung Nordrhein-Westfalen, Düsseldorf.

Here Lichtenstein emulated the appearance of four typical Abstract Expressionistic brushstrokes, complete with drips, except that he did so on a vast scale in comparison with such marks in reality. He also set them against a background of Benday dots which brings into play the notion that we are not looking at an imitation of real brushstrokes, but at a reproduction of such an imitation. We are therefore two stages removed from the originals (and of course the reproduction in this book takes us yet another stage from that source).

A further pictorial witticism arises from the fact that in their original form Abstract Expressionist brushstrokes would have been created in seconds, whereas Lichtenstein's marks took days to create because of their size, detailing and relative complexity.

Michelangelo Pistoletto, *Vietnam,* 1965.
Graphite pencil, oil and transparent paper on polished stainless steel,
220 x 120 x 2.2 cm. The Menil collection, Houston.

Michelangelo Pistoletto was born in Biella, Piedmont, Italy, in 1933. Between 1947 and 1958 he worked with his father as a restorer of paintings. He began making his own pictures in the 1950s; mainly these were portraits of single figures set against flat gold, silver or black backgrounds. Such works formed the basis of his first exhibition, which was mounted in the Galleria Galatea, Turin, in 1960. His first solo show in the USA was held at the Walker Art Center, Minneapolis, in 1966. The following year he won a prize at the São Paulo Bienale, as well as the Belgian Art Critics' Award. After 1968 Pistoletto became involved in Happenings, film, video and theatre as part of the Zoo Group, which he founded. From 1967 onwards he was also involved in the Arte Povera movement. He took up sculpture in the 1970s. Retrospectives of his work have been mounted in Venice in 1976; in Madrid in 1983; in Florence in 1984; in Rome in 1990; and in Barcelona in 2000.

By 1961 Pistoletto had begun covering his canvases with grounds made from metallic paint, and from there it was a short step to using polished stainless steel for his supports. One such base coating was used for the work discussed here. By pasting or photo-silkscreening life-size images of people on to these mirror-like reflective surfaces, Pistoletto was able to blur the boundaries between image and reality, thereby drawing the viewer into the space and thus hopefully involving us further in the visual and thematic dialogue. For example, in the present work – which was made when the Vietnam War was seriously heating up, as was the opposition to that conflict – we become part of the protest simply by appearing within the image. If we protest against being a protester – well, that is incorporated into the statement too. Ultimately Pistoletto's work is completely democratic.

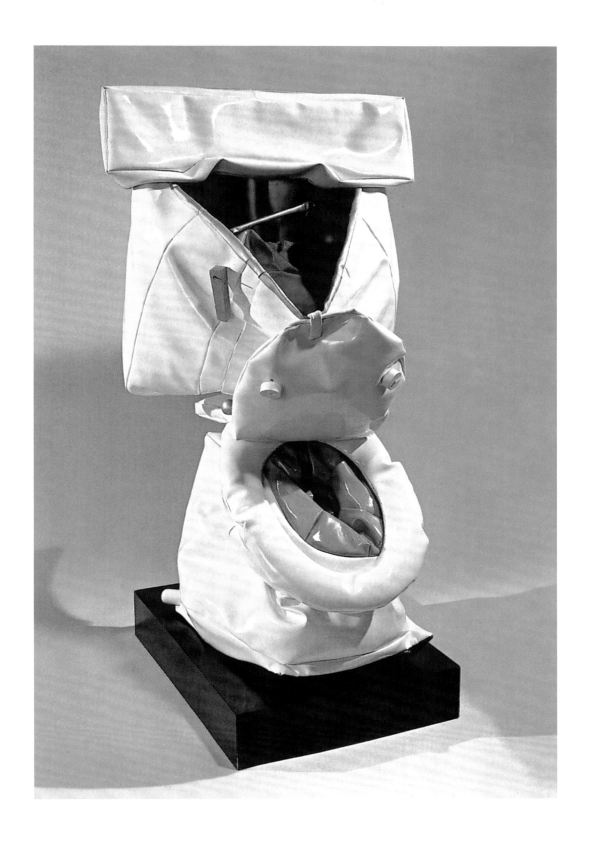

Claes Oldenburg, *Soft Toilet*, 1966.
Vinyl, plexiglass and kapok on painted wood base, 144.9 x 70.2 x 71.3 cm.
Whitney Museum of American Art, New York.

This is a brilliantly witty update of the artefact chosen by Marcel Duchamp in 1917 to demonstrate how anything can be a work of art, no matter how common or 'low' it may be. Just as Duchamp forced us to see beauty in a pedestrian object, so Oldenburg does so as well, albeit by transforming a toilet into something almost as appropriately pliant as the material it would dispose of in reality.

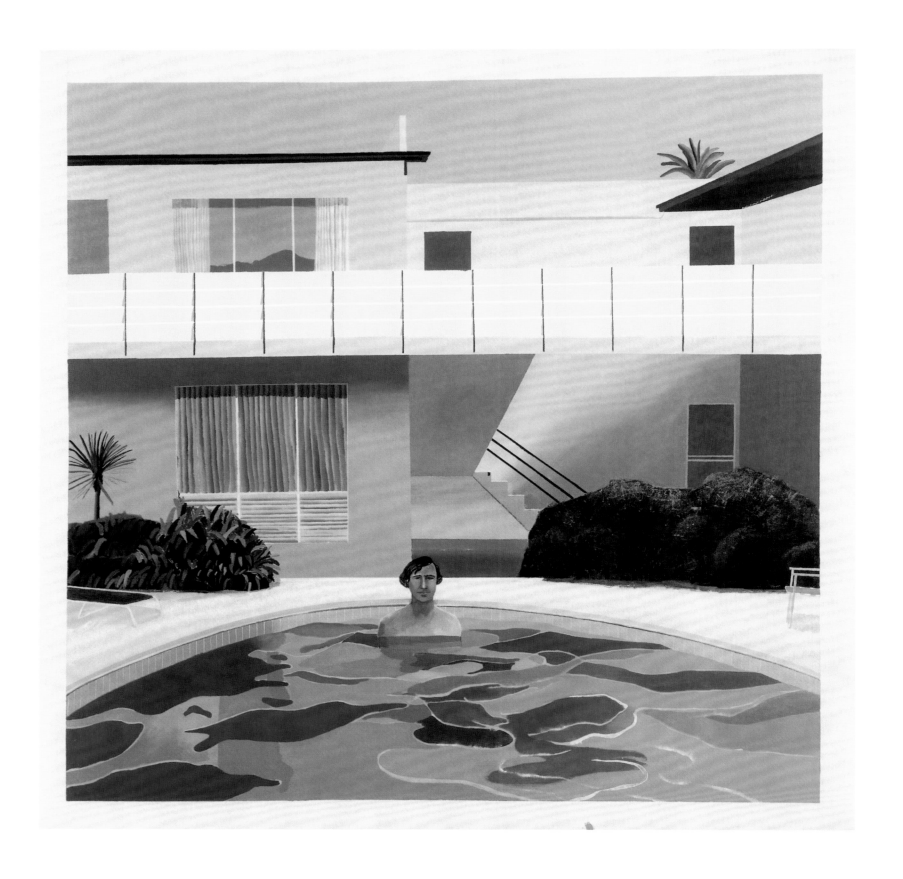

David Hockney, *Portrait of Nick Wilder*, 1966.
Acrylic on canvas, 183 x 183 cm. Fukuoka Sogo Bank, Japan.

As we have seen with Hockney's 'The Rake's Progress' series of etchings and his *California Art Collector* (pages 106, 134), during the first phase of his maturity he had generally renounced traditional ways of representing space in favour of a more freewheeling, ambiguous or even contradictory approach, with the figures depicted in an intentionally naive or crudely-formed manner.

However, by 1966 he had begun to adopt a more conventional attitude to space and the figure, to which he carried over his deep knowledge of Old Master painting. The results can be witnessed here. Spatially the foreground, middleground and background are just as recessional as they would be in a Dutch Old Master painting. This reference is not accidental, for by 1966 Hockney had clearly been looking at works by Jan Vermeer,

especially his *Lady Standing at the Virginals* of 1673-5 in the National Gallery, London. He would introduce that image into a canvas of 1977 and a poster of 1981.

In the present work the assimilation of Vermeer is apparent in the way that most of the vertical and horizontal lines of the house beyond the pool parallel the edges of the canvas, just as lines similarly do so in the Vermeer. Even Nick Wilder stands in a frontal position parallel to the picture-plane. The net result of this parallelism is the impartation of stability to the image, a quality shared with the Vermeer. That stability greatly heightens the suggested movement of the water by contrast. At this time Hockney was exploring different ways of representing such movement, and the solution reached here is very successful. The rich blues and blue-greens of the water and sky set off all the other colours to perfection, and demonstrate Hockney's growing powers as a colourist.

Clive Barker, *Van Gogh's Chair*, 1966.
Chrome-plated steel, 86.4 cm high. Sir Paul McCartney collection.

Clive Barker was born in Luton, Bedfordshire, England, in 1940. He studied painting at Luton College of Technology between 1957 and 1959 but dropped out from the course because of its shortcomings; instead he worked in a nearby car plant and then continued to paint after moving to London in 1961. The familiarity with chrome-plated metal and with leather he accrued from working on cars first led him to create sculptures, although after 1963 he employed specialist craftsmen to make most of his objects; he did so as a form of post-Duchampian rejection of the notion that art and the ability to make things are necessarily related. As well as replicating consumer artefacts, such as Coca-Cola bottles, cameras, torches, toy ray-guns and the like, Barker also made objects bearing artistic associations, as with the present work and a number of sculptures based on imagery by Magritte, Francis Bacon and Eduardo Paolozzi. Barker's first solo exhibition was held at the Robert Fraser Gallery in London in 1968, and further shows in the city followed in 1969, 1974, 1978, 1983 and 2000. A retrospective was mounted in Sheffield and other British towns in 1981-2. Barker also participated in many group exhibitions, notably in New York in 1968 and 1969. From the 1970s onwards he turned increasingly to portraiture, and an exhibition of his heads was held at the National Portrait Gallery in London in 1987. Jeff Koons (q.v.) has openly acknowledged his debt to Barker's work.

Vincent van Gogh's 1888 painting of a chair bearing his pipe and tobacco (National Gallery, London) was indirectly based upon a best-selling 1870 print by the British artist and illustrator, Luke Fildes. That portrays the empty chair of the writer Charles Dickens on the morning after his death. In his portrayal of his own chair, van Gogh was equally attempting to associate a piece of much-used furniture with mortality. It seems unlikely that Barker was aware of this background to van Gogh's painting, but of course he knew that the Dutchman had died virtually unappreciated and penniless; the irony that van Gogh's work would one day accrue enormous financial value is the entire point of this sculpture. By being made in chrome-plated steel, the piece looks both very suave and extremely expensive, thereby stressing the humble ordinariness of van Gogh's chair and its owner's humility in contrast.

As we shall see (pages 234-5), the irony that van Gogh died poor but that his works would later fetch a fortune has held great appeal to contributors to the Pop/Mass-Culture Art tradition, for justifiably it allows them to attack the economic exploitation of art.

Arman, *Bonbons anglais*, 1966.
Paint tubes and paint in synthetic resin, 141 x 161 x 5 cm. Private collection.

This is one of a large group of *accumulations* made in 1966 in which Arman explored paint and its receptacles as a way of commenting upon the abundance of painting in the world, as well as the longevity of art. Like a waterfall, the paint spills from a group of tubes, to be arrested forever and most aesthetically within the resin surround.

Ed Kienholz, *The State Hospital*, 1966 (interior view). Plaster casts, fibreglass, hospital beds, bedpan, hospital table, goldfish bowls, live black fish, lighted neon tubing, steel hardware, wood and paint, 243.8 x 365.8 x 304.8 cm. Moderna Museet, Stockholm.

In 1947 Kienholz worked for a time as an orderly in a state-run mental institution at Lake Medicine, Washington. His memories of the episode remained painful, and they received expression here. The sculpture comprises a large rectangular container which resembles an isolated prison cell. A sign affixed to an outside corner of the box identifies it as Ward 19, while a door into the box bears a small barred window, a handle and an external sliding bolt and catch; we step through the door into the cell. In advance of making the piece, Kienholz vividly explained what he intended it to signify:

This is a tableau about an old man who is a patient in a state mental hospital. He is in an arm restraint on a bed in a bare room....There will be only a bedpan and a hospital table (just out of reach). The man is naked. He hurts. He has been beaten on the stomach with a bar of soap wrapped in a towel (to hide tell-tale bruises). His head is a lighted fish bowl with water that contains two live black fish. He lies very still on his side. There is no sound in the room....Above the old man is his exact duplicate, including the bed (beds will be stacked like bunks). The upper figure will also have the fish bowl head, two black fish etc. But, additionally, it will be encased in some kind of lucite or plastic bubble (perhaps similar to a cartoon balloon), representing the old man's thoughts....His mind can't think for him past the present moment. He is committed there for the rest of his life.

To add to the horror, wet pigment poured across both of the figures and their bare mattresses powerfully suggests dropped food, vomit, urine and excrement. As in *The Wait* (page 137), the live creatures in *The State Hospital* are fed daily and replaced when they die. The constant mindless movement of the black fish suggests human mindlessness, while the neon-lit thought-bubble emanating from the patient on the lower bunk suggests that the upper figure exists only in his mind.

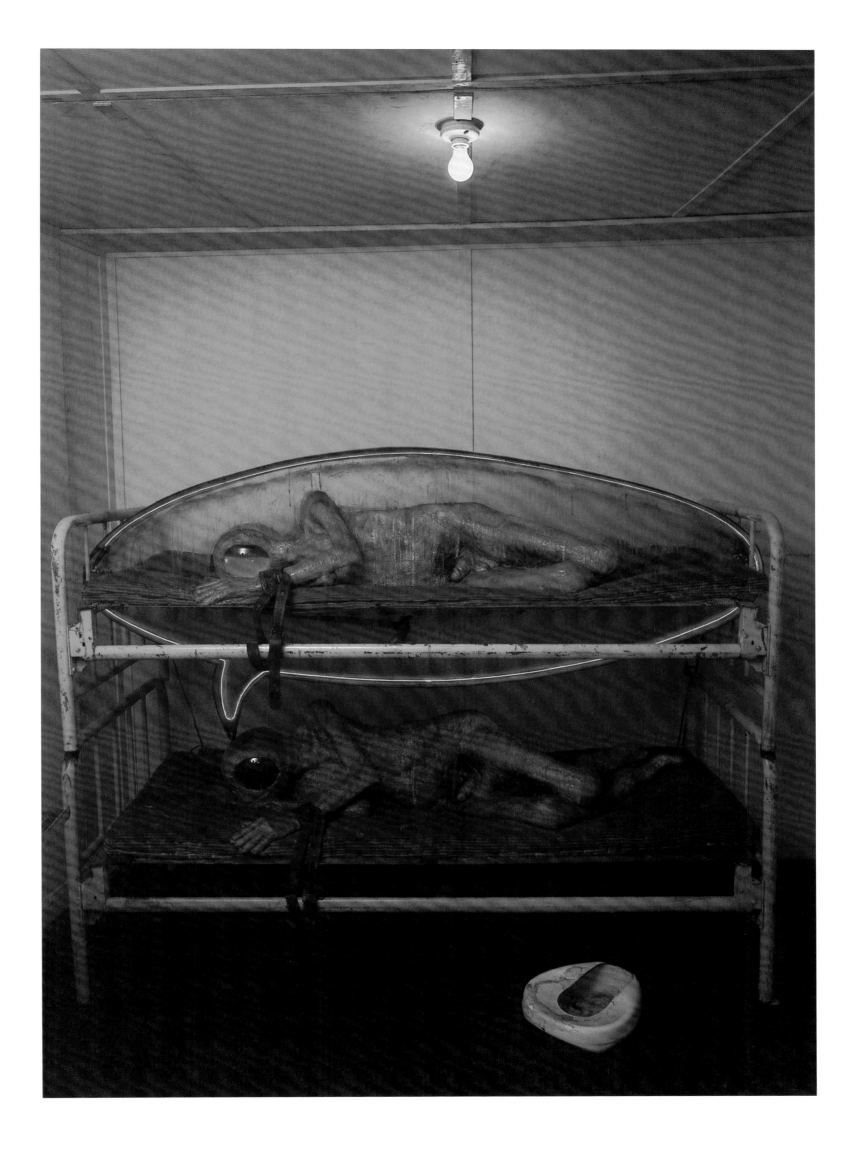

155

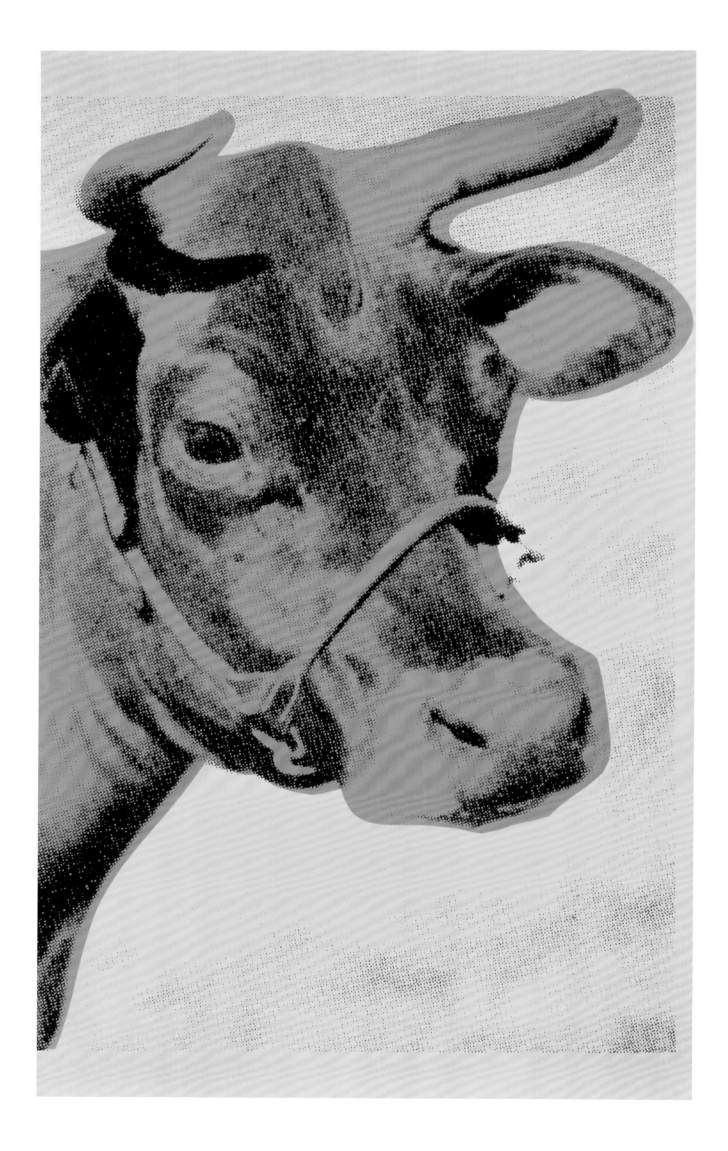

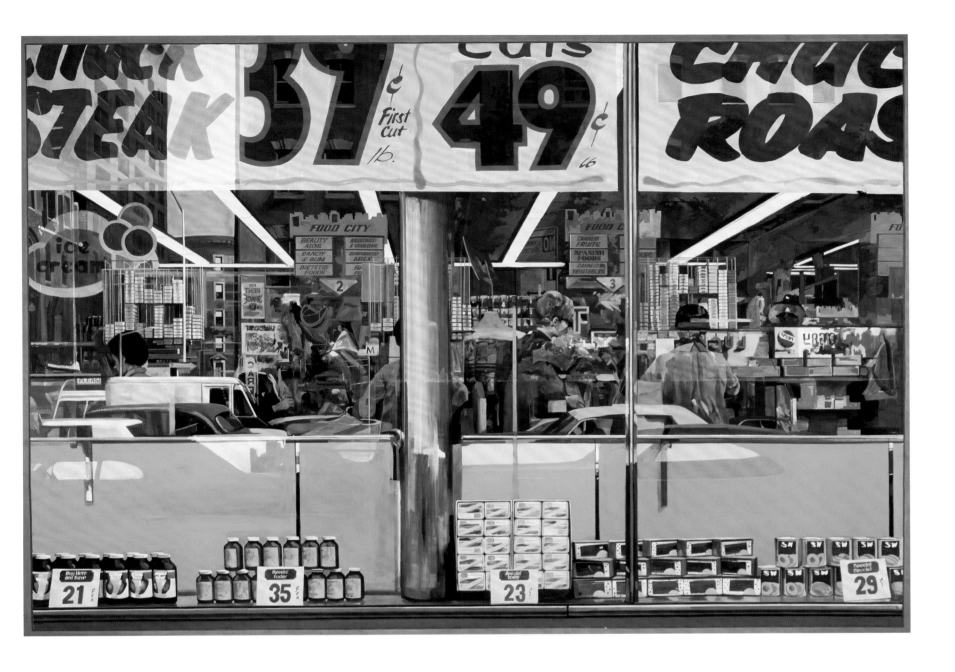

Andy Warhol, *Cow Wallpaper*, 1966. Silkscreen on paper, 115.5 x 75.5 cm.
The Andy Warhol Foundation for the Visual Arts, Inc., New York.

Richard Estes, *Food City*, 1967. Oil on masonite, 121.9 x 172.7 cm.
Akron Art Museum, Akron, Ohio.

Here we see just one section of a printed design that was originally repeated vertically in strips, as in wallpaper. That wallpaper developed logically from the wallpaper effect that Warhol's Flowers paintings had created when shown *en masse* in New York in 1964 and Paris in 1965. The *Cow Wallpaper* was used to cover one of two rooms in the exhibition Warhol held in April 1966 at the Leo Castelli Gallery, New York. Unfortunately only a few of the rolls of wallpaper were sold, thus bringing about a break between artist and dealer (and also now making the few surviving rolls very rare and pricey indeed). However, the wallpaper could never have functioned as a proper wallpaper, for as Charles F. Stuckey has pointed out, "Its left side does not interlock graphically with its right side as repeat patterns must. Instead, Warhol's *Cow Wallpaper* is like a printed film strip of a close-up shot for one of his motionless movies."

Warhol derived the notion of making images of cows from the dealer Ivan Karp, who felt that nobody dealt with pastoral imagery any more. Like the Flowers paintings, the *Cow Wallpaper* operates on a variety of levels: it links with – and perhaps sums up – the pastoral tradition in western art; it points up the repetitiousness of, say, television programmes on 'nature' by which we generally now experience the natural world 'in the comfort of our own homes'; it makes the point that in the modern era, man-made, fixed images usually become just so much cultural wallpaper (and often rather dumb wallpaper at that); and it connects very strongly with the Dada tradition of subverting our notion of what constitutes a work of art, let alone the validity of art itself.

Richard Estes was born in Kewanee, Illinois in 1936. He studied at the Art Institute of Chicago between 1952 and 1956, after which he worked for some ten years in advertising and publishing, making illustrations and arranging layouts. He began to paint full time in 1966 and held his first solo exhibition at the Allan Stone Gallery, New York, in 1968. Subsequently his works have been displayed all over the world.

Estes was a member of a loose confederation of artists known as photorealists. They all made their paintings by copying blown-up colour prints, or by projecting slides directly on to their supports and then painting over the cast images, or by utilising both approaches. These techniques permitted selective editing and the seeing of things that might well have been overlooked or psychologically suppressed. Very frequently photorealist artists displayed as much concern with consumerism and the banality of mass-culture as did other creative figures working within the Pop/Mass-Culture Art dynamic. This is especially true of Estes, as can be seen here.

Estes was especially interested in the spatial ambiguities arising from the views through windows and from their reflections. Thus we see here the interior of a store beyond the stacked goods and placards that line its window, and the buildings and parked vehicles reflected back from that glass. As was the case with many of the American photorealists, the title of the painting derived from one of its minor details, in this case a couple of small flyers fixed to the window.

James Rosenquist, *U-Haul-It*, 1967.
Oil on canvas, 152.4 x 429.3 cm. Whitney Museum of American Art, New York.
Art © 2006 James Rosenquist/Licensed by VAGA, New York, NY

The basis for this painting was a collage made by Rosenquist (collection of the artist). That work is also divided into three areas but instead of the fob watch, frying-pan and pat of butter seen here on the left, it shows tyre treads both from the outside and inside. The right-hand area is also different, being the side of a U-Haul-It van with its brand name written across it.

Probably Rosenquist found all this imagery too automotive. By changing the left-hand section, and presenting just a sheen of reflective metalwork on the right, the artist broadened the consumerist range of the picture and intensified its visual integration. The eye moves across all the reflective metalwork with ease.

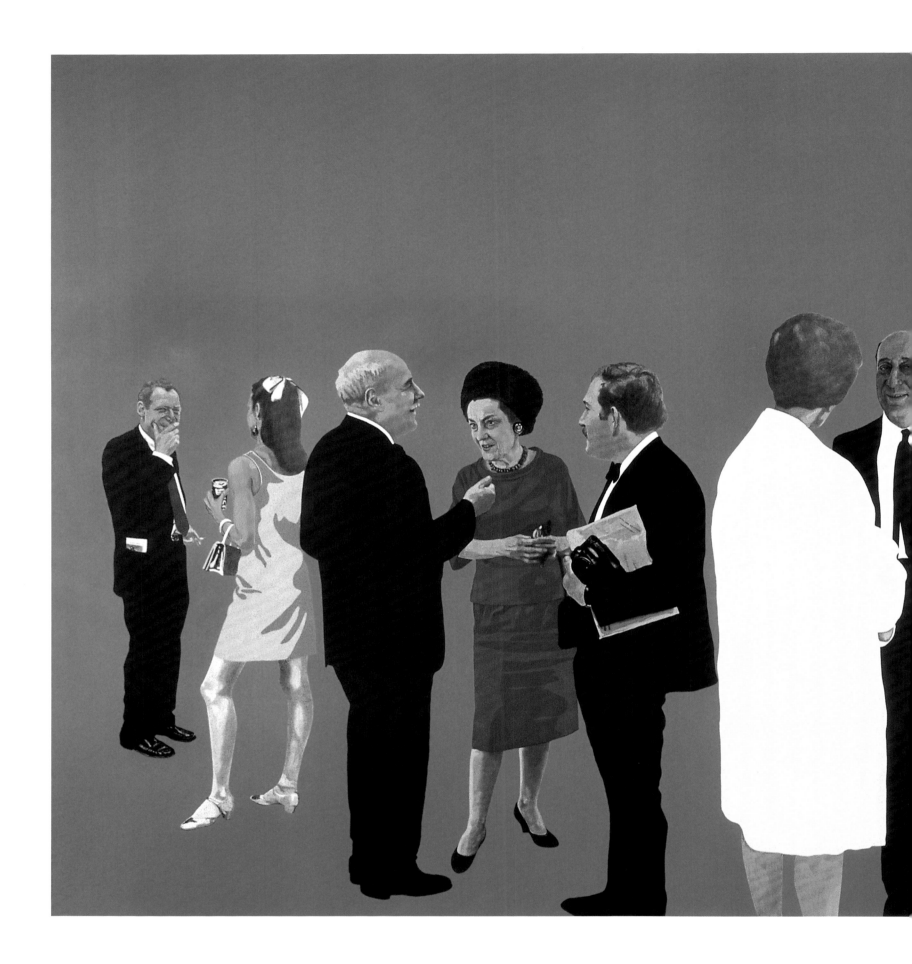

Howard Kanovitz, *The Opening,* signed, inscribed and dated 1967 on the reverse. Acrylic on canvas, 212 x 426 cm. Kunsthalle, Bremen.

Howard Kanovitz was born in Fall River, Massachusetts, in 1929. He studied at the Rhode Island School of Design between 1945 and 1951. Thereafter he moved to New York where he studied at the New School for Social Research in 1951-2, and then at New York University between 1959 and 1962. For a time he worked for the Abstract Expressionist painter Franz Kline. He held his first one-man exhibition at the Stable Gallery, New York, in 1962. Photography formed the basis of his paintings

after 1963. In 1966 a large show of his work featured at the Jewish Museum, New York, and subsequently he has often exhibited in that city. His work has proven especially popular in Germany, and he has also shown in Holland.

This is arguably Kanovitz's best-known work. It captures all the glamour of an important 1960s New York art world launch party by depicting people who were renowned within that milieu. They include the editor of *Art News*, Thomas Hess, on the extreme left; the painter Barnett Newman, third from the left; then Dorothy Miller who had been the first curator

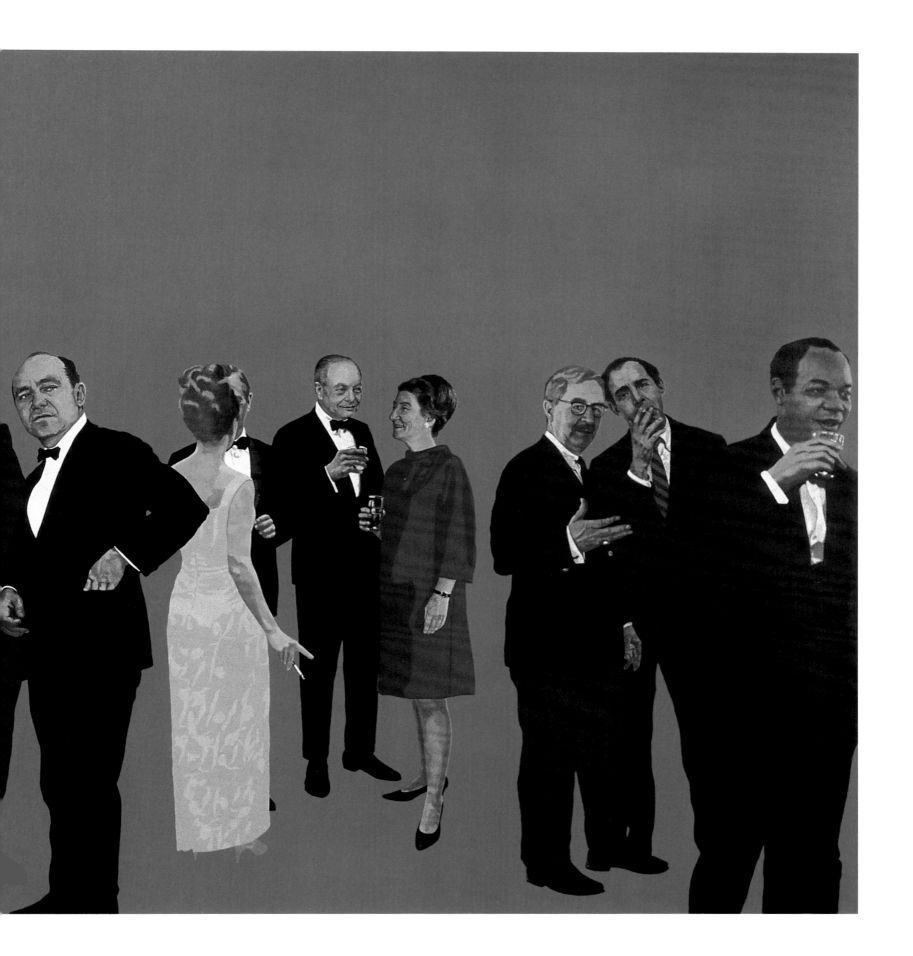

of the Museum of Modern Art, New York, and who was arguably the person 'who did the most for post-war American art'; Kanovitz himself, facing Newman; the critic Sam Hunter looking out at the centre; a partner in the influential Marlborough Gallery, Frank Lloyd, standing glass in hand between the ladies to the right; and the art-historian Irving Sandler smoking a cigarette at the right. The fact that all the figures are placed within a flat space heightens the sense of informality and of jockeying for position within that arena. This is entirely appropriate, for of course competing for status is a marked feature of the art world in social, intellectual, cultural and economic terms.

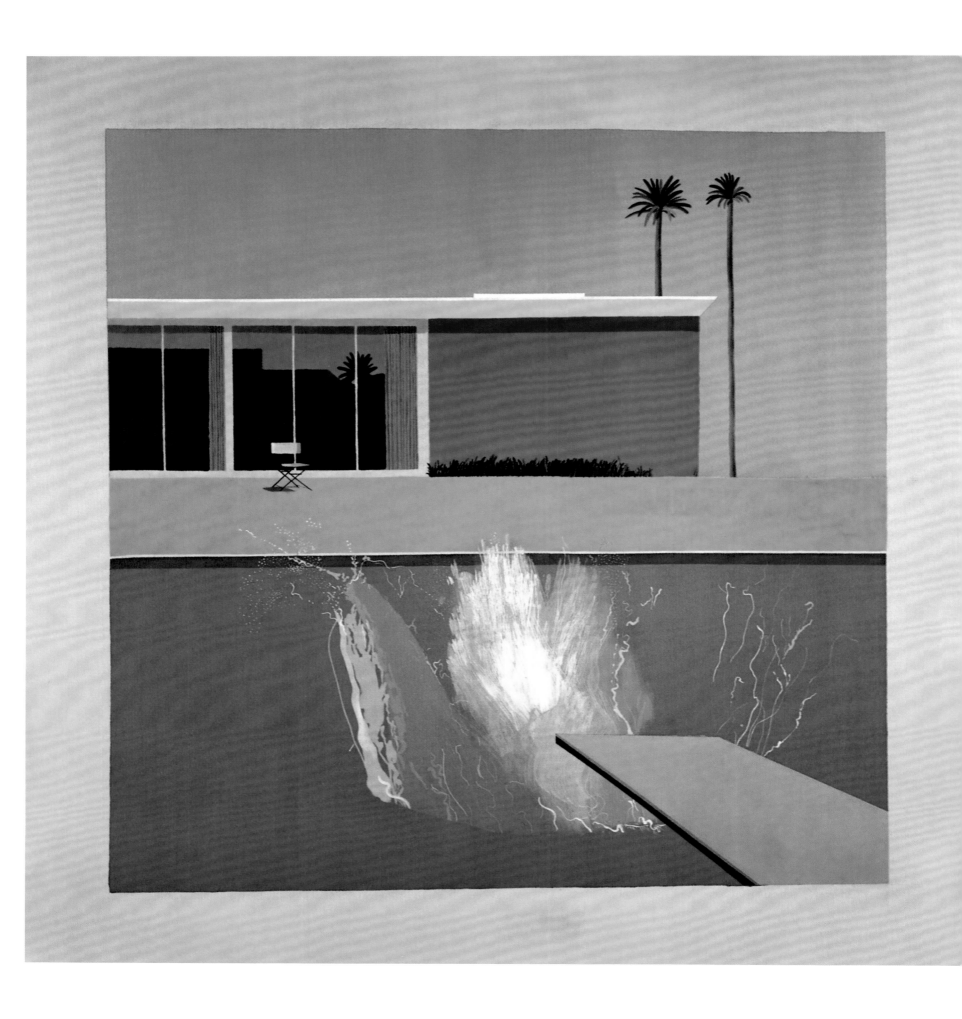

David Hockney, *A Bigger Splash*, 1967.
Acrylic on canvas, 242.6 x 243.8 cm. Tate, London.

This is justifiably Hockney's most popular picture, not least of all because the scene depicted typifies the hedonistic lifestyle towards which so many people aspire within contemporary mass-culture. By the time Hockney painted the canvas he had already created two pictures of splashes in swimming pools, one of which he named *The Little Splash*. That explains the title of the present work.

All is heat and light in the garden of the American Dream. The fairly strident yellow, pink and puce colours of, respectively, the diving board, patio and wall stand at the opposite end of the spectrum to the cool blues of water and sky, thereby generating an immense torridity. That intensity is increased by the climactic white at the heart of the image and by the warm colour of the large, empty surround to the painted area. Hockney created this to reinforce our awareness that we are looking at a fictive space within the canvas, rather than an actual one. He had already been using this device for some time when he created *A Bigger Splash*, as can be seen in the *Portrait of Nick Wilder* of 1966 (page 152).

On the patio stands a chair, of the type we often associate with Hollywood movie directors; its presence suggests that the swimmer, who has presumably just vacated it, is a person of some importance. It is not difficult to imagine the sound of the splash breaking the apparent silence. Because we do not see the swimmer, the vacancy of the scene remains intact.

As in the portrait of Nick Wilder, the influence of Vermeer is apparent, with many lines running parallel to the edges of the image. These create a sense of pictorial rigidity against which the diagonal of the diving board and the free forms of the splash contrast greatly. The unseen swimmer has surely just been physically liberated and refreshed by his dive, as presumably we all would be in such baking surroundings.

Allen Jones, *Perfect Match*, 1966-67.
Oil on canvas, 280 x 93 cm. Museum Ludwig, Cologne.

By the time he created this work, Jones was frequently addressing the clichéd fantasies of female sexuality beloved by many men: huge breasts, long legs, sheer stockings, enormously elevated high-heeled shoes and the like. But simultaneously the artist used these pictorial constituents and fetishistic props as starting points for explorations of rich colour balances and shifts, as well as vivid sweeps of line, as this painting makes very evident.

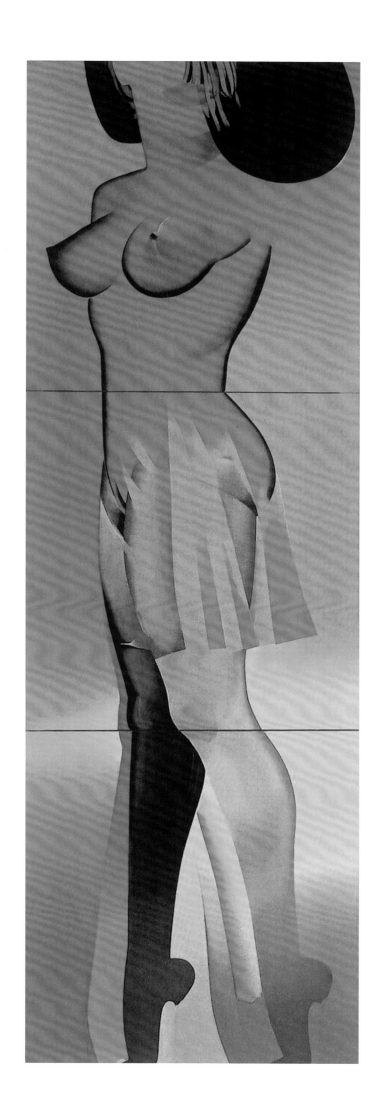

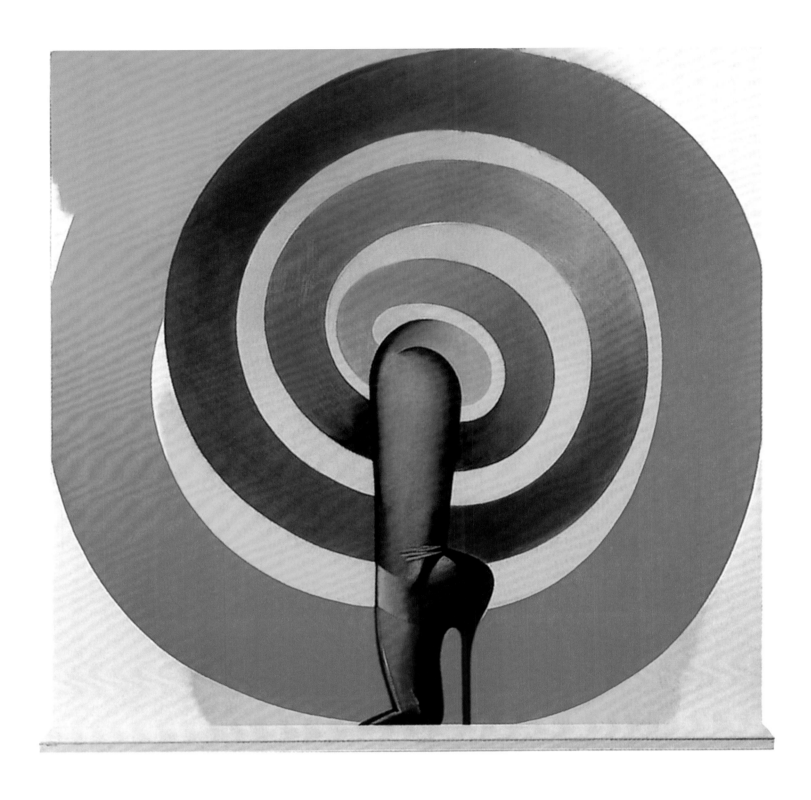

Erró, *The Background of Jackson Pollock*, 1967. Oil on canvas, 250 x 200 cm.
Musée national d'art moderne, Centre Georges Pompidou, Paris.

Erró was born Gudmundur Erró in Olafsvik, Iceland in 1932. Between 1952 and 1958 he studied in Reykjavik, Oslo and Florence where he learned mosaic; subsequently he created several mosaic floors in Reykjavik. After a short sojourn in Israel, in 1958 he moved to Paris where he began exhibiting in 1960. By the mid-1960s he was involved in Happenings and film while continuing to paint. In 1969 he exhibited in Paris, Essen and Karlsruhe. Heavily committed to a politicised art, he often introduced slogans into his surrealistic, poster-like pictures.

This is perhaps Erró's most well-known image. Jackson Pollock looks out at us, with his head again portrayed in red to the side of him. Near the top-left a hand pins down a van Gogh self-portrait, while everywhere else a mélange of artistic quotations ranges from Duchamp, Munch and Beckmann to Chagall, Klee and Ernst, and from Mondrian, Gris and Dalí to Lady Butler, Picasso and Matisse. By underpinning everything with the linear skeins of Pollock's work, Erró imparts an acute sense of restlessness to the proceedings. In overall terms the work not only explores the American painter's modernist background but equally it projects the bombardment of artistic images that besets the world in an age of mass-culture.

Allen Jones, *Sheer Magic*, 1967.
Oil on canvas with wooden shelf faced with plastic, 91.4 x 91.4 cm.
Private collection.

A stockinged leg and shiny shoe with its lengthy heel emerges from a spiral of shifting colour, to rest daintily upon a small ledge placed at the bottom of the image. That base is reminiscent of a stage, and it therefore brings into play associations of some kind of sexually fetishistic public presentation, such as might be encountered in a striptease joint, which was surely the artist's intention. Admittedly, the woman whose leg we see is implicitly reduced to the status of a sex object. Yet on the other hand the work does project a joyous sense of colour – sheer magic indeed, if only in purely visual terms and maybe for men alone.

David Hockney, *American Collectors (Fred and Marcia Weisman)*, 1968.
Acrylic on canvas, 214 x 305 cm. The Art Institute of Chicago, Chicago.

This work was commissioned by the Weismans, who were important art collectors in Los Angeles. Just as he had done in his *Portrait of Nick Wilder* of 1966 (page 152), and *A Bigger Splash* of 1967 (page 162), Hockney drew upon Vermeer to underpin a composition by means of a multitude of horizontals and verticals running parallel with the edges of the canvas, thereby binding everything together. Yet perhaps these careful alignments and the evidently self-conscious positioning of the figures were intended to suggest the social alignments and very self-conscious positioning that were integral to art collecting in the 1960s and remain so today. After all, the title Hockney gave this work makes it clear he was primarily concerned with American art collectors and only secondarily with portraying the couple that commissioned the painting. As we have seen with *California Art Collector* of 1964 (page 134), Hockney did not really care for some of the people who buy art in America, and that seems to have been the case here, for why else would he have made Marcia Weisman so cruelly ape the smile of the nearby totem pole, and Fred Weisman necessarily stare blankly into space?

The sculpture in front of Fred Weisman is by William Turnbull, the piece further off by Henry Moore. As in other Hockney paintings already examined, the overall orchestration of colour is quite masterful. Amid all the fairly pale yellows and blue-greys, the hot pinks of Marcia Weisman's shift fairly leaps out at us, not only contrasting with the dark greys and blacks of her soberly-suited husband but also projecting a sense of aggression that is heightened by the collector's patently false smile. Hockney, the admirer of William Hogarth, had clearly learned a great deal from his illustrious predecessor.

Perhaps unsurprisingly, the Weismans felt stung by this attack, and accordingly they got rid of the painting fairly quickly.

Tom Wesselmann, *Mouth #18 (Smoker #4)*, 1968.
Oil on canvas, 224.8 x 198.1 cm. Courtesy Sidney Janis Gallery, New York.
Art © 2006 Estate of Tom Wesselmann/ Licensed by VAGA, New York, NY

Shaped canvases were all the rage in the 1960s, and here Wesselmann put one to good use by giving us what advertising men, at least, might have wanted us to think of as the quintessence of sexual allure.

Richard Estes, *Welcome to 42ⁿᵈ Street (Victory Theater)*, 1968.
Oil on masonite, 81.2 x 60.9 cm. The Detroit Institute of Arts, Michigan.

The banal exploitation of sexuality that has often proven integral to the growth of mass-culture is the clear underlying theme of this painting. By the 1960s, 42ⁿᵈ Street in Manhattan had become one of the sleaziest streets in New York City, being filled with a plenitude of strip joints, sex shops, cinemas showing porno flicks and the like. Clearly, Estes had great artistic fun there, judging by this highly detailed and loving analysis of the Victory Theater in all its sunlit glory.

The frontal approach to the subject lends a degree of objectivity to the proceedings, and that emotional distancing is heightened by the fact that the scene is so depopulated, the two men on the sidewalk merely serving to establish the scale of things. By surrounding the large advertising hoarding with so much mauve and dark red, Estes really made its yellow colouring stand out.

Ed Kienholz, *The Portable War Memorial*, 1968.
Plaster casts, tombstone, blackboard, flag, poster, restaurant furniture, trashcan, photographs, working vending machine, stuffed dog, dog-leash, wood, metal, fibreglass, chalk and string, 289.6 x 975.4 x 243.8 cm. Museum Ludwig, Cologne.

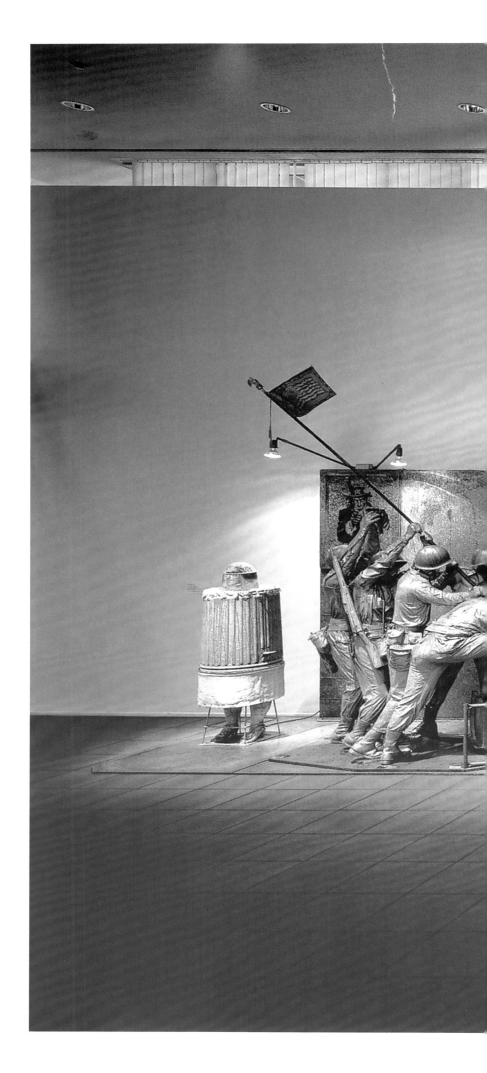

By 1968 the Vietnam War was at its height. With this work Kienholz undoubtedly created the finest anti-war artistic protest of the time, not least of all because he used wit and irony to attack the conflict rather than simply vent his anger.

As the sculptor specified in 1969, the ensemble needs to be examined from left to right. First we see a caricatured portrayal of the patriotically-minded American singer Kate Smith who appears within an upturned trashcan, which also makes Kienholz's attitude to her rather clear. A tape of her rendition of 'God Bless America' by Irving Berlin plays continuously as aural background to the entire work. Behind her, on the wall, is a First World War Uncle Sam 'I WANT YOU' poster. Before it stands Kienholz's parody of the sculpture that Felix de Weldon made between 1951 and 1954 to act as the US Marine Corps War Memorial just outside the Arlington cemetery near Washington DC; in turn that piece derived from a renowned photograph by Joseph Rosenthal taken atop Mount Suribachi on the Pacific island of Iwo Jima on 23 February 1945. Kienholz's parody arises from the fact that his heroes are faceless and are moving their flagpole towards a garden table, as though they were attempting to insert a parasol through its central aperture. By alluding to both of the world wars in 1968, Kienholz was surely reminding his viewers of the importance of such violent confrontations during the twentieth century.

Beyond the table is a huge blackboard. According to Kienholz it contains "457 chalk-written names of independent countries that have existed here on earth but no longer [do so]." The implication of the piece of chalk dangling in front of the blackboard is that we should use it to add the name of the next country to disappear from the map (i.e. The Republic of South Vietnam). The chalk is suspended from an inverted cross which makes its own comment upon the inverted values of an institutionalised Christianity that can permit war to happen. Upon the cross a small box containing a mini-blackboard allows the insertion of a 'V' day acronym, of the kind that had been created in 1945 with the acronyms for the 'Victory in Europe' and 'Victory in Japan' days (e.g. VE Day and VJ Day respectively). Another board permits the insertion of the twentieth century year of any such triumph.

Next we encounter the world of popular mass-consumption. In human terms this is represented photographically by two figures seated at a hot dog and chilli bar; one has a real dog leash fixed to his arm, with its other end tied to a stuffed mastiff. Also apparent are two more sets of garden furniture, which includes a parasol supported by another garden table; a plastic trashbin; a clock; and a functioning drinks vending machine. In conjunction with the references to hostilities on the left, this part of the ensemble both enforces a juxtaposition of consumerism with war, and simultaneously reminds us that during any war the people who stay at home often enjoy life's pleasures while others die ostensibly to defend them (as was especially proving to be the case in Vietnam).

The presence of death is evoked by the final part of the ensemble. This is the huge granite tombstone on the extreme right. At the base of the slab is a tiny, semi-nude, youthful and well-built male figure whose outstretched arms and ankles are pinioned to the stone, while both of his hands and lower arms are eroded, as if burnt by fire. The meaning of his linkage to the tombstone and of his wounds surely requires no explanation.

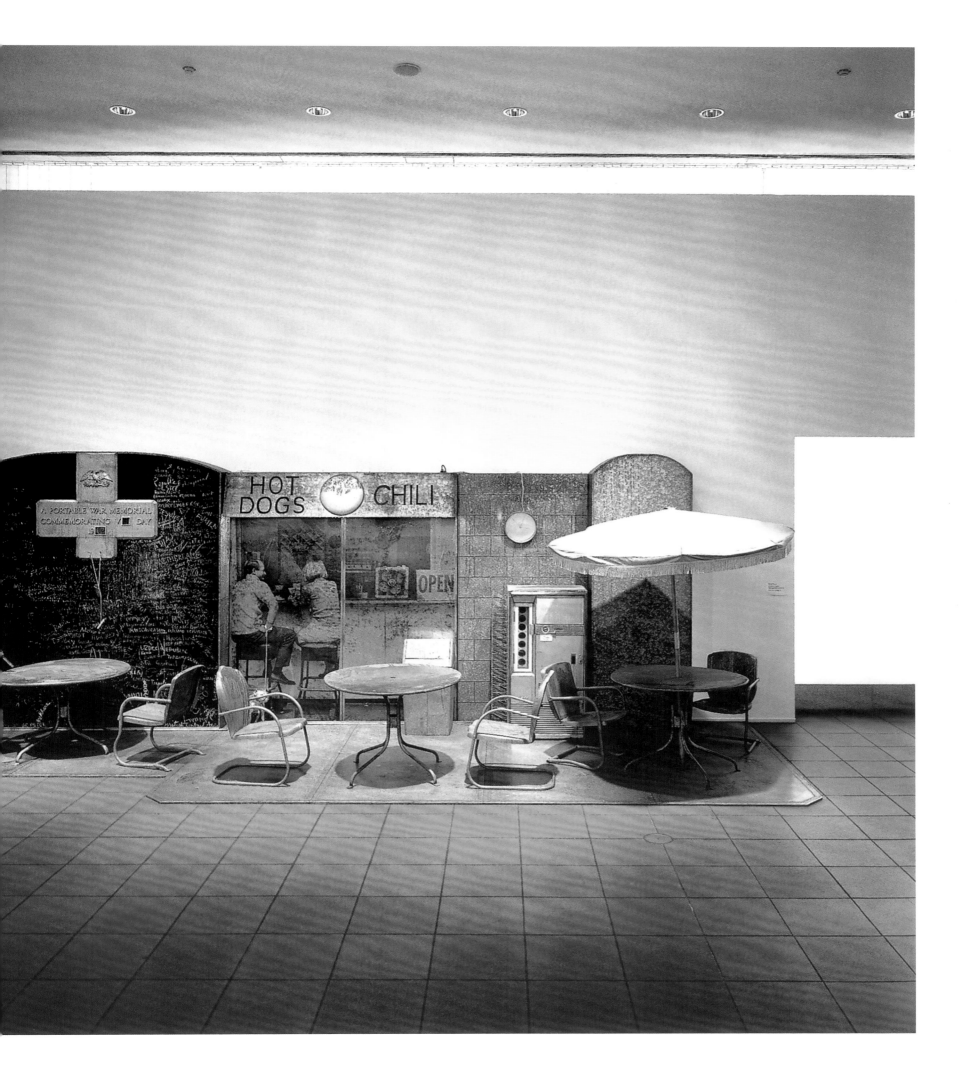

James Rosenquist, *Horse Blinders*, 1968-69.
Oil on canvas with aluminium, 304.8 x 2575.6 cm. Museum Ludwig, Cologne.
Art © 2006 James Rosenquist/ Licensed by VAGA, New York, NY

According to Rosenquist himself, the title of this work refers to the blinkers worn by horses to curb their peripheral vision, and thus prevent them from being startled by what takes place on either side of them.

Rosenquist was very taken with the idea that, instead of putting up a number of pictures around a room with empty wall spaces appearing between them, he could create a single work to wrap around a space, within which those inactive intervals would be wholly integrated pictorially. He had already moved towards the realisation of that aim with the *F-III* of 1964-5 (pages 138-9), but here he achieved it fully.

In the Museum Ludwig this gigantic painting takes up almost an entire room; were it not for the gap through which we enter and exit the space (pages 174-5), the picture

would entirely surround us. Naturally the eye gravitates towards the active sectors of the image, thereby forcing the relatively inactive areas to function as the 'Horse Blinders' that concentrate our attention. The imagery of the active zones imitates external reality: a bunch of severed telephone cables, a fob watch, a human thumb, some beautifully blue water and the same pat of butter seen sliding across a frying pan in *U-Haul-It* (pages 158-9). However, the inactive areas are fairly abstractive and in several stretches not dependent upon external reality at all, as with the sections of dully reflective aluminium. In sum the painting projects speed, a variety of densities, vivid colour shifts and a vague sense of high technology – in other words, it incorporates many of the physical and visual dynamics of modern existence.

James Rosenquist, *Horse Blinders*, 1968-69.
Oil on canvas with aluminium, 304.8 x 2575.6 cm. Museum Ludwig, Cologne.
Art © 2006 James Rosenquist/Licensed by VAGA, New York, NY

James Rosenquist, *Horse Blinders,* 1968-69.
Oil on canvas with aluminium, 304.8 x 2575.6 cm. Museum Ludwig, Cologne.
Art © 2006 James Rosenquist/Licensed by VAGA, New York, NY

James Rosenquist, *Horse Blinders,* 1968-69.
Oil on canvas with aluminium, 304.8 x 2575.6 cm. Museum Ludwig, Cologne.
Art © 2006 James Rosenquist/Licensed by VAGA, New York, NY

George Segal, *The Subway,* 1968. Plaster, metal, rattan, incandescent light, electrical parts, 228.6 x 292.1 x 134.6 cm. Mrs Robert B. Mayer collection.

The sadness communicated by the solitary woman staring vacantly into space is heightened by the fact that everything is drably coloured and bleakly lit by a solitary light. Originally Segal wanted an 8mm film he had shot in the New York subway to be seen through the window. However, the indistinctness of his footage led him to abandon it in favour of an apparatus he devised, whereby revolving lights throw beams to suggest the passage of stations and tunnels beyond the subway car.

Allen Jones, *Chair, Hatstand* and *Table,* 1969. Acrylic painted fibreglass and leather accessories, various dimensions. Collection of the artist.

Jones created this group of sculptures in 1969. Naturally they are very anti-feminist, not least of all because they reduce women to the status of sex-objects, rather than express the reality of their experience. On the other hand, what could be more anti-bourgeois and shocking than sculptures in the form of semi-naked girls dressed provocatively? In fact what we are witnessing here is a familiar modernist assault upon accepted social and sexual morés, or at least the narrow-minded values that were still widespread in the late 1960s.

The sculptures were made to Jones's specifications by a professional sculptor, Dick Beech, who first modelled them in clay, from which the moulds required to cast the works in fibreglass were taken. The sexual apparel was then purchased from a company specialising in such attire.

Richard Estes, *The Candy Store*, 1969.
Oil and synthetic polymer on canvas, 121.3 x 174.6 cm.
Whitney Museum of American Art, New York.

Here again our attention is drawn to the self-indulgent treats of
modern life in all their formidable plenitude, while the absence of
people permits nothing to distract us from the goodies on offer. As
always, Estes sorts out the shop-window reflections, while clarifying
the confusion of objects and spaces seen through glass.

Ed Kienholz, *Turgid TV,* 1969. Television, plaster and paint, 51.4 x 25.4 x 57.2 cm.
Los Angeles County Museum of Art, California.

This is one of two sculptures Kienholz created in 1969 in which he expressed his evaluation of the standard of most contemporary television broadcasting. Although he often worked with a television playing in his studio, and believed the medium to be a potentially superb means of mass-communication, he felt that it had been hijacked by corporate networks which forced frantic consumerism, mindless programming and tendentious news upon their public. In the work not shown, namely *Cement TV* (Nancy Reddin Kienholz collection), the sculptor crammed the inside of a portable television with cement dust to denote that the airwaves are often densely filled but communicate nothing. In the present work a large, dark-brown form not unlike a huge lump of excreta oozes from the front of a television casing. The connection of the television and the turd is, of course, strengthened by the punning title of the piece. Naturally, such a statement might seem somewhat banal but culturally it is certainly on target, especially in America where, as Bruce Springsteen has memorably reminded us, there are usually "57 channels and nothing on."

Duane Hanson, *Supermarket Shopper*, 1970.
Fibreglass, polychromed in oil, with clothing, accessories, supermarket packaging and trolley, 166 cm high (life-size). Ludwig International Forum für Kunst, Aachen.
Art © 2006 Estate of Duane Hanson/ Licensed by VAGA, New York, NY

Duane Hanson was born in Alexandria, Minnesota, in 1925. He first studied art at Macalester College, St Paul, Minnesota, where he received his BA in 1946, and then studied sculpture at the Cranbrook Academy, Bloomfield Hills, Michigan, where he held his first exhibition in 1951. Between 1953 and 1960 he lived in Germany, where he showed his work in Bremen in 1958. After returning to the United States to live in Atlanta, Georgia, in 1973 he finally settled in Davie, South Florida. His first New York exhibition was held at the OK Harris Gallery in 1970. Subsequently he mounted many shows in America and Europe. He died in 1996.

Hanson was a highly realistic sculptor, as this work demonstrates. What differentiates him from most equally representational sculptors, however, is that he never used his mature work simply to replicate appearances; instead, he employed it to isolate particular social types, such as the supermarket shopper (as here), the gawping tourist (page 186), the slovenly housewife, the down-and-out, the drug addict, the bank guard, the litterbug photographer and so on. Usually the sculptures are life-sized and always they were cast from life, with Hanson looking out for models whose physiognomies and build would best stand for the social types he wished to personify. To that end he would make plaster casts from his model, from which he would form moulds to be used to create the final works in various kinds of fibreglass. These sculptures would then be airbrushed, painted, have hair and other details added, and finally be clothed in real garments and shoes according to type.

We have all surely seen this type of slatternly, overweight woman trudging around a supermarket. By holding up such an accurate mirror to reality, Hanson forces us to a renewed awareness of the values such people represent.

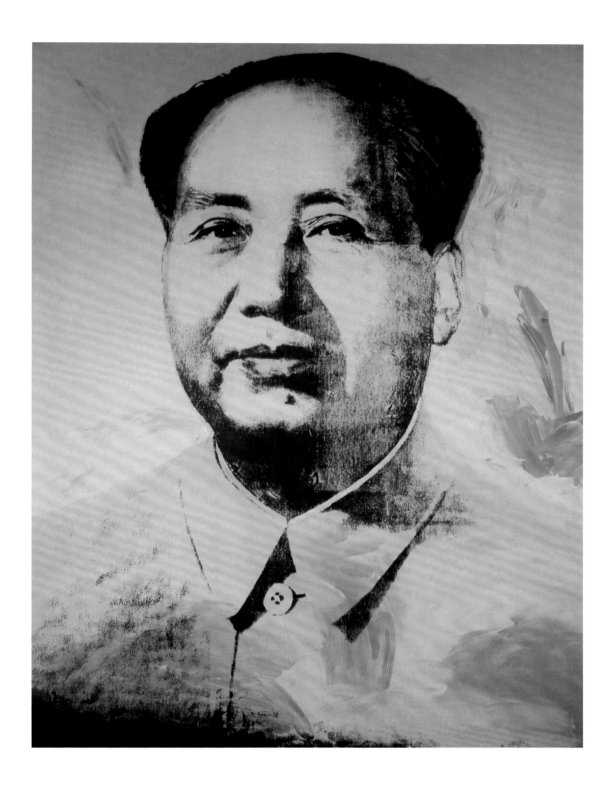

Duane Hanson, *Tourists*, 1970.
Polyester and fibreglass, polychromed in oil, with clothing and accessories, man 152 cm high, woman 160 cm high (life-size). Scottish National Gallery of Modern Art, Edinburgh. Art © 2006 Estate of Duane Hanson/ Licensed by VAGA, New York, NY

The irony of this work arises from the fact that the tourists are apparently peering at something worth looking at but are entirely oblivious to the fact that they themselves are a sight for sore eyes. As ever, Hanson's alertness to the nuances of social behaviour and dress is caustic and exact.

Andy Warhol, *Chairman Mao*, 1972. Silkscreen ink on synthetic polymer paint on canvas, 448.3 x 346 cm. Saatchi collection, London.

With the odd exception, between about 1961 and 1966 Warhol went out of his way to obtain the maximum degree of surface flatness in his paintings. To that end, the flattening inherent to silkscreen printing aided him enormously, although the pictures he made using the technique retain a certain vibrancy because of the grainy tooth of the canvas upon which the images were deployed. Such flatness may be seen as Warhol's way of achieving the maximum degree of impersonality in his works, a detachment that stands in extreme contrast to the emotionalism often expressed through thickly-worked paint by the Abstract Expressionists. But by the end of the 1960s Warhol also began to use paint more thickly and expressively before he finally overprinted a photo-silkscreened portrait, as here. Probably this painterliness was his way of reinvesting the act of painting with some validity, for of course the major physical and sensory (not to mention sensual) difference between painting and photography resides in such a tactile emphasis.

As already noted, in his Chairman Mao series Warhol appropriated a communist holy icon and, with rich irony, then sold such images to western capitalist art lovers. In this particular painting the use of yellow for the underpainted flesh tones may have been intended to augment that irony by inducing associations of the 'yellow menace', an abusive term applied to Chinese communists by the American media during the Cold War, especially at the time of the Korean conflict in the early-1950s.

By working on a vast, billboard scale Warhol augmented the cultural associations of the image, for politicians customarily employ billboards to convince us of their virtues. Chairman Mao Zedong (as he is known today) was certainly no exception in that respect.

Richard Estes, *Diner*, 1971. Oil on canvas, 101.9 x 127 cm.
Hirshhorn Museum and Sculpture Garden, Smithsonian American Art Museum,
Washington, D.C.

The stainless steel and glass diner with its clean lines and Art Deco curves is an American institution, and unsurprisingly a number of photorealist painters took these stylish, affordable and classless eating houses as their subject-matter. Here Estes paid homage to the Empire Diner which still stands on the corner of 10th Avenue and West 22nd Street in Manhattan. The row of telephone booths was introduced from elsewhere, thereby indirectly making it clear that photorealist painters can be just as selective regarding the formation of their images as are any other types of artist – they do not merely paint what they see (or even what their cameras see).

By making the diner and the line of telephone booths run right across the canvas in parallel with its top and bottom edges, and by omitting any figures, Estes strengthened the inherent formal values of the image. All the textures of the buildings, structures and pavements are lovingly explored, especially the reflectivity of metal. Against the fairly low-keyed greys, buffs, greens and blues spread across the picture, the red lines of the roof really stand out brilliantly.

Peter Phillips, *Art-O-Matic Cudacutie,* 1972.
Acrylic on canvas, 200 x 400 cm. Galerie Neuendorf, Frankfurt.

After Phillips moved to New York in 1964 he drew further upon the mass-communications imagery of machines, technological patterning and soft-core sexuality, developing highly complex visual statements about style and glamour, as here. He also began adding a more impersonal quality to his surfaces by employing one of the favourite tools of the advertising artist and photographic retoucher, the airbrush, which permits the perfect modulation of one colour into another. The results are resplendent, virtuosic images that openly revel in the banality of consumer culture.

Ed Kienholz, *Five Car Stud*, 1969-72.
Four cars and a pick-up truck, plaster casts, guns, rope, masks, chainsaw, clothing, oil pan with water and plastic letters, paint, polyester resin, Styrofoam rocks and dirt, various dimensions. Kawamura Memorial Museum of Art, Sakura, Japan.

Here we witness the castration of an American black by white supremacists, all of whom are sporting grotesque Halloween face-masks to disguise their identities. Four of the assailants pinion the poor victim by holding down his arms or by standing on one leg as his other leg is pulled aside with a length of rope; another thug performs the castration. A sixth, shotgun-toting racist eggs on the others, while the man standing on the foot of the victim holds a further gun. We can infer he is a true Christian from the fact that he wears a crucifix around his neck. In the pick-up truck a white girl is vomiting; it remains unclear if she was the companion of the black youth or is simply throwing up because of what takes place before her. In one of the cars a bespectacled boy gazes intently at the scene; presumably he is the son of one of the attackers. All the vehicles were made in America, and each of the cars carries a license plate bearing the inscription 'State of Brotherhood'.

The victim has two heads, one inside the other. The inner head originally topped a United States Army display mannequin and looks impassive; the outer, plexiglass head made by Kienholz is understandably screaming. A large automotive oil pan doubles as the victim's torso and is filled with black water which suggests blood. On the surface of the liquid two sets of plastic letters gently bobble. One of them says 'NIG', the other 'GER', and occasionally they come together to form the entire racist epithet (to which connective end a submerged pump stirs up the water).

Given the many racist attacks by whites on blacks that have taken place in America since 1972, this sculpture has lost none of its relevance. As Kienholz said of it, "I think of that piece in terms of social castration...like what a tragedy [it is] we didn't use the richness of America, which includes the black."

Ed Kienholz, *Five Car Stud,* 1969-72.
Four cars and a pick-up truck, plaster casts, guns, rope, masks, chainsaw, clothing, oil pan
with water and plastic letters, paint, polyester resin, Styrofoam rocks and dirt, various
dimensions. Kawamura Memorial Museum of Art, Sakura, Japan.

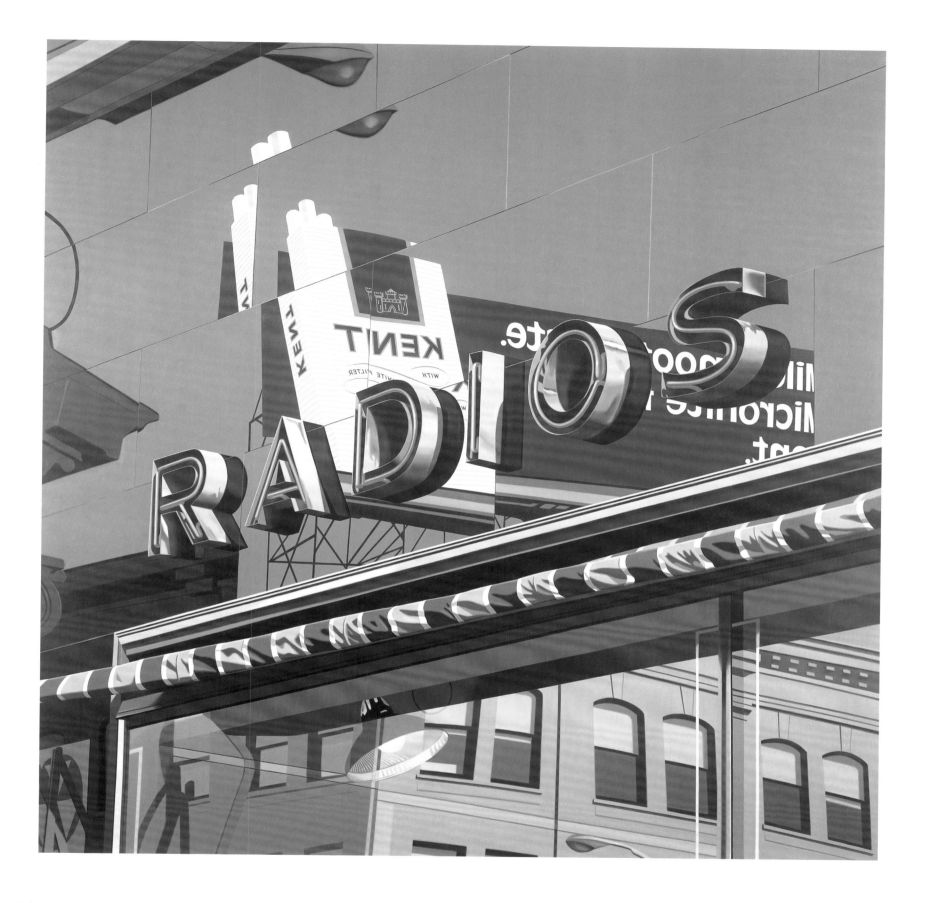

Robert Cottingham, *Radios*, 1977.
Oil on canvas, 198 x 198 cm. Whitney Museum of American Art, New York.

Robert Cottingham was born in Brooklyn, New York, in 1935. He studied between 1959 and 1963 at the Pratt Institute in Brooklyn. His first one-man show was held at the Molly Barnes Gallery in Los Angeles in 1968. Subsequently he has exhibited all over the world.

Cottingham principally painted trucks in the mid-1960s, before turning his attention to houses, which he entirely divorced from their skies and backgrounds. During the 1970s he increasingly turned his attention to shop fronts and the upper parts of buildings, with their plethora of signs. Such narrow sections of edifice had always appealed to him, not only because their formal patterns and colouristic riches allowed him to bring out the purely abstractive qualities of things but also because they permitted him to capture many of the key symbols of American consumerism. Thus in the present work it is easy to appreciate Cottingham's responsiveness to the unusual and rather marvellous shapes made by the reflected and fragmented Kent cigarette hoarding, as well as to the interplay between those forms and the inherent shapes of the shop's upper part. Similarly, the reflections of buildings upon the plate glass window interact with the lines of the glass and the spotlight inside the store. Everywhere spatial ambiguity increases the pictorial interest and variety, and of course Cottingham is highly responsive to the confusion of the urban environment, from which he extracts both clarity and beauty.

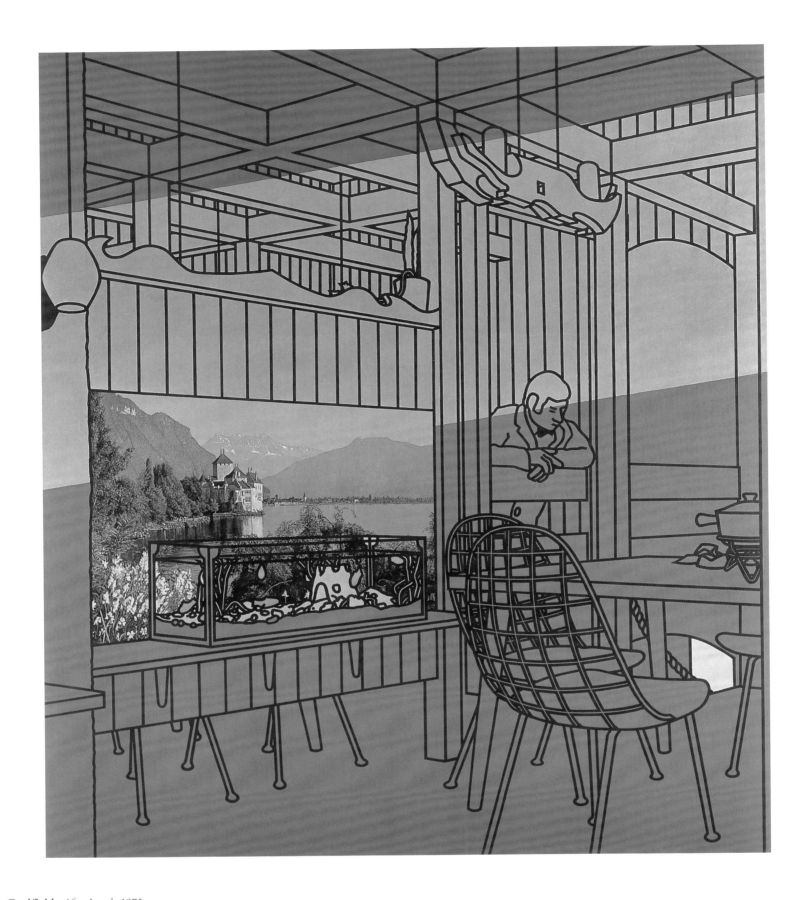

Patrick Caulfield, *After Lunch*, 1975.
Acrylic on canvas, 244 x 213.4 cm. Tate Gallery, London.

Patrick Caulfield was born in London in 1936. He studied at Chelsea School of Art between 1956 and 1960, and then at the Royal College of Art between 1960 and 1963. His initial one-man exhibition was held at the Robert Fraser Gallery in London in 1965, and he first showed in New York the following year. Many exhibitions followed globally. Retrospectives of Caulfield's prints were mounted in 1973, 1977, 1980 and 1981, in which year a large retrospective of his paintings was held in Liverpool and London. He died in 2005.

Caulfield was another painter within the Pop/Mass-Culture Art tradition who consistently amplified the vulgarity of things. By flattening and simplifying his forms, and by frequently taking his subject-matter from the most ordinary of interiors such as hotel lobbies, dining rooms, restaurants, bars, cafés and offices, as well as domestic spaces containing retro or just badly designed furniture, he transformed what was already banal into a subtle form of kitsch. In later years he indulged his penchant for painting still-lifes of food, ceramics, flowers, wine glasses, desk lights, lanterns, pipes and the like, often pushing the images to the verge of abstraction.

In the present painting Caulfield explored the contrast between two types of imagery: his customary flattened and simplified forms, and photographic realism, with all its detailing and complex naturalistic colours. The waiter lolls on a support, presumably tired from his lunchtime exertions. The intensity of the overall mauve colouring is sharpened by the contrasting colours of the landscape mural, fish tank and goldfish.

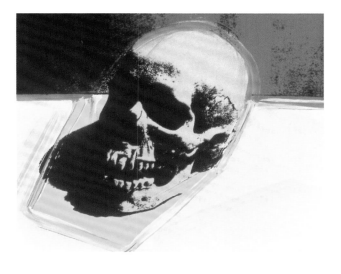 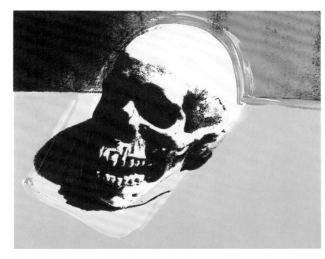

Andy Warhol, *Skulls*, 1976.
Silkscreen ink on synthetic polymer paint on canvas, each 38.1 x 48.3 cm.
The Andy Warhol Foundation for the Visual Arts, Inc., New York.

Despite Warhol's customary declaration that there are no meanings behind the surfaces of his works, the Skulls series demonstrates his underlying seriousness of purpose. The images were made from photographs of a skull he had bought in a Paris flea market around 1975. He was encouraged to develop the series by his business manager, Fred Hughes, who reminded him that artists such as Zurbarán and Picasso had painted skulls to great expressive effect. Moreover, Warhol's studio assistant, Ronnie Cutrone (who became his professional helper in 1974), also encouraged him to portray skulls by remarking that it would be "like doing the portrait of everybody in the world".

At Warhol's behest, Cutrone took a great many monochrome photographs of the skull from a number of different angles. He lit it harshly and from the side so as to obtain the most dramatic visual effects through maximising the light and dark contrasts, as well as enhancing the shadows cast. In most of the Skulls images (such as the ones seen here), the use of vivid colours tends to glamorise the object. That glamorisation is highly ironic, given the way that the leering skull points up the superficiality of glamour: in the midst of life we are in death indeed, as Andy Warhol the media Superstar was only too painfully aware after he had been shot by a demented follower in 1968.

THE ART SHOW

KIENHOLZ 1963 - 1977

THE ART SHOW 1963

This tableau is just what the title says. It is an art show set in a commercial gallery in either Los Angeles (slacks on the women) or New York (coats and galoshes). On the walls (or standing on the floor, hanging from the ceiling) is displayed the newest annual fad. These will be invented works in an invented style for an invented artist by the name of Christian Carry.

Mingling among each other and the art works are the art lovers. This should be an interesting bunch, wearing all styles of personalities and faces. I will probably place this tableau in 1966 to be able to use mini-skirts on some of the lovelies.

Also, I plan sound recordings of actual gallery openings, and a desiccated punch bowl.

PRICE: Part One $ 15,000.00
 Part Two $ 1,000.00
 Part Three Costs plus artist's wages

Ed Kienholz and Nancy Reddin Kienholz, *The Art Show*, 1963-77.
Plaster casts, clothing, plexiglass boxes, recorded sound, audio speakers, automobile air-conditioning vents and fans, furniture, wall sculptures, paintings, drawings, books, punch bowl, glasses and tablecloth, dimensions variable. Courtesy L.A. Louver Gallery, Venice, California.

Although Kienholz first conceived this work in 1963, it was not until he met Nancy Reddin in 1972 that the project began to materialise. Following the completion of the work four years later, it was exhibited at the Pompidou Centre in Paris in 1977, after which it was shown in Düsseldorf, Munich, Berlin, the Louisiana Museum in Humblebaek (Denmark), Dublin, San Francisco and Houston. It was also included in the vast Kienholz retrospective that toured New York, Los Angeles and Berlin in 1996-7.

The Art Show comprises nineteen men and women plus a dog, and all the figures were modelled upon people known to Kienholz and his wife; they include the sculptor Eduardo Paolozzi, the collectors Monte and Betty Factor, and the art curator and one-time director of the Pompidou Centre, Pontus Hulten. As with the people who are represented in *The Beanery* of 1965 (pages 146-7) and later sculptures, plaster bandages formed the basis for the moulds from which the figures were cast. Every one of those people is dressed in real clothing, over which fibreglass resin was brushed to unify the works visually. Parts of the figures were also painted. Kienholz and Reddin made fourteen collages in order to develop this ensemble, and they are displayed on the gallery walls. To one side a receptionist is seated at a desk, with a typewriter, floorlight and bookcase filled with art books and catalogues behind her. Some of the people represented hold wine glasses, which tells us we are witnessing a gallery opening rather than an ordinary moment during the life of an exhibition. The guests wear the type of smart but casual attire usually seen at such soirées. Naturally, the physical relationship of the figures, pictures and furniture varies according to the space in which the work is exhibited.

Amid their faces all of the people sport automobile air-conditioning vents which Kienholz originally retrieved from a Los Angeles scrap yard. Internal motors and fans blow forth hot air that parallels the metaphorical hot air often spoken at art world functions. Within the heads are audio speakers connected to a tape recorder mounted on the chest of each figure, and they constantly supply a typically vacuous background babble of pretentious art-world remarks – what Kienholz described as "all that art world twaddle that critics write, which doesn't have much meaning and [which] no one understands or gives a damn about anyway." The model for one of the figures was a Russian girl who supplied her dialogue in her native tongue, on the basis that "The art reviews from [Russia] are just as stupid as from anywhere else." For his contribution Paolozzi drew up a series of questions and answers which he read in a wholly random and disconnected order, thus making 'the usual kind of critical sense'. The *Art Show* might not afford the most profound of insights but it certainly captures the shallowness of an age in which art, money, power and pretentiousness have all become more intermingled than ever.

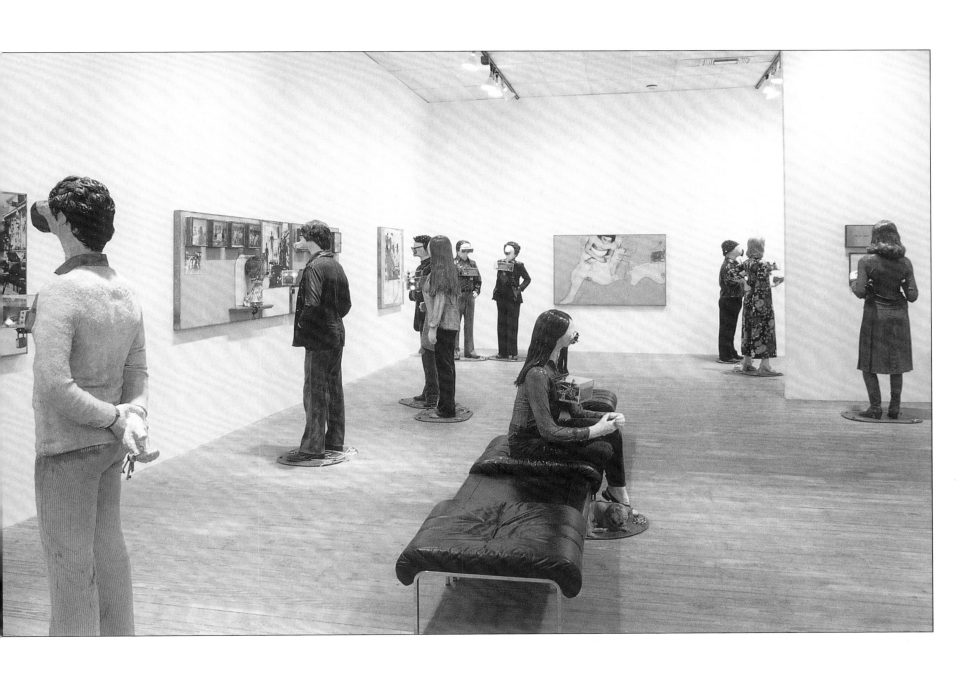

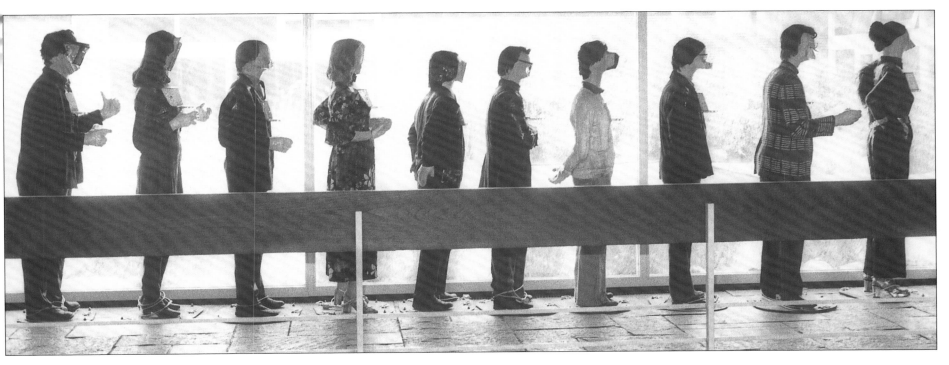

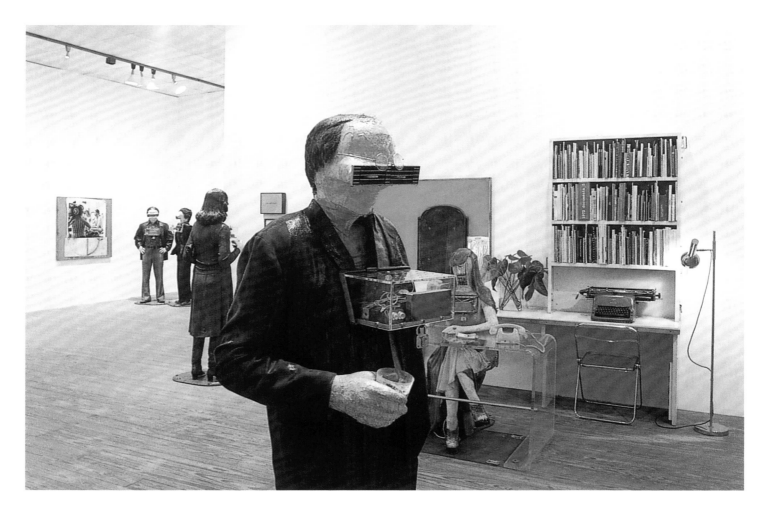

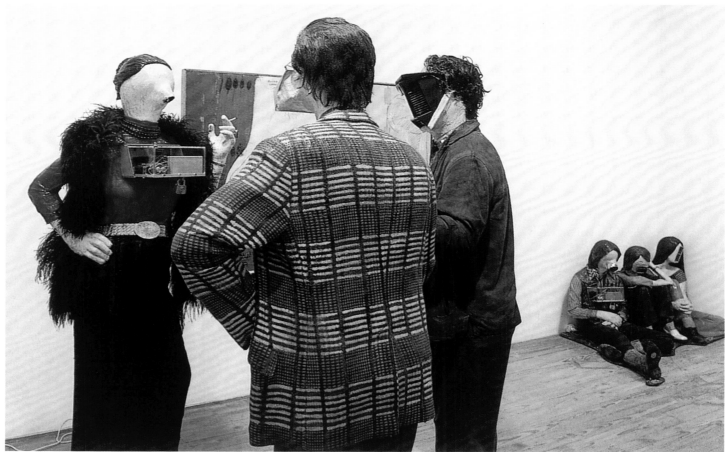

Ed Kienholz and Nancy Reddin Kienholz, *The Art Show,* 1963-77.
Plaster casts, clothing, plexiglass boxes, recorded sound, audio speakers, automobile air-conditioning
vents and fans, furniture, wall sculptures, paintings, drawings, books, punch bowl, glasses and
tablecloth, variable dimensions. Courtesy L.A. Louver Gallery, Venice, California.

Wolf Vostell, *Television Obelisk – Endogenous Depression (Homage to Gala-Dalí and Figueres),* 1978. 15 televisions coated in mortar diluted with pink cement, with bust and television antenna, 13 metres high. Theatre Museum Dalí, Figueres, Catalonia, Spain.

Wolf Vostell was born in Leverkusen, Germany in 1932. He first learned photolithography and in 1954-5 studied painting and typography in Wuppertal. In 1955-6 he attended the École des Beaux-Arts in Paris, where he studied painting, anatomy and graphics. At the Düsseldorf Academy in 1956-7 he also studied art while simultaneously exploring the Talmud and the paintings of Hieronymus Bosch. By now his work was in the forefront of contemporary artistic experimentation, and from 1958 onwards he organised the Décollage tearing-down of posters, images he further defaced by overpainting. He also began participating in Happenings and in 1962 was one of the founders of the FLUXUS group. This was dedicated to live expression and violently opposed to tradition. Between 1963 and 1965 Vostell held several solo exhibitions in New York. In 1966 one of his Happenings, Dogs and Chinese not allowed, *was created over a period of two weeks throughout the New York subway system. Later activity involved the setting of cars in concrete; the making of films; and the creation of a mobile museum, in the form of a 'FLUXUS train' which toured north-west Germany. Exhibitions and retrospectives of his work were held in Cologne in 1966; in Nuremberg and Venice in 1968; in Paris in 1974; in Berlin in 1975; and at three museums in Spain in 1978-9. In 1976 Vostell founded his own museum in Malpartida, near Cáceres in Spain. He died in 1998.*

What connected Vostell with mass-culture was television, for in 1958 he was the very first artist to incorporate working TV sets into assemblages and paintings. The apparatuses would remain integral to his output thereafter, as would cars and even jet airplanes and missiles. Occasionally he would combine televisions with cars, as happened in 1981 when he adorned a Mercedes limousine with 21 television sets linked to a camera, and in 1991 when he created his *Auto-TV-Wedding.* This comprised the smashed wreckage of a Mercedes sedan covered in television sets and wine glasses. The work was eerily prescient of the death of Diana, Princess of Wales, just six years later.

In September 1978 Vostell, Salvador Dalí and the mayor of Malpartida met at the Dalí museum in Figueres and contracted that both artists would exchange works for their respective museums. For the Malpartida museum Dalí authorised Vostell to realise his idea for a 'Backdrop to Parsifal', while Vostell made this work for the courtyard of the Figueres museum. Structurally it comprises two concrete posts, with the televisions supported by iron crossbeams. Five of the televisions actually work, and they also double as video monitors. By calling the work 'Obelisk', and by topping the piece with a classical-looking bust (which supports a television antenna), Vostell brought into play associations of the memorial purposes of such ancient monoliths. Naturally, a tower made out of television sets also lends itself to contemporary memorialising, for daily we are bombarded with commemorations and the like over the airwaves.

The overall form of the *Television Obelisk* clearly derived from the 29.2 metre-high *Column Without End* of 1937-8 by the Romanian sculptor Constantin Brancusi. This too stands in the open air, in the small Romanian town of Tîrgu-Jiu, and is equally made up of 15 modules. Like that statement about an endless chain of being, Vostell's work reminds us that television is apparently infinite. And the second part of his title furthers that message, for the word 'endogenous' means 'growing from within'. Vostell's titular related meaning is therefore clear: television spawns itself, spreading depression as it grows and grows and grows....

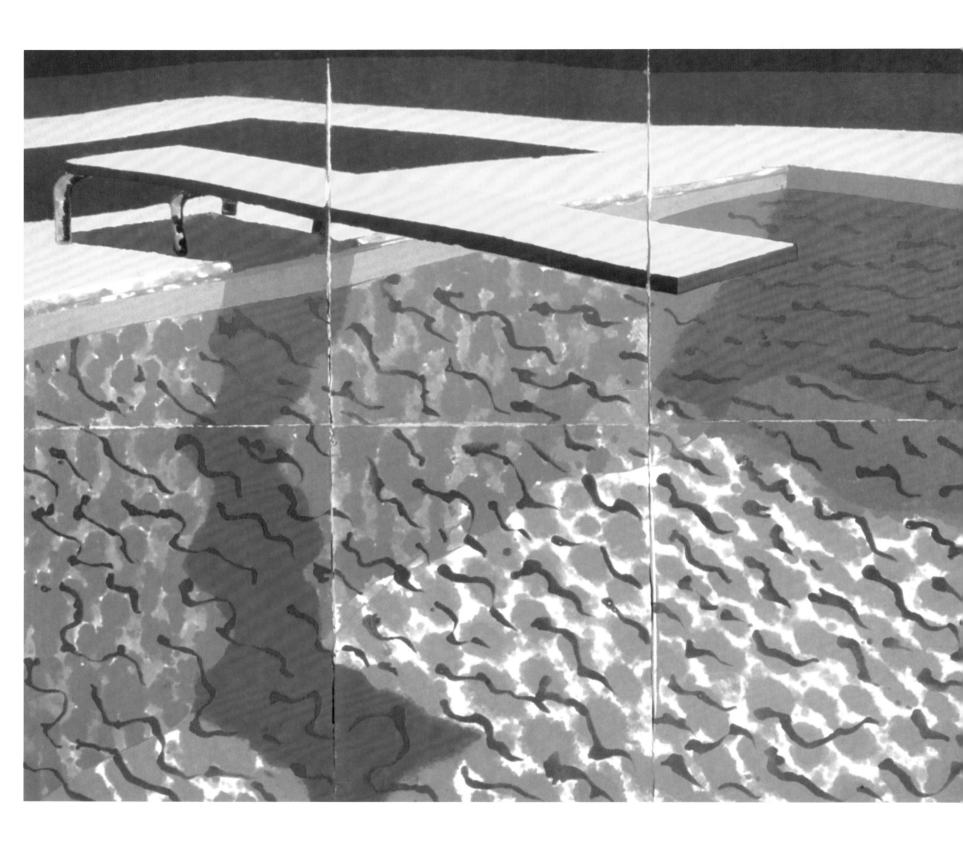

David Hockney, *Le Plongeur (Paper Pool #18)*, 1978.
Coloured pressed paper pulp, 182.9 x 434.3 cm.
Bradford Art Galleries and Museums, West Yorkshire, England.

This work forms part of a series of twenty-nine prints made at Tyler Graphics near
Mount Kisco in New York State between August and October 1978. Instead of colour
being inked on to the surface of paper as is normally the case with prints, Ken Tyler
had found a way of pressing pigment into the sheet while it was still in a pulpy state
during the papermaking process, thereby effecting a total fusion between carrier and
image. This technique appealed to Hockney, not least of all because it imparted
enormous richness and depth to the colour. However, as it proved impossible to make

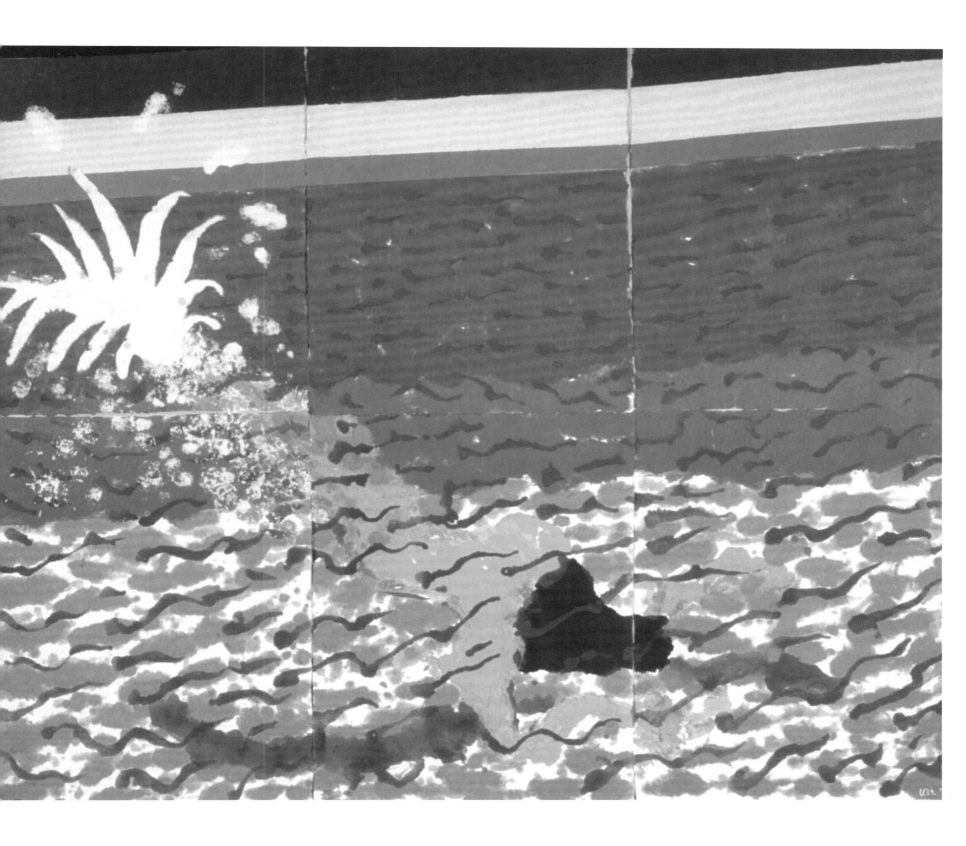

the sheets of paper as large as the artist required, the images are composites of smaller sheets joined together. The pool depicted was the one owned by Ken Tyler near his workshop, and the model for the swimmer was David Hockney's friend, Gregory Evans. Each image was developed from numerous drawings and Polaroid photos taken of the swimmer and pool. The set of prints marked Hockney's final engagement with a subject he had explored very fruitfully since the mid-1960s, and thus with an aspect of hedonism that has proved enormously attractive in the age of mass-culture.

Arman, *New York Marathon,* 1978.
Accumulation of basketball sneakers on wooden backing, 180 x 280 x 10 cm.
Patrick Combes collection, Paris.

Here, and not for the first or last time either, Arman created a total congruence between subject and object, for what could more aptly allude to a gigantic assembly of people running through urban streets than this vast accumulation of sports shoes? Moreover, what could more generally represent the huge stacks of artefacts that stand at the heart of modern society?

The red laces are looped within the shoes and then hang down to form vertical lines not unlike the streams of paint in Arman's *Bonbons Anglais* of 1966 (page 154). The looping and fairly parallel lines could suggest marathon runners first milling around and then all following the same path.

Ed Paschke, *Strangulita*, 1979.
Oil on canvas, 116.8 x 203.2 cm.
Collection of Martin Sklar, New York.

Ed Paschke was born in Chicago in 1939. Upon graduation from the Art Institute of Chicago in 1961 he was awarded a travelling fellowship, with which he toured Mexico. He received his Master's degree from the same institution in 1970; between those two periods of study he was drafted into the army and then toured Europe; spent a period painting in New York; and worked as a commercial artist in Chicago to support his activities as a painter. He held his first solo show at the Deson-Zaks Gallery in Chicago in 1970. In that same year he was profoundly impressed by a large Warhol exhibition in Chicago. He also took the first of many higher-education teaching posts. His initial New York exhibition was mounted at the Hundred Acres Gallery in 1971 but received unfavourable reviews, a response that strengthened his resolve to stay in Chicago. Subsequent shows proved more successful and included an exhibition that toured Britain in 1973, as well as displays in Paris and Cincinnati the following year. Subsequently his work was seen many times in solo and

collective exhibitions across the world. A retrospective was mounted at the Pompidou Centre, Paris, in 1989. Paschke died in 2004.

Until about 1977 Paschke painted curious, rather surrealistic images of musicians, circus performers, transvestites, weird-looking women, masked figures, the vertically-challenged, film stars and the like, occasionally with a violently threatening edge. However, in that year he also began to assimilate the influence of neon-lighting effects and the linear patterns typical of electronic communications and medical diagnostic machines. These phenomena can be seen here, along with a touch of the violence. The combination of imagery and overlaid lines suggests the victim has been successfully strangled, with the patterns taking a fairly even course, as though heartbeat, mental activity and other bodily functions are now ceasing.

James Rosenquist, *Star Thief*, 1980.
Oil on canvas, 518.2 x 1402.1 cm.
Private collection, Museum Ludwig, Cologne.
Art © 2006 James Rosenquist/ Licensed by VAGA, New York, NY

In 1981 the retired astronaut and then-President of Eastern Airlines, Frank Borman, blocked the use of this painting in the new Miami air terminal (for which it had been commissioned). Perhaps that is unsurprising, for to untutored minds the image would appear to be composed of unconnected fragments of reality. These take the form of several rashers of bacon, a few pieces of machinery, some slivers of a glamorous female face as it might be seen in an advertisement, a tangle of electrical wiring, and a large-grid architectural structure, all set against an interstellar backdrop. However, only a little considered thought proves necessary to make sense of the work.

The painting is a brilliant metaphor for the earth passing through space. Instead of depicting it as a globe covered in land and water, Rosenquist has denoted it by means of some of the products and activities that typify aspects of human development: the animal husbandry and architecture by which we respectively feed and house ourselves; the mechanical and electronic inventions by which we make our lives more comfortable and communicative; and the presentational and selling imagery through which we might appeal to others and thus prosper. This vast reflection of human talents floats in space, stealing light from the stars.

Patrick Caulfield, *Dining/Kitchen/Living*, 1980.
Acrylic on canvas, 180 x 180 cm. Tochigi Prefectural Museum of Fine Arts, Japan.

Caulfield's responsiveness to patterning received full rein here, with a very jazzy feeling being imparted by the insistent wallpaper. As in the work by the same artist discussed above (page 196), here again he made a somewhat vulgar interior look far more banal by painting it in such a detached manner. And once more we see the placing of a small area of intense realism within a more abstractive surround, in order to intensify the visual impact of opposed types of imagery.

Andy Warhol, *Diamond Dust Joseph Beuys*, 1980.
Silkscreen ink and diamond dust on synthetic polymer paint on canvas, 254 x 203.2 cm.
Marx collection, Museum für Gegenwart, Berlin.

Joseph Beuys (1921-86) was perhaps the most influential of post-war German sculptors and conceptual artists. By the time of his death he was also the most highly valued artist in the world, something that certainly appealed to Warhol (who was not far behind him in the league table of top artistic earners). Beuys was one of the founders of the German Green movement, and was especially brilliant at communicating through the mass-media. He first met Warhol in New York in 1979 and the American artist was commissioned to paint his portrait the following year. Later Warhol went on to create further images of Beuys, including sets of silkscreen prints, published between 1980 and 1983. And a portrait entitled *Joseph Beuys in Memoriam* created after the sculptor's death overlays a positive image of his head with camouflaged patterning. Warhol had a low opinion of Beuys's work, but the German sculptor esteemed Warhol highly for the conceptual complexity of his art. The two exhibited their works alongside one another in Berlin in 1982 when the Marx collection – to which this portrait belongs – went on display in the National Gallery there.

This is one of Warhol's many reversal pictures, in which he emulated the appearance of a photographic negative. The injection of glamour noted above in connection with the Skulls images (page 197) was effected here not by means of an underpainting of garish colours; instead, Warhol sprinkled synthetic diamond dust over the image while the silkscreen ink was still wet, thus bonding the two together. Although the diamond dust is not easy to see in reproduction, in reality it gives off a brilliant glitter that introduces potent associations of a showbiz glitziness that is entirely and wittily appropriate to Beuys's role as an art-world superstar.

Ed Paschke, *Nervosa*, 1980. Oil on canvas, 116.8 x 108 cm.
Collection of Judith and Edward Neisser, Chicago.

Judging by the body-language and facial expression of the man seen here, he appears to be depressed. That feeling of despondency is certainly amplified by the generally cool colours and fairly straight lines which are evocative of the electronic patternings displayed by medical diagnostic machines.

Ed Kienholz and Nancy Reddin Kienholz, *Sollie 17*, 1979-80.
Wood, plexiglass, furniture, sink, lights, photographs, plaster casts, pots, pans, books, cans, boxes, three pairs of underwear, linoleum, leather, wool, cotton, soundtrack, glass, metal, paint, polyester resin, paper, metal coffee can, sand and cigarette butts, 304.8 x 853.4 x 426.7 cm. Private collection.

In 1965 Kienholz was walking down a second-floor corridor in the Green Hotel, Pasadena, California, when he

> *… passed an open door. Inside was an old man sitting on the edge of his bed playing solitaire on a wooden chair that was facing him. The room was furnished in average, seedy hotel style, and the light was slanting in through the only window in a soft and pleasant way. The thing that struck me as I walked past was the conflicting signals I read from the scene. The strongest came from the man, "What the hell are you looking in here for? This is my place and you just keep your goddamn nose out of it." The lesser feeling was, "Oh, God, I'm so lonely, why don't you stop and talk a little bit?"*

The memory stayed with Kienholz and eventually resulted in this work, of which we are only seeing the hotel room, for the sculptor also represented the dingy hotel corridor outside. This takes the form of a wide wall pierced by two doors. A length of carpet runs along the wall, upon which are mounted fire-escape and exit-signs, plus a public telephone and a phone directory. Names, messages and numbers are scribbled all around the phone,

and these have been boosted by exhibition visitors down the years. In front of the wall are a sand-filled fire bucket and a chair.

Of the two doors to the wall, one is closed and bears a toilet sign, while the other, being open, allows us to see the view reproduced here, although in reality we cannot enter the room as the aperture is sealed with a sheet of clear plexiglass. The barrier of hostility encountered by Kienholz in 1965 has now become a physical barrier instead, and it forces us to become voyeurs or people who look but do nothing.

The title of the ensemble both provides us with the name of the occupant of the room and alludes to the word 'solitude', which is, of course, the work's theme. And the number in the title equally draws attention to the title of the renowned 1953 prisoner-of-war movie, *Stalag 17*, directed by Billy Wilder. Like a prisoner, Sollie is also caged up, although obviously not by anyone but himself.

All around Sollie are his meagre possessions. He is represented three times simultaneously, and is only ever dressed in underpants. In his first guise he lies on his bed, reading a paperback western and holding the book in one hand while he plays with his genitals with the other. His head is a framed photograph which, by its very flatness, suggests that Sollie is rather a two-dimensional personality, without the kind of inner resources that would see him though his loneliness. A framed photo of Sollie in profile also caps the man's second appearance, sitting on the edge of his bed looking very forlorn indeed. And in his third guise we see him from the rear, his head as flat as ever and his shoulders hunched, with a hand scratching an armpit as he stares out the window. He seems the very epitome of boredom. Beyond him stretches part of the Spokane skyline as viewed from one of the decaying hotels and other condemned buildings in the old part of that city in Washington state, from which Kienholz and his wife gleaned many of the materials for this work and three related ensembles known collectively as the Spokane series. In the other sculptures Kienholz and his wife represented the check-in desk of a cheap hotel and its surrounds; a shop converted into a shrine to Jesus; and the corridor of an apartment house, none of whose six doors open but each of which gives out the sounds of everyday living when approached. In all four works Kienholz and Reddin projected the desolation that far too often stands at the heart of modern life.

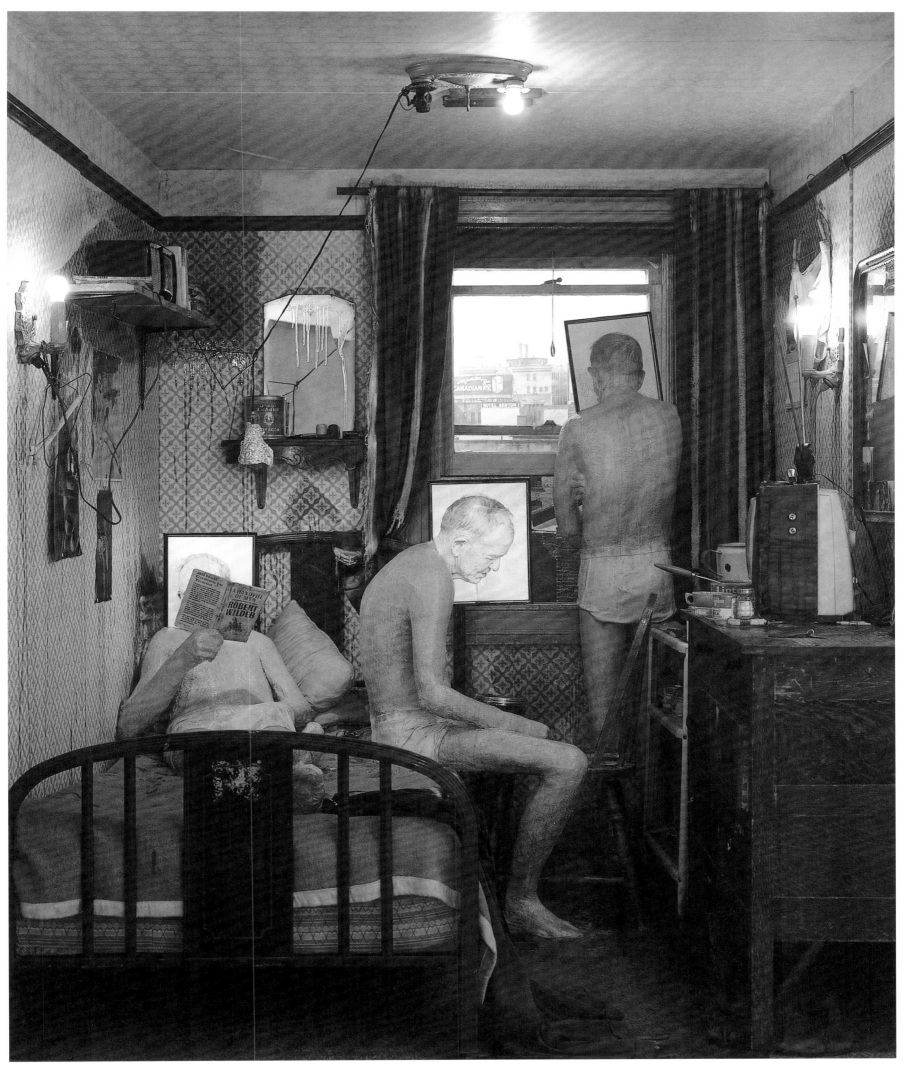

Tony Cragg, *Britain Seen from the North*, 1981.
Plastic and mixed media, 440 x 800 x 100 cm. Tate Britain, London.

Tony Cragg was born in Liverpool in 1949. After studying at Wimbledon School of Art, London, he attended the Royal College of Art, London, from where he graduated in 1977. He held his first one-man show at the Lisson Gallery, London, in 1979. He was accorded a major show at the Tate Gallery in 1989, and further exhibitions followed in Eindhoven, Washington, Madrid, Munich, Paris, and Liverpool. In 1988 he represented Britain at the Venice Biennale, and the following year he won the Turner Prize. More recently he was awarded the Shakespeare Prize. He lives in Germany.

Here Cragg portrayed himself looking across a mainland Britain lying on its side. The island is composed of fragments of the industrial detritus that constantly litters our surroundings, such as items of old clothing, discarded boots, plastic toys, bits of packaging, machine parts, and the like. The result is a highly colourful and formally varied low-relief display that memorably suggests political, industrial and social fragmentation, as well as the disorientation it produces.

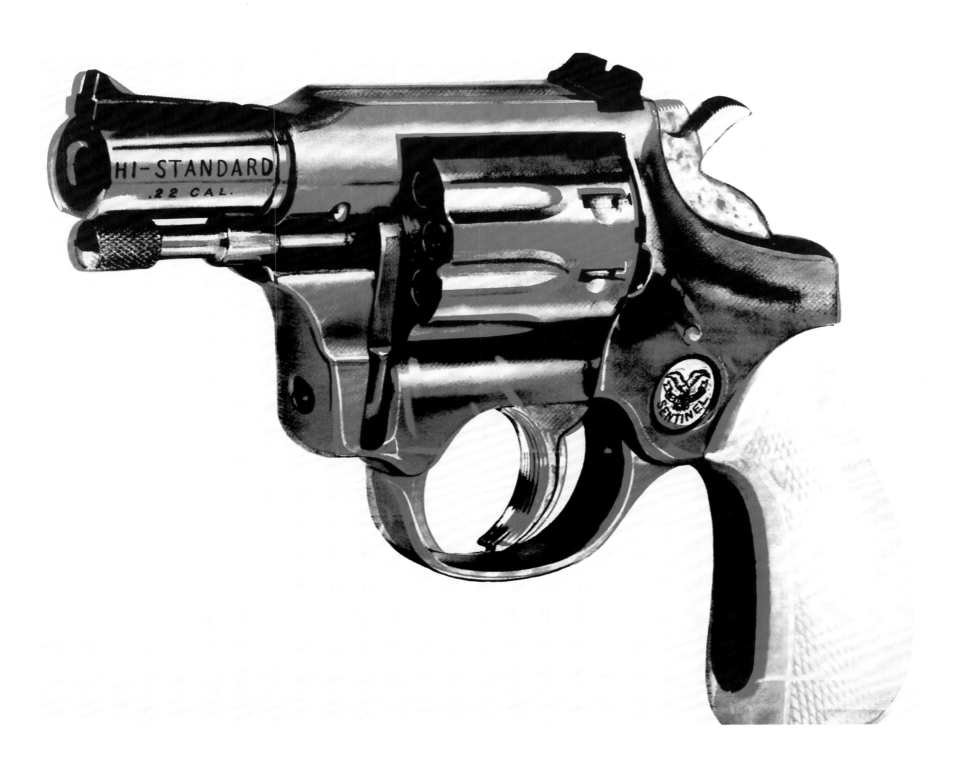

Andy Warhol, *Gun,* 1981.
Silkscreen ink, acrylic paint on canvas, 177.8 x 228.6 cm.
Anthony d'Offay Gallery, London.

Given the personal suffering inflicted upon Warhol by means of a gun when he was shot
in 1968, it seems natural, if somewhat masochistic, that he should have represented such
objects as cultural icons, which of course they are to a great many Americans. The
autobiographical significance of such images is heightened by the fact that the gun
represented is a .22 snub-nosed pistol, one of which had been carried as a backup
weapon in an attempt to kill the artist in 1968.

The chilling associations of the subject-matter are heightened by the fact that the
portrayal of each gun is so impersonal. That neutrality accurately mirrors reality, of
course, for a gun is merely a tool in the hand of the person who wields it. Once again
Warhol's visual detachment projects the utter emptiness of modern life, as represented
by its artefacts.

Ralph Goings, *Ralph's Diner,* 1982.
Oil on canvas, 112.4 x 168.9 cm. Alpert Family Trust.

Ralph Goings was born in Corning, California in 1928. He studied at the California College of Arts in Oakland, graduating in 1953, and at the Sacramento State College, from where he graduated in 1965. He then continued to teach painting at various institutions throughout California before retiring from teaching in 1969. He held his first solo exhibitions at the Artists Cooperative Gallery in Sacramento in 1960, and at the OK Harris Gallery in New York in 1970. Since then he has exhibited many times in New York and participated in group shows throughout America and around the world.

In the 1960s Goings worked initially in the manner of Rosenquist, and then in the style of Thiebaud. However, he moved over to photorealism by the 1970s, having found his major interests to be pick-up trucks, chain restaurants and diners. More recently he has also painted many still-lifes of the groups of objects found in diners, such as condiments, sugar bowls, metal jugs and the like.

Ralph's Diner was located outside a small town in Pennsylvania, and it was demolished some years ago. The landscape beyond the windows was introduced from photographs taken in upstate New York. Judging by the enormous numbers of print reproductions of this canvas that are sold in shops and over the internet, it is one of the most popular photorealist pictures ever created. It is not difficult to see why, for the very subject clearly appeals to the many people for whom diners are stylish and relatively cheap places to eat. Goings certainly captures the stylishness by employing a Vermeer-like painterly technique.

The line of empty stools leads the eye towards the solitary customer, thereby inviting us to join him.

Mark Kostabi, *Goya O Boya*, 1982.
Oil on canvas, 91.4 x 121.9 cm. Marion Javits collection, USA.

Mark Kostabi was born in Los Angeles in 1960. He studied art at California State University at Fullerton. His first solo exhibition was held at the Molly Barnes Gallery in Los Angeles in 1982, while his initial New York show was mounted at the Simone Gallery in 1983. In 1982 he opened Kostabi World, his own art-production and selling space in New York. He has exhibited globally, in 1992 holding a retrospective in Tokyo and in 1998 mounting a large retrospective in Tallinn, Estonia (from which country his parents had emigrated to the United States).

In 1975 Andy Warhol stated:

> *Business art is the step that comes after Art. I started as a commercial artist, and I want to finish as a business artist. After I did the thing called "art" or whatever it's called, I went into business art. I wanted to be an Art Businessman or a Business Artist. Being good in business is the most fascinating kind of art.*

In this respect Kostabi has followed directly in Warhol's footsteps, for like most businessmen he creates virtually none of his works himself; instead, he pays teams of subordinates to think up and then create all his pictures (including the signatures affixed to the canvases). He likens himself to the chairman of some large industrial corporation, wherein he takes care of the overall strategic and marketing side of things, leaving his subordinates to produce the actual goods. Kostabi's art-producing empire therefore parallels other commercial concerns exactly. This is not to say, however, that the results are necessarily negligible artistically, for as the present work demonstrates, Kostabi can produce some witty takes on the world. In this particular instance – which Kostabi did actually paint himself – Goya's *Shootings of 3 May, 1808* (Prado, Madrid) is updated, so that instead of seeing Spanish prisoners about to be shot by the French in the light of a large lantern resting on the ground, that box has become a television set holding its anonymous viewers in thrall.

Sir Peter Blake, *The Meeting* or *Have a Nice Day Mr Hockney,* 1981-83.
Oil on canvas, 97.8 x 123.8 cm. Tate, London.

In this update of the French painter Gustave Courbet's 1854 group portrait *The Meeting* or *Bonjour, Monsieur Courbet* (Musée Fabre, Montpellier), art renews itself amid the hedonistic backdrop of southern California. Courbet's famous canvas shows him being welcomed by his patron Alfred Bruyas to the provincial French town in which the picture was painted and now hangs. Here Peter Blake welcomes his friend David Hockney to Venice Beach, California. This is a witty reversal of the truth, for Blake was always the visitor to the United States while Hockney resided in California. To the left the British abstractive painter Howard Hodgkin stands in for Bruyas's manservant Calas who also appears in the Courbet oil.

Hockney holds a giant paintbrush. In addition to substituting for the painting gear carried by Courbet, this could have stemmed from reality, for an American company, Think Big, used to produce such artefacts in its range of huge ornamental products. Blake appropriated the crouching blonde and other figures from roller-skating magazine illustrations, while the setting derived from photos he had taken in Venice Beach in 1980.

James Rosenquist, *4 New Clear Women*, 1983.
Oil on canvas, 518.2 x 1402.1 cm. Collection of the artist.
Art © 2006 James Rosenquist/ Licensed by VAGA, New York, NY

Giant cogwheels turn on the right, as slivers of the faces of four somewhat artificially glamorous women interpenetrate at the centre, and the tracks of stars as recorded by time-lapse photography curve around on the left. By their contrast, the large numbers of circles to right and left heighten the pictorial impact of the X-shape at the centre.

In overall terms the image clearly constitutes a metaphor for the way in which many women have often been reduced to socially fragmented beings by the mechanistic pressures of modern life. Given such a message, the punning title of the work seems both accurate and ironic.

Allan McCollum, *Plaster Surrogates,* 1982-84,
Enamel on cast Hydrostone, various sizes. Private collection.

Allan McCollum was born in Los Angeles in 1944. His first solo exhibition took place at the Jack Glenn Gallery in Corona del Mar, California, in 1971 and subsequently he has held many shows across the United States, Europe and the Far East. He has also worked on several public projects in the USA, France, Sweden and Mexico. Between 1988 and 1998 retrospectives of his work were mounted in Frankfurt, Eindhoven, Valencia, Malmo, London, Hanover and Lille.

The multitudinousness of things, and endless diversity within that repetitiousness, has proven central to McCollum; as he recently stated, he has "spent over 30 years exploring how objects achieve public and personal meaning in a world constituted in mass-production." To that end he first made his reputation with a group of extremely varied *Surrogate Paintings* he created after 1978, and subsequently he has maintained it with the *Plaster Surrogates* which are large numbers of monochromatic variants of those coloured, painted objects. Given that human beings are constant variants of two basic models, the overall repetitiousness and internal variation of McCollum's art parallels our reality exactly.

McCollum has spoken of the *Surrogate Paintings* in terms that are equally applicable to the *Plaster Surrogates* that derived from them:

> *The motivation behind making the* Surrogate Paintings *was to represent something, to represent the way a painting 'sits' in a system of objects. If you look at installation shots, or pictures taken of art galleries – that was the picture I had in mind. I was trying to reproduce that picture of an art gallery in three dimensions, a tableau. So with the* Surrogate Paintings *the goal was to make them function as props so that the gallery itself would become like a picture of a gallery by re-creating a gallery as a stage-set. To me, this was a clear representation of the way paintings looked in the world, irrespective of whether there's a 'representation' within the painting or not.*

In the *Plaster Surrogates*, therefore, as in their *Surrogate Paintings* forbears, we are necessarily looking at a distanced comment upon the multitudinousness of objects that collectively constitute the 'art world'. In an age in which – as Joseph Beuys once commented – 'everyone is an artist' and the planet is increasingly flooded with framed pictures, McCollum's statements about vast ensembles of such artefacts seem very apt.

Keith Haring, *St Sebastian,* signed, titled and dated 'August 21 1984' on the overlap, 1984.
Acrylic on muslin, 152.4 x 152.5 cm. Courtesy Tony Shafrazi Gallery, New York.

Keith Haring was born in Kutztown, Pennsylvania in 1958. Between 1976 and 1978 he studied art in Pittsburgh and then moved to New York where he attended the School of Visual Arts. He exhibited extensively in New York before mounting his first solo show at Club 57 in New York in 1981. His first gallery display followed in 1982. In 1983 he exhibited in New York, London and Tokyo, while during the next year he created murals in Australia, Brazil and the USA. In 1985 he began painting on canvas, as well as took up sculpture and stage design. Later he opened a store selling Keith Haring products, created further murals, exhibited widely in America and Europe, and worked extensively on behalf of children's charities. He died of AIDS in 1990.

The principal feature of Haring's work is a linearity we usually associate with cartoons. He had always felt an affinity with cartooning, although he regarded the activity as somewhat inartistic until he saw works by Dubuffet, Alechinsky, Christo, Warhol and anonymous graffiti artists in New York. In 1981 Haring created his first chalk drawings on sheets of black paper pasted over expired advertisements in New York subway stations. He did so as an expression of his belief that art should be made freely for the people. In the process he also discovered the curious respect people pay to art, for although chalk is easily effaced, generally his works were respected. (Sadly this was not the case with his subway drawings of the mid-1980s, for by then their economic value was so great they were usually stolen shortly after having been made; as a result, Haring gave up creating them.)

By the 1980s the instant communicability of Haring's images had made him a huge hit with the public, if not necessarily with art critics. We can easily see why the public liked his work in this particularly witty example of his output at its best. St Sebastian is thought to have been a secret Christian in 3rd-century Rome, where he was a member of the Imperial Guard. When the Emperor Diocletian found out, he ordered Sebastian to die by being tied to a tree and pierced with arrows; although the future saint survived the ordeal, he was later cudgelled to death. Because of the secrecy of the saint's religion, the fact that his body was repeatedly pierced, and the way he was often painted as a beautiful young man, he has become the unofficial patron saint of gays, of whom Haring was one.

Here Haring's saint looks decidedly Picassoesque and 'unbeautiful'. In a curiously prescient pointer to 9/11, his sides are pierced by airplanes, rather than arrows. The erection is, of course, a reference to the homosexual associations of the saint.

Sandy Skoglund, *Germs are Everywhere*, 1984.
Live model, furniture, chewing gum, Cibachrome photograph, 76.2 x 101.6 cm.
Private collection.

Sandy Skoglund was born in Quincy, Massachusetts, in 1946. She studied art at Smith College, Northampton, Massachusetts between 1964 and 1968, during which time she spent her junior year at the Sorbonne and at the École du Louvre in Paris. She then attended graduate school at the University of Iowa, from where she graduated in 1972. That same year she moved to New York where she worked through the rest of the decade as a conceptual artist. By the end of that period her work had come into more concrete focus, and she caused quite a stir with her installations/photographs Radioactive Cats *and* The Revenge of the Goldfish *at the Whitney Biennial in 1981. Since then she has created installations around the world. In 1997 a retrospective of her work toured various leading museums throughout the United States.*

Skoglund makes installations using people and objects, which she then photographs. Occasionally she markets the installations, while the photographs are sold widely, both as limited edition Cibachrome prints – one of which is reproduced here – and as books, posters and postcards. This strategy permits her to reach a very wide audience.

Many of Skoglund's works can border on the surreal, as with *Revenge of the Goldfish*, which shows a girl asleep, a boy sitting on the edge of her bed, and an entirely blue room filled with large, richly-coloured goldfish. But surrealism does not seem so intrusive in the present work, with its suburban housewife, her hair in curlers, resting with a beverage in her hand and presumably looking with satisfaction upon the living-room she has just cleaned. However, as the title tells us and the blobs on the walls demonstrate, germs are everywhere....

This is possibly the first sculpture ever made using chewing gum as one of its materials.

Ed Paschke, *Electalady*, 1984.
Oil on canvas, 188 x 233.7 cm.
Collection of James and Maureen Dorment, Rumson, New Jersey.

Colouristic breakdown as seen here is surely familiar in the age of advanced photography, electronics and the mass-media. The horizontal lines suggest the patternings of medical diagnostic machines, the dark, glowing greens of the flesh might well evoke X-ray photographs, and the blank orange-yellows of the eyes take us into strange psychological territory indeed. The garish red of the lips links subtly to the heightened banality of the portraits of Marilyn Monroe by Andy Warhol, the artist that Paschke considered to be the most significant creative figure in America.

Tim Head, *State of the Art*, 1984. Cibachrome photograph, 18.9 x 274 cm.
Arts Council collection, The South Bank Centre, London.

Tim Head was born in London in 1946. Between 1965 and 1969 he studied at the University of Newcastle-upon-Tyne, where one of his teachers was Richard Hamilton. In 1968 he worked in New York as a studio assistant to Claes Oldenburg. The following year he attended an advanced course run by the sculptor Barry Flanagan at St Martin's School of Art, London. He first exhibited in London in 1970. Since then he has shown extensively throughout Britain and continental Europe, as well as in New York. In 1987 Head was awarded the first prize at the John Moores exhibition of contemporary art in Liverpool. A retrospective of his work was held at the Whitechapel Art Gallery, London, in 1992.

This was the first of Head's large Cibachrome photographs of artificial cityscapes fashioned from manufactured objects. After carefully assembling a vast array of consumer products, including sex toys and games with militaristic and fascist themes, Head had this picture taken by the photographer Richard Davies. In 1989 the artist described the work as:

A city skyline
A synthetic landscape with consumer products
An accumulation of technological fallout
A gloss of seductive surfaces
A conglomerate of objects that are merely signs
A cemetery of images
A techno-military-erotic-leisure complex...
Picture of a disposable present
A still-life

It is easy to apprehend the 'city skyline', with its huge phallic objects standing for skyscrapers. Naturally, the title of the work refers to cutting-edge technology and although many of the artefacts are now obsolete, the work still typifies the altars that we all constantly fashion from the objects of mass-consumption.

Don Eddy, *C/VII/A*, 1984. Acrylic on canvas, 190.5 x 152.4 cm.
Courtesy of the Nancy Hoffmann Gallery, New York.

Don Eddy was born in Long Beach, California in 1944. Between 1967 and 1970 he studied at the University of Hawaii in Honolulu, and at the University of California in Santa Barbara. He held his first solo exhibition at the Ewing Krainin Gallery in Honolulu in 1968, and his first New York show at French and Co. in 1971. Subsequently he has exhibited all over the USA, as well as in Europe and Japan.

Of late, Eddy has created pictures from photographs of landscapes and shop windows, but for the canvas reproduced here, as for much of his work made during the 1980s, he carefully arranged collections of kitsch and other objects upon reflective shelves in his studio. He then photographed the displays many times in both colour and monochrome,

using varying depths-of-field for the images. A slide taken from each print made for a given work was then projected onto a canvas, over which the tonal values were initially established before the final painting was undertaken. Eddy is a master of the airbrush, a tool he learned to use when working in his father's car customising workshop as a young man. Everything in his paintings is made using this device, which produces seamless transitions from one colour to another.

Eddy's crowded, richly-coloured, brilliantly-lit and sharply highlighted still-lifes act as vivid reminders of the glut of artefacts now filling the world. Again, photorealism serves to explore the nature of perception, while equally commenting upon the values of consumerism and mass-culture.

David Hockney, *Pearlblossom Hwy., 11-18 April 1986, no. 2*, 1986.
Photographic collage, 198 x 282 cm. Collection of the artist.

Although by 1982 Hockney had long used photography to provide information for his paintings, early in that year he began making large photocollages out of sizable numbers of Polaroid instant-development photographs. He did so in order to investigate new ways of exploring pictorial space and the psychology of perception. Over the following four-and-a-half years he created more than 370 such composite images, not only employing Polaroid photography but also 110 and 35mm photography as well. The present work was his final photocollage and it is made up of over 600 separate Polaroid prints. For parts of the picture, such as the road signs, the artist took his camera up a ladder in order to avoid distorting the internal perspectives.

The final composite not only forces us to look at each part of the image with new eyes; it also projects the bleakness of a landscape bestrewn with all the familiar debris of an uncaring consumer society. Naturally, the abundant signs and injunctions make the landscape even uglier, and given that they clutter a fairly empty place, the picture sardonically comments upon unnecessary human intrusion within the natural world.

Arman, *Office Fetish*, 1984.
Group of telephones, 135 x 76 x 76 cm.
The Detroit Institute of Art, Michigan.

By 1984 the mobile revolution was not even in its infancy and so it would be wrong to suggest that Arman was being prescient here. But the telephone as an integral part of commercial life had been around for a long time, so the title of this accumulation was certainly apt, especially as many office workers did fetishise their phones by the 1980s and, indeed, increasingly do so now.

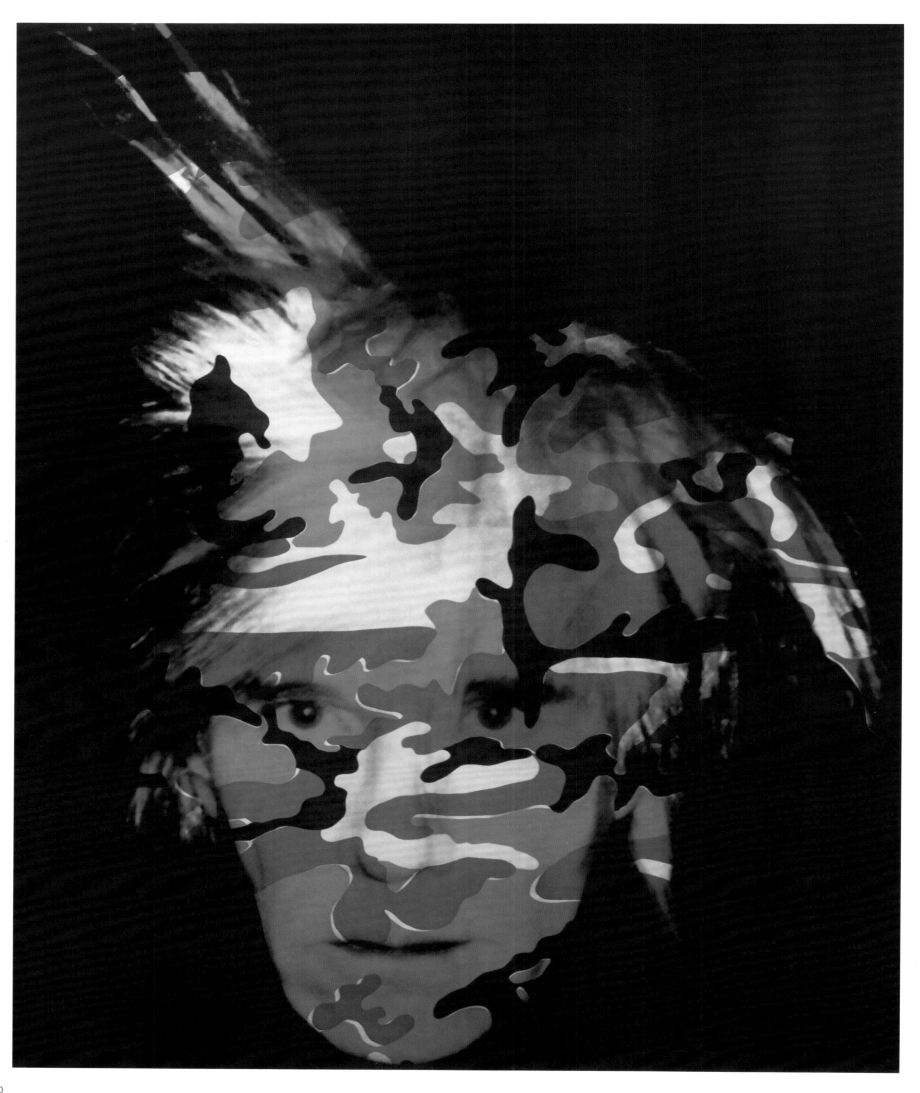

Andy Warhol, *Camouflage Self-Portrait*, 1986.
Silkscreen ink on synthetic polymer paint on canvas, 208.3 x 208.3 cm.
The Metropolitan Museum of Art, New York.

The camouflage patternings seen here were derived from some standard United States military camouflage that Warhol had purchased in an army surplus store in 1986. Initially he used the camouflage to create a group of abstract paintings, but eventually he put it to much more fruitful use in representational images, as here.

After 1963 Warhol became a master at masking his real self from public gaze. To art critics, art historians and media questioners he usually went out of his way to appear naive, mentally slow, emotionally detached and even robotic. Yet this was a complete act, for in private Warhol was very worldly, mentally quick, frequently emotional, always manipulative (which is a true measure of his worldliness, for manipulativeness necessitates an understanding of human character) and anything but robotic. And intellectually he was highly sophisticated, as his works make abundantly clear. The late series of camouflaged self-portraits therefore project the real Andy Warhol in a very direct fashion indeed, for camouflage is a means of masking true appearances.

Naturally, the camouflage in these late self-portraits forces the images to the interface with abstraction, a frontier the painter had explored very often in previous works. The spikiness of the hair contrasts strongly with the swirling, curvilinear shapes of the camouflage, and together they imbue the image with a startling visual impact.

Haim Steinbach, *Pink accent²*, 1987.
Two 'schizoid' rubber masks, two chrome trash receptacles, four 'Alessi' tea kettles on chrome, aluminium and wood shelf, 139.7 x 279.4 x 58.4 cm. Milwaukee Art Museum, Wisconsin.

Haim Steinbach was born in Rehovot, Israel, in 1944. His family moved to the USA soon afterwards, and he took out US citizenship in 1962. Between 1962 and 1968 he studied at the Pratt Institute, Brooklyn, part of which involved a year at the Université d'Aix, Marseilles. Between 1971 and 1973 he completed his studies at Yale University. His first exhibition was held at the Sonnabend Gallery, New York in 1990, since when he has shown all over the world.

Steinbach has specialised in arranging common consumer artefacts on shelves of his own devising that visually relate in form, size and colour to the objects they support. Of course, by taking his articles from the real world, Steinbach follows in Duchamp's footsteps, although unlike the creator of the first 'ready-mades', he does not challenge the nature of art. Instead, he divorces everyday objects from their normal contexts and, by means of repetition, unusual juxtapositions of disparate objects, and the creation of visual consonances and dissonances, he forces us to a new awareness of the visual values of articles we normally take for granted. He can also occasionally introduce wit to the proceedings, as here.

Because the trashbins are so streamlined, brilliantly reflective and hard, and the kettles so bright, curvilinear and rigid, they contrast greatly with the soft, pliable forms of the masks. Moreover, the impersonality of the metal objects heightens the subjective quality of the masks equally by contrast, making those faces look very manic indeed.

231

Chris Burden, *All the Submarines of the United States of America,* 1987.
625 cardboard, wood and wire model submarines, 7.6 x 20.3 x 4.4 cm each;
overall 96 x 240 x 144 cm. Dallas Museum of Art, Texas.

*Chris Burden was born in Boston, Massachusetts in 1946. He studied art at Pomona College,
Claremont, California, from where he graduated in 1969, and architecture, physics and art at the
University of California at Irvine, from where he graduated in 1971. He first exhibited in Los
Angeles and Cincinnati in 1974, and in New York in 1977. Subsequently he has made site-specific
works internationally, and exhibited all over the world.*

For Burden, art can and should mean almost anything. Among his many ways of
expressing himself since 1971 he has spent five days crouched inside a tiny locker; he has
had himself shot; he has risked electrocution by thrusting electric cables into his chest; he
has had nails driven through the palms of his hands as he lay face-up on the back of a car;
he has set fire to himself; he has created a mechanism by which visitors to an art gallery
gradually push a wall of that building down simply by entering a space; he has created a
million-dollar assembly of 100 one-kilo gold bricks surrounded by matchstick men; he has
created an alternative Vietnam War memorial to the one in Washington DC, in the form
of twelve huge copper panels engraved with the names of the three million Vietnamese

killed during the Vietnam War; and he has promoted touring displays of videos showing
disasters in California because, as he says, "Nothing makes people feel better than seeing
disaster fall upon a rich and excessive society in a distant place."

The present, breathtaking installation was first exhibited at the Whitney Biennial in
New York in 1987. It records all 625 submarines that had constituted the underwater fleet
of the United States Navy between the inception of that branch of the service in 1897
and 1987; the names of each of the vessels are listed on a wall of the gallery. The small
cardboard models are not differentiated in shape, and thus do not reflect the
technological evolution of the submarine over those ninety years. The models hang by
wires of varying lengths from the ceiling, and because of their overall density they look
like a shoal of tiny fish.

This is one of those many sculptures of the second half of the twentieth century where
the component objects do not matter – it is their aggregation that is all-important. The
ensemble vividly projects the sheer vastness of the modern military machine, with all its
ramifications of political determination, massive finance and industrial might.

Chris Burden, *All the Submarines of the United States of America, detail,* 1987.
625 cardboard, wood and wire model submarines, 7.6 x 20.3 x 4.4 cm each;
overall 96 x 240 x 144 overall. Dallas Museum of Art, Texas.

Rose Finn-Kelcey, *Bureau de Change*, 1987-2003.
12,400 coins, false wooden floor, security guard, video surveillance camera and colour television monitor, viewing platform and spotlights. Weltkunst collection of British Art, on long-term loan to the Irish Museum of Modern Art, Dublin.

Rose Finn-Kelcey was born in Northampton, England, in 1945. She studied at Ravensbourne College of Art, Surrey, and Chelsea School of Art, London. Her first solo exhibition was held at the Chisenhale Gallery in London in 1992. She has shown and created work in Mexico and South Korea, as well as across Britain.

The output of Finn-Kelcey has ranged from performance activities, to flags, to the creation of atmospheric environments. However, this is arguably her most imaginative, substantial and impressive work to date. It has been installed seven times: in 1987 in Newcastle, Bradford and Manchester; in 1988 in London; in 1990 in New York and Oxford; and in 2003 in Dublin. Its centrepiece is a re-creation of one of Vincent van Gogh's Sunflower paintings. This is made not in paint but in coins, which in Dublin comprised 12,400 Euros and defunct Irish Punts. The medium of money is most apt of

course, for poor van Gogh only ever sold a single painting during his lifetime, whereas the version of Sunflowers reproduced by Finn-Kelcey is the one sold to a Japanese insurance-company executive in 1987 for the then-world record sum of 24.5 million pounds sterling. The translation of art into money is therefore totally congruent, and it makes a powerful point about the extraordinary commodification of art in our time. Moreover, as Finn-Kelcey's title makes clear, art is now a form of exchangeable currency, as mafiosi and drugs gangsters know only too well, for they often steal valuable works of art for use as collateral in their nefarious deals.

A suitable visual perspective upon the van Gogh-as-money is afforded by the viewing platform. The security guard, video surveillance camera, television monitor and fake wooden floor all induce associations of the highly artificial but rigorously controlled conditions that often pertain when immensely valuable works of art are lent or sent out by their owners, as happened in 1963 with the loan of Leonardo da Vinci's *Mona Lisa* by the Louvre, Paris, to the Metropolitan Museum, New York, and in 1964 with the Vatican's display of Michelangelo's *Pietá* at the New York World's Fair (where it could only be witnessed by people standing on a slowly moving walkway). Naturally the security guard and video apparatus are necessary anyway, for if they were not present who knows what might happen to the cash?

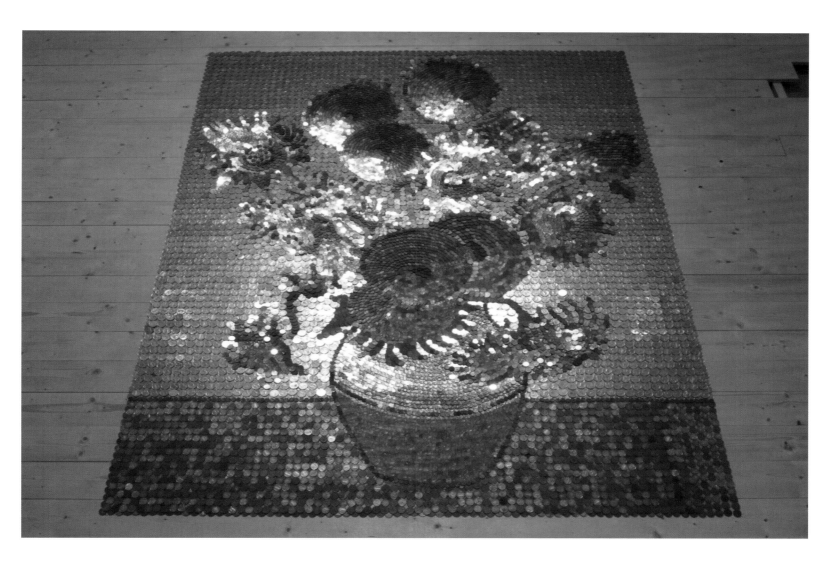

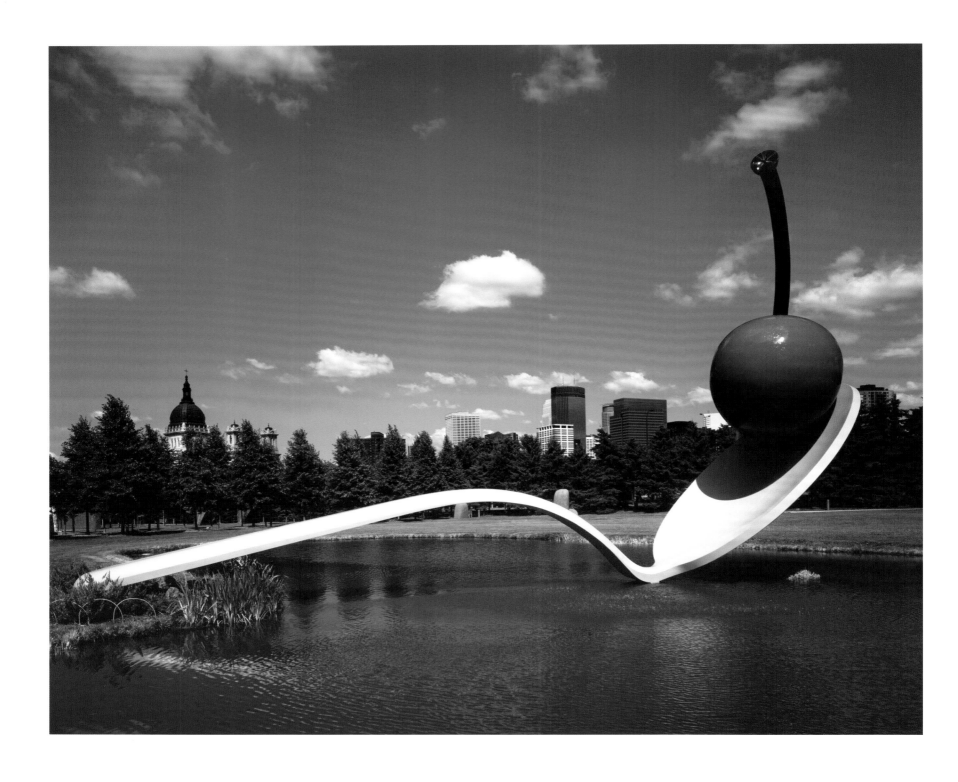

Claes Oldenburg and Coosje van Bruggen, *Spoonbridge and Cherry*, 1987-88.
Stainless steel and aluminium painted with polyurethane enamel, 9 x 15.7 x 4.1 metres.
Minneapolis Sculpture Garden, Walker Art Center, Minneapolis.

Spoonbridge and Cherry forms part of a succession of huge objects created by these two artists after they first collaborated on a representation of a garden trowel in 1976. Among their jointly-made sculptures are elegant and witty treatments of a baseball bat, pool balls, Robinson Crusoe's famous umbrella, a hat in three stages of coming down to earth, a pickaxe, a garden hose, a small version of a proposed bridge in the form of bent screws, a stake-hitch type of rope knot, some building tools in a seemingly precarious balancing act, a knife slicing through a wall, a dropped bowl with scattered slices and pieces of fruit, an erect pair of binoculars, a rubber stamp, a handsaw in the process of sawing, an up-ended ice cream cone, and a representation of Cupid's bow and arrow. All of these and many more pieces adorn public spaces, museums, offices and factory buildings, and undoubtedly they always intervene between the viewer and normality, hopefully to stimulating effect.

Here Oldenburg and van Bruggen took an enormously mundane mass-produced object and, by enlarging it, subtly transformed our perceptions of reality. Oldenburg has stated that he often receives his best inspirations when seated at the dinner table and he had long contemplated creating a sculpture of a spoon, for in 1962 he had acquired a

kitsch novelty item in the form of a spoon resting on a blob of fake chocolate. The cherry was van Bruggen's idea, being inspired both by the formal geometry of the proposed sculpture-garden setting in Minneapolis, and by the associations of Versailles induced by that formality, as well as by the rigid dining etiquette imposed at the French court by King Louis XIV.

The work stands in the eleven-acre sculpture garden, amid a pond shaped to look appropriately like a linden seed, for linden trees line the walkways that crisscross the garden. A fine trickle of water spreads continuously across the cherry from the base of its stem, in order to make it gleam constantly, while another spray of water simultaneously trickles from the top of the stem down over the cherry, on to the spoon and into the pond below. Naturally, in winter this water freezes, changing the beauty of the piece entirely.

The spoon weighs 2630 kg, the cherry 544 kg; both were created at two New England shipbuilding yards. In order to avoid staining the bowl of the spoon, purified city water had to replace well water as the source of the liquid. The work was entirely repainted in 1995, a fate that befalls most outdoor coloured sculptures.

Photographs of the piece are the most requested images of the Walker Art Center, which is surely a measure of how the transformational power of art remains vital in a mass-culture that often provides plenty of glitz and glamour but almost always lacks magic, or at least the kind of magic provided by Oldenburg and van Bruggen.

Jeff Koons, *Michael Jackson and Bubbles,* 1988.
Porcelain, edition of 3, 106.7 x 179 x 81.3 cm. Sonnabend Gallery, New York.

Jeff Koons was born in York, Pennsylvania in 1955. Between 1972 and 1975 he studied at the Maryland Institute College of Art in Baltimore, and between 1975-6 at the Art Institute of Chicago, where he was taught by Ed Paschke. In 1976 he returned to the school in Baltimore for a further year. He then worked as a Wall Street commodities broker, as well as at the Museum of Modern Art, New York. His first exhibited work was a window installation at the Monument Gallery, New York, in 1980, and in 1985 his first solo show was mounted at the same gallery, as well as in the Feature Gallery, Chicago. He has since exhibited all over the world. A large retrospective toured Minneapolis, Aarhus and Stuttgart in 1993.

In his first mature works Koons dealt with commonplace consumer artefacts such as vacuum cleaners. He also made a fairly remarkable piece of sculpture by bringing two basketballs into gravitational equilibrium. But subsequently, like Warhol and others, he specialised in attacking the banality within modern culture by magnifying it to the point of absurdity. Such is the case here. As if the bogus prettiness, sentimentality and artificiality of Michael Jackson were not enough to stomach in reality, Koons has given us the singer as a golden-white boy, along with his pet. By association, the gold reminds us of the huge wealth Jackson has engendered, while the whiteness underlines the musician's largely unsuccessful attempts to deny his true colour.

Keith Haring, *The Great White Way*, 1988.
Acrylic on canvas, 426.7 x 114.3 cm. Estate of Keith Haring.

This large phallus-shaped canvas is composed of subsidiary images, rather like some gigantic, horizontal and flat totem pole. Many of the images pertain to the processes, conditions and artefacts of modern life, including industrial activity, weaponry, money-making and AIDS. The latter link is especially enforced by the picture's underlying pink colour, with its gay associations.

At the base of the huge penis a man/phallus struggles to free himself from a snake or spring coiled round him. His hands hold penises that curl themselves around the heads of others. On either side men sport crucifix-shaped penises, while above the man a gaggle of people are engaged in a fight. Further up a male metamorphoses into a machine, with a dollar sign on his/its chest. Small figures cling to him/it while others struggle to turn the large handles and cogs that stand where his/its head should be. At the top of this machine a platform supports two figures bearing a crown; on either side men are pierced by large crosses. Yet further up still a man brings forth other men, while on the next level two pigs leer at a bound, dangling man whose feet are held by a vaguely human figure who forms one of two links in a chain; a metallic chain also binds two pregnant women on either side of this first fetter. All around are guns, a tank, a nucleus, knives, scissors, an airplane, a bomb and yet another dollar sign. The top human link in the chain emanates from the womb of a woman whose head doubles as the head of yet another woman, from whose outstretched hands emanate two more wombs, each containing babies; the female ideogram appears on her midriff. Finally, at the apex of all this activity a winged male with an erection is cojoined on either side by men emerging from other men whose bodies are shaped like condoms.

For a New Yorker, which Haring became by adoption, the 'Great White Way' is Broadway, with its teeming nightlife and, in its theatrical district at least, its gay cruising, as the artist was well aware. Of course in the context of a phallus the title also clearly refers to the duct through which semen is passed, although it is difficult to imagine how the fluid could easily do so here, given that the organ is so blocked with people and things.

Ashley Bickerton, *Tormented Self-Portrait (Susie at Arles)*, 1988.
Mixed media construction with black padded leather, 228.6 x 175.2 x 45.7 cm.
The Museum of Modern Art, New York.

Ashley Bickerton was born in Barbados in 1959. He studied at the California Institute of the Arts, from where he graduated in 1982, and on the Whitney Museum Independent Studies Program, from which he graduated in 1985. By that time he had already held his first solo exhibition, in the Artists' Space, New York, in 1984. Since then he has shown in New York, Chicago, Paris, La Jolla, San Diego, Philadelphia, Houston and Lausanne.

Bickerton first rose to prominence with industrial-looking objects in the present vein. The 'Susie' of the title is a reference to himself in his alternative sexual persona, while the mention of Arles suggests a link between his dual sexual self and the torments of Vincent van Gogh in that Provençal town. Yet the 'torment' of the self-portrait's title is clearly ironic, for the object looks utterly mechanistic, with the many corporate logos embellishing it representing the artist's consumerist interests. Bickerton's signature, which twice appears vertically near the bottom, takes its natural place alongside all these tokens of commercial identity.

David Mach, *One Hundred and One Dalmatians,* temporary site-specific installation at the Tate Gallery, London, 28 March-26 June 1988. Painted plaster dogs, electronic and electrical goods, beds, chairs and other items of furniture, carpet, approximately 16 x 16 x 4 metres.

David Mach was born in Methil, Fife, Scotland, in 1956. He studied at Duncan Jordanstone College of Art, Dundee, between 1974 and 1979, and at the Royal College of Art, London, between 1979 and 1982. At both institutions he won numerous prizes, both for sculpture and for drawing. He held his first London exhibition at the Lisson Gallery in 1982. Since then he has exhibited all over the world, often creating site-specific installations on a massive scale.

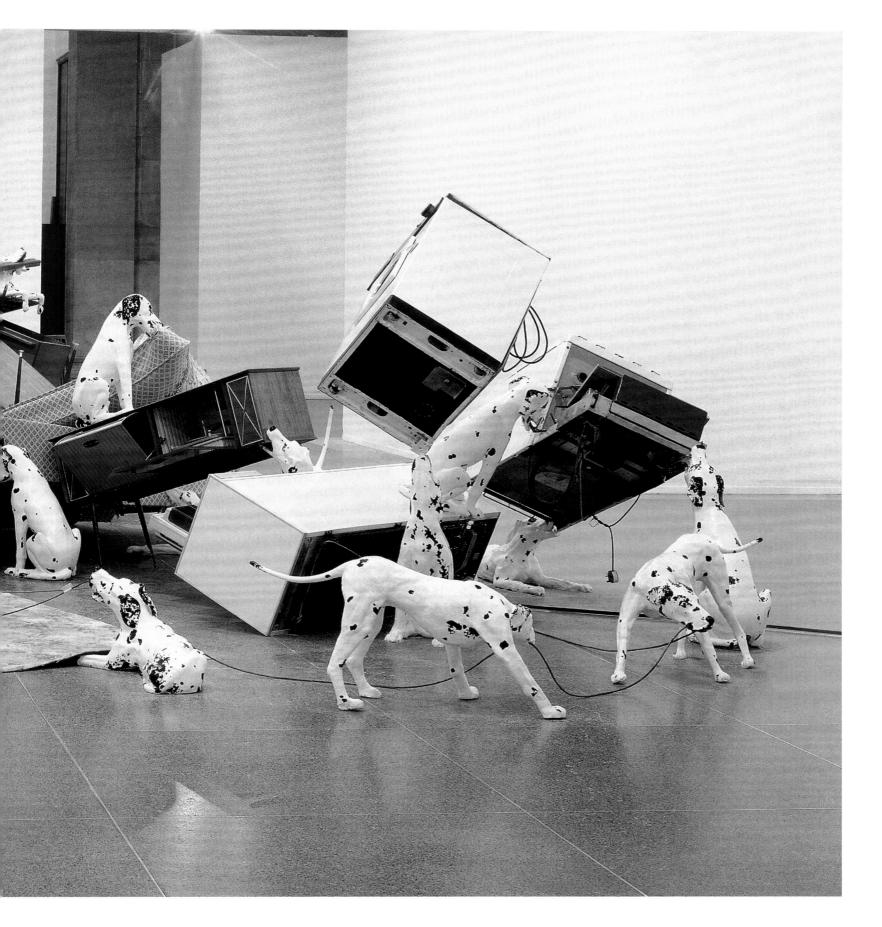

This was one of Mach's smaller ensembles. Representations of around fifty animals in four different poses were first cast in white plaster in a workshop and then transported to the Tate where they were painted with black spots. Some of the dogs had their jaws cut open – so that they would subsequently appear to be biting the furniture – and all the cracks in the plaster were then filled. The dogs that would be weight-bearing were cut open for internal strengthening by the insertion of metal armatures. All this work took place on site, watched by the public.

One Hundred and One Dalmatians did not illustrate the Walt Disney film but posited another such cinematic congregation of dogs taking over a house and forming its own arrangement of things – in other words, nature striking back at the modern world, as represented by its consumer goods.

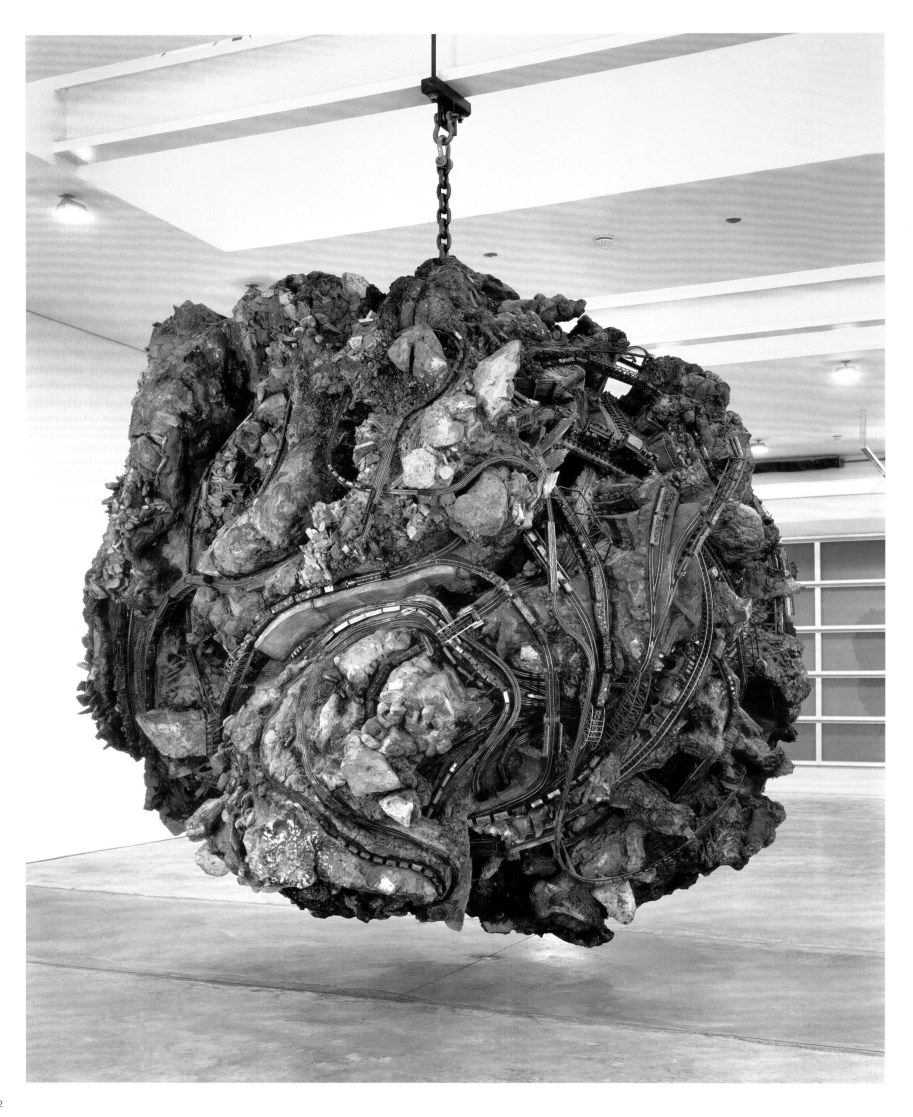

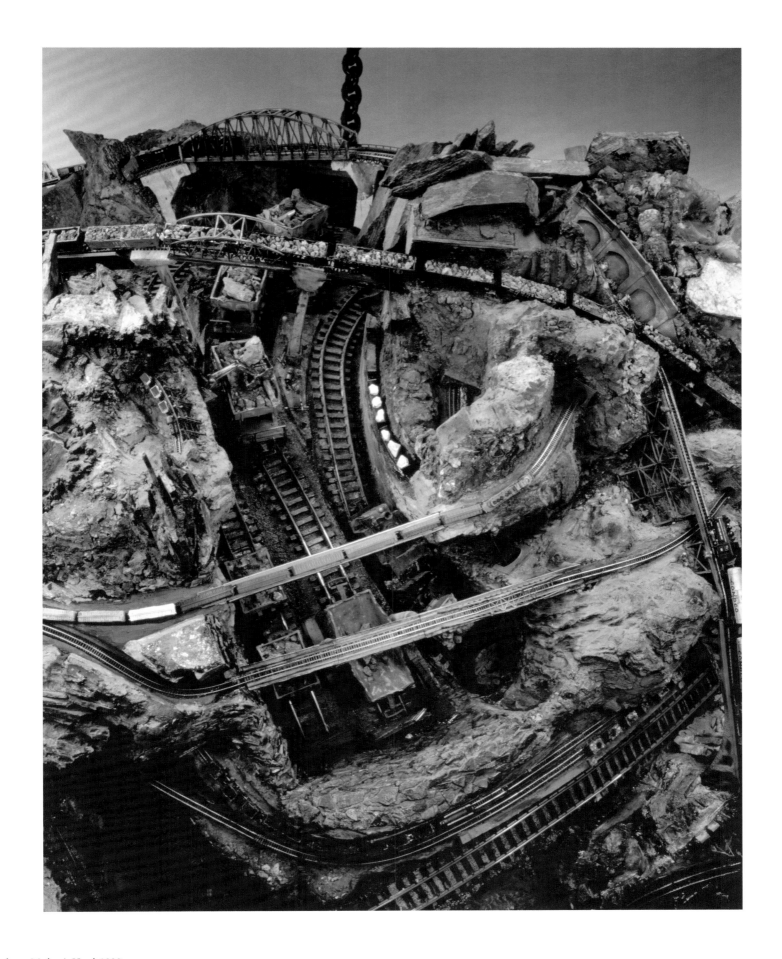

Chris Burden, *Medusa's Head*, 1990.
Rocks, concrete, steel, plywood, miniature railway tracks and vehicles, paint, 4.2 metres in width, 4.9 metres in height. Collection of the artist.

In ancient mythology Medusa was one of three sisters, the Gorgons, whose staring eyes, fangs, dangling tongues and snakes for hair made them so repulsive they turned everyone who gazed upon them into stone. Here Burden drew upon such a creature to create a stunning metaphor for the way our species is currently transforming our planet into something just as ugly. Miniature railway lines, complete with small locomotives and freight cars, snake their way across the shattered rocks, gorges and crevices of the orb to represent Medusa's hair, although because of the laws of gravity the trains are stuck down and can only move in our minds.

The sculpture hangs from the ceiling and weighs 5080.3 kg, a factor that has forced at least one gallery to have its supporting beams strengthened.

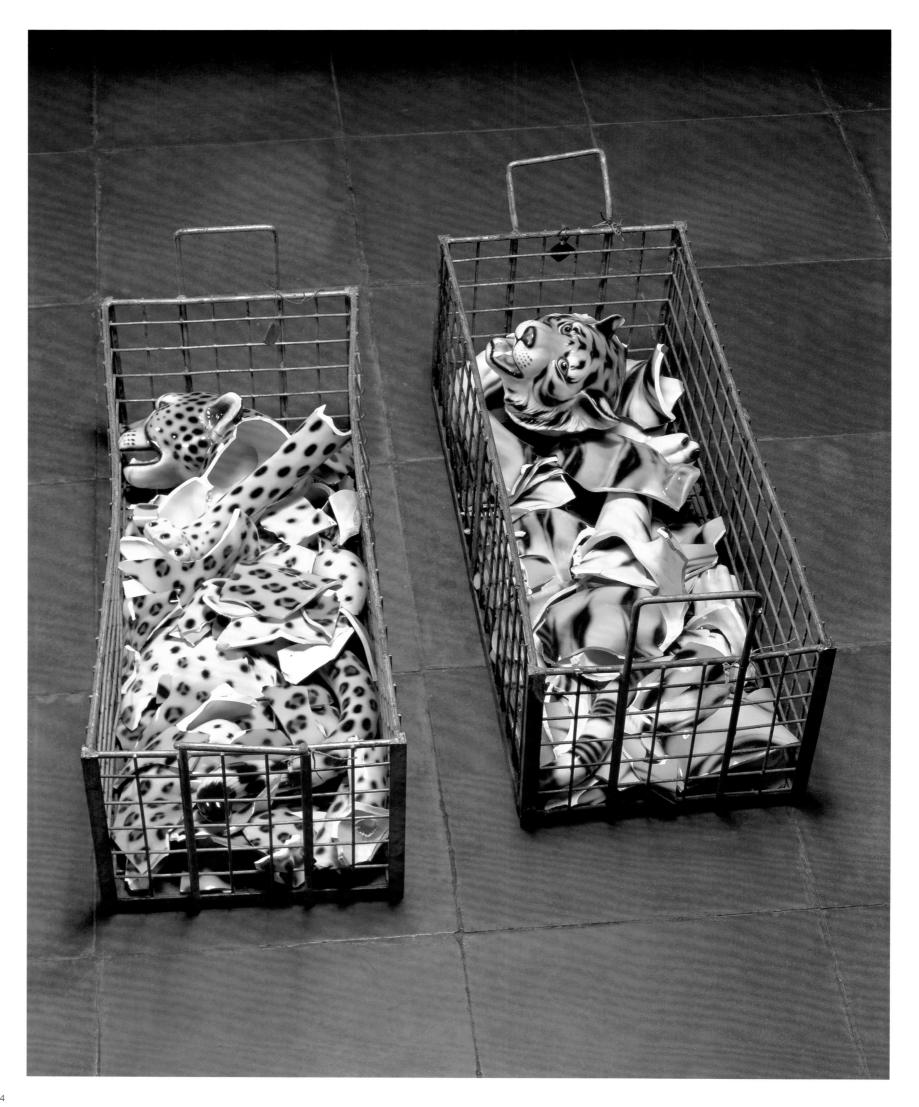

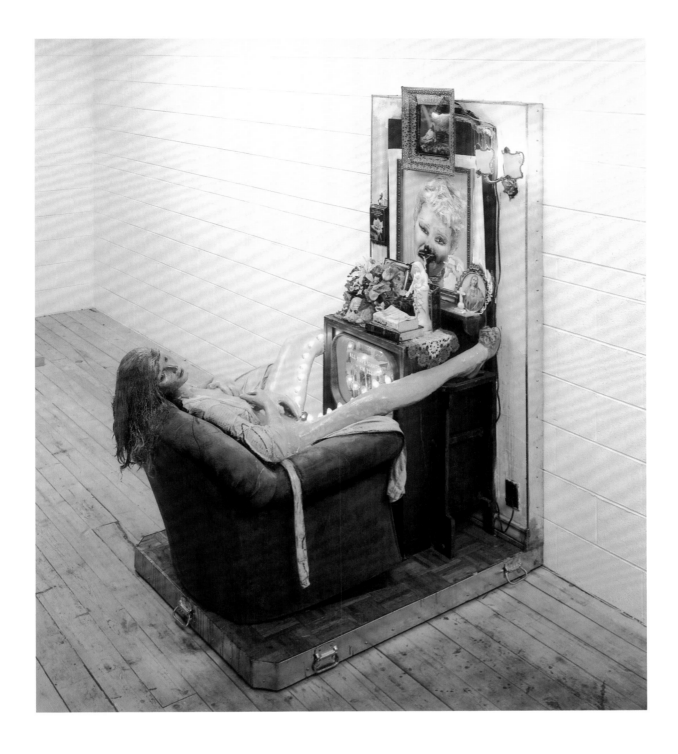

Ed Kienholz and Nancy Reddin Kienholz, *All Have Sinned in Rm.323*, 1992.
Plaster cast, wig, clothing, slippers, stuffed chair, television, lights, photograph, dolls, artificial flowers, paint and polyester resin, 201. 3 x 106.7 x 165.1 cm.
Collection of Nancy Reddin Kienholz, courtesy L.A. Louver Gallery, Venice, California.

Here is television viewing with a difference, as Kienholz and Reddin hit at three targets simultaneously: they equated tele-evangelism with masturbation; they attacked the utter humbug of many of those who preach over the airwaves; and they ridiculed religious kitsch.

Clearly, the key to the installation is the nauseatingly fake shrine which forms its centrepiece. At its heart is a large photograph of the American television evangelist and singer Tammy Faye Bakker. In the 1980s she and her then-husband, fellow-evangelist Jim Bakker, caused outrage when it emerged they were living hypocritically in enormously affluent style upon the proceeds of their television preaching, and that Jim Bakker had committed major fraud in order for them to do so. As a result he was eventually sentenced to forty-five years in prison (although that penalty was subsequently reduced to eight years on appeal). It might well be that Kienholz knew Frank Zappa's 1988 song *Jesus thinks you're a jerk*, which attacks such tele-evangelists, although the sculptor had always deprecated the hypocrisies of religion anyway. It is therefore unsurprising that he regarded Tammy Faye Bakker as representing everything false about Christianity in America. The girl lies back apparently sated, with her brightly lit legs straddling the television as though offering up her most private parts to it. On the box sits a small toy dog, its eyes agog at what it sees.

Tony Cragg, *Zooid*, 1991.
Steel bins, two sand-blasted porcelain statues, 93 x 37 x 30 cm each.
Courtesy Lisson Gallery, London.

Cragg possesses a strong sense of metaphor, as this work demonstrates. After obtaining two expensive, commercially-produced life-sized porcelain replicas of leopards – the kind of kitsch often found in interior decorator's shops – he then broke them into shards, which he placed within a pair of steel industrial containers. By entitling the work *Zooid*, he necessarily generates associations of the way zoos can curb animal behaviour, especially as the wiring of the containers suggests the bars of a cage. And by placing reminders of animal life within industrial containers, Cragg also communicates a point about the relationship of the natural world to industrialisation more generally. Naturally, in all this his attitude towards sculptural kitsch is made brutally clear.

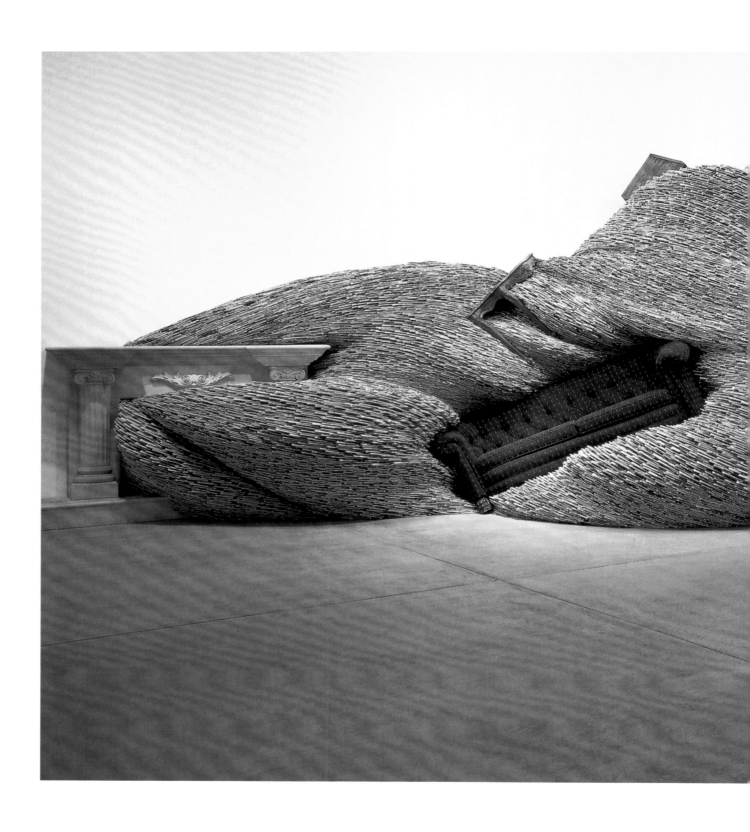

David Mach, *Fully Furnished*, temporary site-specific installation at the Museum of Contemporary Art, San Diego, California, between 29 January and 7 April 1994. Newspapers, fireplace mantel, sofa, surfboard, baby grand piano, tanning machine, table and other items of wooden furniture, painting, plastic stallion, approximately 3.6 metres high by 9.1 metres long.

Among the large number of temporary, site-specific installations made by David Mach using various types of materials were a replica of a Volkswagen car fabricated out of German yellow-page telephone directories, which was created in Dusseldorf in 1982; a semblance of a Polaris submarine formed from rubber tyres, which was assembled in London in 1983; and a mock-Doric temple created out of tyres placed atop a mini-Acropolis constructed out of shipping containers at Leith Docks in Edinburgh, Scotland, in 1994. But the majority of Mach's more ambitious works have been composed of thousands upon thousands of pristine, folded newspapers and magazines, amid which he has introduced other kinds of objects.

This is a typical example of such a construct. For the work Mach toured San Diego borrowing or purchasing whatever took his fancy from shops, garden centres and the

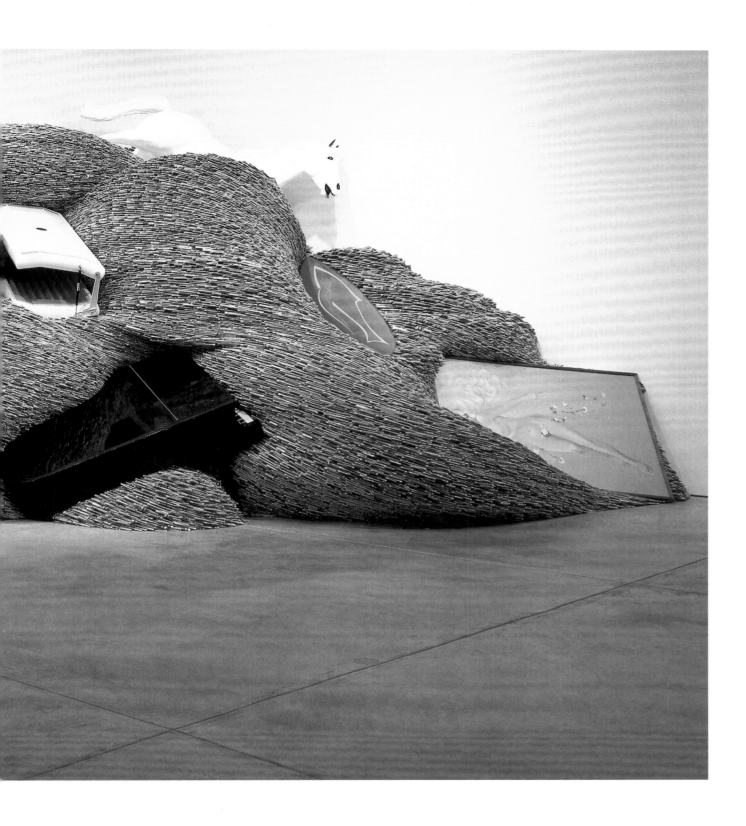

like. The newspapers were Sunday editions of the San Diego *Union-Tribune*, and in total they weighed 14,224 kg. They were supported internally by a core of around 200 wooden pallets. The newspapers were not chosen merely for their physical qualities. Instead, they were intended to act as metaphors for the media bombardment of our age, as Mach has made clear:

> It's no mistake [many of my sculptures] are made with tons and tons of magazines and newspapers, both of which come at us everyday in their zillions, in a bombardment of information. They are like the physical manifestation of the airwaves, messages in the ether become solid. A kind of junk-mail hell or internet highway pile-up.

The San Diego ensemble evoked some stylish but deranged home. As in similar installations made elsewhere, the newspapers appeared to swirl with abundant rhythm and energy around and across the various objects placed amongst them. Mach included the plastic rearing stallion because it epitomised Californian artificiality, while the surfboard understandably introduced local associations. The large kitsch painting of a nude blonde female originally hung on the ceiling of a barber's shop to provide its customers with something to think about as they raised their heads to be shaved.

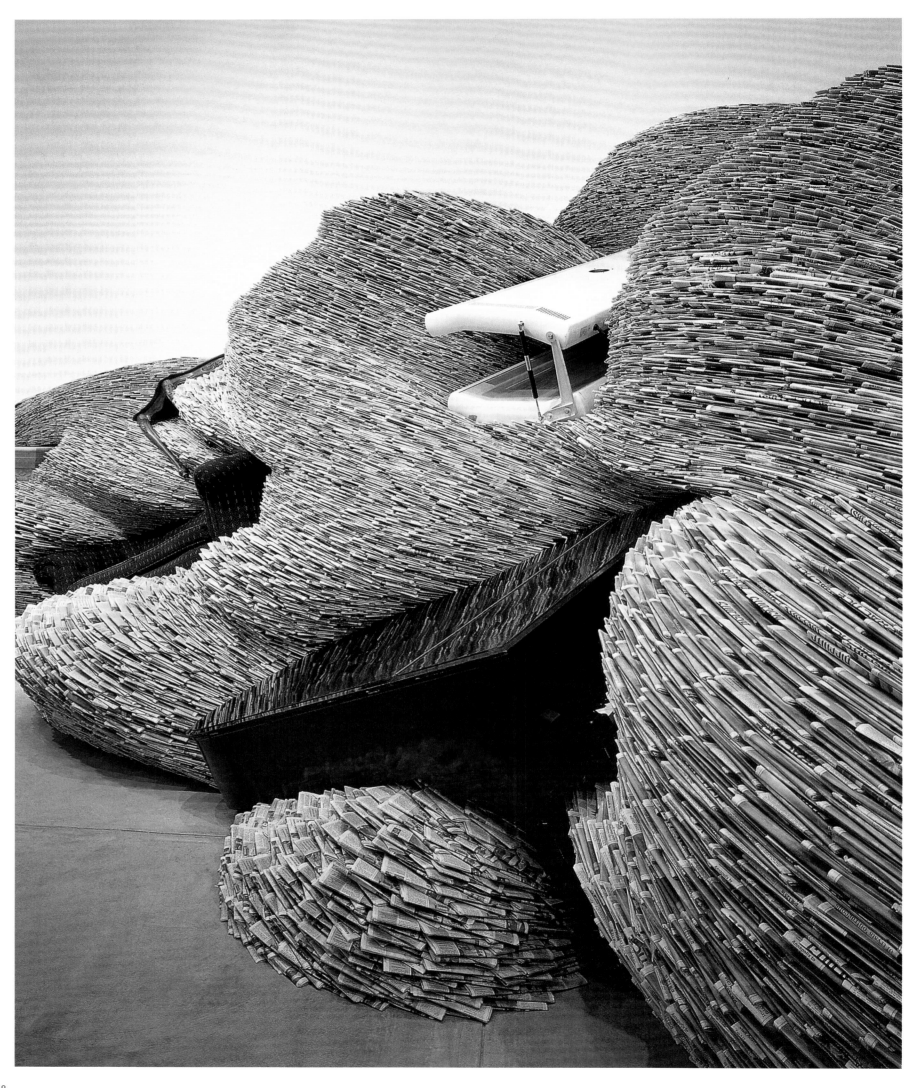

Arman, *Hope for Peace,* war memorial, 1995.
32 metres high, eighty-three T-34 tanks, howitzers, armoured personnel carriers and other combat vehicles, 6000 tons of concrete. Ministry of Defense, Beirut, Lebanon.

Form fuses totally with content here, as Arman used the actual weapons of war to commemorate its victims on a massive scale. The memorial was inaugurated on 2 August 1995. With its triangulated shape and great height, it is reminiscent of some ancient ziggurat. Once again, and perhaps more potently than ever, Arman employed mass-produced objects to generate all kinds of associations concerning the productiveness and wastefulness, energy and ambition, and inventiveness and destructiveness of modern man. The work demonstrates most vividly how the concern with contemporary life as expressed through its mass-produced artefacts still flourishes long after it first surfaced artistically in the late-1950s. What better monument could there be to the twentieth century, the most brutal and yet most affluent period in history to date?

Olafur Eliasson, *The Weather Project,* temporary site-specific installation, Tate Modern, London, 16 October 2003-21 March 2004.
Semi-circular steel frame 14 metres in diameter supporting 204 mono-frequency lamps, with a second semi-circular frame stretched with projection-screen material 15 metres in diameter placed in front of it; 285 mirrors, each 1.5 x 5.75 metres covering just over 3000 square metres and attached to a suspended ceiling secured to existing roof trusses; haze created using a glycerine/sugar-based, colourless, odourless chemical mixed with water, pumped by means of sixteen time-regulated hazer machines.

Olafur Eliasson was born in Copenhagen, Denmark, of Icelandic parentage in 1967. He studied at the Royal Academy of Arts in Copenhagen between 1989 and 1995. In 1999 his reputation was established by two works, one exhibited in Dundee, Frankfurt and Wolfsburg, the other in Los Angeles, Milan, Turin and Reykjavik. Since then he has held solo shows in Iceland, Europe, Japan and the USA. He has also participated in several group exhibitions. In 2003 he represented Denmark at the Venice Biennale.

Eliasson has described his works as 'phenomena-producers', to which end he has tinted a river, made rainbows, created artificial rain, covered museum floors with several tons of igneous rock imported from Iceland, and also carpeted gallery floors with ice. *The Weather Project* partly grew out of discussions with the director of Tate Modern, as well as with the Swiss architects responsible for the museum. Naturally, it was also inspired by the vast space Eliasson had to deal with, namely the Turbine Hall of Tate Modern. As its name indicates, this had originally served as the engine room for the huge turbines which provided electricity between 1963 and 1981 for the Bankside Power Station, the building that now acts as Tate Modern. That creation of electricity in the space further influenced Eliasson's formation of a disc resembling the sun, which in reality was a semi-circular arc made out of brilliant yellow/orange mono-frequency lights usually employed for street-lighting. The semi-circle was turned into a full circle by mirrors fixed to the entire length of the Turbine Hall's ceiling. In the hall below, a smoky haze intermittently issued from the walls at periods determined by the artist. As it was possible to walk behind the 'sun' to see the array of lamps forming it, an awareness of process constituted an integral part of the sculptural statement.

Above all else *The Weather Project* gave visual expression to Eliasson's belief that "The weather has been so fundamental to shaping our society that one can argue that every aspect of life – economical, political, technical, cultural [and] emotional – is linked to or derived from it." His controlled environment was probably the most popular work of contemporary art ever to have been created in London, for during the six months or so it was on display well over two million people went to see it, of whom it may safely be supposed that a large proportion never usually look at contemporary art. And the many visitors not only looked at the work – they also lay on the floor, arranging themselves or joining hands and feet with others to make figure-patterns reflected by the mirrored ceiling way above them. This possibility of interaction with the installation was a major cause of its popularity, as was the simulation of a sun that is only rarely and bleakly seen during a London winter. Then there was the huge scale of the piece, with its link to the sublime expanses often represented by British landscape painters.

It must be doubted that more than a tiny percentage of people who went to see *The Weather Project* had much notion that the work dealt with meteorological issues, for a false sun, a mirrored ceiling, a little haze and some slight documentation distributed freely to visitors were hardly capable of summoning forth such complex considerations. Far from giving any thought to the weather, most viewers clearly wanted just a hedonistic visual experience, which they certainly received in abundance. But because of Eliasson's claim that "every aspect of life... is linked to or derived from" the weather, the work necessarily dealt with mass-culture. Moreover, the ensemble was undoubtedly aimed at a mass-audience by dint of the very space for which it was created, and equally it demonstrated that mass-culture can itself appropriate a work of art irrespective of its creator's intentions. Certainly *The Weather Project* made evident the deep, continuing need within our society for visual beauty on a majestic scale, let alone for art which enjoys the approachability that has always formed such a central feature of Pop/Mass-Culture Art during the entirety of its existence.

SELECTED BIBLIOGRAPHY

ALLOWAY, Lawrence, *American Pop Art*, New York and London, 1974

ALLOWAY, Lawrence and **LIVINGSTONE**, Marco, *Pop Art USA-UK*, Tokyo, 1987

ALLOWAY, Lawrence, *Roy Lichtenstein*, New York, 1983

AMAYA, Mario, *Pop as Art: The New Super-Realism*, London and New York, 1965

ARTHUR, John, *American Realism: The Precise Image*, Tokyo, 1985

BAILEY, Elizabeth, *Pop Art*, London, 1976

BENEZRA, Neal, *Ed Paschke*, New York and Chicago, 1990

CELANT, Germano, *Tony Cragg*, London, 1996

COMPTON, Michael, *Pop Art*, London, 1970

FRANCIS, Richard, *Jasper Johns*, New York, 1984

FRITH, Simon, *Art into Pop*, London and New York, 1987

GOLDMAN, Judith, *James Rosenquist*, New York, 1985

HASKELL, Barbara, *Blam! The Explosion of Pop, Minimalism and Performance 1958-64*, New York and London, 1984

LIPPARD, Lucy, *Pop Art*, London and New York, 1968, rev.1970

LIVINGSTONE, Marco, *Pop Art, A Continuing History*, London, 1990

PIERRE, José, *An Illustrated Dictionary of Pop Art*, Paris 1975, London, 1977, Woodbury Ct 1978

RUDD, Natalie, *Peter Blake*, London, 2003

RUSSELL, John and **GABLIK**, Suzi, *Pop Art Redefined*, London and New York, 1969

STITCH, Sidra, *Made in USA*, Berkeley, Los Angeles and London, 1987

TUCHMAN, Phyllis, *George Segal*, New York, 1983

VARNEDOE, Kirk, *Duane Hanson*, New York, 1985

WALKER, John, *Cross-overs: Art into Pop, Pop into Art*, London and New York, 1987

WALKER, John A., *Art in the Age of Mass-Media*, London, 1983

WOODS, Gerald, **THOMPSON**, Philip and **WILLIAMS**, John, *Art without Boundaries: 1950-70*, London, 1972

David Hockney, A Retrospective, exhibition catalogue, Los Angeles County Museum of Art, 1988

Kienholz, A Retrospective, exhibition catalogue, Whitney Museum, New York, 1996

Roy Lichtenstein, exhibition catalogue, Hayward Gallery, London, 2003

David Mach, London, 1995

Ed Paschke, exhibition catalogue, Pompidou Centre, Paris, 1989

Pop Art, exhibition catalogue, Royal Academy of Arts, London, 1991

INDEX